BIRDS
OF NORTH AMERICA

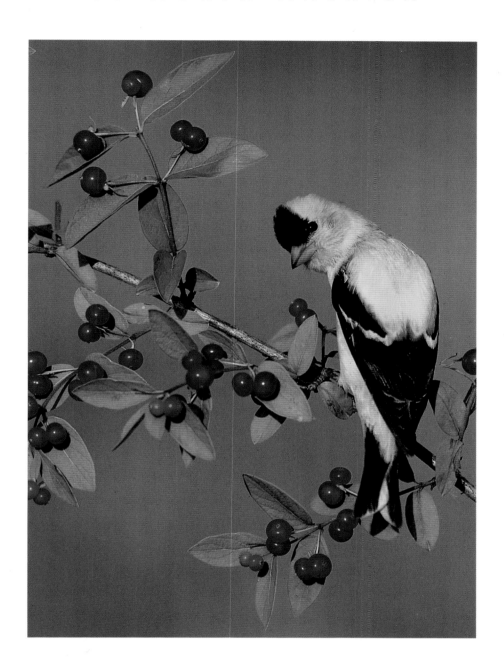

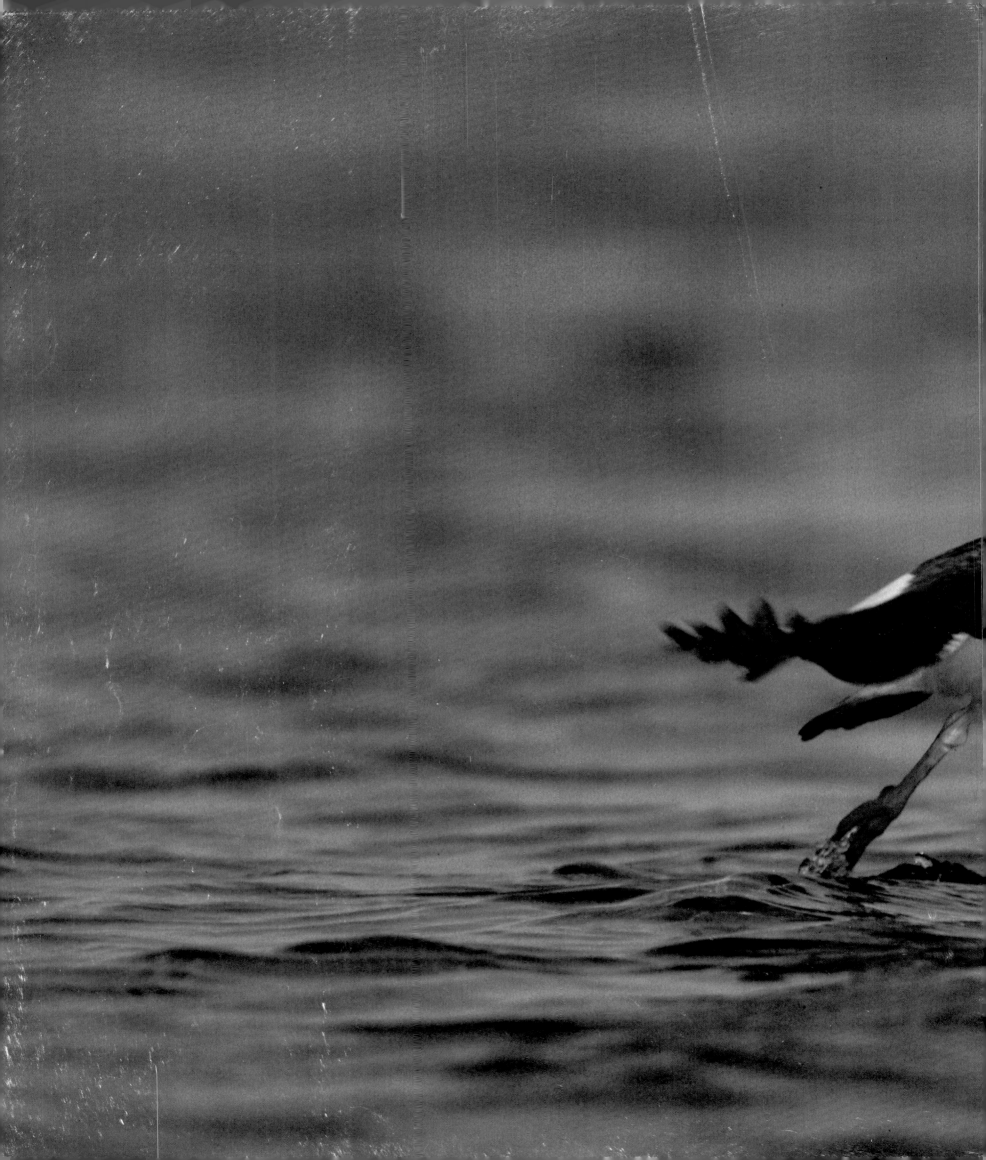

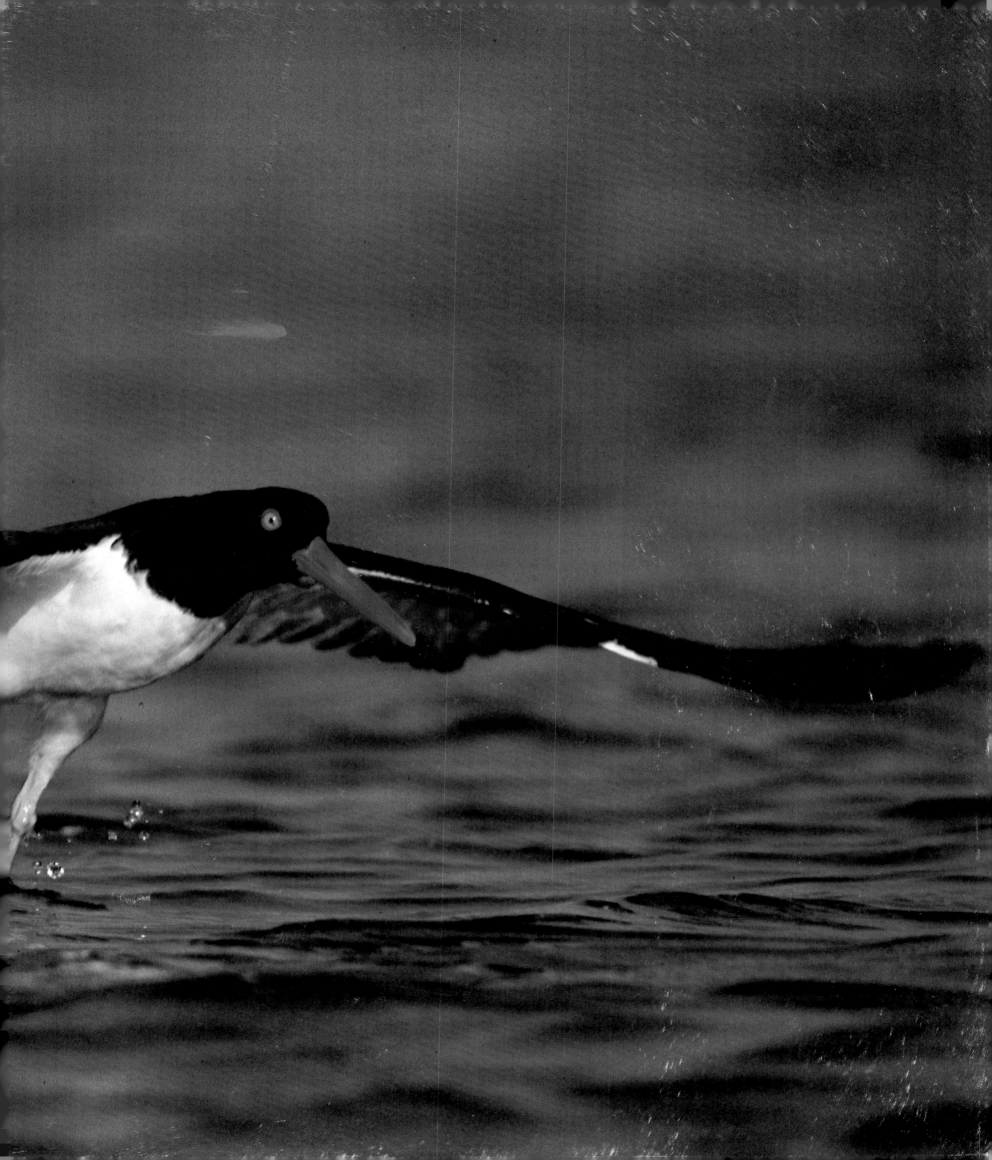

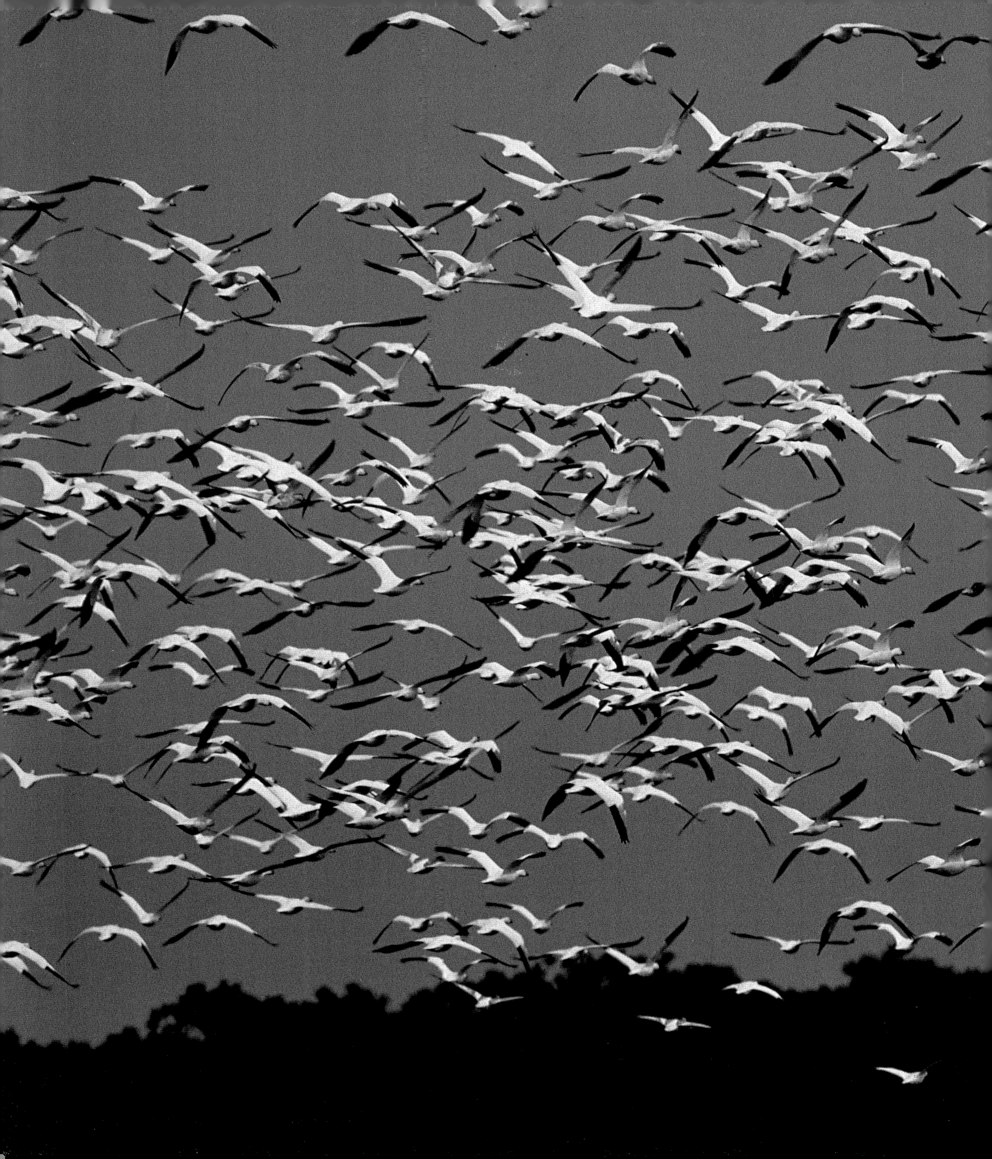

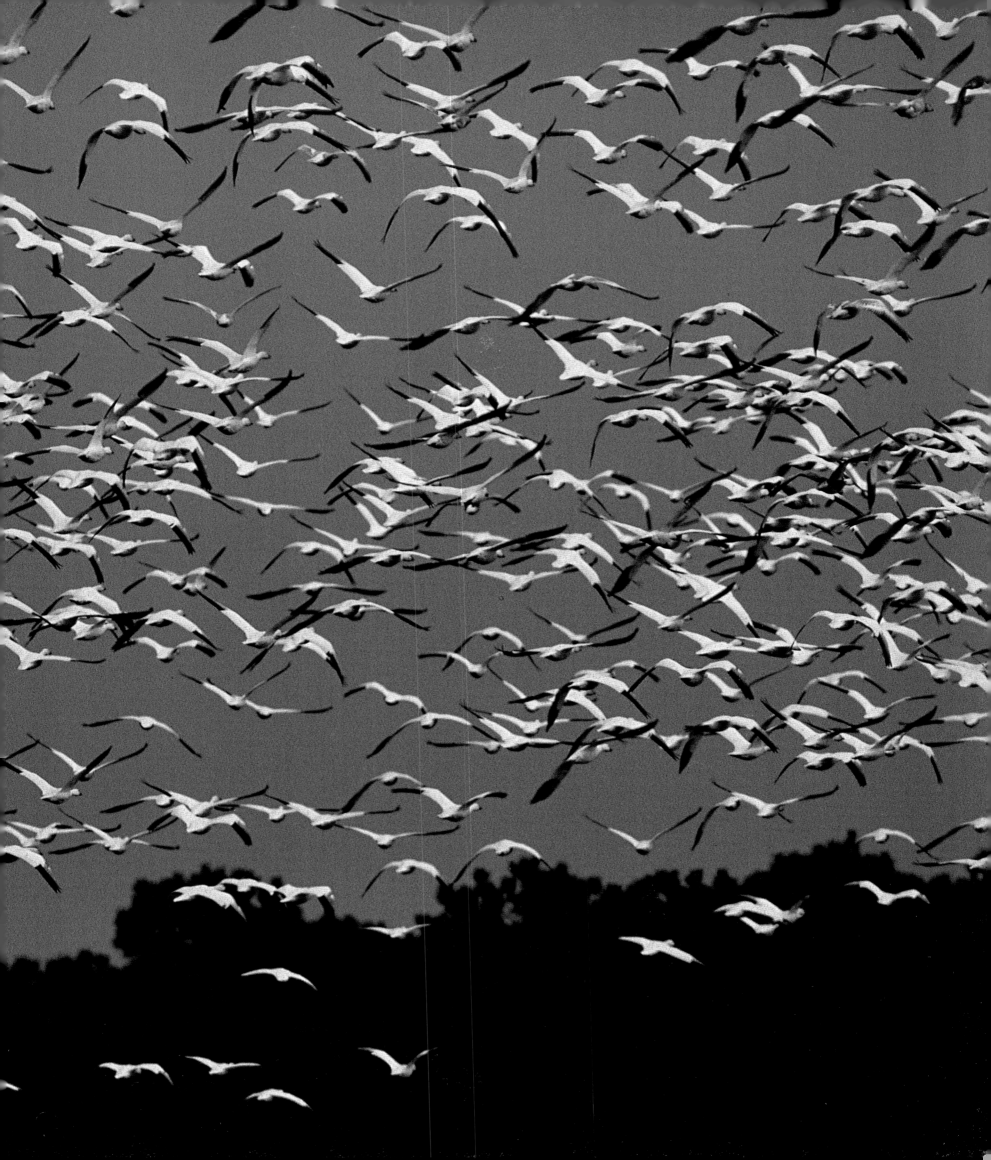

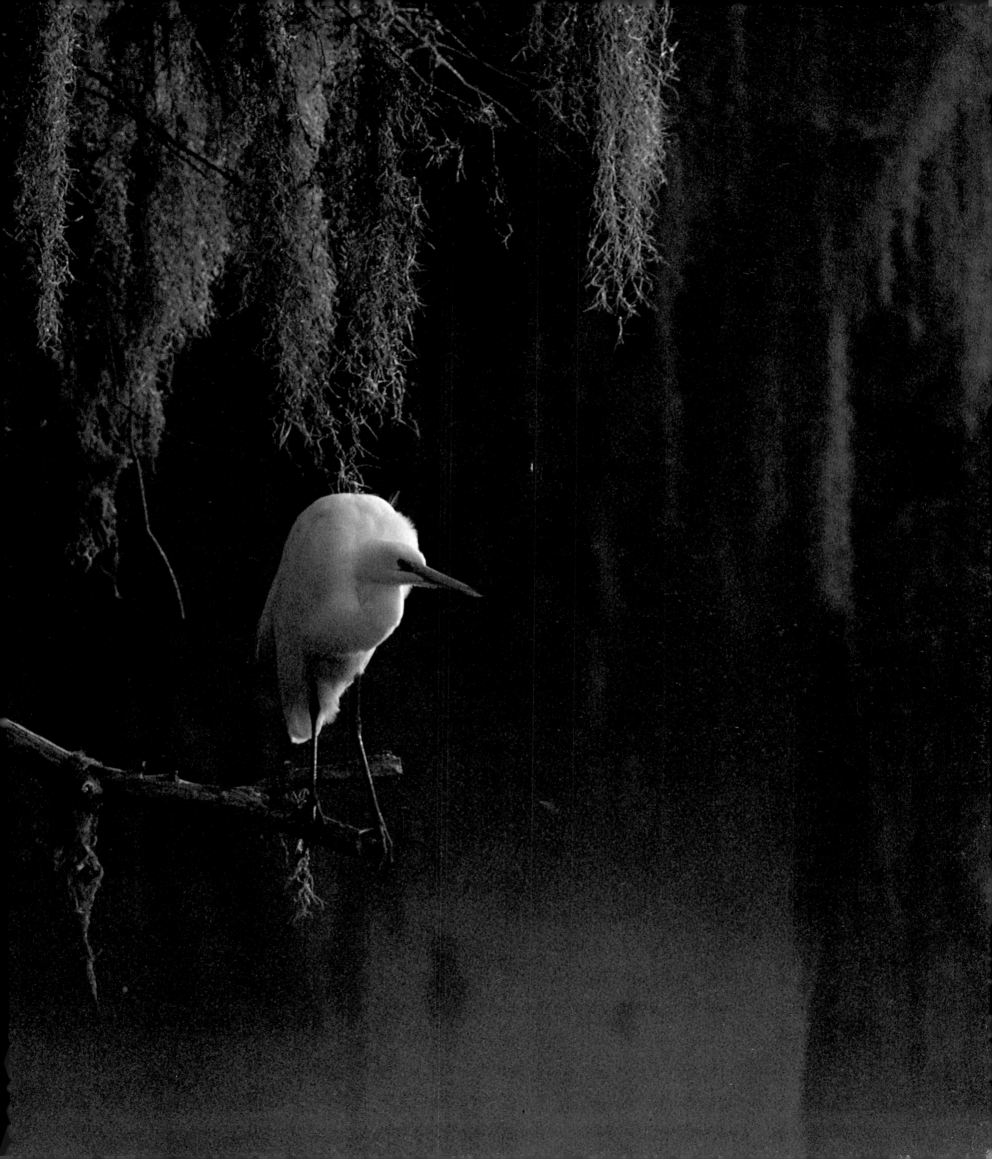

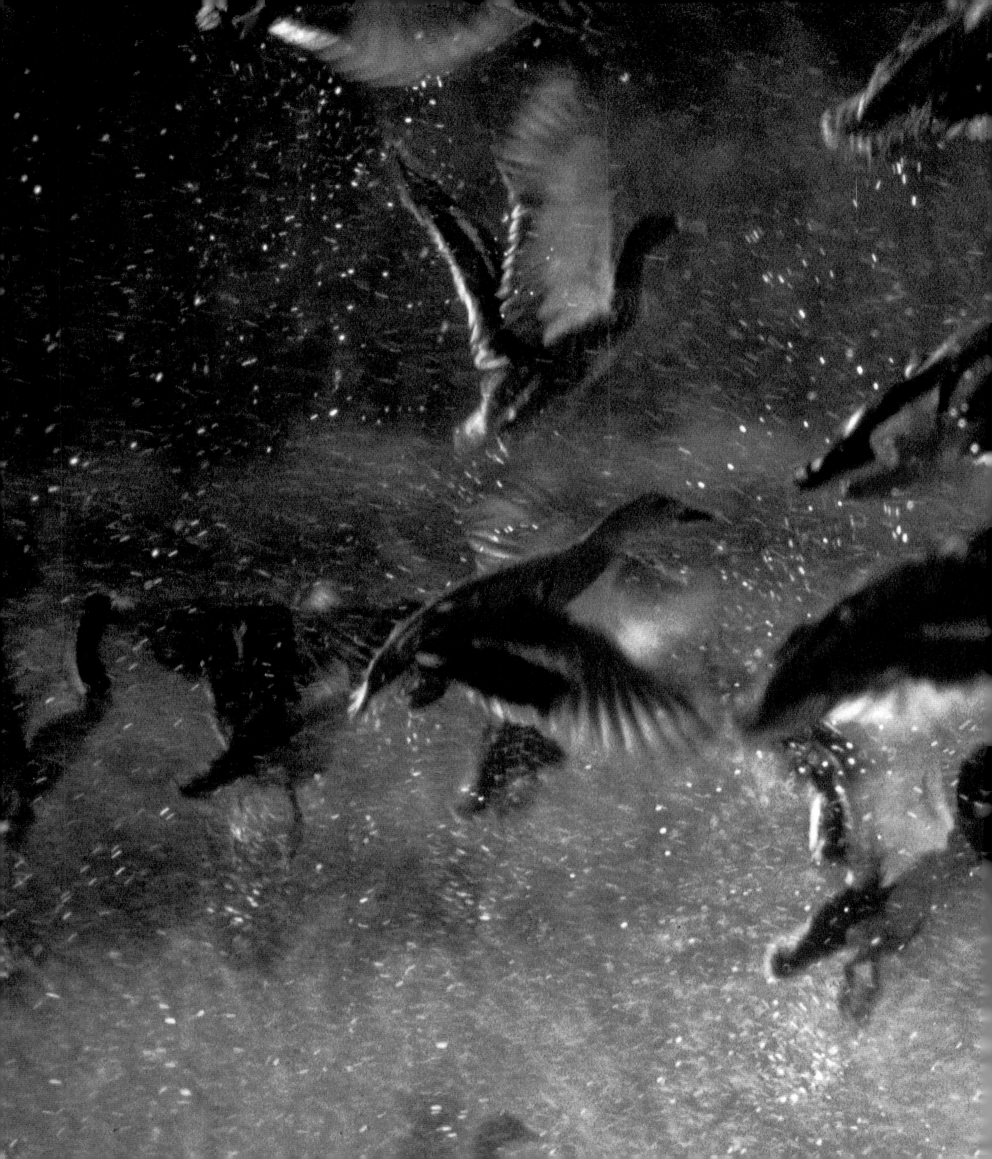

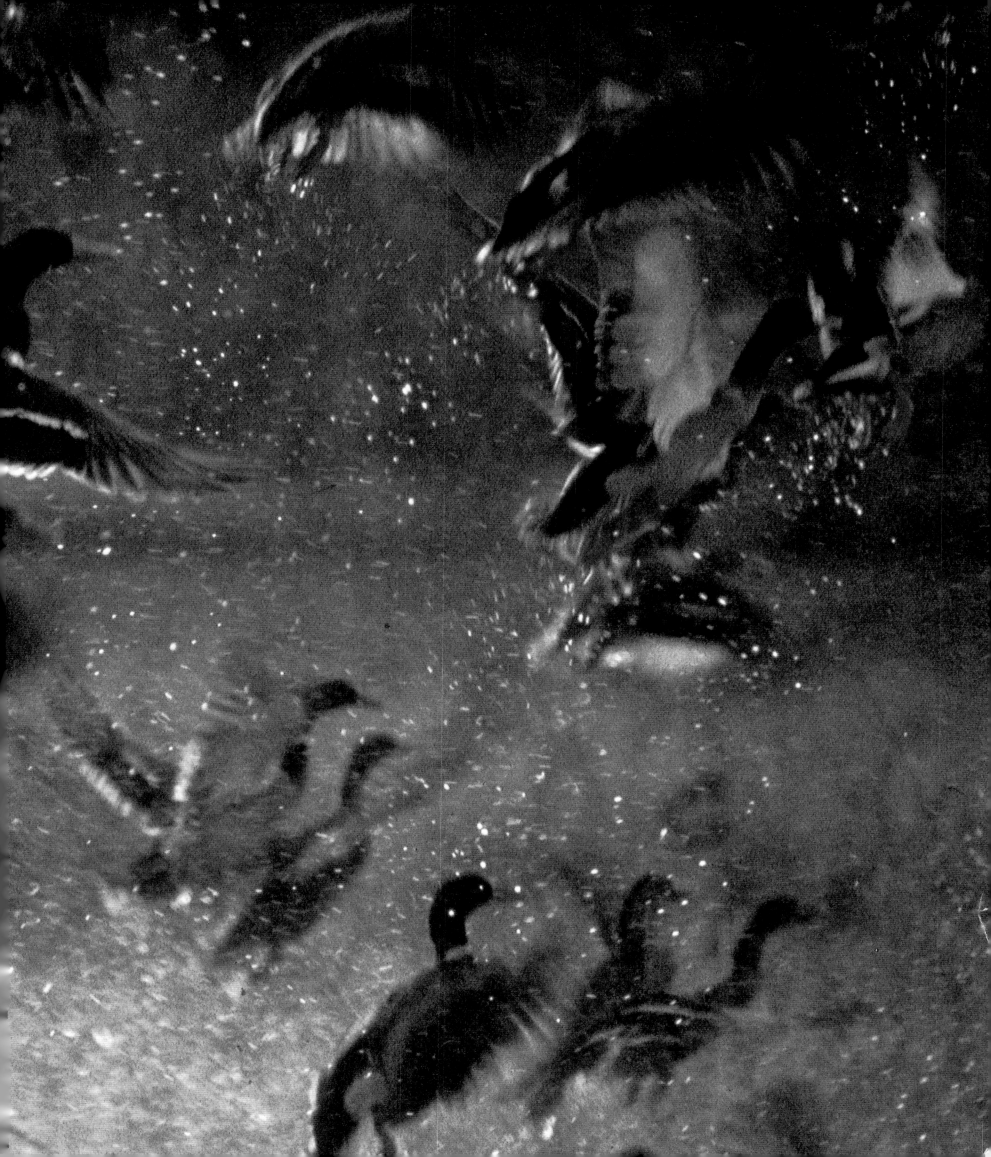

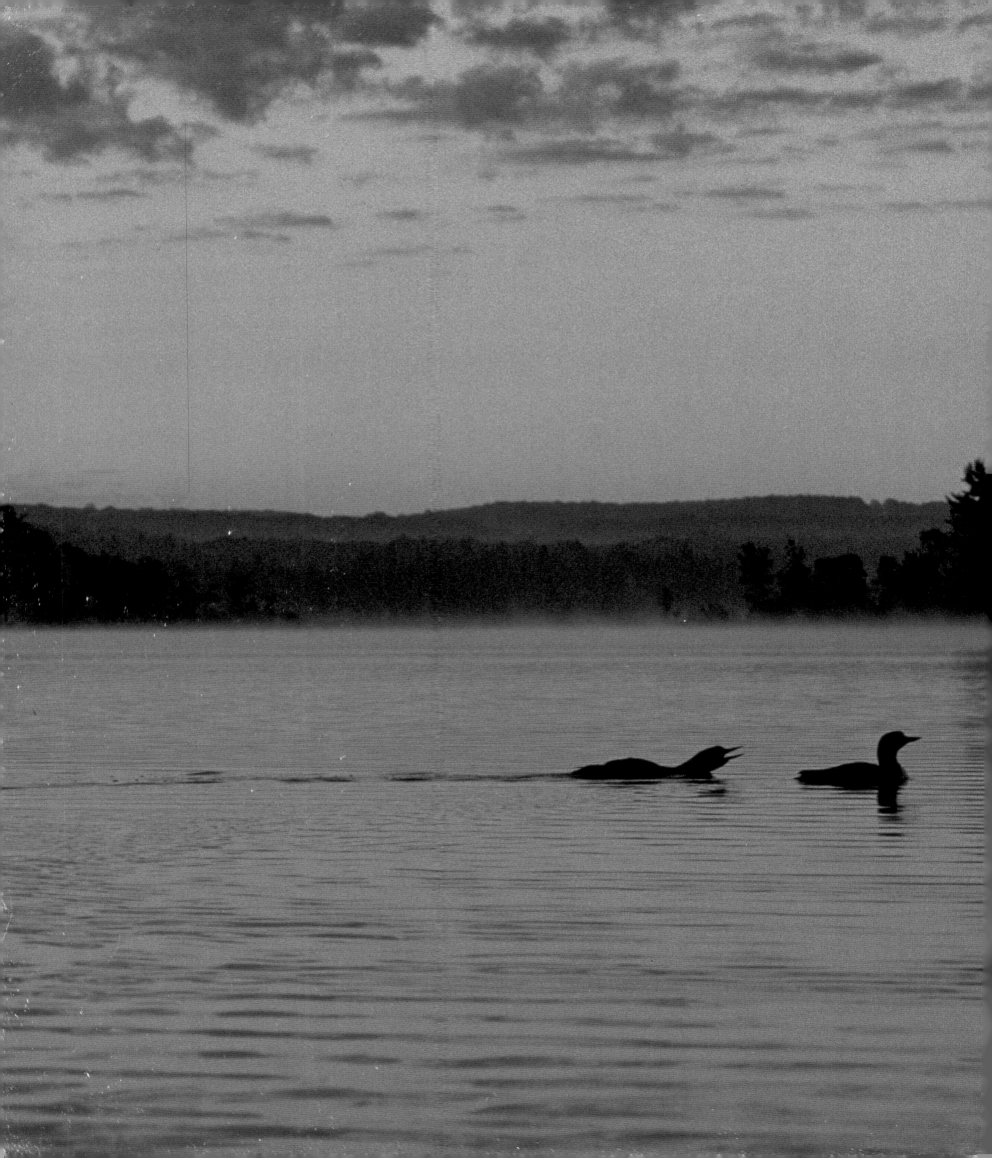

BIRDS

OF NORTH AMERICA

NOEL GROVE

BEAUX ARTS EDITIONS

Birds of North America
Copyright © 1996 Hugh Lauter Levin Associates, Inc.
ISBN 0-88363-363-9

PRODUCED BY

Charles O. Hyman, Visual Communications, Inc., Washington, D.C.

DESIGNED BY

Kevin Osborn, Research & Design, Ltd., Arlington, Virginia

ILLUSTRATIONS CREDITS

Abbreviations: (t) top, (b) bottom

ERWIN AND PEGGY BAUER

8-9, 67, 71(t), 72, 89, 101, 103, 106, 116–117, 152, 159, 164, 168, 170, 174–175,
184–185, 190, 201, 218, 222, 226, 226–227, 236, 236–237, 238(b), 242–243, 246

BATES LITTLEHALES

22, 23, 26–27, 29, 31, 36–37, 37, 38(t), 38(b), 42, 60, 69, 70, 73, 83, 84–85, 88,
104–105, 107, 119, 121, 122, 127, 128, 129, 137, 141, 143, 146–147, 162, 167,
171, 172(b), 173, 178(t), 181, 186–187, 194–195, 206–207, 210–211,
220–221, 223, 228, 230, 231, 233, 238(t), 245

KEITH LOGAN

16, 25, 32–33, 45, 48, 56–57, 58, 59, 66, 68, 74–75, 90, 96, 130–131, 132, 144, 145, 179

ROD PLANCK

46, 51, 53, 61, 76–77, 87, 97, 98–99, 110–111, 123, 126–127, 134, 150–151, 176–177, 178(b), 192, 205, 207,
208–209, 210, 212–213, 215, 220, 232, 234, 235, 240

CARL R. SAMS II

2–3, 6–7, 10–11, 18–19, 20, 40–41, 52(b), 54, 55, 63, 71(b), 92–93, 112, 124–125,
140, 148, 156, 160, 160–161, 163, 169, 172(t), 182–183, 197, 200,
202–203, 213, 214(t), 214(b), 239, 247, 252

ROB SIMPSON

Cover, 4–5, 13, 14, 39, 49, 52(t), 65(b), 81, 91, 100(t), 139, 149, 155, 165,
188–189, 199, 204, 216–217, 229, 241

GEORGE E. STEWART

1, 30–31, 34, 35, 43, 44(t), 44(b), 47, 50, 62, 64, 65(t), 78, 94, 95, 100(b), 102,
108–109, 142, 166, 180–181, 184, 186, 219, 224, 224–225, 244, 248–249

PRINTED IN HONG KONG

Left column:

Red and gray phases of eastern screech owl appear together in autumn foliage in Virginia.

HALF TITLE
Sunbeam bright, a male goldfinch ponders the berries of a pyracantha bush. Common in all the lower forty-eight states, the seedeater is widely known as the "wild canary."

PAGES 2-3
Food-gathering tool ablaze in the sun, an American oystercatcher prepares for take-off in shallow water. Namesake prey may be eaten by severing muscles that hold its tough shell shut. Large crabs are flipped on their backs and stabbed through the central nervous system.

PAGES 4-5
A blizzard of snow geese fills the air over Chincoteague National Wildlife Refuge in coastal Virginia. Continental populations of the white flyers are the highest they've been in a century.



PAGES 6-7
Spanish moss and fog set a somber mood as a great egret perches in a southern swamp. Black legs distinguish it from a white form of the great blue heron.

PAGES 8-9
Exploding mallards raise spray from the waters of Bosque del Apache National Wildlife Refuge in New Mexico. Pools fed by the Rio Grande draw thousands of waterfowl to this oasis in the Chihuahuan desert.

PAGES 10-11
A male common loon sounds off to its mate on a serene lake at sunrise. The haunting calls of these large water birds symbolize wild, northern country, but they will tolerate human presence if their nests are not disturbed.

PAGE 13
A jaunty neck scarf brightens the ruby-throated hummingbird, seen over most of the eastern United States. When hovering, the penny-weight bird's wings beat fifty-eight times a second, creating the sound that named it.

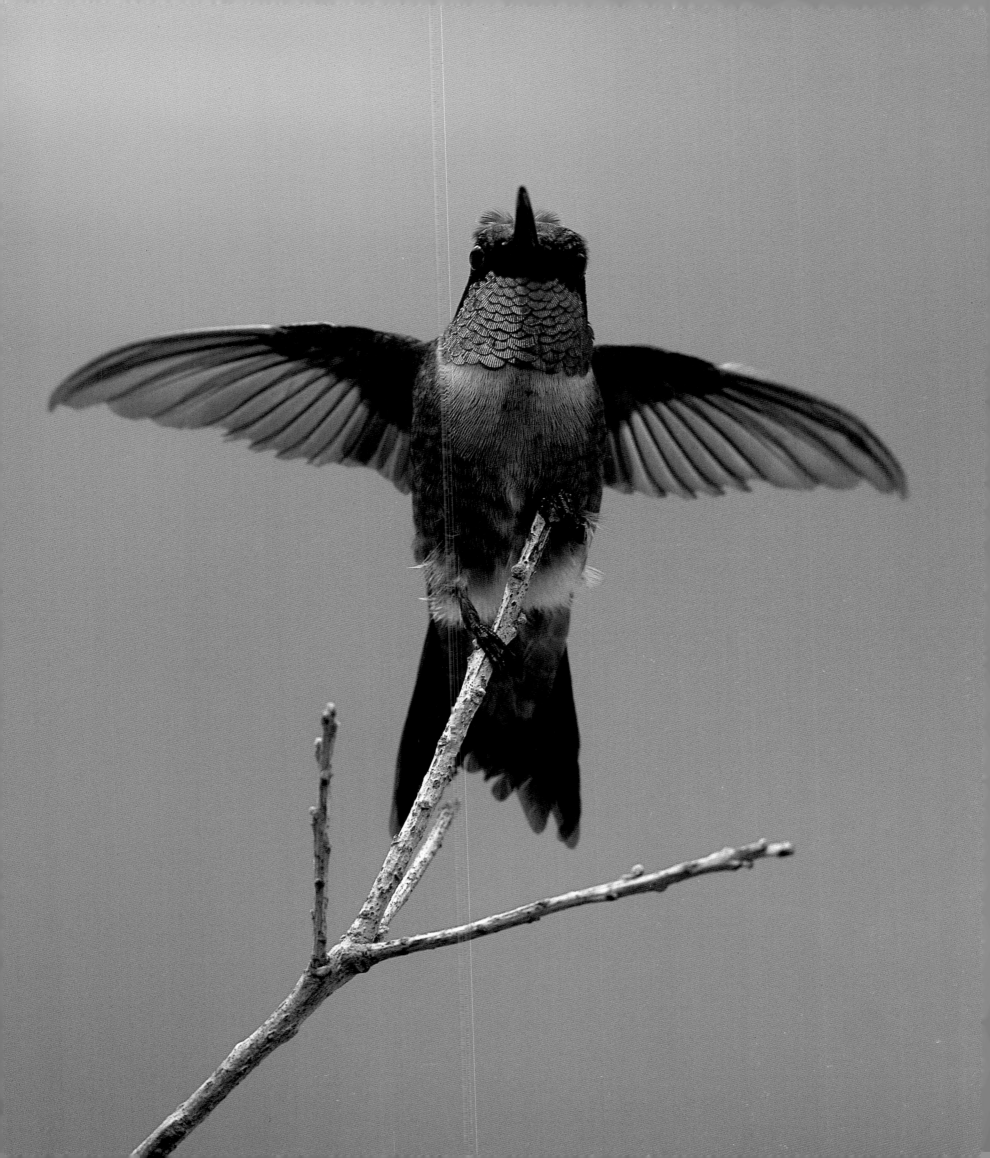

CONTENTS

A deadwood perch holds insects for a red-headed woodpecker, which also feeds on berries and acorns. Its drum roll drilling also carves nest holes in fence posts and dead trees.

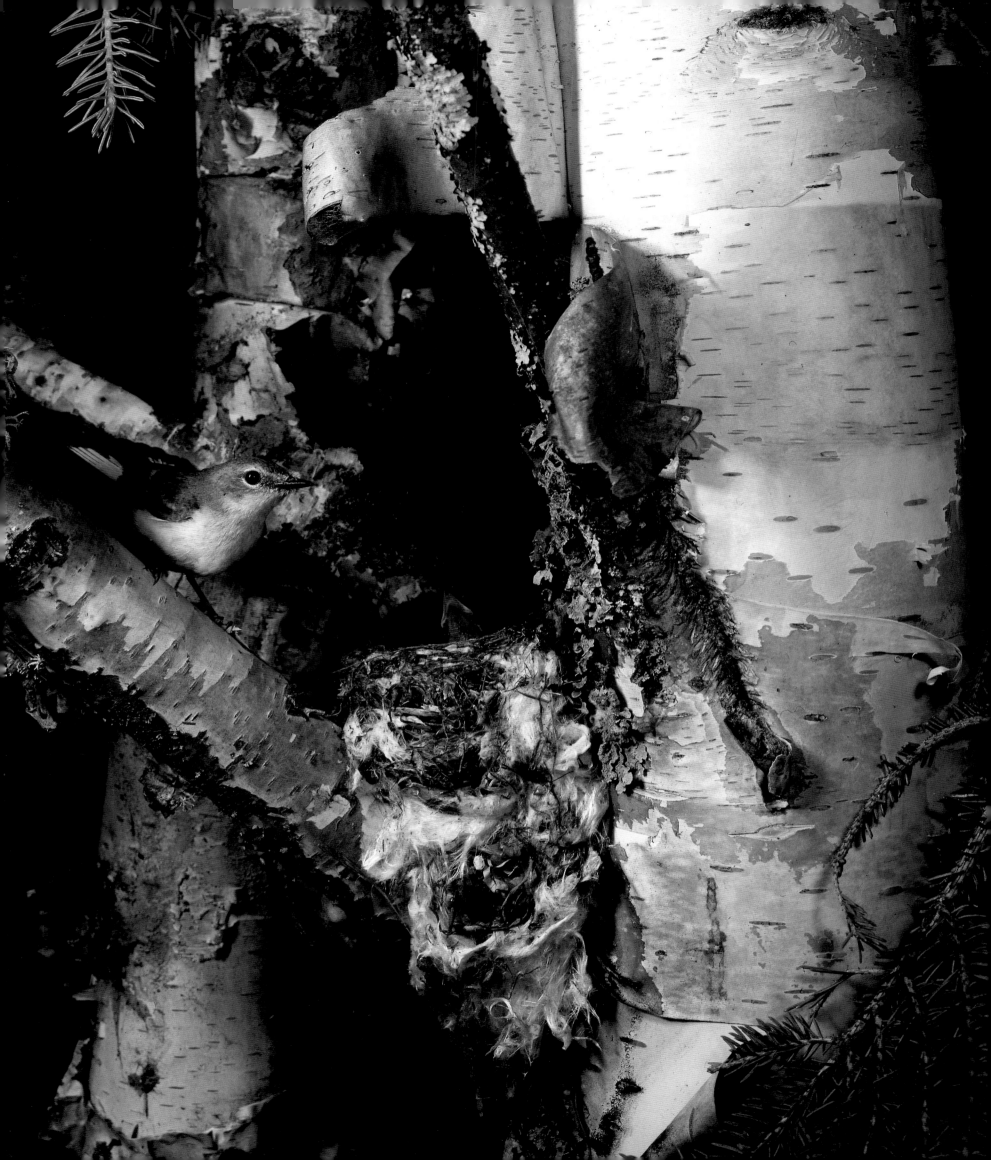

INTRODUCTION

Gossamer materials help camouflage an American redstart's nest in the fork of a white birch, where the female oversees a beseeching chick. Insect eaters, the adults are seldom still, constantly fidgeting, hopping from twig to twig and flitting through foliage in search of food.

THIS BOOK is a compendium of simple wonder, a collection of intimate portraits and details about a group of marvelous animals whose world we can never truly share. It does not claim to be an encyclopedia of all the known facts about North American birds. Nor does it picture and identify every single species seen on the continent. Plenty of other books do that.

Few of the photographs seen here depict birds in dramatic confrontation or performing spectacular feats or maneuvers. Instead, birds are seen being themselves, as we most often see them—seeking food, displaying finery, building nests, caring for their young, or simply pausing along journeys from one important place to another. Here are windows into their private lives, views we may ponder in ways denied us by their normal shyness and quick movements. Their elegance speaks for itself.

The emphasis in the text is on the remarkable nature of information about birds, not on volumes of information. The specific sound that a certain songbird makes is deemed less important than the mechanism by which many songbirds are able to sing so sweetly. A listing of the prey of each raptor takes a back seat to information on how raptors locate and capture their meals. Like the quiet photographs, the straightforward facts about birds are often astounding. Sparrows have more neck joints than giraffes do. Owls catch mice they can't even see. The abundance of waterfowl in the Chesapeake may have saved Jamestown.

We have not followed the traditional classification of birds, the class Aves with its twenty-seven orders and the orders with their numerous families. The six chapters of this book group birds more informally, according to their functions, or ways of life. There is no ornithological group known as "Specialists," but we think the functions and habits of certain birds so amazing as to deserve singling them out.

The contributors to this volume do not claim to be ornithological authorities, although such experts reviewed the contents, commenting and making suggestions before publication. For this we are grateful to many, but especially Dr. George F. Watson, formerly with the Smithsonian Institution, and Dr. Jerome A. Jackson, of Mississippi State University. What the photographers and the author share is a fascination with the mysterious, often spritely, and frequently beautiful creatures we call birds. They preceded us on this planet by millions of years and they continue to live all around us, and yet it is amazing how little we know about them. We hope this book tells you more about our lifelong neighbors.

Noel Grove

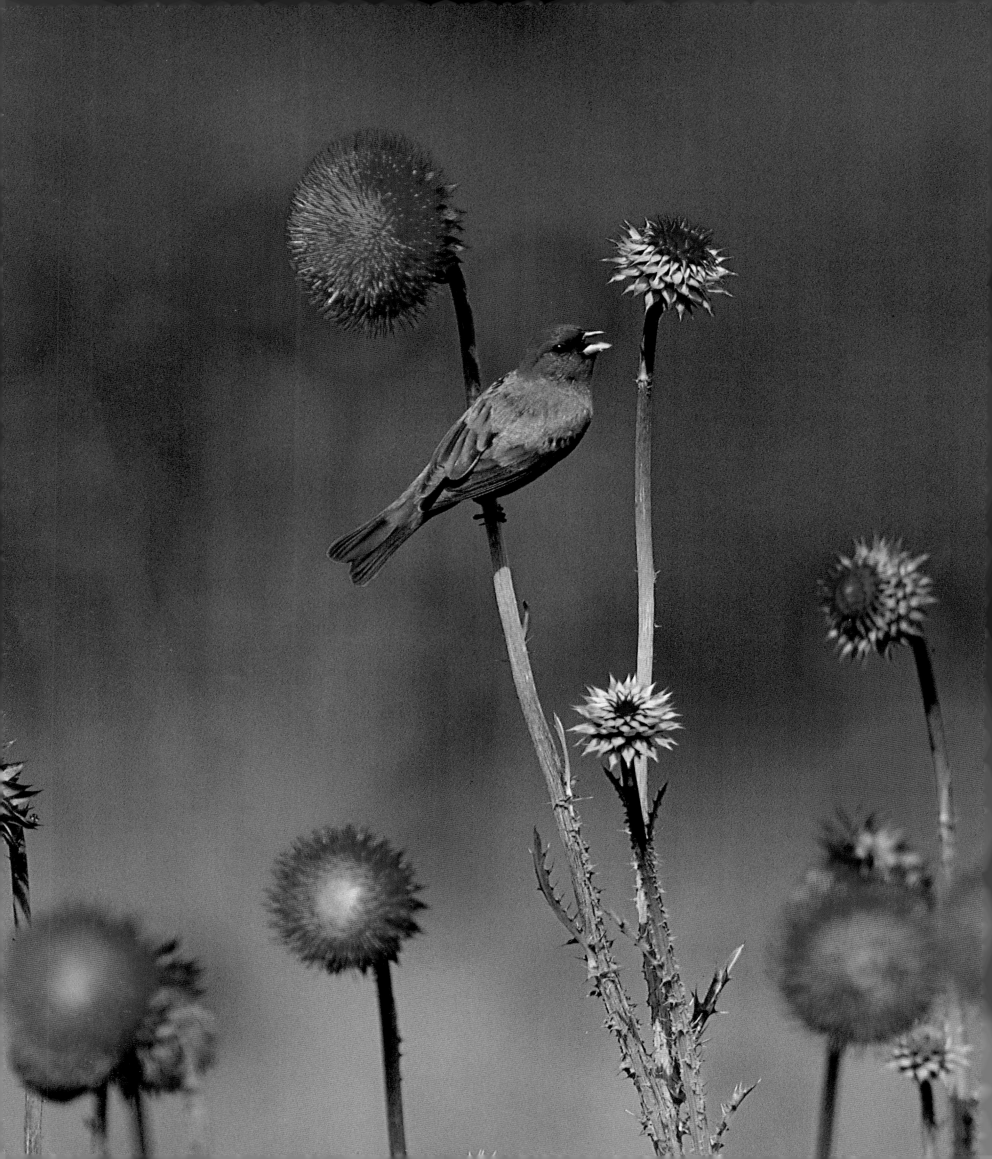

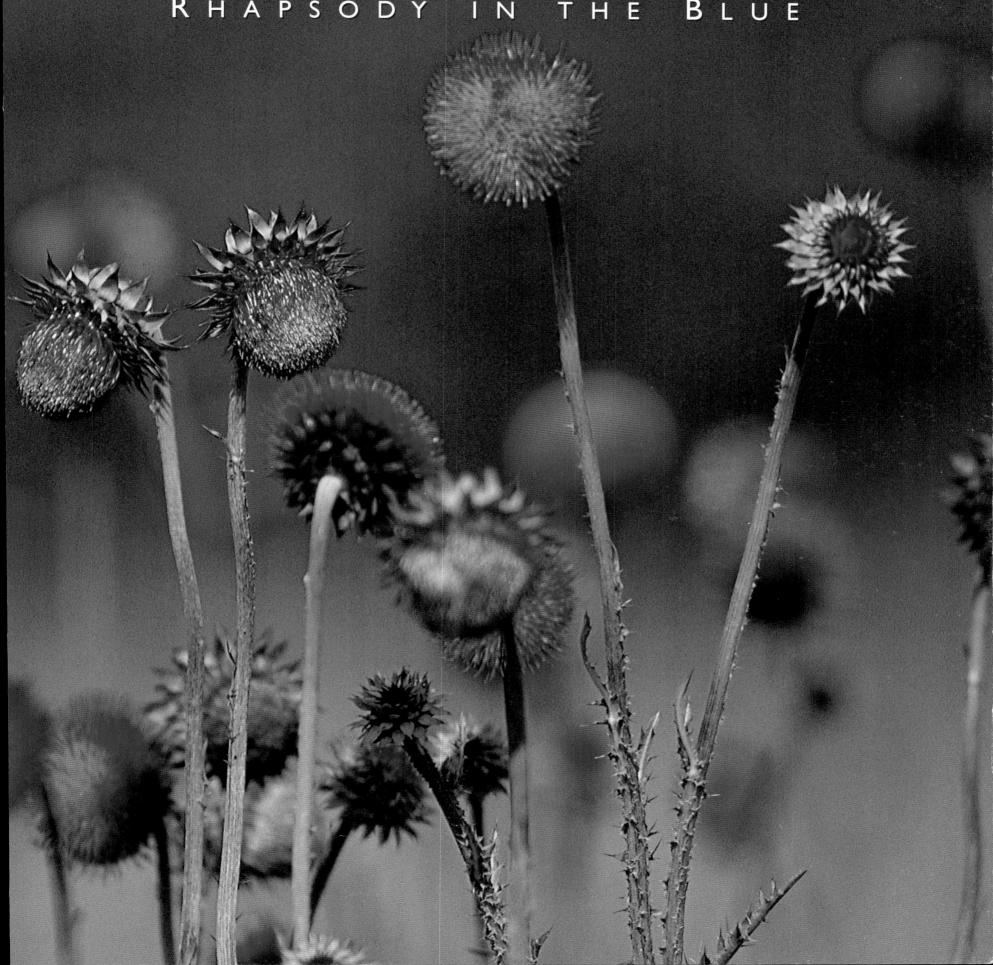

SONGBIRDS

RHAPSODY IN THE BLUE

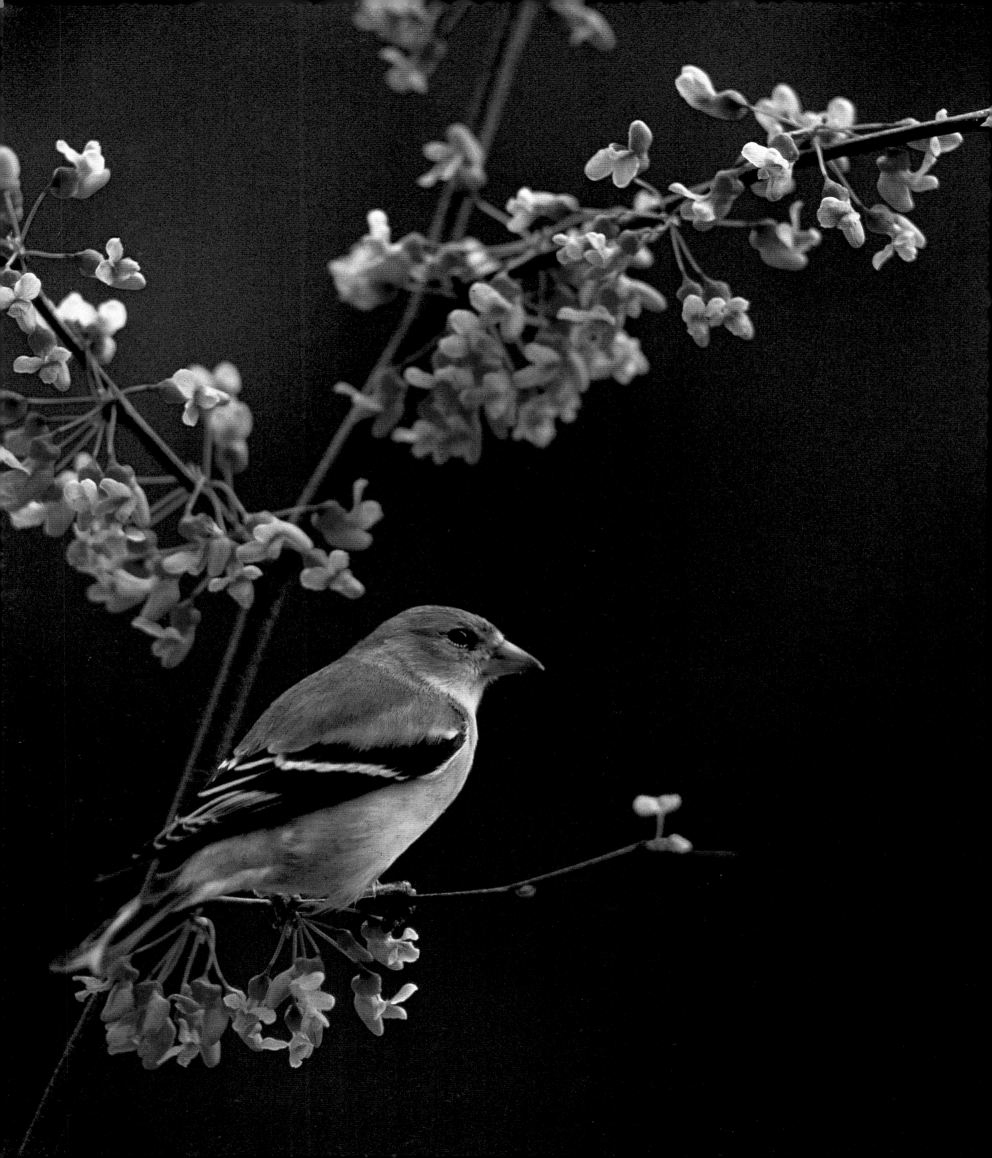

SONGBIRDS

RHAPSODY IN THE BLUE

In a redbud bower a female goldfinch awaits enticements from a potential mate. Songs of seduction and warnings to rivals fill the air over North America in spring as songbirds pair up for nesting. Singing is heaviest during the morning and evening hours, although a few species sing all day.

PAGES 18-19
Singing and swaying, a male indigo bunting serenades amid nodding thistle heads. Most songbirds are vigorously tuneful only during spring breeding, but the deeply blue male continues singing well into August. The female is dull brown with subtle streaks on the breast. Oncoming winter drives indigo buntings to the subtropics.

YOU MAY NOT SING LIKE A BIRD, eat like a bird, or be free as a bird, but you probably share more with the feathered world than you realize. Sometimes our behavior ties us closer to birds than to many mammals that we consider more similar to us. "Like us, birds are active during the day, while many mammals are not," says Jerome Jackson, ornithologist at Mississippi State University. "Birds mirror our own aspirations about parenthood, seeming to be attentive and caring about their young, when of course they are merely acting on instinct. They often come willingly to environments created by people, and take food we provide for them. Mammals tend to see in black and white but like us, birds have color vision and often use it to select ripe fruit. And they sing, which gives us pleasure."

Songbirds make us better people, a notion based on unscientific evidence. More rare than Kirtland's warbler is the serious birder with a bad disposition. Those who seek to know about creatures addicted to singing and flying seem to find their own earthbound existence more agreeable. Bird sounds have been part of wilderness therapy offered to convicted young inner-city felons, with positive results observed. Consider Robert Stroud, the birdman of Alcatraz, a violent man who kept canaries, studied them, and discovered gentleness in their company. Stroud's *Digest of the Diseases of Birds* is considered a pioneering classic in ornithology.

Millions of caged finches—particularly canaries—should be evidence enough of the calming effect of avian melody. The practice of capturing and caging wild birds dates back at least to the ancient Greeks. Flying free, birds are our most visible and audible contacts with the natural world of wildlife. In North America, except in extremely desolate places, it is almost impossible to go more than a few minutes without seeing or hearing them.

Nearly 800 species regularly own the air over the United States and Canada. Some are moving gems, like our hummingbirds, goldfinches, and lapis-colored bluebirds. The painted bunting with its broad strokes of purple, green, and red seems a kindergartner's fantasy of what

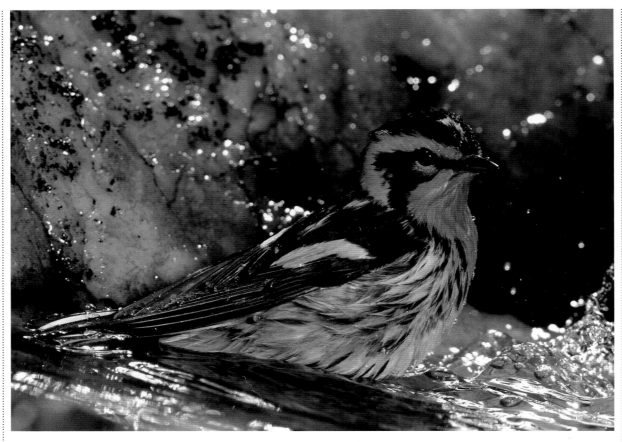

Freshening up, a male Blackburnian warbler splashes water on itself. When pools are not available, warblers dampen themselves by flitting among wet leaves. Wintering in the tropics, a Blackburnian will ally itself with a flock of another species, driving away others of its own kind if they try to join.

a bird should be. Many birds lacking in beauty make up for it in song. A host of wrens and numerous types of sparrows— "little brown jobs," or LBJs, as birders call them—provide the nearly unseen symphony we hear when we step outdoors. Without it, the continent would be a dismal place.

Just as most people talk but not all convince, most birds vocalize but not all sing. A crow emits a number of meaningful calls but we do not consider it melodious. Our New World vultures merely hiss, growl, and croak. The sheer complexity and melodiousness of sounds from the songbirds, on the other hand, register on our brain as pleasant music. Haydn, Vivaldi, Liszt, and Beethoven have tried to duplicate bird sounds in their symphonies, and twentieth-century composer

Oliver Messiaen has incorporated bird calls into ten of his major works. The poet's debt is even greater. Keats, depressed over the death of his brother Tom, envied the carefree song of the nightingale that *singest of summer in full-throated ease.* Shelley observed that the skylark seemed to be pouring out its heart, *Like a Poet hidden in the light of thought.*

On our side of the Atlantic were different birds and different poets, but the same effect. Walt Whitman listened to the mockingbird's varied tunes along the ocean shore, imagined it mourning a lost mate, and put words to each separate song that the mockingbird copies from other species. The result, in *Out of the Cradle, Endlessly Rocking,* was feathered free verse:

O madly the sea pushes upon the land,
With love, with love.
O night! do I not see my love fluttering
 out among the breakers.

No other living things sing as sweetly or possess such a sound system as the songbirds, which comprise roughly half the species in North America. Our "voice box," the larynx, is situated at the top of the trachea, or windpipe. A bird's voice box, or syrinx, is at the bottom of the trachea, at the point where the bronchial tubes split to go to the lungs. The location at the base of the trachea instead of at the top has a trumpeting effect, the difference between playing a trumpet and playing a trumpet's mouthpiece. The volume increases with long-necked birds such as cranes and swans. An extreme example can be found abroad. The trumpet bird of New Guinea, capable of producing rich, bell-like tones, is only thirteen inches long but has a twenty-inch trachea that lies in coils inside its chest cavity.

Two tympanic membranes in the music-making syrinx vibrate as air passes over them, and muscles around them change the tension and shape of the membranes to create different sounds. The more muscles, the more varied the sounds that are produced. The croaking vulture has no muscles, geese have two, and the gifted songbirds have between five and nine. A series of air sacs outside the lungs can store a greater volume of air than the lungs alone could hold. Were Pavarotti so equipped with reserve air supplies he might sing the "La donna è mobile" aria in one breath, maybe two.

Birds sing as a way of communicating in the brush and foliage where they perch. They

Rivaling blossoms hanging nearby, a male indigo bunting bathes in a verdant setting. Bathing keeps feathers clean and tidy. Once wetted, many birds fly to a perch to dry off and groom themselves. Migrants to Mexico, indigo buntings are rare beneficiaries of forest destruction, eating seeds of grasses that replace trees.

send a variety of messages. A singing male may be warning other males to stay out of the area, or enticing a female into his boudoir. Once she's there the song may turn to one of seduction, and with their relationship consummated, later serve merely as an identifier and locator: "I'm over here, honey, in the hazel thicket." Although males usually do the singing, both male and female may declare their location, their territory, and their bond. Bluebirds, cardinals, and Baltimore orioles sing duets.

In temperate zones, singing is usually triggered by light, although a few nocturnal birds such as nightingales and mockingbirds sing at night. Lengthening days kick off a breeding—and therefore a singing—season. The intense chorus you hear in North America's spring consists of birds vigorously competing

for mates, luring in potential paramours, warning away competitors. Songs of both love and war fill the air, and are sung very persistently. A red-eyed vireo is on record as singing a total of 22,197 songs in one day.

Singing therefore goes on for many temperate months and with some species, even in winter. Some birds proclaim their territory long after mating. Fledglings emerge and begin practicing songs for their coming adult role. Finally, songs are trilled outside the territory or during migration, perhaps to keep birds in touch with others of their kind, perhaps just out of a sense of well-being.

For all our admiration of them, birds apparently evolved from animals that we seem to admire the least, the reptiles. Feathers are elongated scales, and birds and reptiles share other similarities, such as bone, muscle, and joint structure, blood cells, and egg type. The earliest complete skeleton of a bird, named *Archaeopteryx,* was found in Bavarian deposits approximately 150 million years old. Its bony framework resembled a small dinosaur, right down to a lizardlike tail and a mouthful of teeth.

One might imagine lizards millions of years ago in desperate attempts to escape predators, leaping off rocks or trees into space with legs outspread and discovering the ability to glide somewhat, by the parachute effect of extended scales. Eons pass, scales become softer and lighter, turn into feathers, legs move during the glide, and flying begins. Feathered bird it might have been, but *Archaeopteryx* was not well equipped for this new locomotion, with inadequate muscles and solid, heavy bones. Improvements came gradually, and

sixty million years ago there existed ancestors of many modern birds such as herons, ducks, hawks, and owls. Songbirds of some kind were trilling at least ten million years ago. Some no longer exist, but many species that we know today have had thousands of years to perfect their serenades.

Along with diversification came vast improvements in anatomy. The bony tail of *Archaeopteryx* was jettisoned, as were the heavy teeth. Many bones became fused together, making bird bodies more rigid than those of mammals. To compensate, the skeleton developed extra cervical vertebrae, or neck bones, allowing the birds to clean themselves, feed more easily, and look around for danger. We mammals, including the giraffe, have seven cervicals. Even the stocky little sparrow has fourteen, and a swan has twenty-five. Most bird bones are hollow, rendering them lighter, while laced with struts, making them strong. Even cellular makeup has changed to bird advantage. Pennsylvania State researchers Austin Hughes and Marianne Hughes found that birds have smaller "spacers" between coding sections of their genes. This allows smaller cells with more surface area per unit volume, which permits faster oxygen exchange—important for the extreme metabolic demands of flight.

Air sacs, lighter than flesh or bone, permeate a bird's body, in muscle, viscera, and just under the skin. They also help cool the animal, for hard-flying birds run a hot motor. Our brains would fry at the temperature of a chimney swift, 111.2 degrees Fahrenheit. Fuel consumption is also high, requiring a kind of carburetor called a crop, or gizzard, which grinds

Wary cedar waxwings with sleek crests and robbers' masks oversee their brood, which will leave the nest around the age of sixteen days. Both adults have lost the glossy red wing flecks that adorn some, explaining their names. Unlike some bird parents, waxwings will continue to feed young handled by humans.

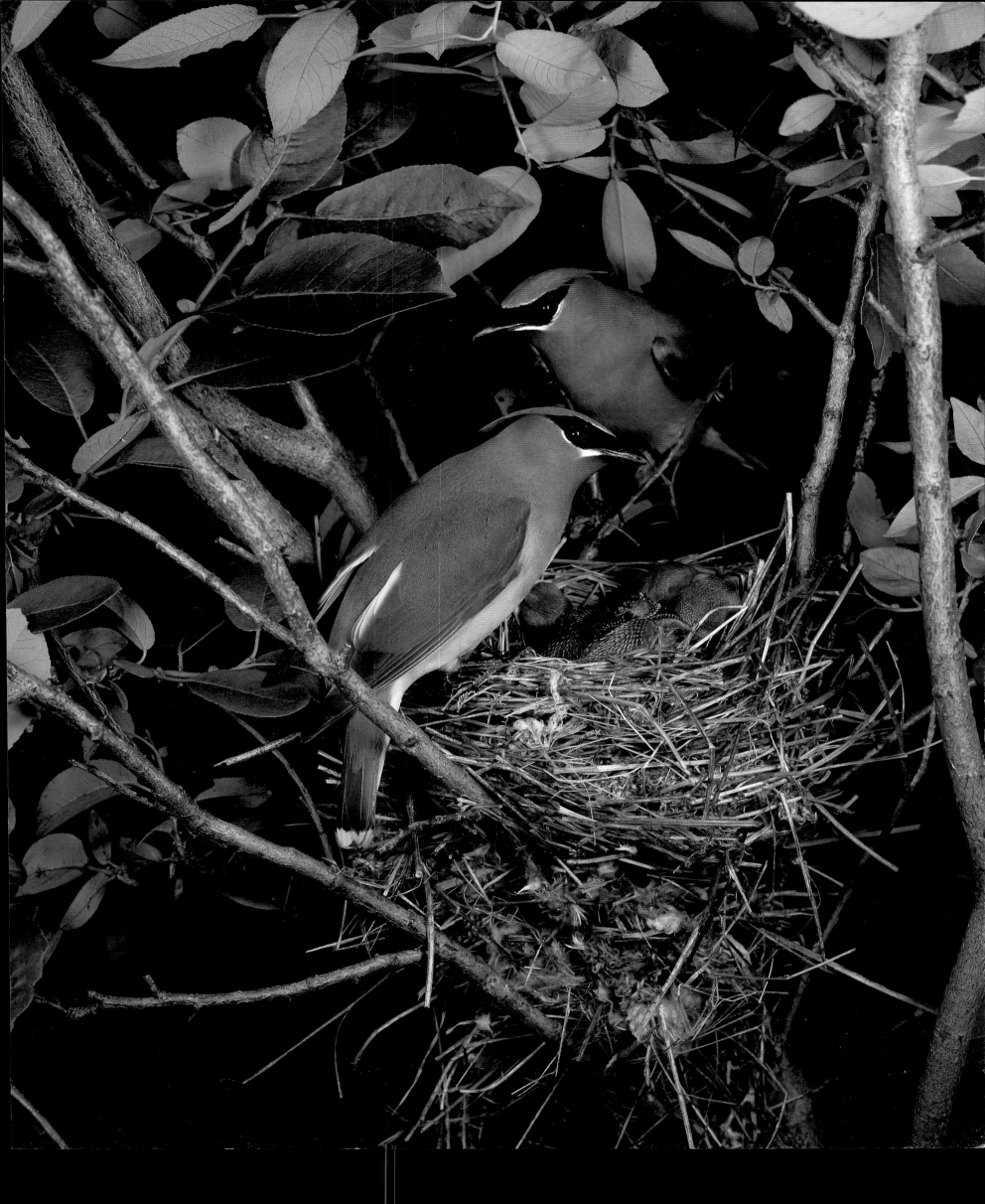

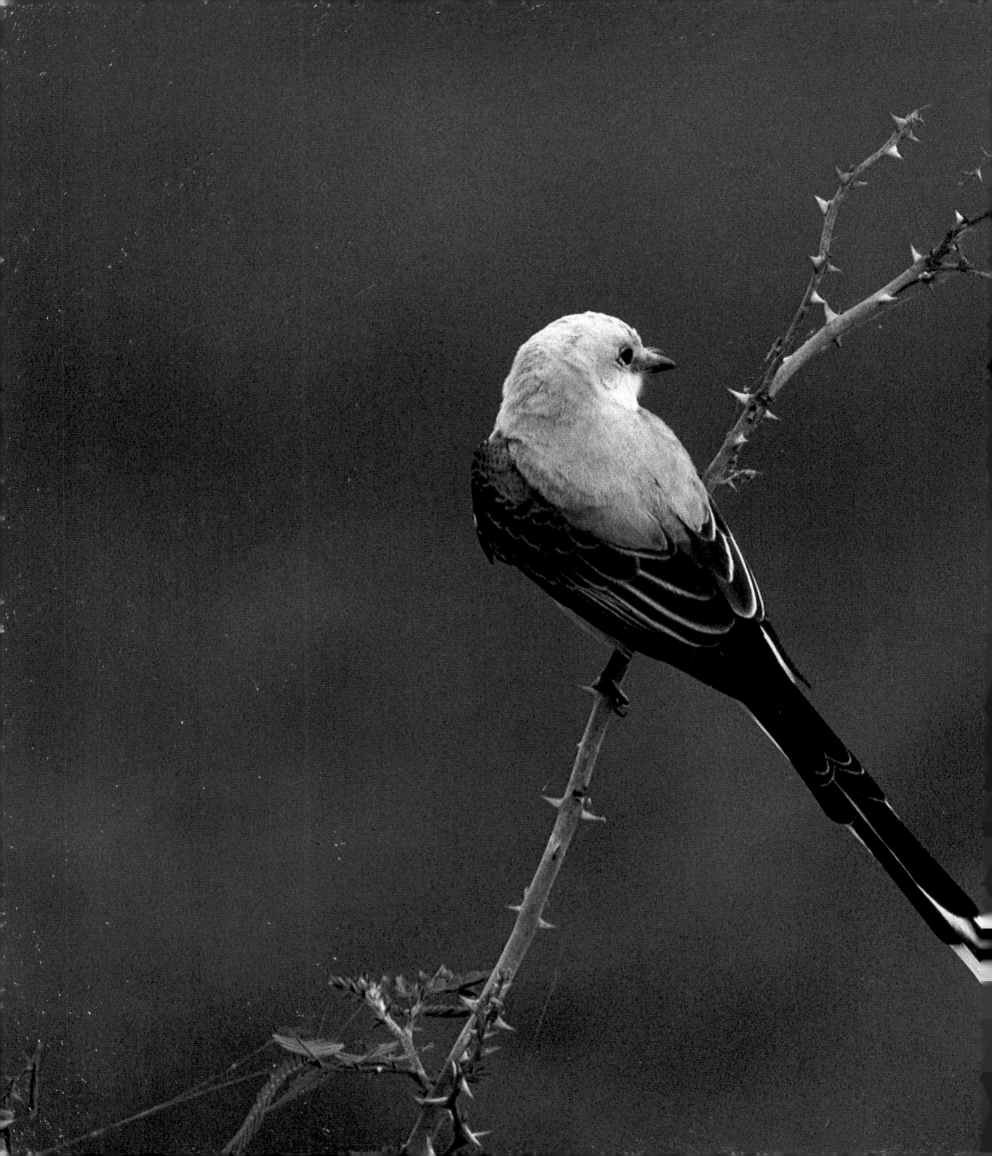

and prepares food before feeding it into combustion chambers of stomach and intestines. And the appetite! A flicker's stomach was found to contain 5,040 ants after one meal. A house wren was observed feeding its young 1,217 times between dawn and dusk. And can you imagine eating 200-300 pounds of food in a day? Kingfishers have been known to eat twice their weight.

If "eating like a bird" is way off the mark, "light as a feather" is a bull's-eye. Marvels of toughness for their size, feathers have tensile strength that allows some of them to bend double without breaking, and others the resistance to row a bird swiftly through the air. If plucked, a new feather immediately grows in its place, then dies once it reaches full length. The numerous barbs that extend on either side of the shaft are held together by tiny hooks. You can tug the barbs apart, but by stroking them lengthwise they will eventually fasten together again, preceding Velcro by a few million years and in fact, serving as its model. Birds are often fastening torn barbs together again when they preen themselves, fussy as teenagers before a prom, smoothing ruffled feathers and pulling them gently through their bills. By applying oil from a gland at the base of the tail they can waterproof their feathers. By fluffing them up to trap air, a bird keeps warm, as we have found by wearing down-filled coats.

Bird flight is behind the expression "free as a bird," and that too is misleading. Free, yes, but from egghood on, birds are besieged by every creature with fangs, claws, beaks, and in our case, large brains. Many birds will plunder each other's eggs for the protein, if they can get past

mom and dad. Cowbirds simply move in, lay an egg, and leave it for foster parents to raise. Since cowbird chicks hatch sooner, they feed sooner and therefore starve smaller songbirds hatched in the same nest. When cowbirds were complete itinerants following the buffalo their effect on other species was more spotty than it is now.

Some birds, such as blue jays and crows, will carry off and eat the nestlings of others. Carnivorous mammals such as foxes, raccoons, weasels, and domestic cats also find baby birds a tasty snack. Snakes can sense the presence of nestlings several feet off the ground and climb to devour the entire brood. We've made it easier for these and other predators. Many prefer open areas, and by fragmenting our forests we've created ready access to birds at the edges and concentrated the nests. Indirectly, we're the biggest eliminator of all.

Ornithologists have been puzzling for years over the disappearance of some songbirds. More than half the migratory species in North America are now in decline. Destruction of their wintering habitat in the forests of Central and South America is certainly part of the picture, but only part. We may also be removing the food sources they need along their journey by building on them or paving over them, according to a study of much-developed Block Island off Rhode Island, a way station for some birds headed south and north.

Changes in our land and in our activities all over North America have taken a toll as well. Trees have given way to grasslands, grasslands are sacrificed for row crops, row crops bow to pavement and condos. Illinois has lost 95 percent of the volume of its prairie songbirds since

PAGES 26-27
Prim on a thorny perch, a scissor-tail flycatcher will nevertheless viciously attack larger crows and hawks in defense of its nest. In flight the long tail feathers often split wide like open shears. Barely visible here are the salmon-colored undersides. State bird of Oklahoma, the flycatcher dips and wheels with butterfly grace over open plains.

the 1950s. Transmission towers, cars, airplanes, and even flying golf balls are believed to kill sixty-two million birds a year in the U.S. alone.

We can't stop golf any more than we can stop growing food crops, but until we take measures to protect them, songbirds will continue to disappear. With enough habitat they can outproduce all the towers and smacked golf balls we can muster. The farmer that levels a woodlot or clears a brushy fence row may gain some crop space, but he will also lose birds that feed on crop-destroying lepidoptera caterpillars. Our southern neighbors might consider that cutting down rain forests benefits only a few landowners, while a wisely used rain forest can generate more income per acre for more people as the products grown there are utilized.

We're learning. A system of verdant corridors known as greenways that have been snaking across the country over the past decade offer pathways for both birds and people. In Connecticut a former freight canal is becoming the Farmington Canal Greenway that allows green space from highly urbanized New Haven to extend twenty-six miles into the middle of the state. There it connects with a preserved ridge line that runs through an agricultural community. Eventually the corridor will span the entire state, creating a long, thin, natural haven for both people and birds. In Illinois, the Page County Forest Preserve System twenty miles west of Chicago bought up 24,000 acres of open space over decades in anticipation of the urban development. As expected, houses, lawn mowers, and streets proliferated, but present as well are green river drainages and blocks of woodlands, prairies, and wetlands connected

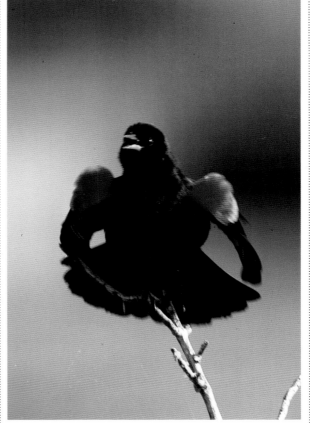

Blazing epaulets signal other red-winged blackbirds that this male has marked out a territory. From coast to coast and north into parts of Alaska, the song of red-wings in marshes and meadows signals the coming of spring. Their closely woven nests of grasses are plaited a few feet above ground among wetland reeds or tall stiff stems found in meadows.

by green corridors. "It's not the original prairie, but it offers potential bird habitat that wouldn't be there otherwise," says Dan Ludwig, animal ecologist for the Forest Preserve System. In the Northwest a giant corridor is planned, the Mountains to Sound Greenway bordering Interstate 90 for 120 miles from the Cascades to the Seattle waterfront. Swatches of bird habitat are being saved all over the continent. Can they keep pace with the swatches that continue to disappear?

The countless small, highly vocal birds that flit from barn to post seem to be perfectly willing to share space with us. The least we can do is leave a little of the natural world we inherited from them so they can continue a way of life that predates our own. They will return the favor many times over, in song.

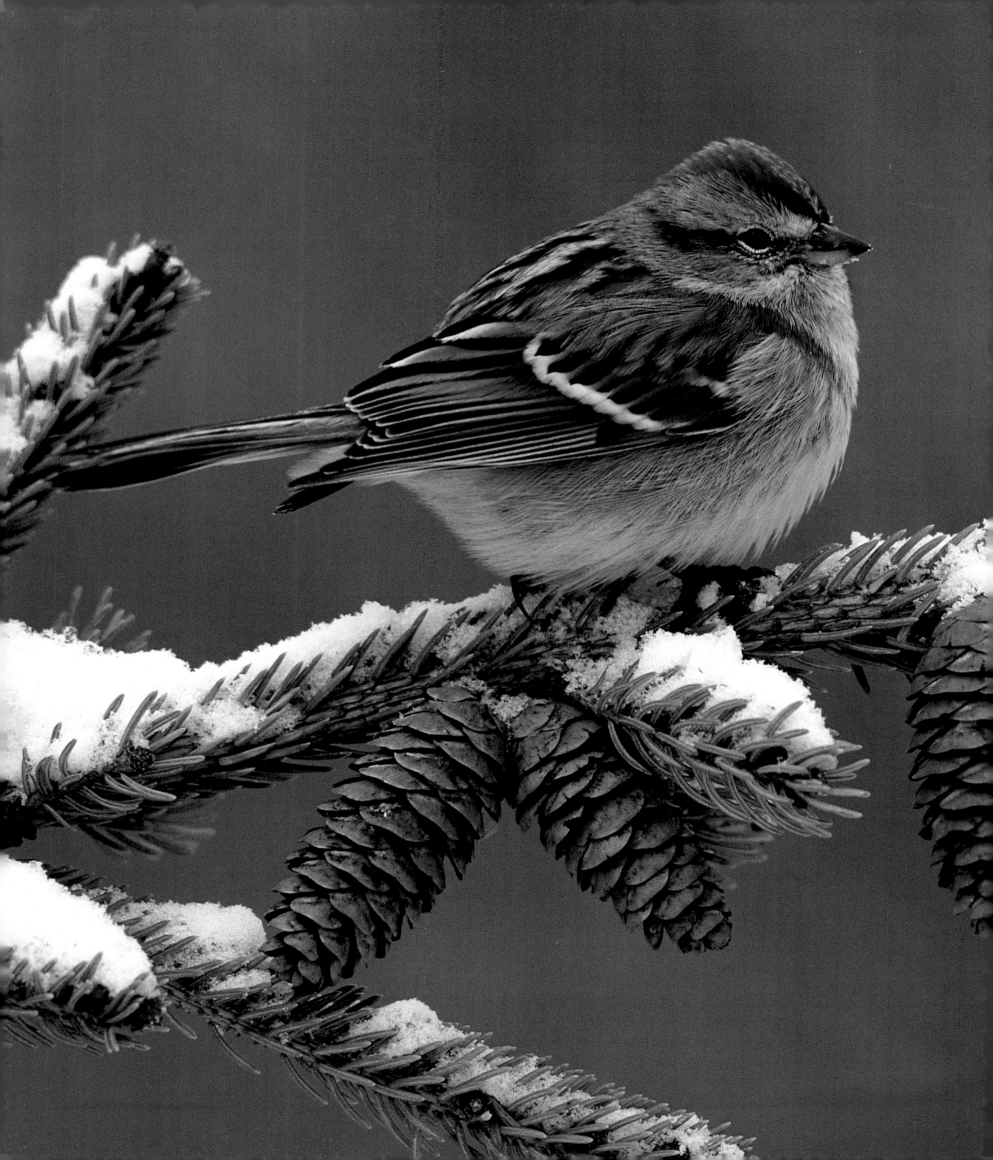

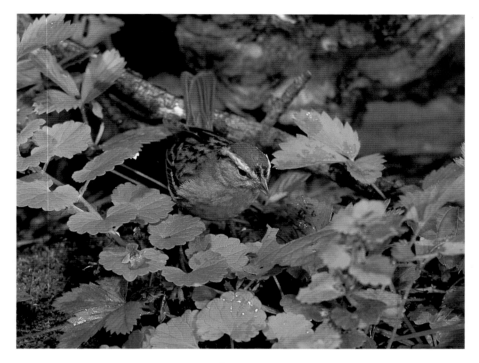

Fluffed up for warmth, an American tree sparrow
(OPPOSITE) *perches on a spruce bough. In winter these*
hardy songsters retreat from Arctic breeding grounds to
southern Canada and the lower U.S., where they pick
fallen seeds from the snow. A look-alike, the male
chipping sparrow (ABOVE) *also wears a chestnut cap*
and "mascara" streak through the eye, but flies
to far southern states in cold weather.

PAGES 32-33
Cheery singer over an entire continent, the song sparrow
may vocalize at any time of year. Locally variable in
color and size, all subspecies show dark streaks on
the breast with one darker spot in the middle.

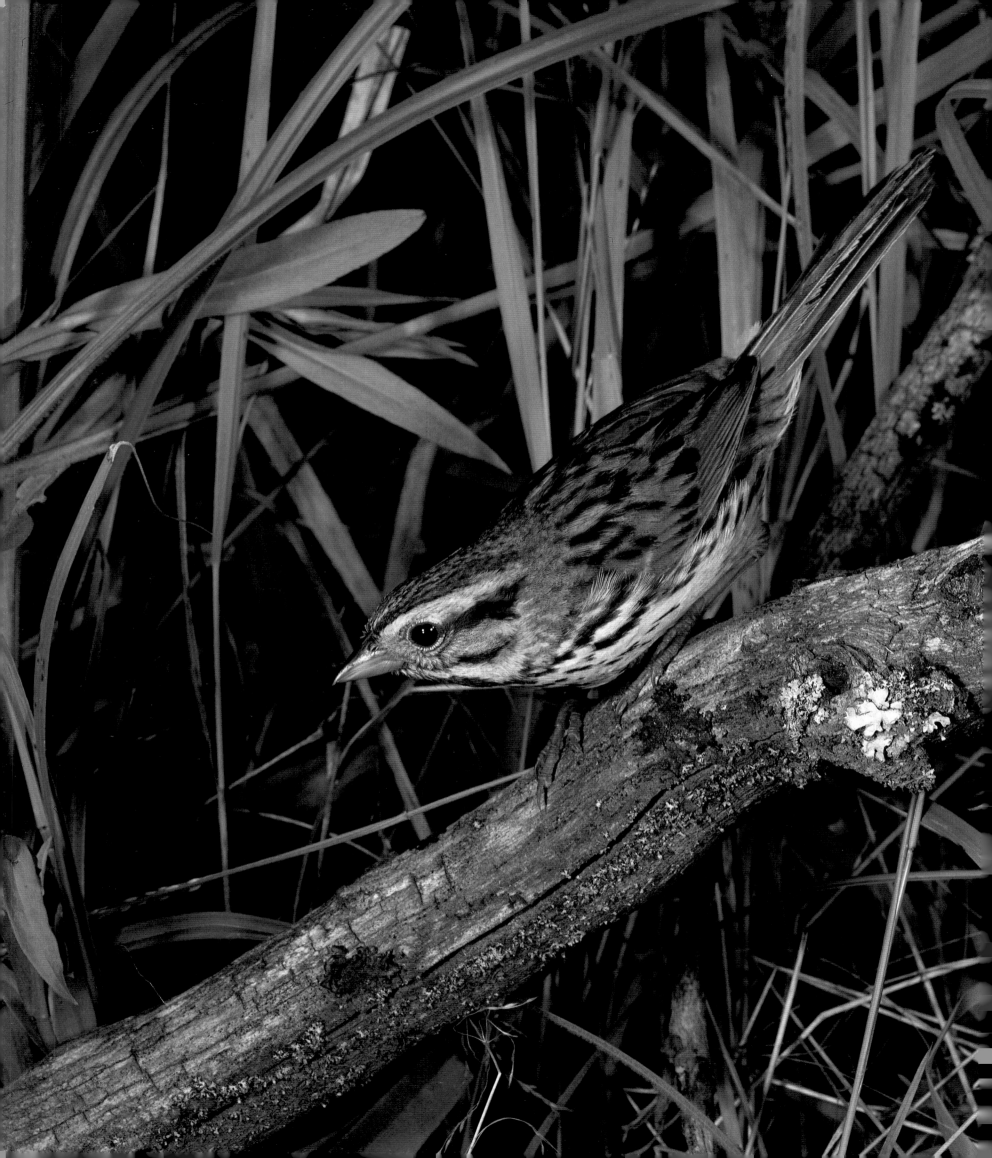

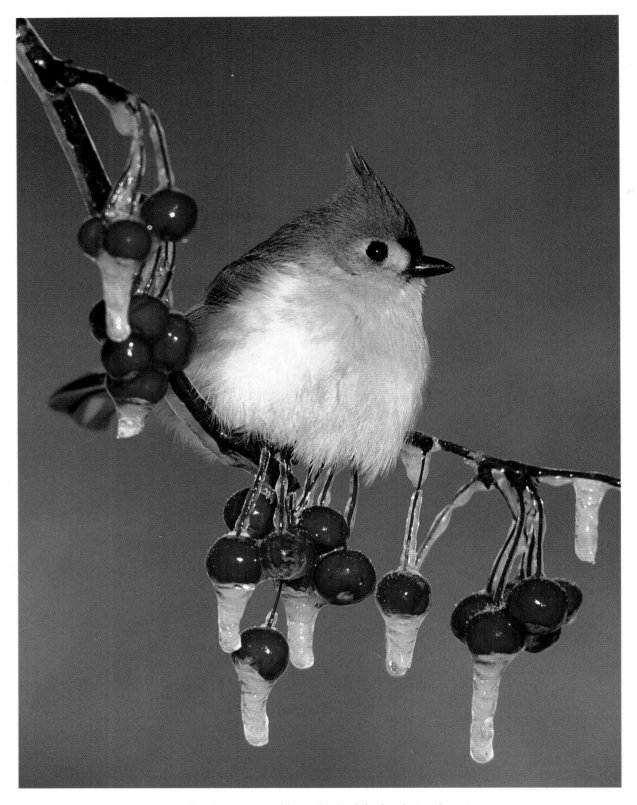

*Braving winter cold, two birds of the family Paridae
perch near ice-coated berries. Both the black-capped
chickadee (OPPOSITE) and the tufted titmouse (ABOVE)
hustle hidden seeds and hibernating insects and their
eggs long after most songbirds have fled south.
Frequent visitors to bird feeders, they catabolize
body fat into warmth by shivering, but some
may freeze in harsh winters if fat
reserves are depleted.*

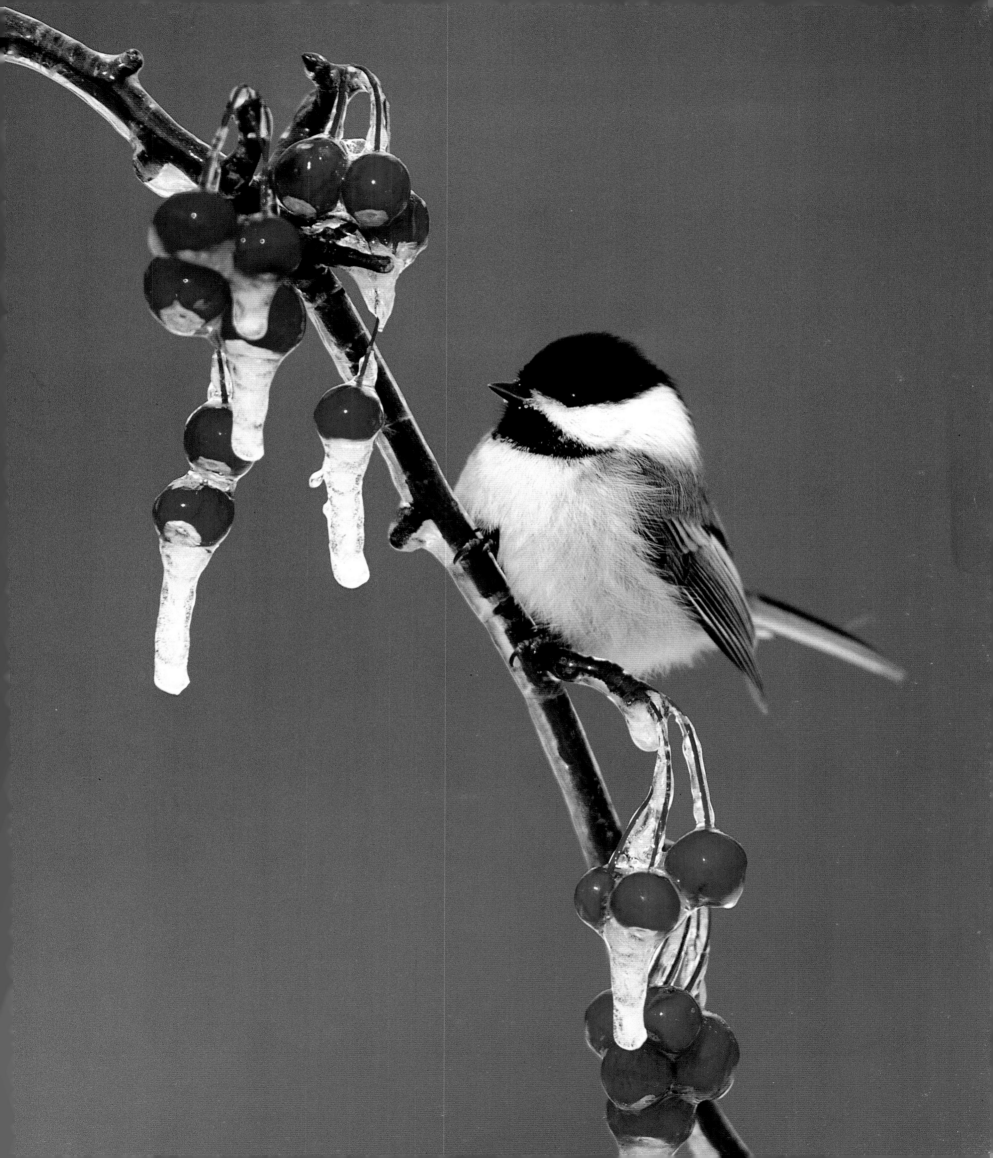

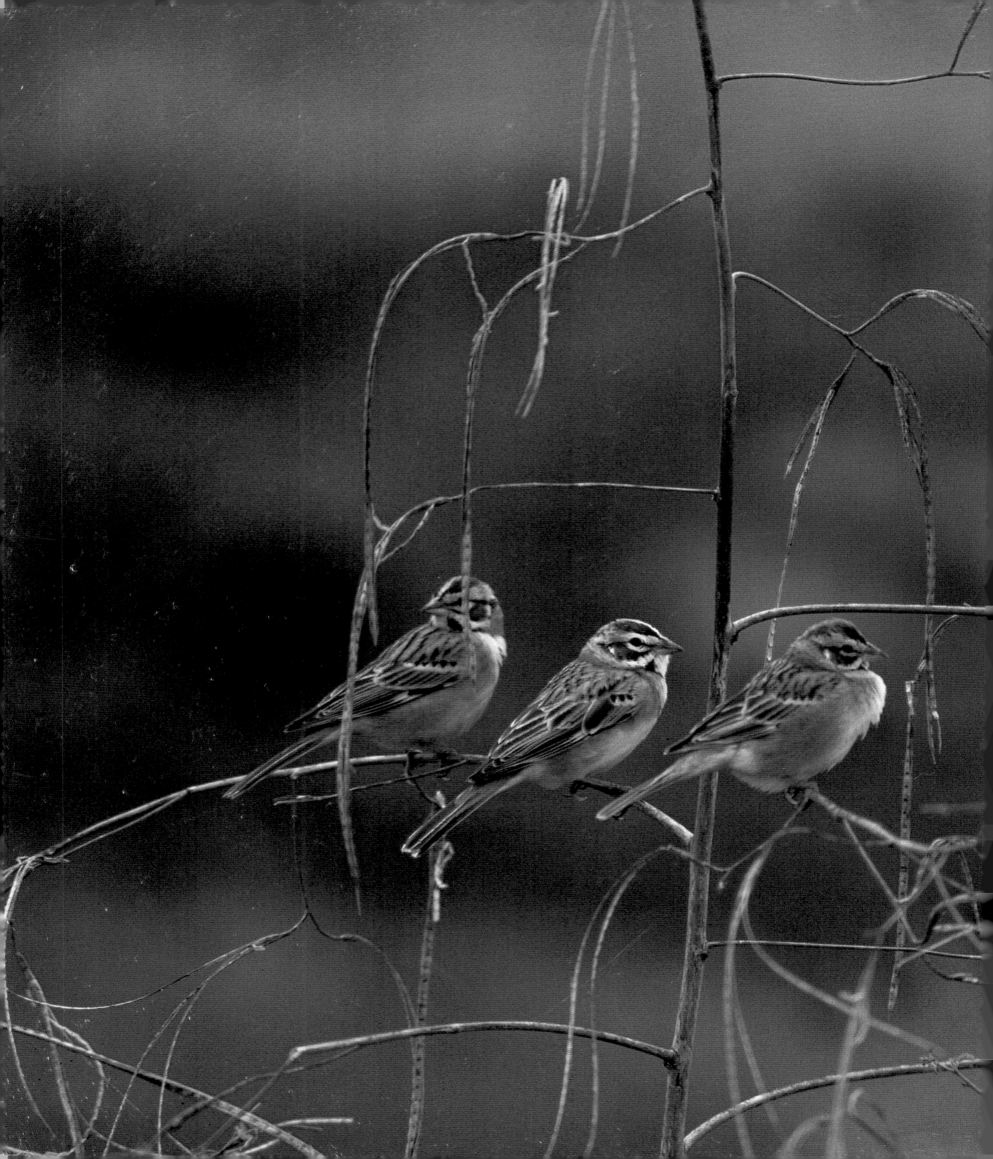

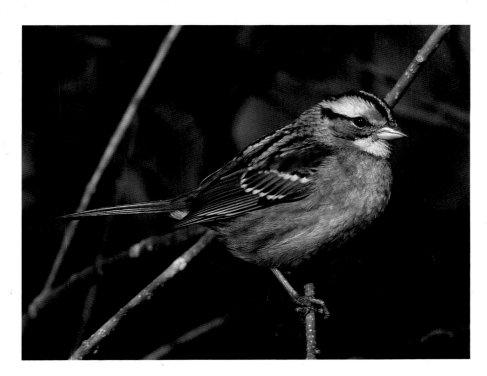

*A trio of lark sparrows (OPPOSITE) takes a low-level view
of the world on a dried plant. Like the famed songsters
whose name they took, the plump sparrows nest on the
ground and, larklike, sometimes sing while hovering.
As if self-conscious about its faint yellow eyebrow,
rare color in a sparrow, a white-throated sparrow
(ABOVE) sits hunched-up on a twig.*

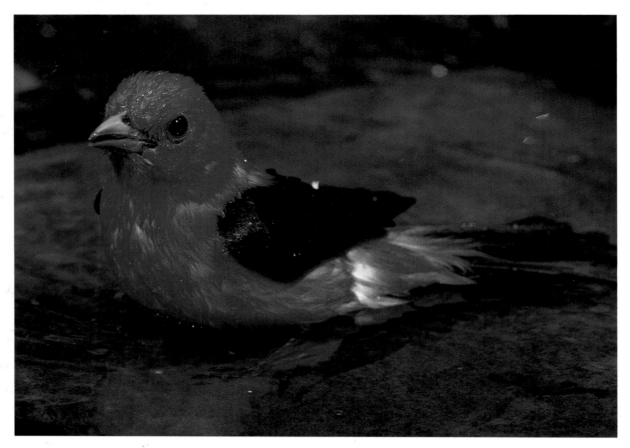

*Fireball of a bird, the male scarlet tanager dazzles the eye
in breeding season. By late summer he turns mottled red
and green in molting to winter dress of yellow-green,
similar to the year-round colors of the female. A
sloshing bath enhances his red color to a brilliant
sheen. As shy as he is radiant, the male tanager
frequents the shadows high in leafy trees,
feeding mostly on insects and fruit.*

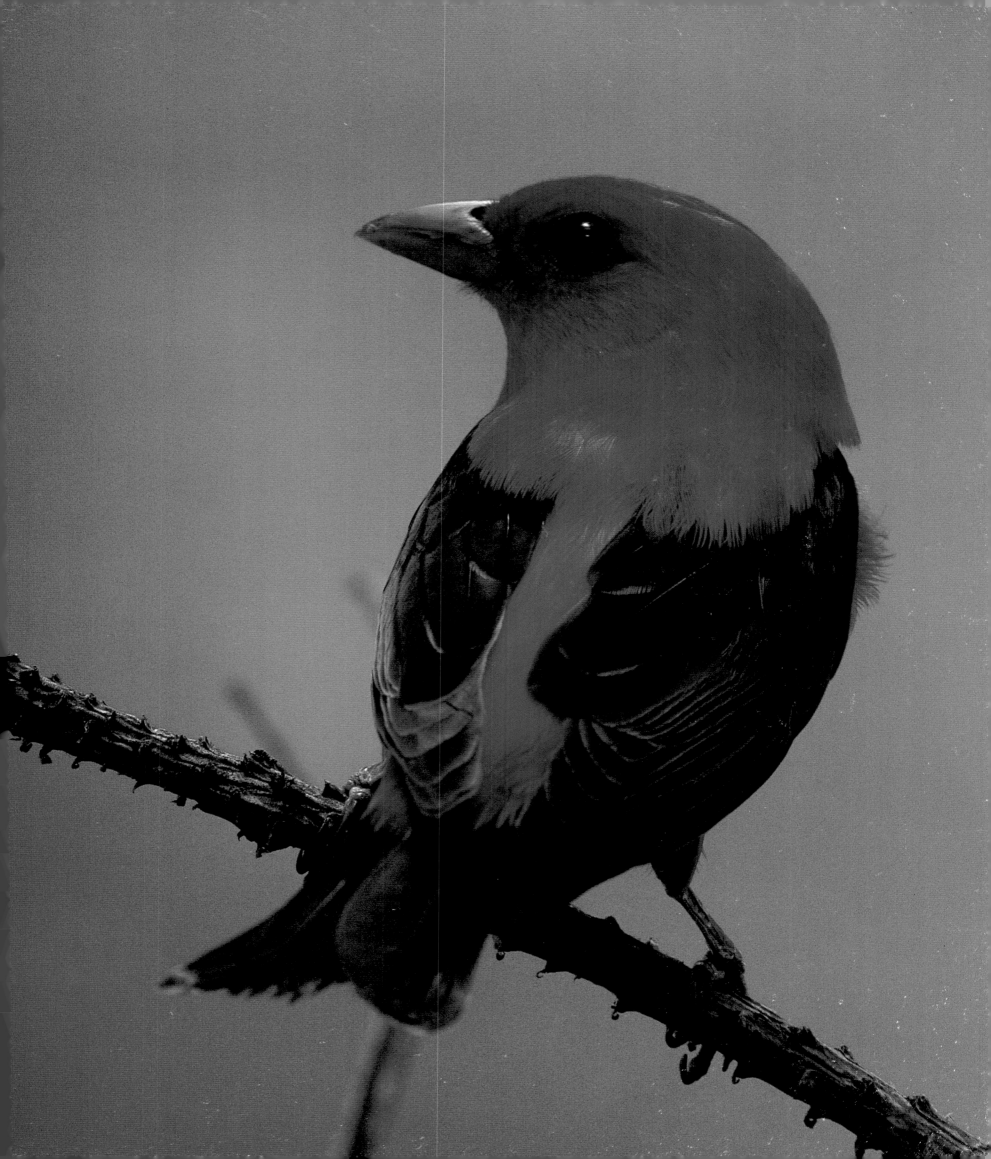

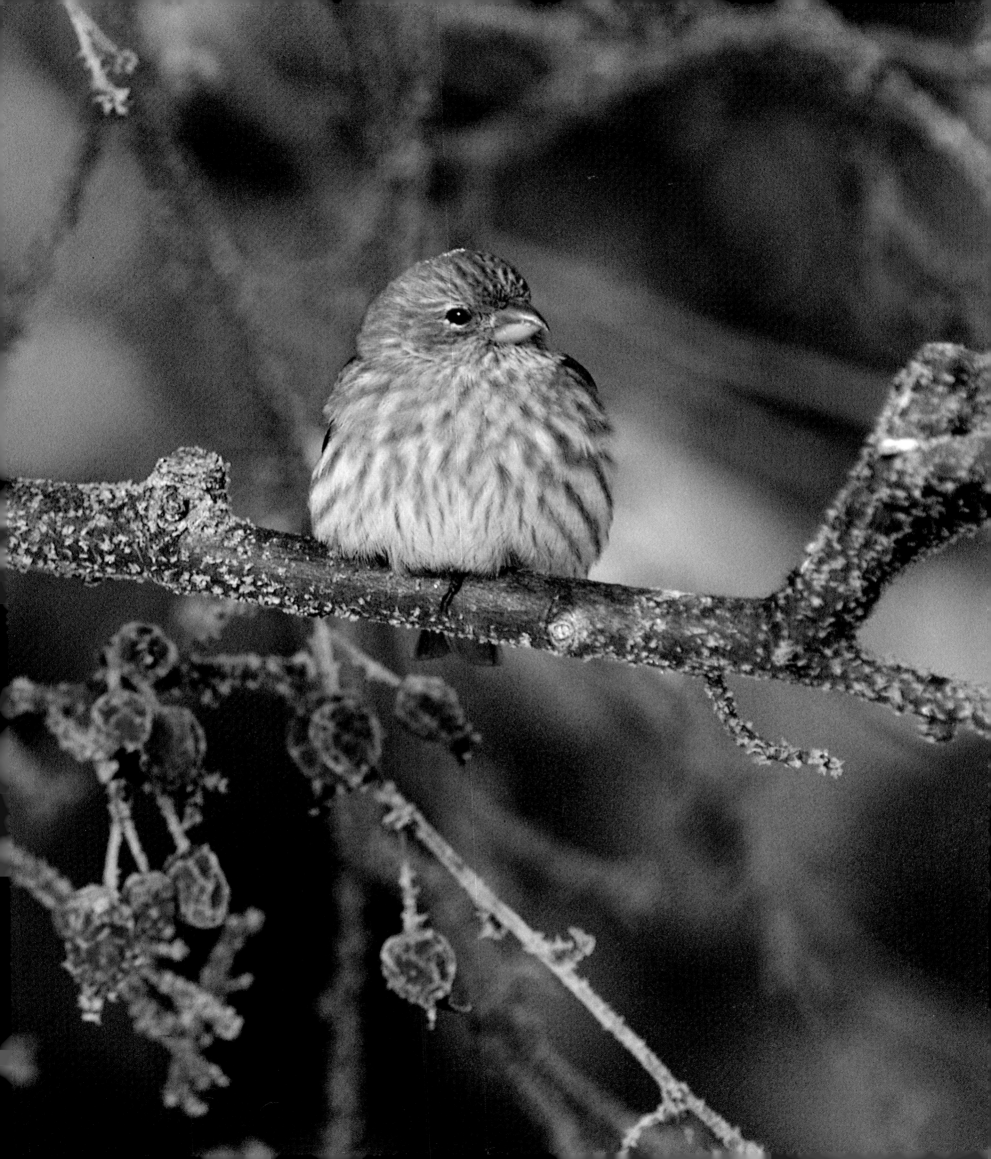

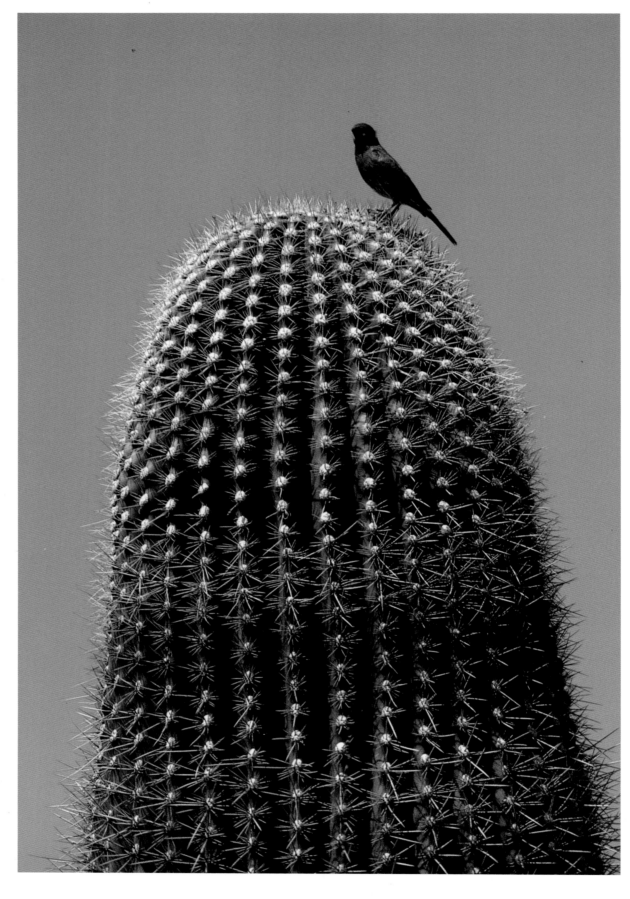

PAGES 40-41
Finch à la berries:
A female house finch
perches on a frosty branch.
Introduced accidentally
on Long Island in 1940
when pet dealers released
contraband captive
"Hollywood finches,"
the western bird is
now abundant east
of the Mississippi.

A careful landing places
a male house finch safely
atop a saguaro cactus in
Arizona. Less precise in
its selection of nesting sites,
it may weave a dish of dry
stems in the fork of a tree
limb, an old hat, or in a
hanging plant on a
protected porch.

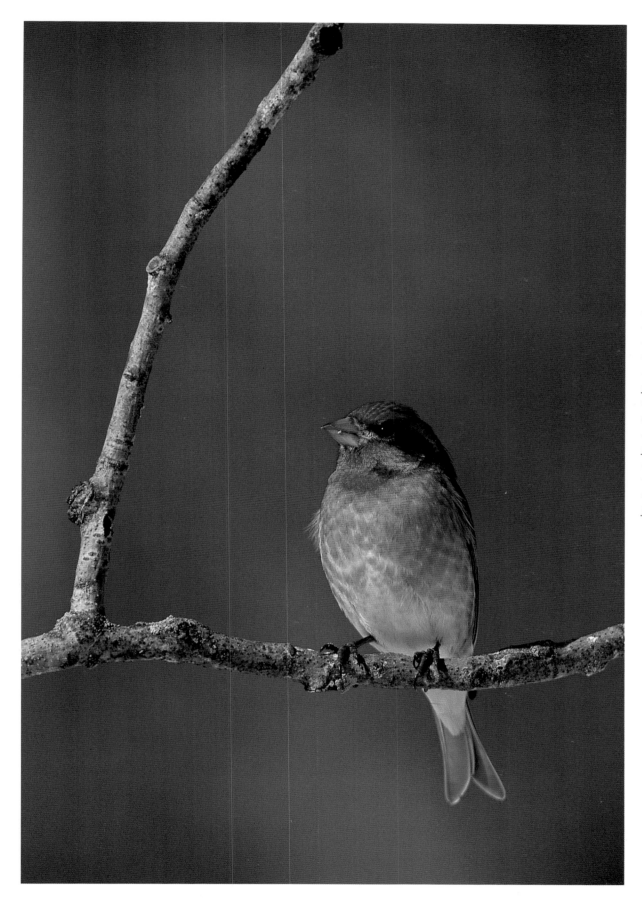

The male purple finch is not purple at all, but deep rose-colored. That's the least of the problems in identifying New Hampshire's state bird, for it resembles two close relatives, Cassin's finch and the house finch. Hardier than the house finch, the purple finch brings color and song to winter and may be seen bathing in a stream in freezing temperatures.

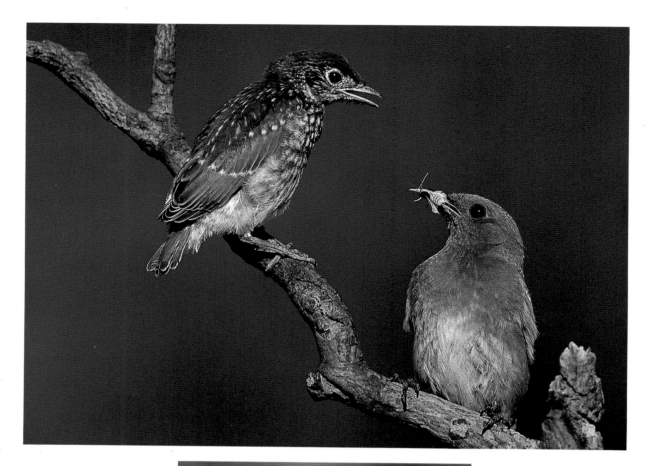

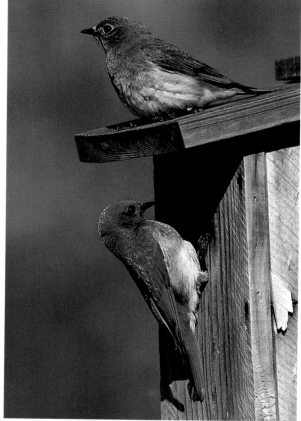

A piece of sky comes to earth as a mountain bluebird enters its nesting hole in the Canadian province of Alberta (OPPOSITE). Generally found above 5,000 feet, mountain bluebirds lack the chestnut fronts of the eastern and western species. A home-hunting pair of eastern bluebirds inspect a man-made box (LEFT). A fledgling being tended by an adult (ABOVE) shows the spotted breast that marks these birds as thrushes like the American robin.

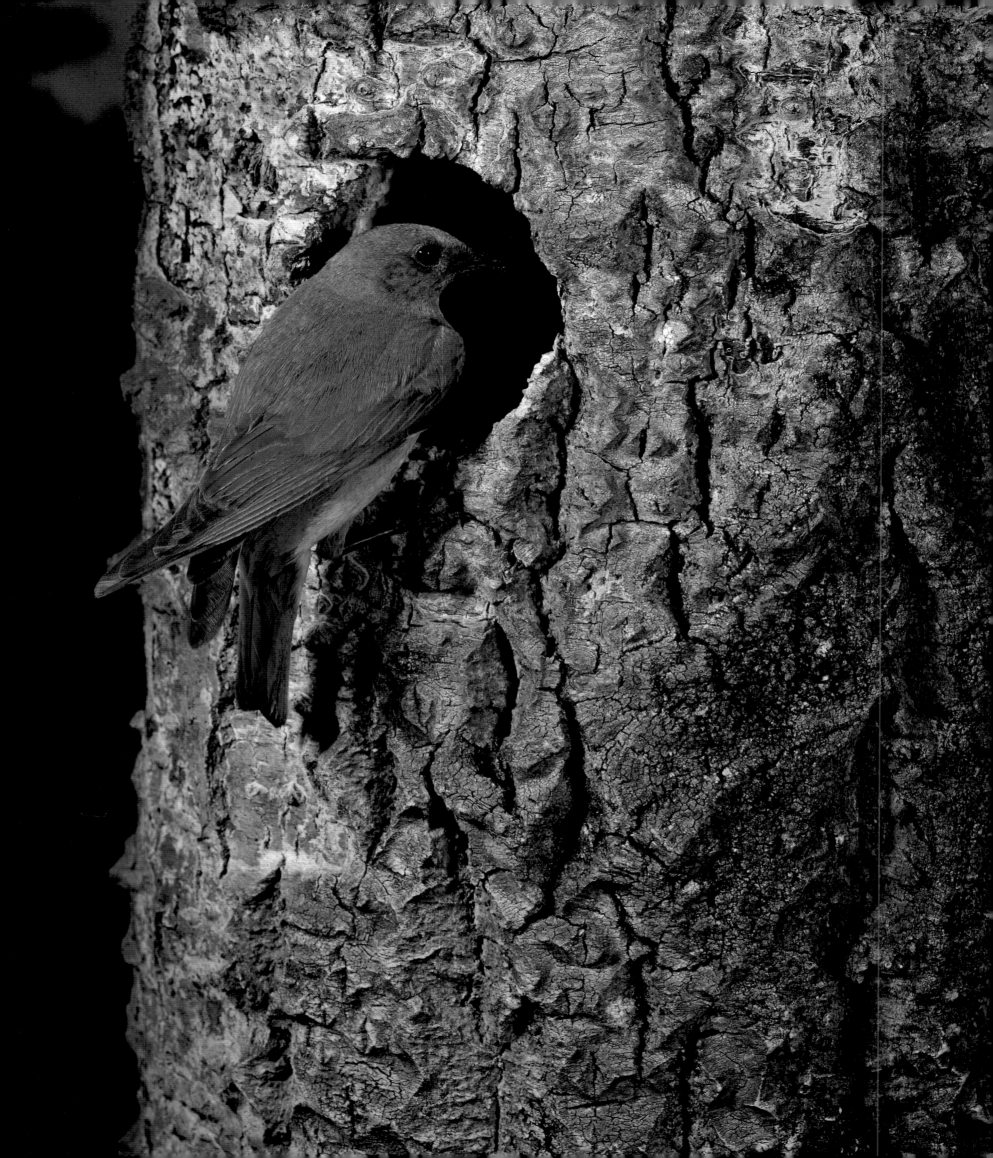

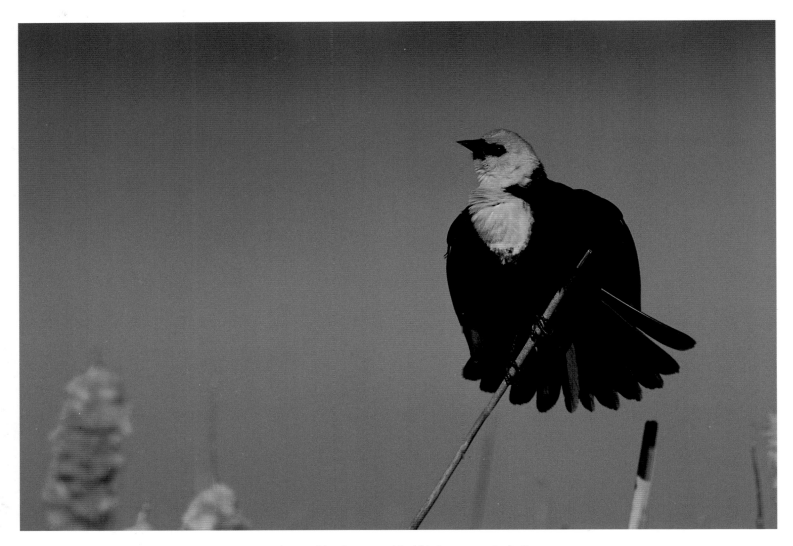

Reedy marshlands attract blackbirds (ABOVE), including this yellow-headed one flaring his plumage in a courtship display. A female red-winged blackbird (OPPOSITE) does the split on two reeds as she carries an insect to her nestlings. In mating habits, the two species differ. The red-winged male breeds females that enter his territory; the yellow-headed male pursues females and lures them home.

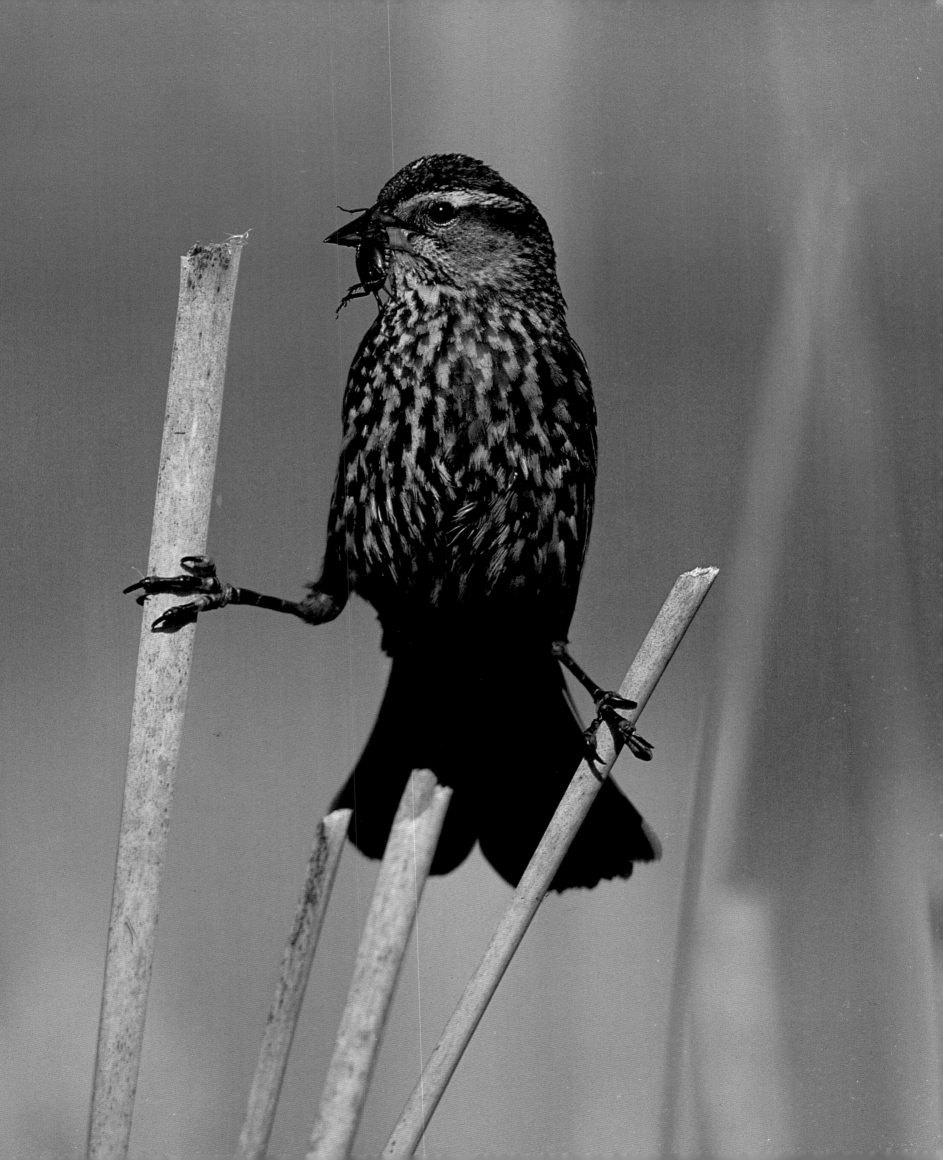

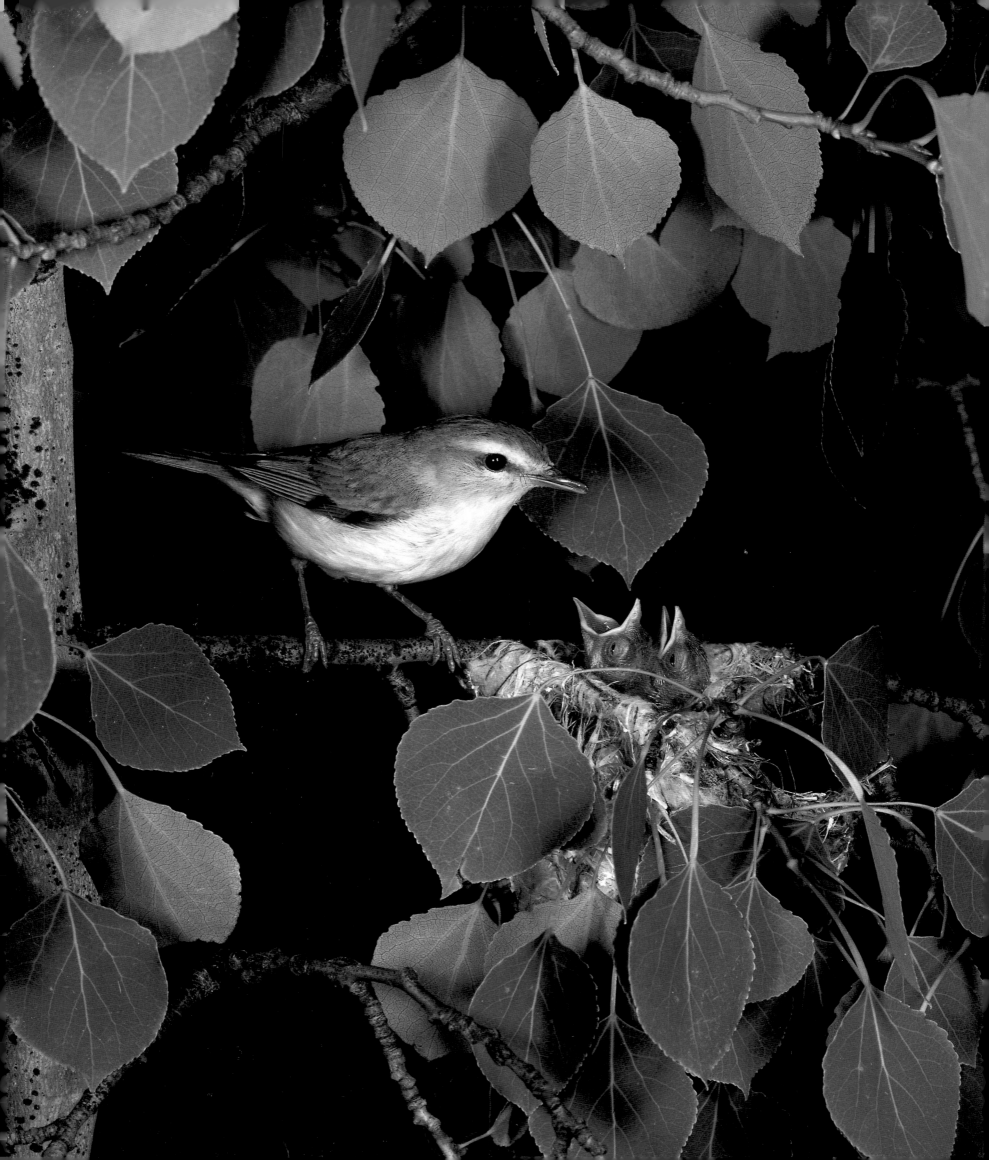

*Brightest coat worn by its kind is found on the yellow-
throated vireo (ABOVE). It constructs a hanging cup
of spider webs, mosses, and fine grasses, with lichens
on the outside for camouflage. Gossamer materials
went into the nest of a Philadelphia vireo (OPPOSITE)
tending two hungry mouths. First described by
a migrant in Pennsylvania in 1842, it breeds in
northern border states and southern Canada.*

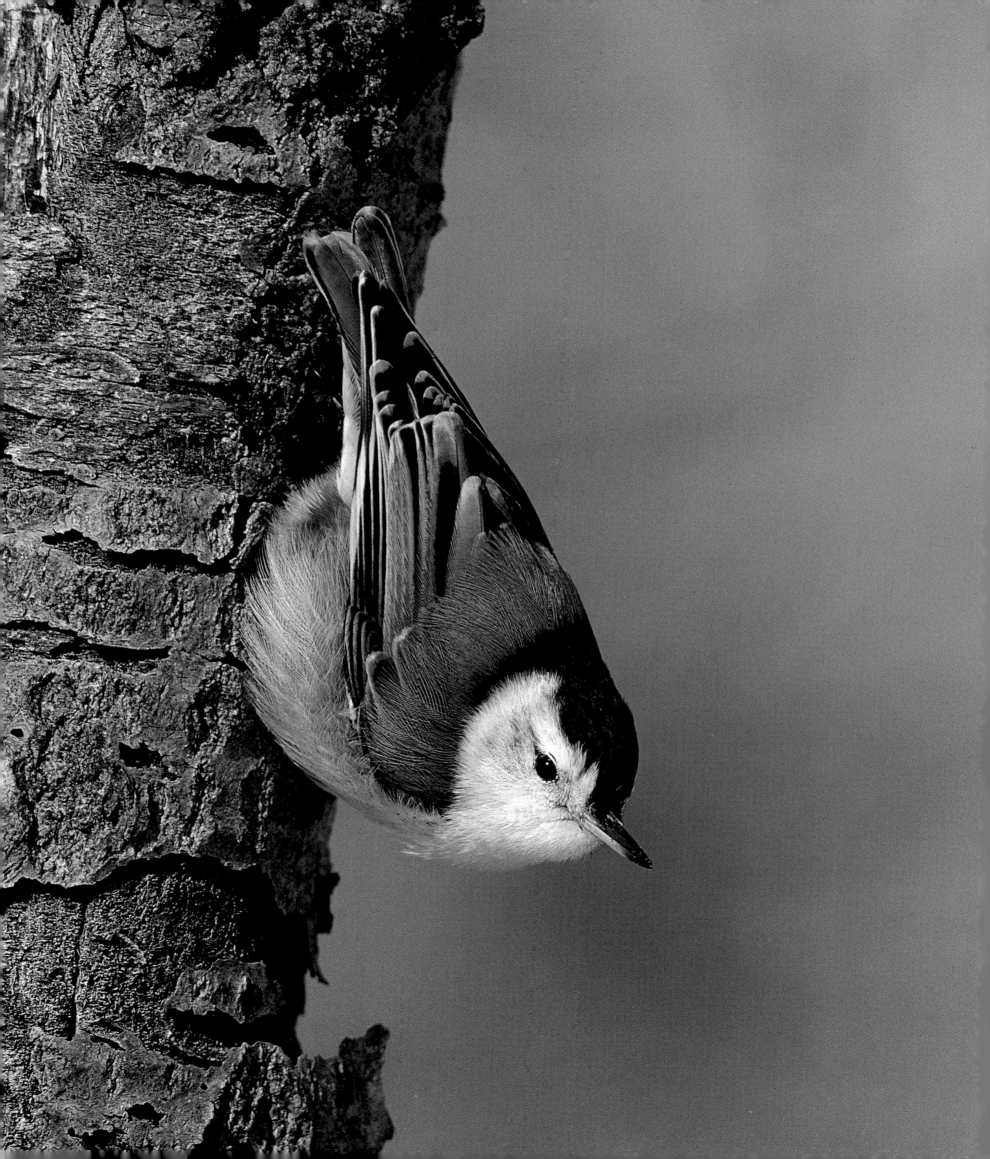

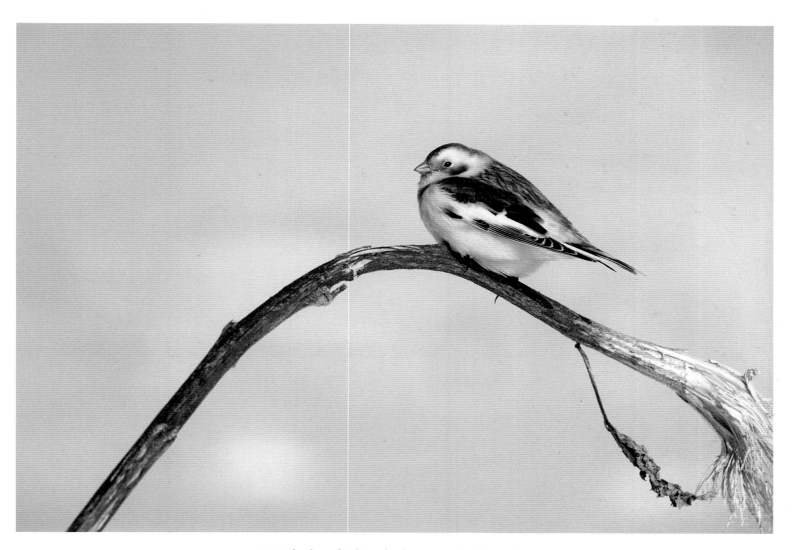

"Upside-down bird" early observers called the white-breasted nuthatch (OPPOSITE) *for its tendency to skitter headfirst down tree trunks. True to its name, the snow bunting* (ABOVE) *breeds in polar regions and retreats south only so far as snow no longer buries its food supply. Swooping and veering in flocks during migration the buntings drift like snowflakes blown before the wind.*

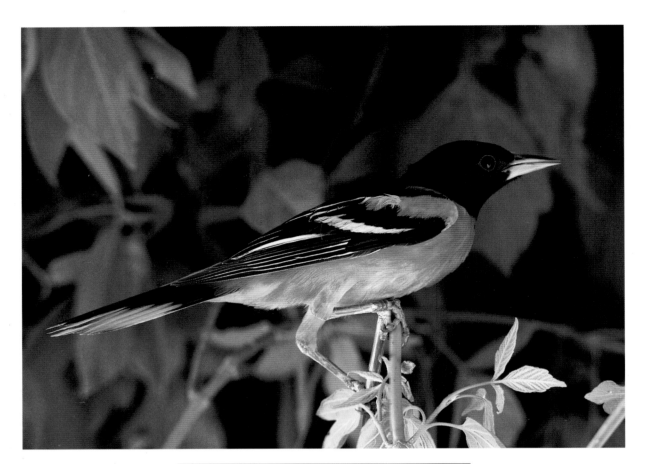

In full-throated song a western meadowlark (OPPOSITE)
*holds forth from a South Dakota fence post. Although
nearly identical to the eastern meadowlark the two do
not hybridize, since females respond to different male
tunes. A relative of both is the Baltimore oriole* (TOP),
*named because its colors matched those of the Lords
Baltimore, colonizers of Maryland. A royal coat
adorns the indigo bunting* (ABOVE),
perched among white flowers.

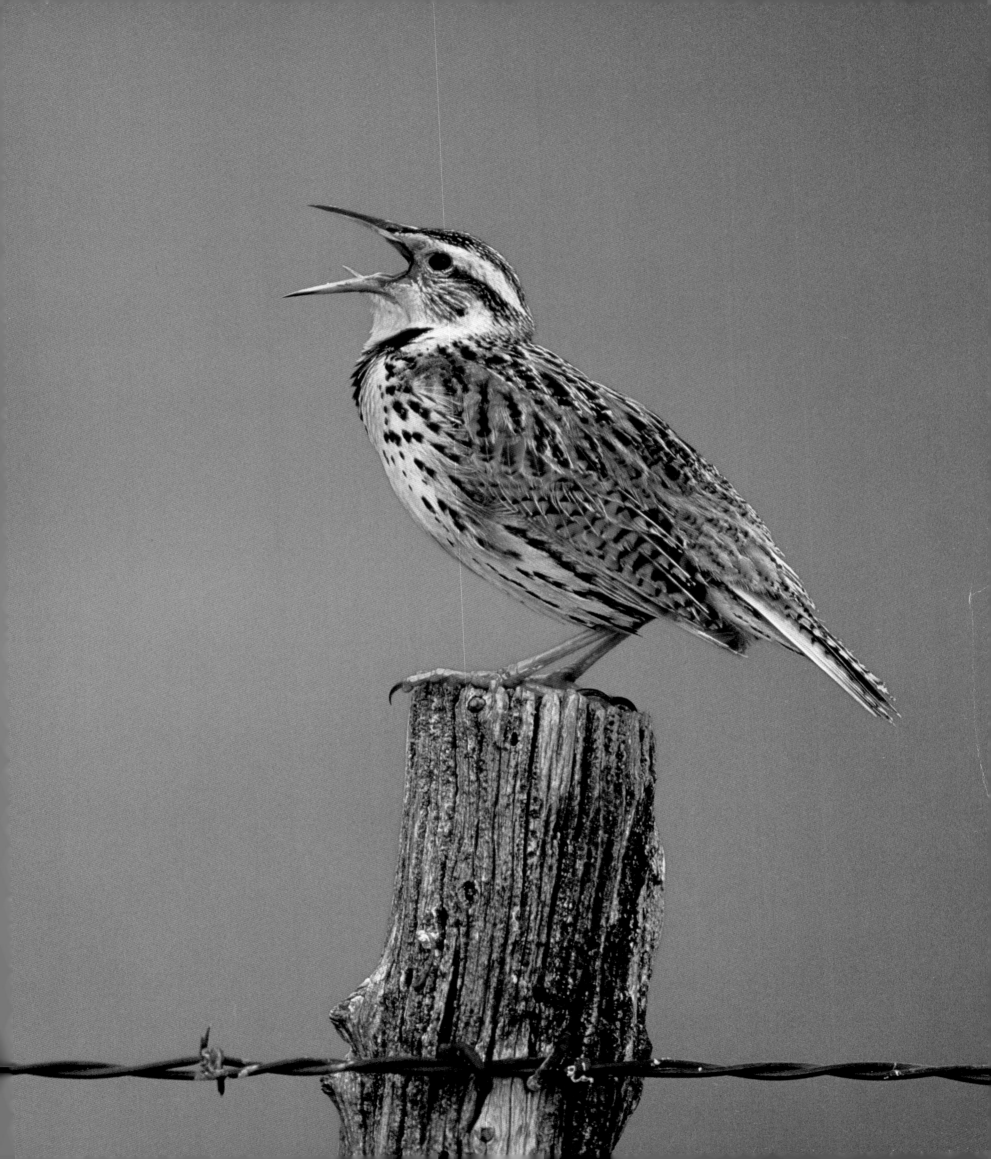

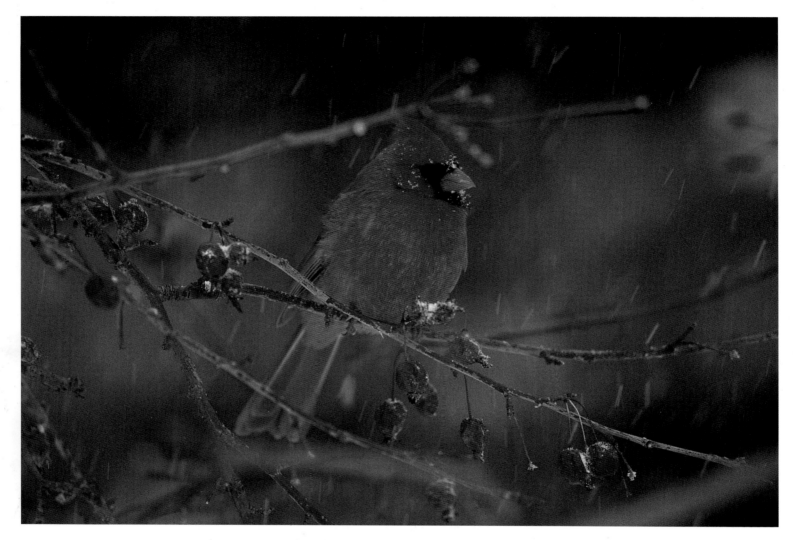

*Brighter than berries on a branch, a male northern
cardinal (ABOVE) can withstand cold weather if
sufficient food is available. Fat reserves stored
between breast muscles, over the abdomen, and
under the wings will see it through a three-day
snowstorm without eating. Colors of a female
(OPPOSITE), perched on a snowy branch, are
more subdued. Both sexes sing year-round.*

PAGES 56-57
*Wide-ranging warbler, a male Tennessee tends
hungry mouths in a well-concealed nest built
on Canadian turf. Winters may find the
bird in Venezuela or Panama.*

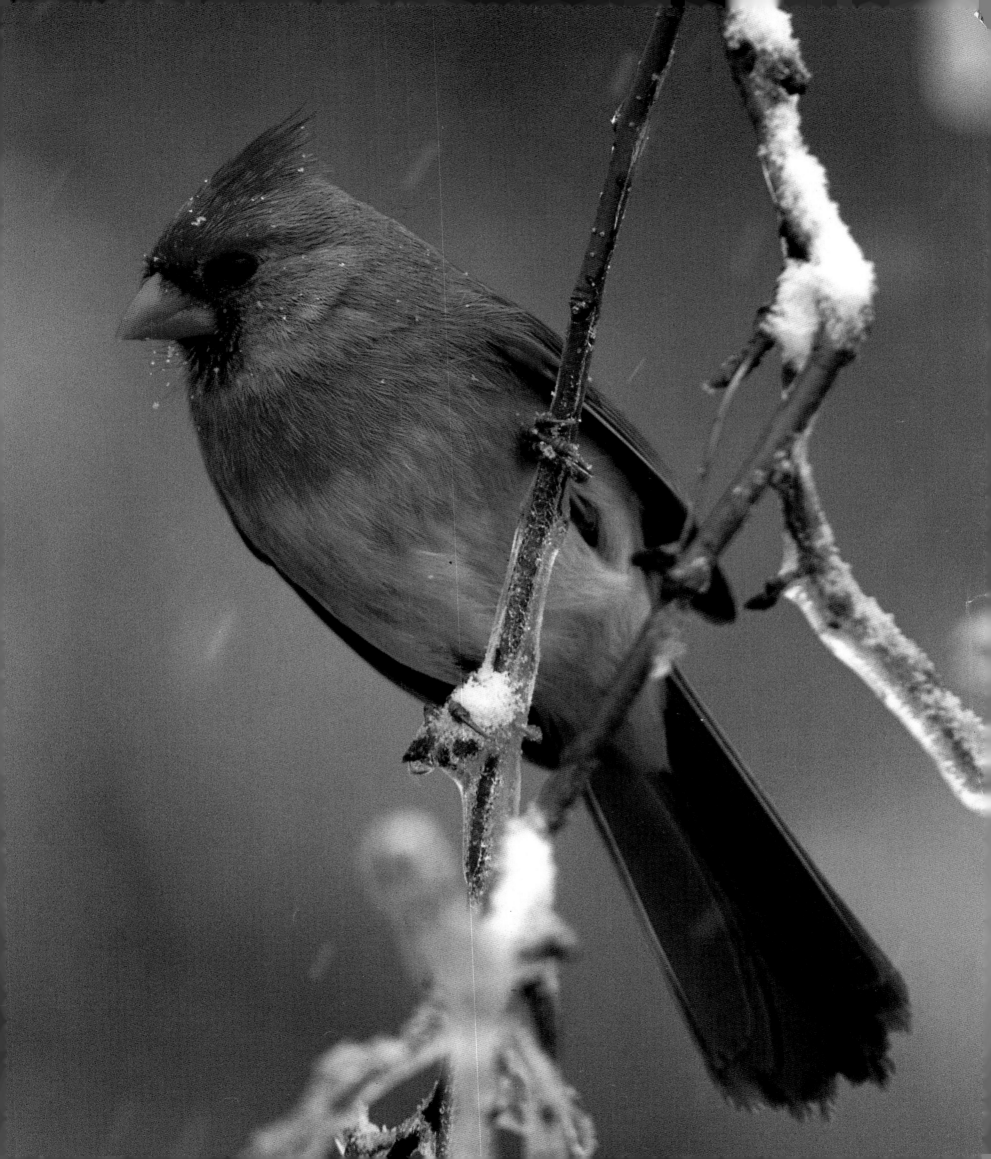

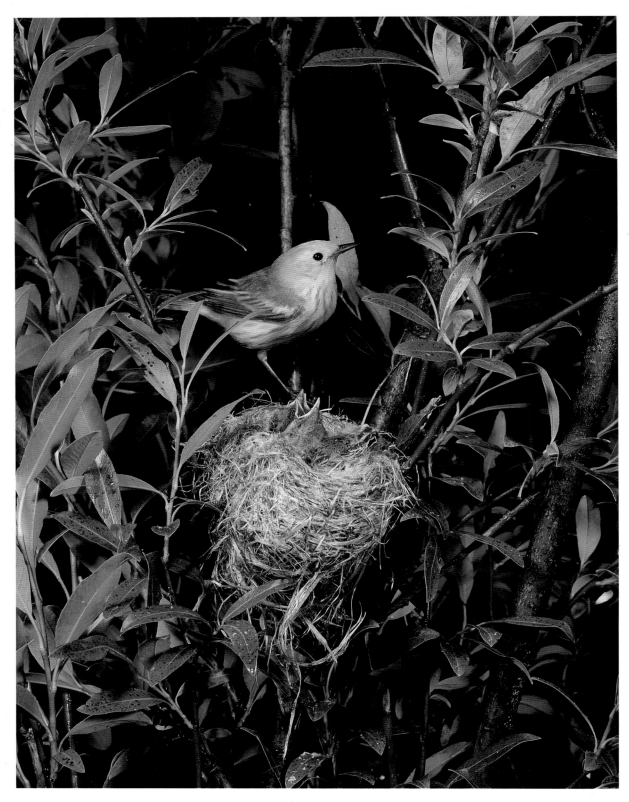

*Beautiful and dutiful parent, a yellow warbler (ABOVE)
pauses over pleading youngsters. Unlike some birds,
yellow warblers often refuse to hatch cowbird eggs
laid in their nest, by building a new layer over the
intruding egg. Nesting amid dry leaves on the
ground may have given the worm-eating
warbler (OPPOSITE) its unearned name.
Usually it feeds on beetles,
caterpillars, and spiders.*

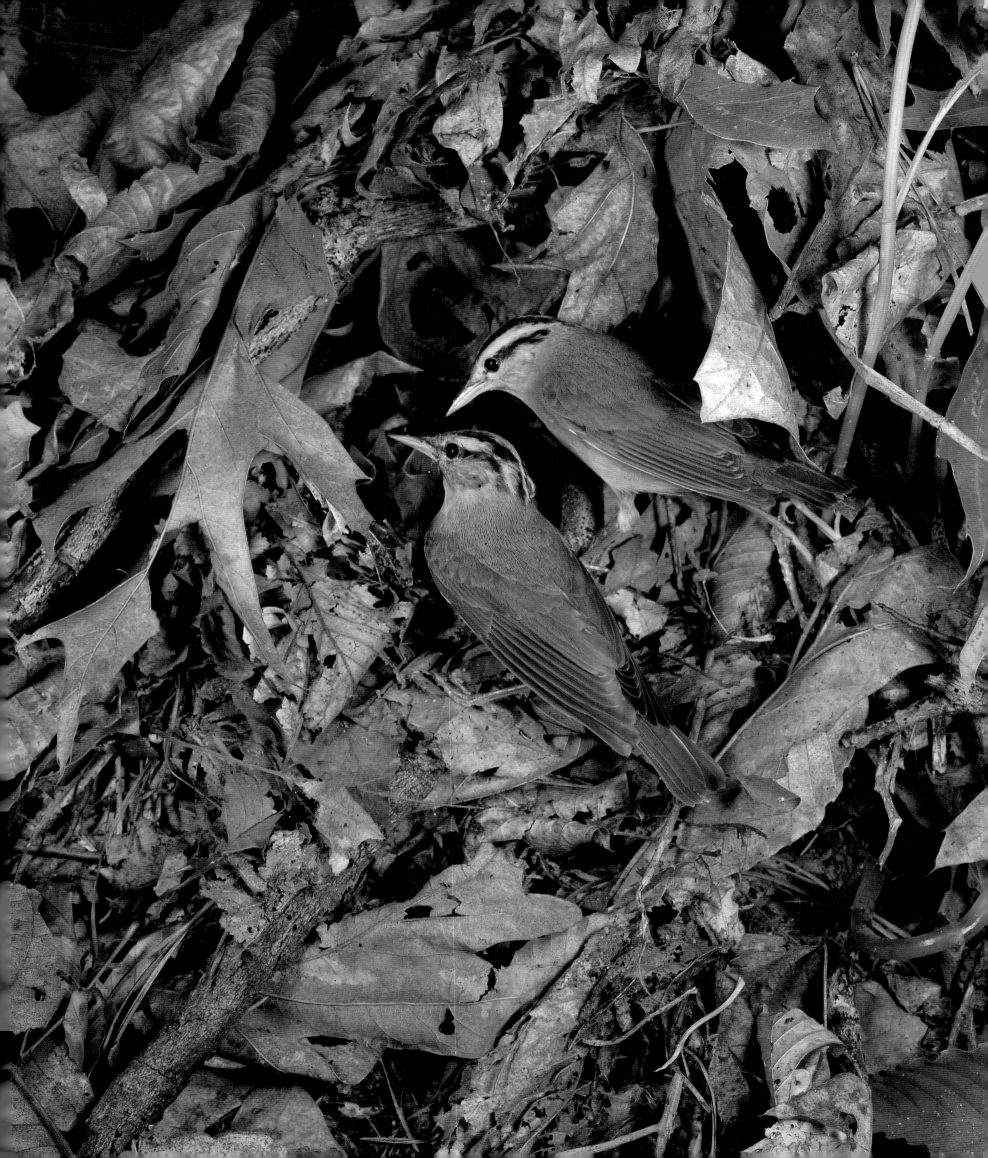

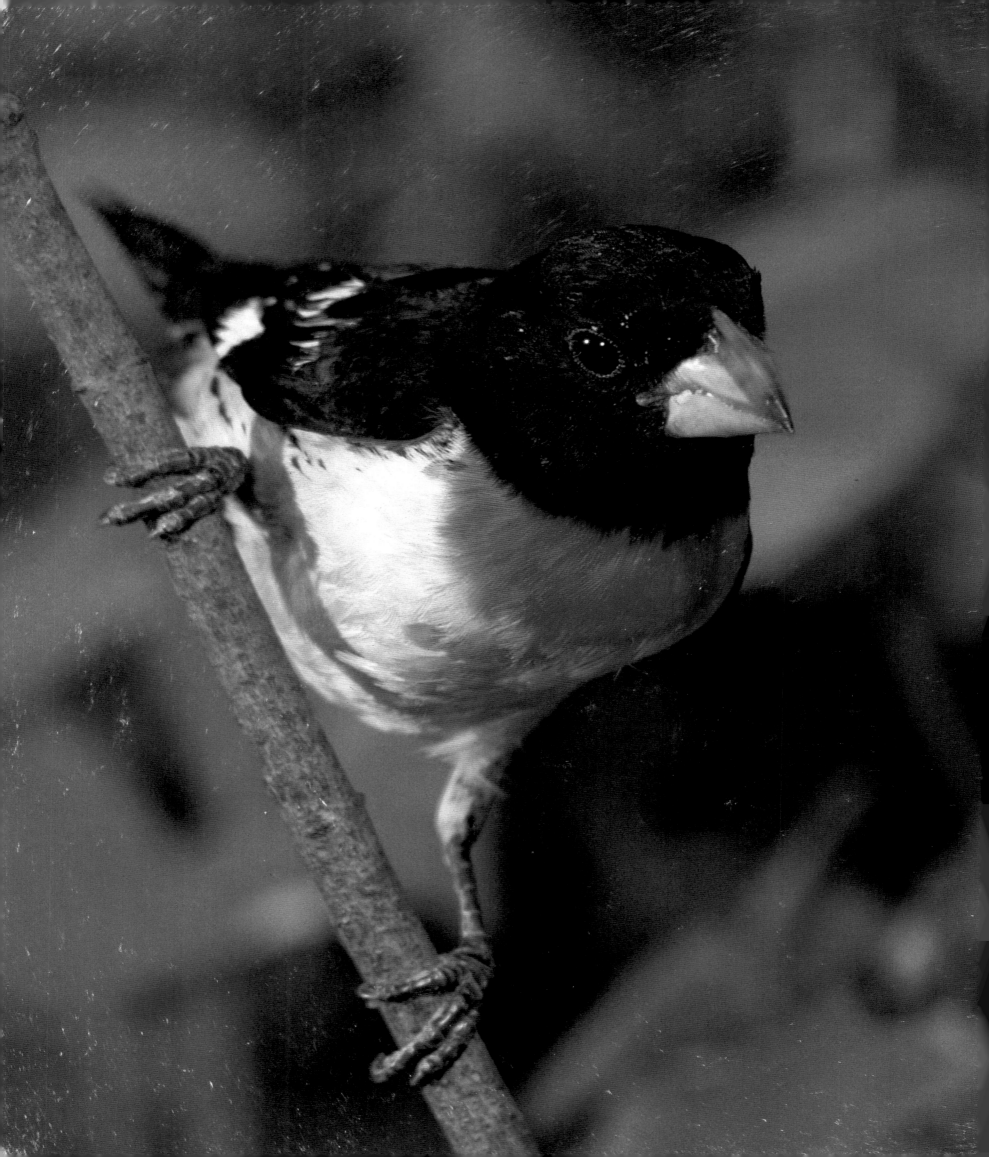

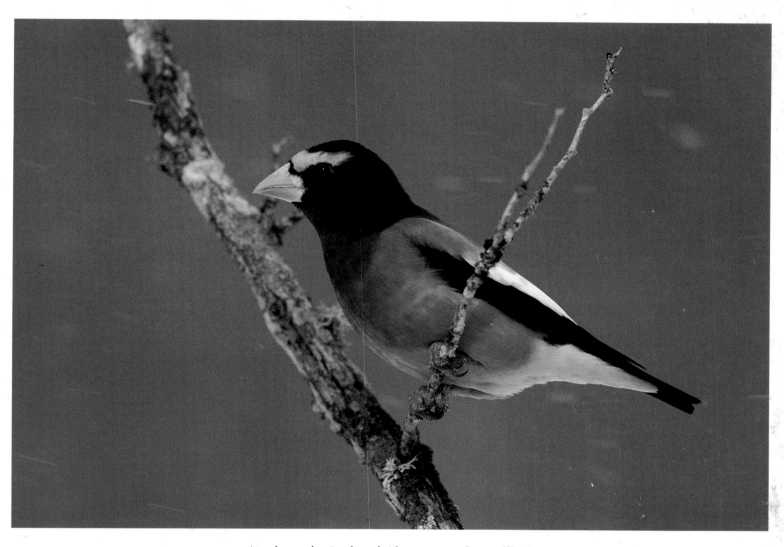

A male rose-breasted grosbeak (OPPOSITE) shows off both
parts of his name. The thick, triangular bill cracks seeds
for eating, but the bird also feeds on beetles, borers, and
locusts. The male helps incubate the eggs, rare behavior
among bright-colored songbirds. Formerly rare in the
East, the evening grosbeak (ABOVE) has spread to
both coasts. Misnamed, it flies any time of day.

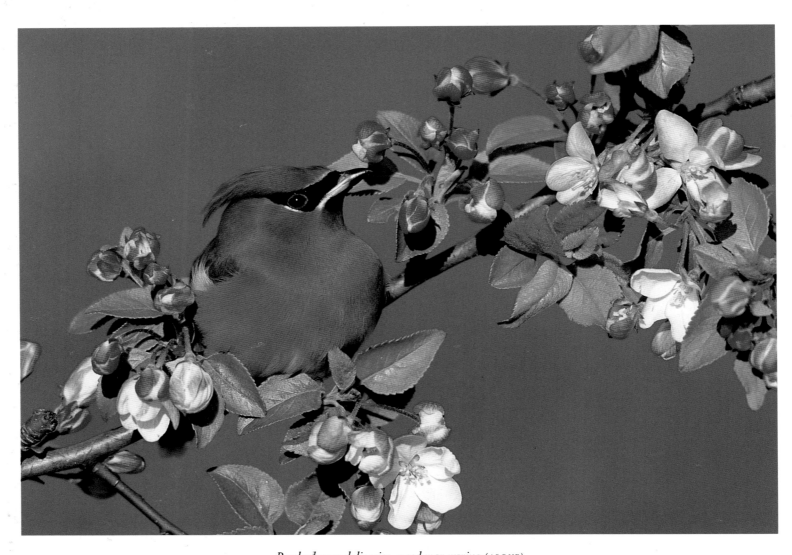

Perched near delicacies, a cedar waxwing (ABOVE)
contemplates a meal of apple blossoms. During
courtship a male and female may pass petals back
and forth as if exchanging gifts. Addicted to fruit,
the birds range over the lower provinces and
forty-eight states. Eating alone, a pine grosbeak
(OPPOSITE) gobbles crabapples. Normally found
in conifer forests, it extracts seeds with
its strong, stubby beak.

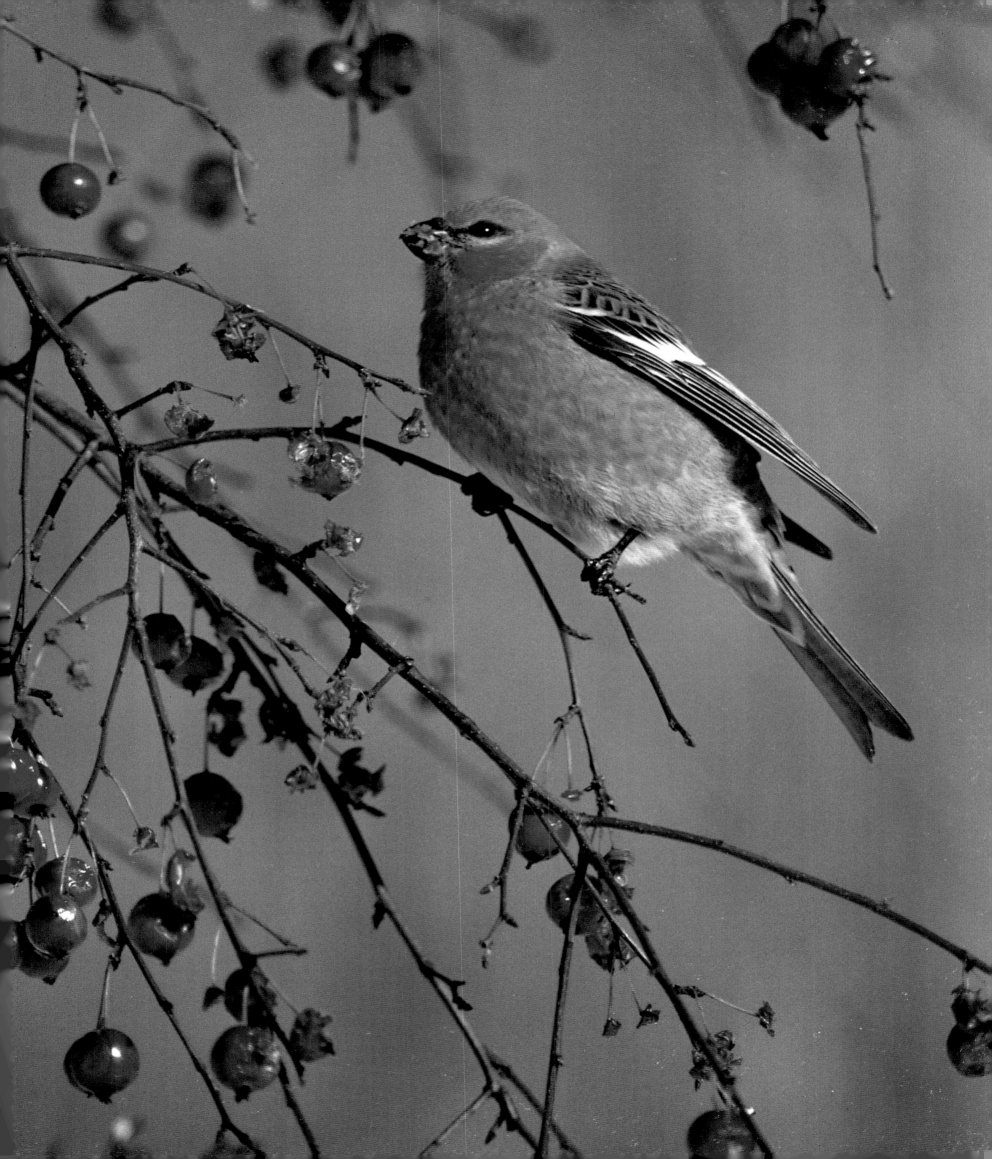

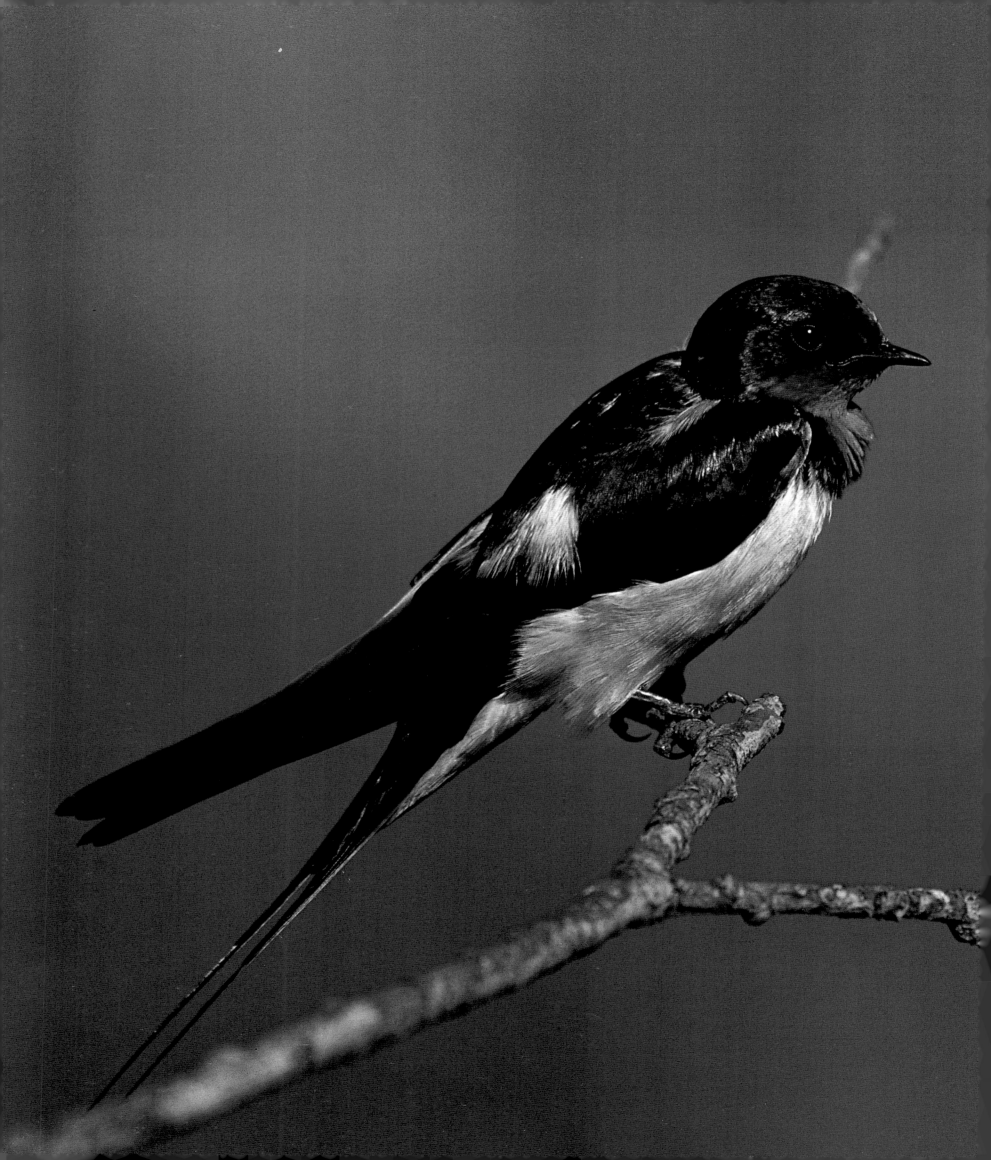

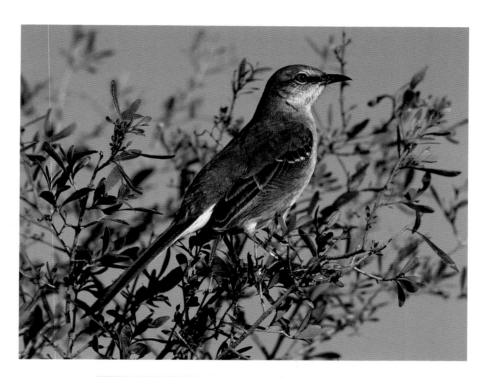

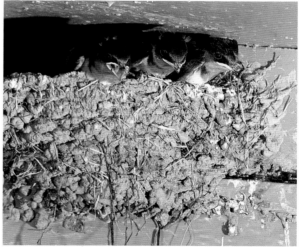

The barn swallow (OPPOSITE) was named by early colonists, who noted that it plastered its nest of mud pellets and straw on the beams of outbuildings. Three fledglings (ABOVE) peering from a nest may be enticed to fly by an adult hovering with food just beyond reach. A fierce defender of its nest, the northern mockingbird (TOP) will dive on dogs, cats, snakes, or people approaching too closely.

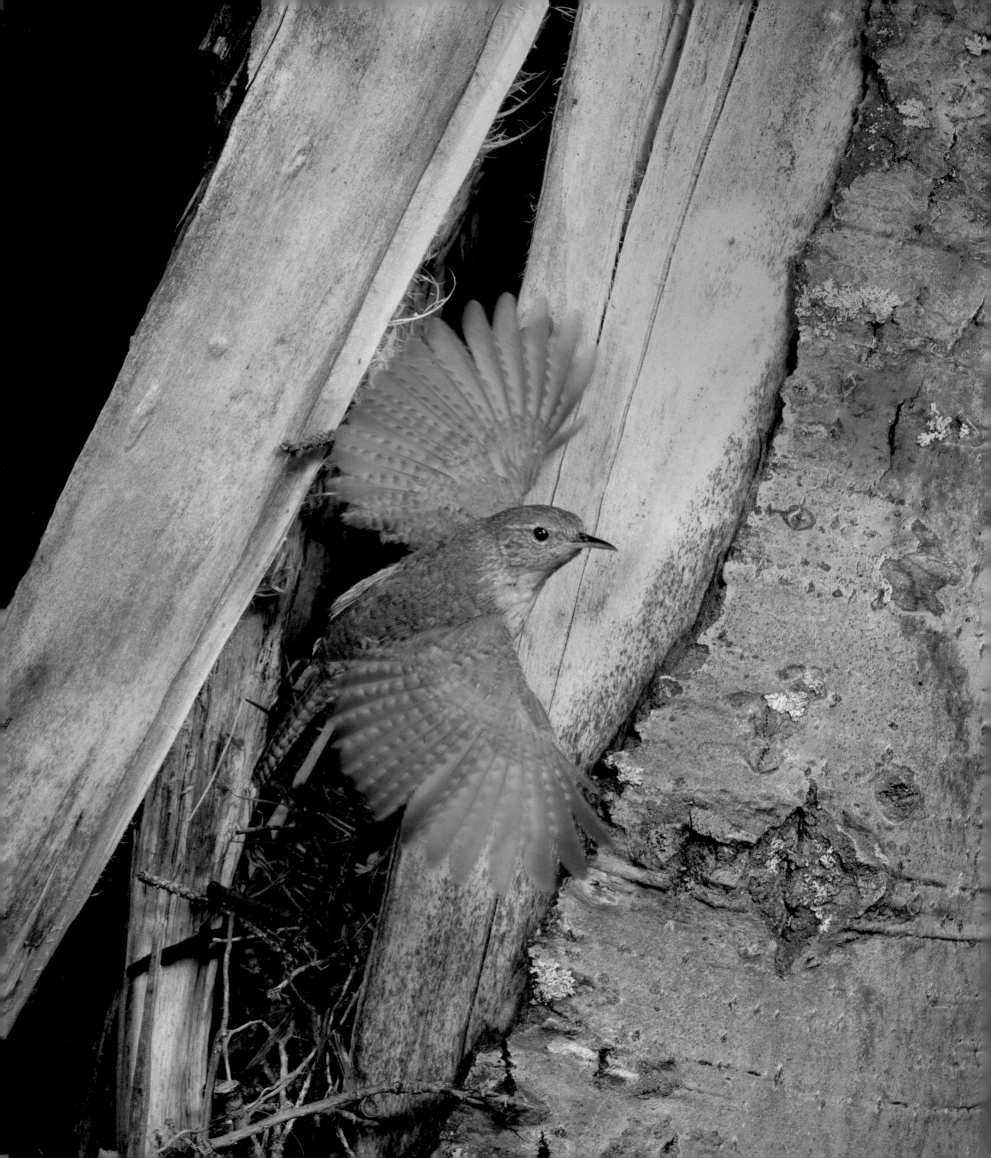

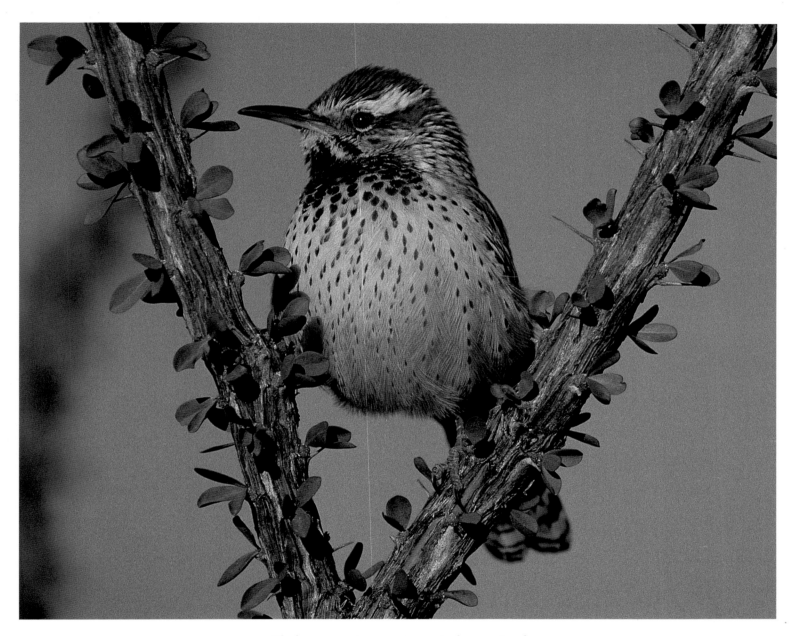

The house wren (OPPOSITE) nests in the crannies of buildings, but also in mailboxes, abandoned machinery, or an old woodpecker hole. Ojibway Indians gave the ardent singer a name that translates, "a big noise for its size." A larger family member is the cactus wren (ABOVE), at home in thorny surroundings. Arizona's state bird builds feather-lined nests with side tunnels to ward off the cold of desert nights.

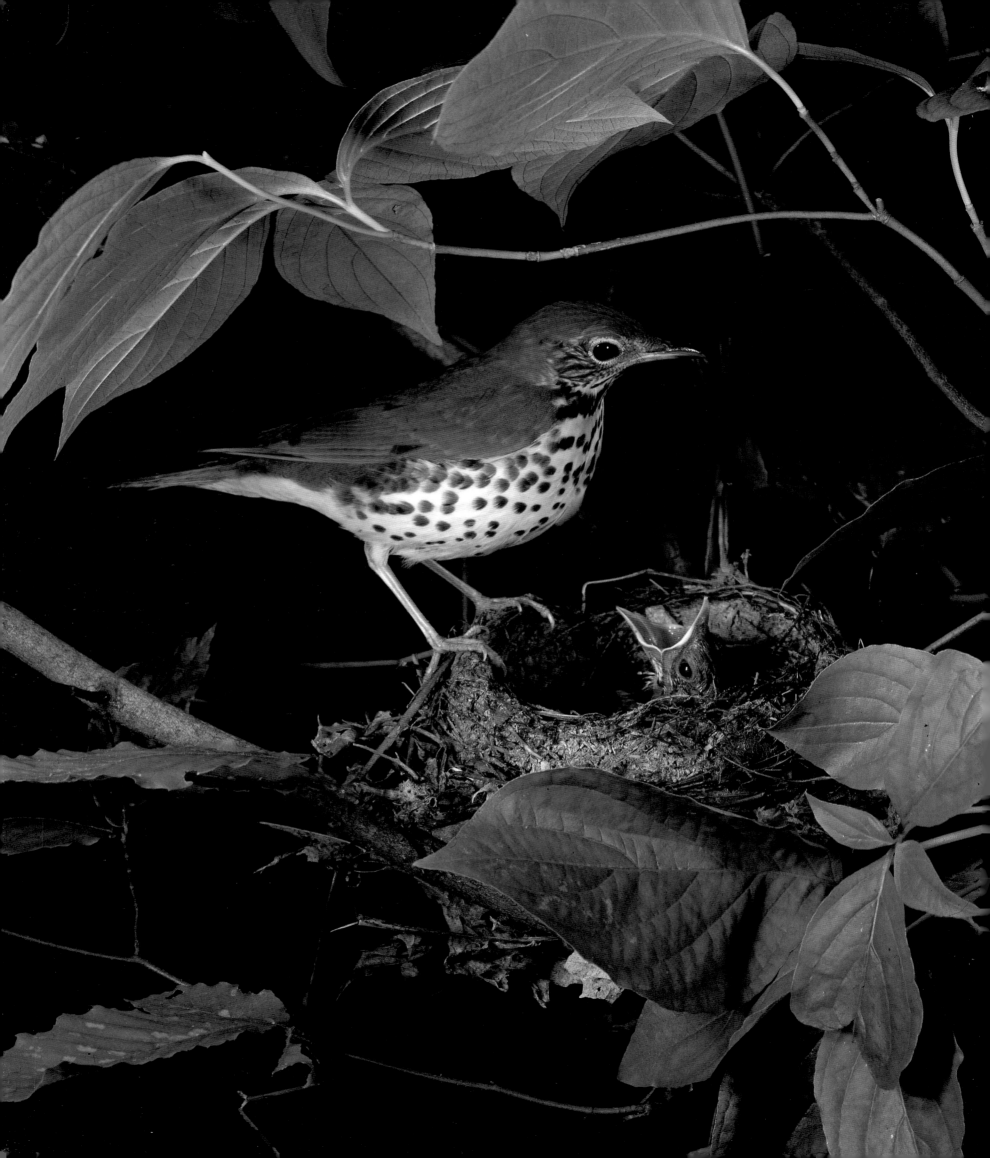

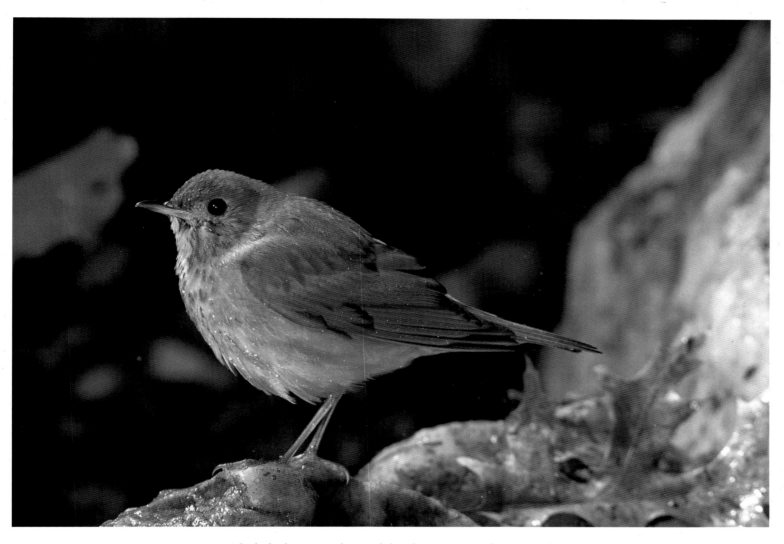

Thick shade attracts the wood thrush (OPPOSITE), whose spotted
coat camouflages well in dappled sunlight. Male and female,
which look the same, share in parental duties and may raise
two broods in a season. Its reclusive relative, the veery
(ABOVE), is more often heard than seen as it too
prefers dark retreats in moist woodlands.

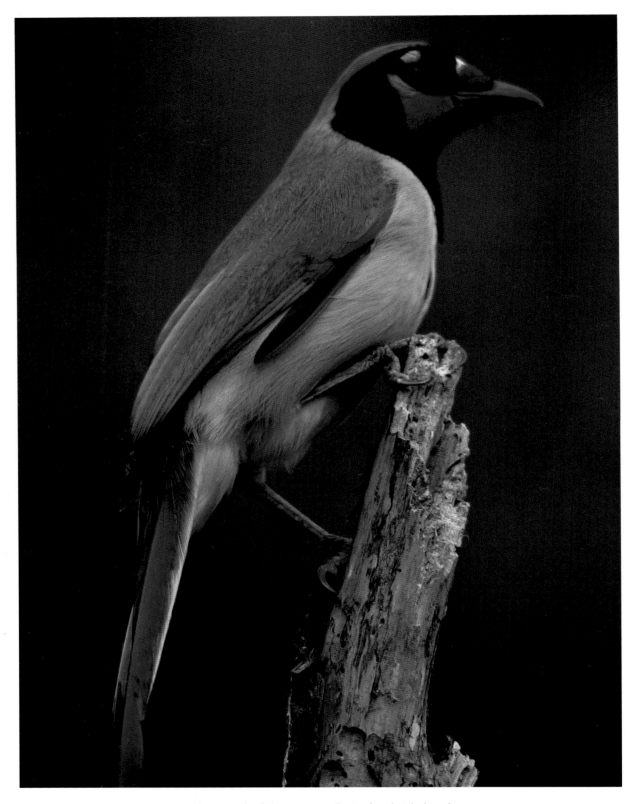

*Dark mask of the green jay fits its family's habit of
scavenging items from ranches and robbing other birds.
An inquisitive nature draws it to inspect human
intruders. Tropical, it ranges to the southern tip
of Texas. In the lush vegetation where it is
usually seen its coloration blends in well
with dappled sun and dark shadows.*

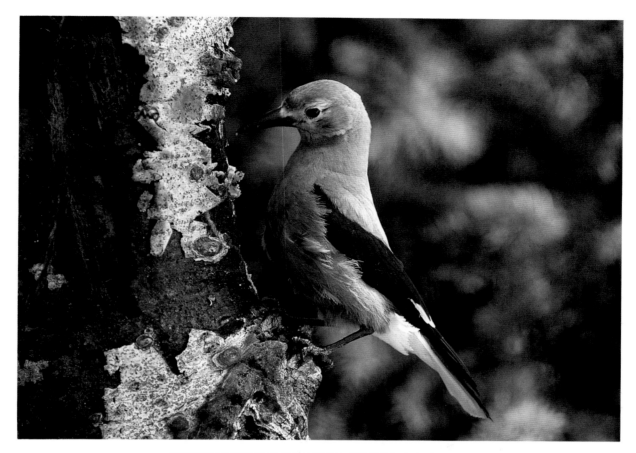

The foot-long Clark's nutcracker (TOP) *is an aggressive
thief in western campgrounds. It also uses its long black
bill to pry or crack open evergreen cones and reach their
seeds. Unlike smaller jays, it flies with slow, heavy wing
beats. The Florida scrub jay* (ABOVE) *gets communal
help in nesting. Birds of the previous year's brood
help defend the nest and feed the young.*

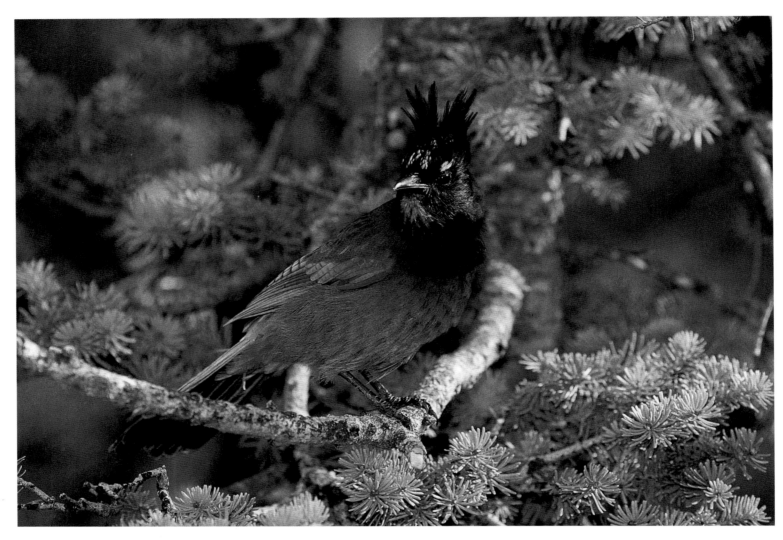

*The raucous voice of Steller's jay rings through western
mountain slopes. Loudest of the jays, it nevertheless
sings a soft, sweet song to its own kind that humans
rarely hear. Like other jays, it sometimes preys
on the nestlings of other birds but its
diet is mostly vegetarian.*

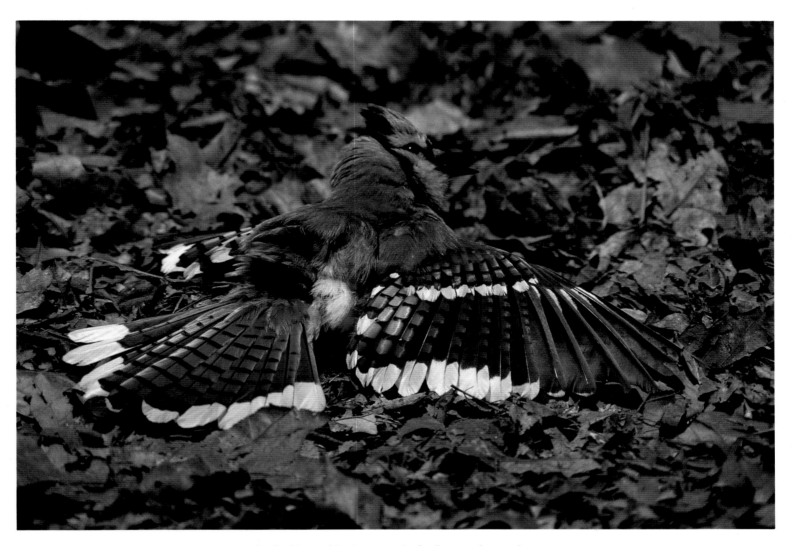

Sunbathing, a blue jay opens its feathers, perhaps so heat
will drive insect pests to its head where they can be
scratched. The sun also releases vitamin D from oil
in the jay's feathers. Swallowed as the bird preens
itself with the oil, or absorbed through the
skin, the vitamin D may prevent rickets.

PAGES 74-75
Gaping mouths of blue jay youngsters offer wide red
targets for a parent bringing a tasty morsel. Despite
their bullying reputation, blue jays are careful
parenting partners. Both sexes work at
building the nest and will attack squirrels
that sometimes eat their eggs.

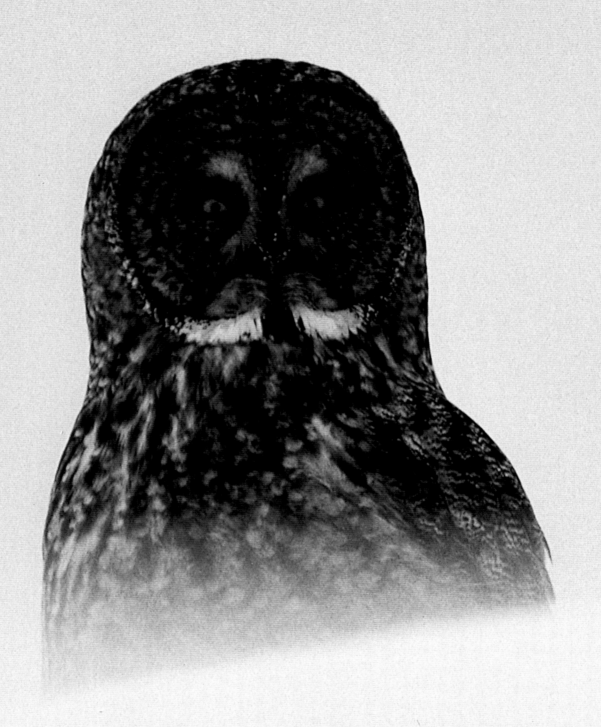

RAPTORS

CHECKERS AND BALANCERS

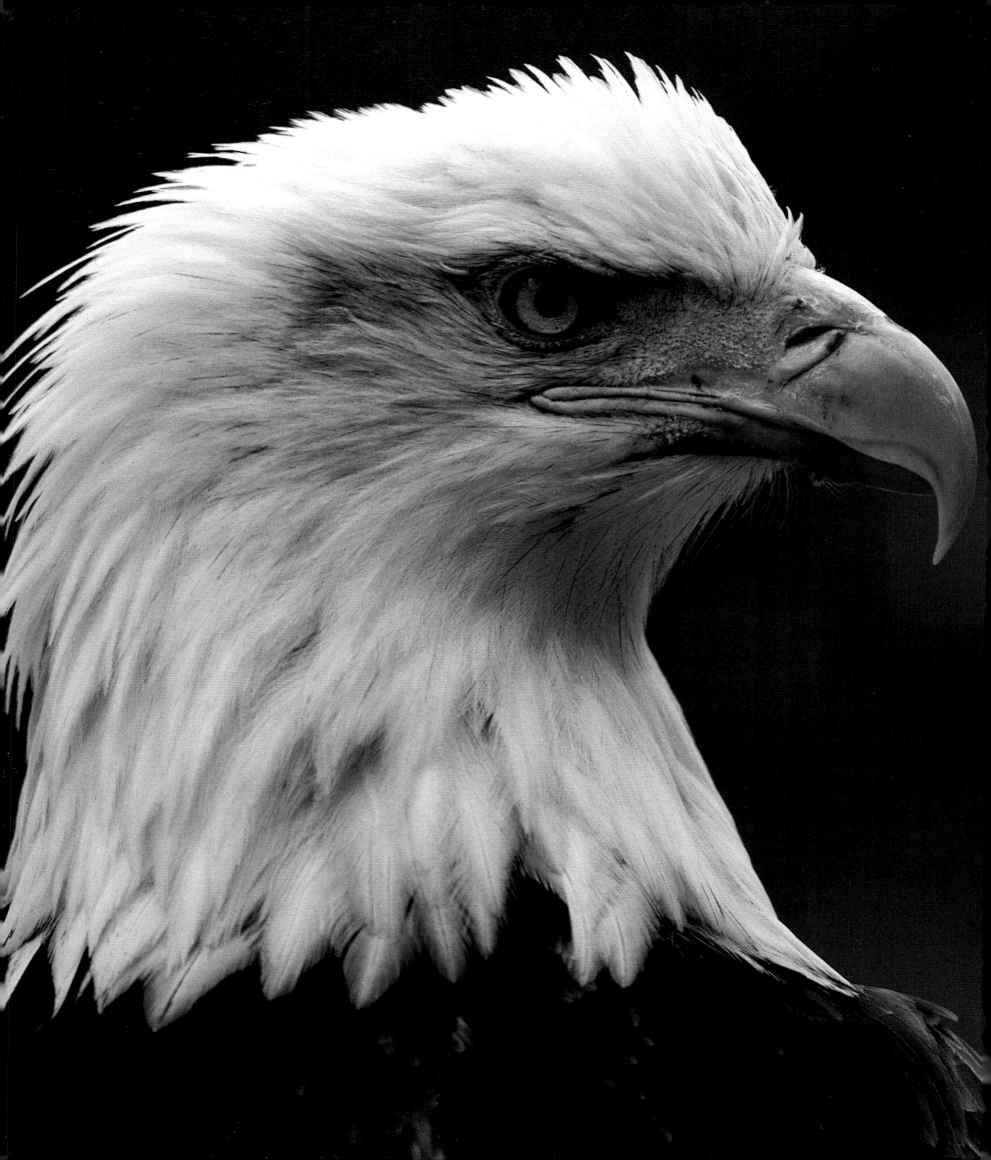

RAPTORS
CHECKERS AND BALANCERS

Symbol of strength for a nation, paragon of power among birds, the bald eagle with its white head, massive hooked beak, and fierce gaze epitomizes the regal look of many raptors. Once threatened by hunting and the thinning of its egg shells by DDT, our national emblem is now off the endangered list and on the increase in the U.S.

PAGES 76-77
With a glare as icy as the world it inhabits, a great gray owl sits amid drifting snow and extreme cold in Michigan. Like most raptors, it is superbly equipped for capturing food. Feathered facial disks channel the slightest whisper of sound to its keen ears, guiding the owl to prey that may be hidden under the snow.

W E MAY THINK OF SONGBIRDS as friendly, melodious neighbors, but we have too often categorized raptors as the stern, muscular warriors of the bird world. The family name stems from the Latin word *raptare*, meaning "to seize and carry away," and indeed they are built for aggression, for killing, grasping, and tearing. The flesh-eating hunters include hawks, eagles, owls, many of them large birds with slow, deliberate wing beats that epitomize strength. Perhaps it's the makeup of their far-seeing eyes, or the projecting brows on some, but even their gaze appears uncompromisingly fierce. Little wonder that people supportive of military action are known as "hawks."

Military comparisons to raptors are numerous and often quite apt, especially in aerial combat. Raptors were diving on targets millions of years before Hitler's Stukas. Owls are the original Stealth bombers, virtually undetectable as they approach a target in the dark. Eagles in mating displays execute the same moves that a fighter pilot can make, such as loops and rolls, and a few that they can't, such as cartwheeling.

The real hawks of the world have never warred against humans but we, unfortunately, have sometimes declared war on them. Perhaps their power, aggression, and fierce appearance seemed a challenge to human domination of nature, for we killed them wantonly for decades. Eagles were shot as livestock-killing vermin before the Bald and Golden Eagle Protection Act was passed in 1940. Earlier in this century almost any large, daytime raptor was called a "chicken hawk," although no species exists by that name. Naturally, in the days when families in our predominately rural continent had chicken yards of fryers and laying hens, hawks viewed them as fat, slow prey. Some were taken, although field mice, rats, small birds, and baby rabbits made up the bulk of the hawk's diet.

Perhaps the largest continuing slaughter of raptors over the years took place on Hawk Mountain in Pennsylvania. Every fall the high-soaring hawks known as buteos follow updrafts

created by the Appalachian ridges in a soaring migration southward, and for years shooters gathered on the mountain to blast them out of the sky for sport as they flew low over the promontory. Today nearly 50,000 people visit the mountain annually to watch, not shoot, the thousands of hawks soaring past, and to learn more about them in the well-staffed facilities of the Hawk Mountain Sanctuary, the world's first refuge for birds of prey. Our relationship with raptors shows signs of improvement elsewhere. In Oregon, the Portland General Electric power company now builds ten-foot extensions above potentially lethal utility poles as safe nesting sites for ospreys. Peregrine falcons, once threatened with extinction, now nest in tall buildings in Baltimore, Maryland, and elsewhere in the East, preying on over-abundant pigeons in cities. After a half-century absence, aplomado falcons have been reintroduced to south Texas, where they feed on large insects and noisy grackles.

We are finally learning that raptors are enforcers of nature's balance. The countryside might be overrun with rodents were it not for the night work of owls, sometimes referred to as "flying mousetraps." Before man dominated North America, raptors helped some mammals control the population of snakes. Even the young of wolves and bobcats, predators with few other natural enemies, are not safe from golden eagles.

Despite destructive setbacks, raptors have fared well with humans over the long run of history, having often been adopted as symbols of wisdom, courage, and determination. The Athenians adopted the little owl, *Athena noctua,* as their mascot, and Aristophanes claimed the battle of Marathon was won partly because large numbers of hissing owls swooped on Persian troops, terrorizing them. In Egyptian hieroglyphs, falcons sometimes represented kings. Long before the bald eagle became the emblem of the United States, Roman legions carried eagles of silver and gold on poles as standards representing military power.

Eagles, hawks, and falcons are the most glamorous of the raptors because of their dominance of the skies and their air of authority. For the business of capturing animals on the ground or snatching other birds in mid-air, they are superbly equipped. Our knowledge of the offensive weapons of birds is generally focused on their beaks, and the hooked end of a raptor's bill gives it a lethal look. But the primary killing instruments for many are the curved talons on their feet. After the birds dive at high speed to make contact in the hunt, the opposing, needle-sharp stilettos pierce the bodies of their prey in a powerful pincer motion, incapacitating vital organs and snapping vertebrae. Some of the extremely fast birds grab smaller birds in mid-air, but they may also knock their prey to the ground with a stunning or killing blow. Peregrines swoop at speeds approaching 200 mph and strike prey with impacts that produce clouds of feathers. Bald eagles snatch fish from the water while barely wetting their feathers. Ospreys splash into the drink, bob to the surface, then wing their way back into the air while clutching their catch. Miscalculations

sometimes happen. Fishermen have reported finding drowned eagles and ospreys floating at sea, their talons still stubbornly imbedded in fish that were too large to lift. In their death struggles, the fish pulled the birds under the water.

Fast though they may be, hunting birds are not rocket scientists. The most distinctive feature of eagles and hawks is their incredible eyes, which take up so much of the skull cavity that the brain is dwarfed by them. The eyes of eagles are larger than ours, on a bird that may weigh slightly less than ten pounds. The spacious eyeball allows a maximum amount of light to enter through the cornea to reach the numerous cones on the retina, allowing the perception of extremely fine detail.

It is no surprise that daytime hunting birds can see at a distance of at least two and a half times farther than we can and perhaps as much as eight times farther. Why else refer to sharp-eyed people as "hawk-eyed" or "eagle-eyed"? But imagine trying to eat dinner while looking through a long-distance lens. To see well close-up, as well as at a distance, hawks and eagles direct an image onto either of two locations on the retina at the backs of their eyes. It is believed that one location, called the central fovea, is associated with close-up vision, and the other off to the side, called the temporal fovea, is associated with distance vision. All birds have this double fovea set-up, but the field of vision for hunting birds is much improved because the eyes are mostly face forward, giving a wide field for scanning. When you see a hawk "making lazy circles in the sky," with its head down in search of prey,

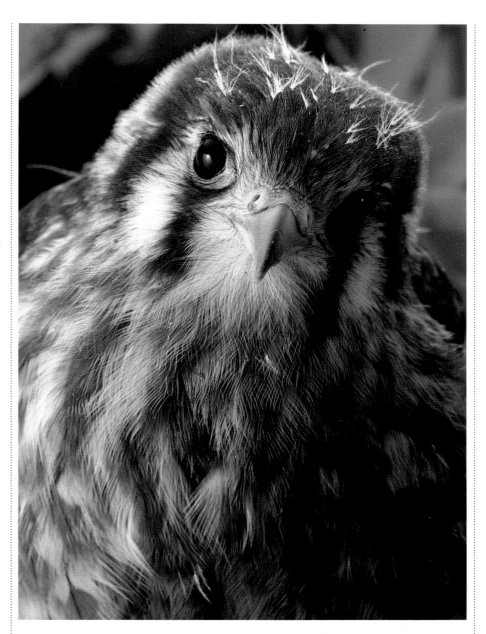

it is using its long-distance equipment. When seated on a tree snag and cocking its head sideways to peer down at the prey in its grasp, it is directing the image straight back to the central fovea for close scrutiny.

Evolution does not take lightly such a valuable asset. Since the large eyeballs project beyond the contours of the skull, leaving them susceptible to injury, that bony projecting brow overhanging the eyes of some raptors acts as an overhead shield and perhaps also

Falcon princess, a female kestrel fledgling wears a garland of nestling down. The smallest and most common of North American falcons may live eleven to twelve years, barring collisions with highway vehicles, a leading cause of death. Larger raptors live longer natural lives, some more than two decades. Fatalities to birds of prey by human predation appear to be on the decrease.

cuts down on glare. A third eyelid offers additional protection. Like us, raptors have top and bottom eyelids that meet in the middle of the eye when closed. But like all birds, they also have a third lid, a tough and transparent covering called a nictitating membrane that glides over the eye from side to side, moistening and cleaning it. The membrane also covers the eye to protect it against injury when a bird impacts with its prey.

As if that weren't enough visual equipment, a recent Finnish study indicates that hawks have yet another advantage to help them find prey. Since rodents are notorious for cycling between abundance and population crashes, the problem for the hawks is finding areas of heavy congregation so they don't waste time and energy wheeling over a rodent-lean landscape. Voles and other small rodents mark their little grassy highways with urine and feces, waste material that is visible in ultraviolet light. To hawks and falcons, those highways are highlighted as though with magic marker. The birds are able to see in the ultraviolet light range, which allows them to spot the areas of heaviest activity and therefore concentrate their efforts where success in food-gathering is most likely. If the deck seems stacked against rodents, consider that each field mouse procreates fifty times more than a single raptor.

Little is known of the hearing capabilities of hawks and eagles, although for most, eyesight seems more important. The champions of hearing are the owls.

Owls have achieved the reputation in our folklore as being brainy, an idea that probably comes from the facial disk that gives the appearance that they are wearing spectacles. That, plus their contemplative demeanor, reminds us of someone studious and probably inspired the phrase "wise as an owl." When one considers the extent of their visual and auditory equipment and the small space left for a brain, owls might actually rank high among bird dullards. But then, we are the species that also says someone is "silly as a goose," when any hunter knows that wild geese fully comprehend the opening day of hunting season and the exact range of a 12-gauge shotgun.

In the hearing arena, however, owls are geniuses. Barn owls can zero in on a mouse in total darkness, just by following the scurrying of tiny feet. Great horned owls can detect a snake moving through the grass. Great gray owls can hear a field vole running under two feet of snow, then plunge through the fluff to capture it.

Whereas most birds have a small round external opening for ears, owls have long vertical slits, and the skull cavity allowing passage of sound to the brain is large. On some, the two openings are offset, one higher than the other, enhancing depth perception which helps to identify the exact origin of a sound. Registering on the owl's brain is the difference in time it takes for a sound to reach one ear compared to the other, perhaps a difference of 150 microseconds (a microsecond being one millionth of a second). The intensity of the sound allows each ear to distinguish vertical from horizontal at the sound source. The bird makes adjustments with its

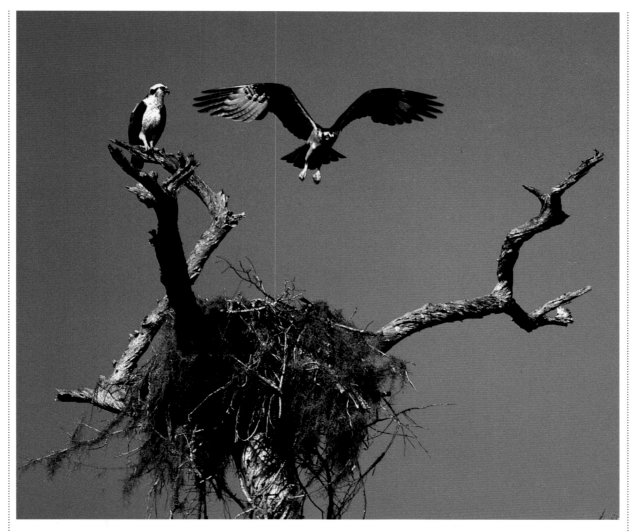

Home is a mass of sticks in a dead treetop for a pair of ospreys. Large nests atop power line poles cause conflict with utility companies; some now provide safe alternate structures nearby that the birds readily use. Ospreys, like eagles, were threatened by DDT, but elimination of the chemical and conservation activities have halted the decline. The fish-eaters thrive around stocked artificial reservoirs.

head until the sound is perfectly aligned in both ears, and in line with its eyes (which are very close to the ears), and when thus locked on target it bores in for the attack on prey it cannot even see.

All this is possible because of the facial disks that channel the sound toward the ears and eyes, much as you might cup a hand behind your ear to hear something better by catching more vibrations. The owl's feathery disks can be flexed to pick up the slightest rustle. With these locators at full alert, the bird can then make its silent approach thanks to another feathery adaptation. Anyone who

has surprised a bird at close range knows how loud wing flaps can be, from the whir of wind through feathers that are rowing desperately. With silence essential, the wings of owls have feathers with soft, fluted leading edges, so the air can flow through noiselessly.

A final adaptation occurs in digestion. If possible, owls prefer to swallow their meals whole, but this means ingesting bones, hair, feathers, and beaks that might not break down sufficiently to pass through their entire digestive system. So the indigestibles gather in a clump which the owl eventually coughs up in a neat little packet known as an owl pellet.

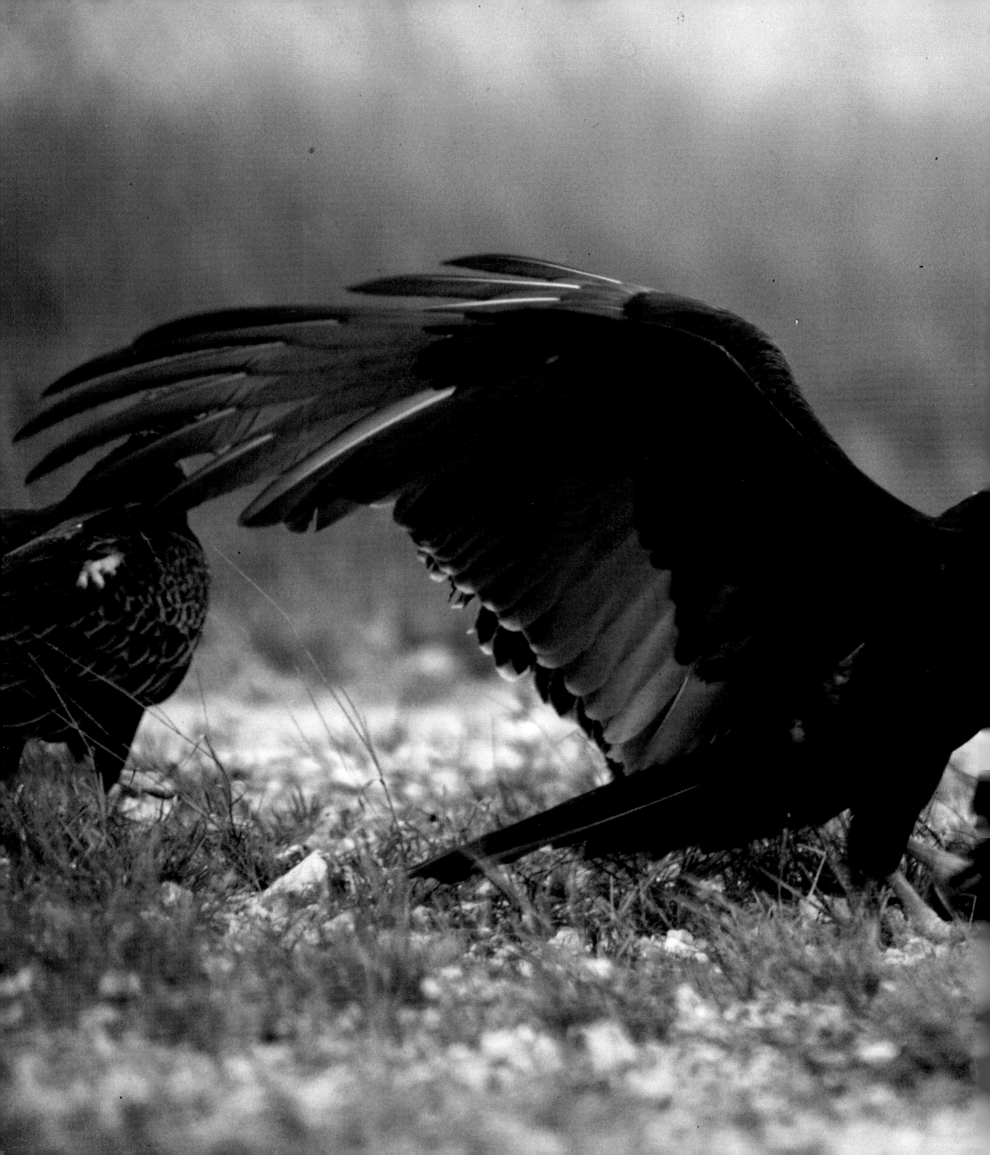

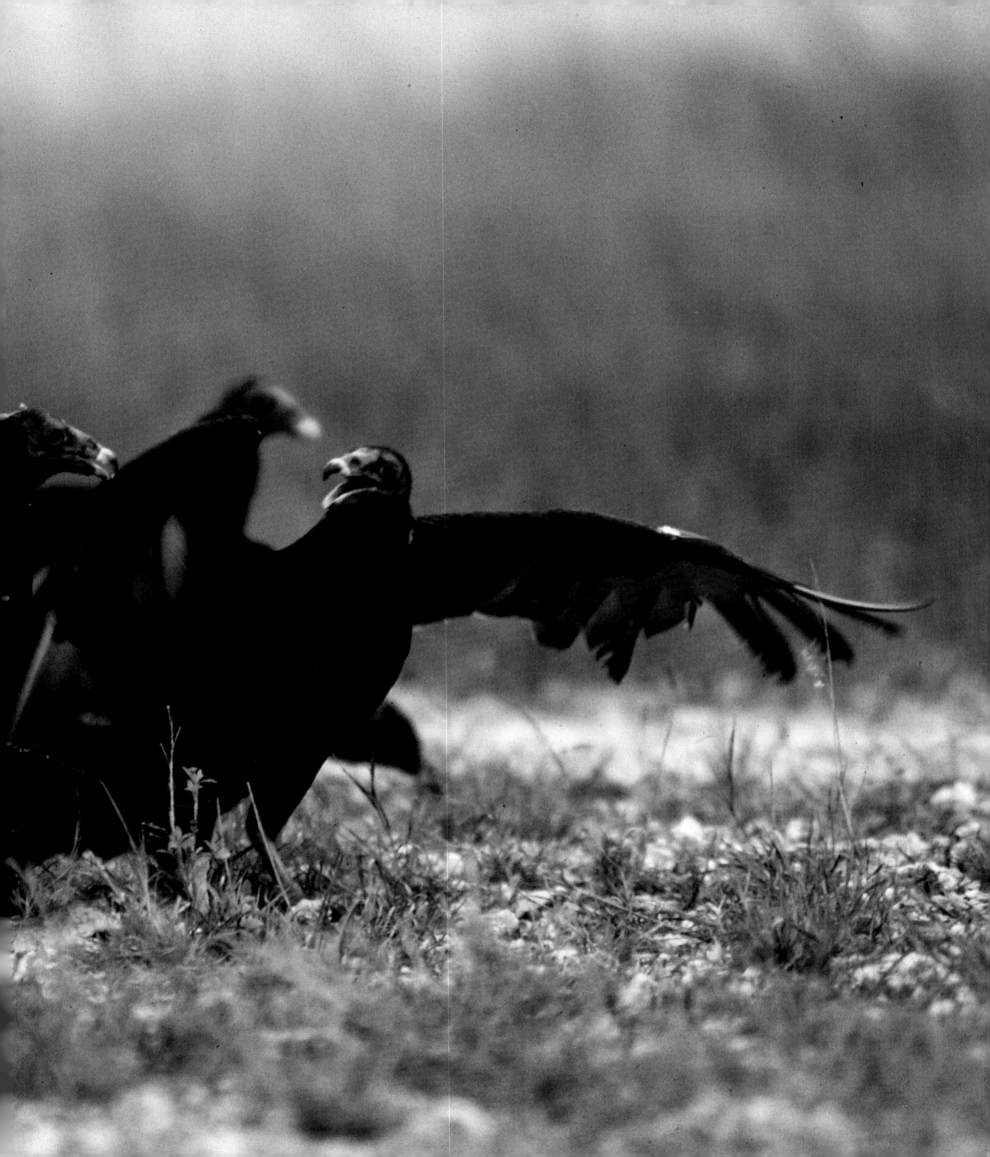

These may land beneath an often-used eating roost, simplifying the job of zoologists studying owl diet.

Much less fastidious are the eating habits of vultures, which in the New World are probably more closely related to storks than to raptors. In fact, their featherless heads allow them to partake of their often-gory diet without worrying about preening matted feathers.

We call brave people eagles, compare wise ones to owls, but those who take from the helpless we refer to as vultures. For the most part, the only thing these maligned raptors take are rotting carcasses that would otherwise stink up a landscape for days and foster clouds of flies. Unfortunately, in times of want they sometimes become impatient and assume raptorlike behavior. Our principal North American vultures, the turkey vultures and especially the more aggressive black vultures, will occasionally attack the living. In early 1995 in southwest Virginia, black vultures began swooping down on newborn calves and lambs, pecking them to death, and a living cat was snatched from a lawn and carried 100 yards before it was dropped. Residents began to worry about letting toddlers play outdoors unattended. Wildlife officers blamed a harsh winter that resulted in less road kill for the birds. Our highways, and the animal carcasses they produce, are probably responsible for the increase in vulture populations in recent years. But when the asphalt cupboard is bare, the scavengers get desperate.

Road kill has not helped the population of our largest vulture, the California condor, now numbering fewer than fifty, with most of them in captivity. With wingspreads of ten feet for soaring, the condors prefer miles of wide open spaces, a commodity in short supply these days in southern and central California. As slow on takeoff as an overloaded DC-10, they are killed in collisions with automobiles when they do descend to our level. Even where habitat is available, condor mortality has mounted in recent decades. The birds ingest bullet fragments while eating deer and coyotes shot by human hunters, and die of lead poisoning. Collisions with electric lines also prove fatal, and one died by drinking antifreeze in a parking lot.

The plight of the California condor has aroused sympathy, and elaborate protection measures have been adopted for that species of vulture, at least. Birds born in captivity are now trained to avoid utility poles before they are released in the wild, and to fear people; keepers sneak up and turn them upside down —and vultures hate that!

Elsewhere, the more common smaller vultures continue to suffer as much of an image problem as owls enjoy an image windfall. We consider them ugly with their skin heads, their necks and shoulders hunched like an undertaker with osteoporosis, and their habit of cooling off by defecating on their own legs. Plus, we hardly consider carrion a delicacy, and a creature that feeds on putrid meat can hardly expect to win our admiration. A little respect is in order for these funereal birds, however. They carved out a niche as nature's morticians long before there were people around to turn up their noses at an efficient job of clean-up.

PAGES 84-85
Turkey vultures squabble on a snowy field. More plentiful than the more southerly black vulture, they are found throughout the contiguous U.S., an expansion aided by the increase in road kill remains and human garbage. Although similar in appearance to Old World vultures, which are closely related to eagles and hawks, New World vultures and condors probably share their ancestry with storks.

Daytime hunting and hawklike hovering helped give the northern hawk owl its name. Normally a bird of Alaska and Canada, a harsh winter or shortage of prey may have forced this one south to a spruce in northern Michigan. With its long tail and dark facial markings it may be mistaken for a short-necked falcon.

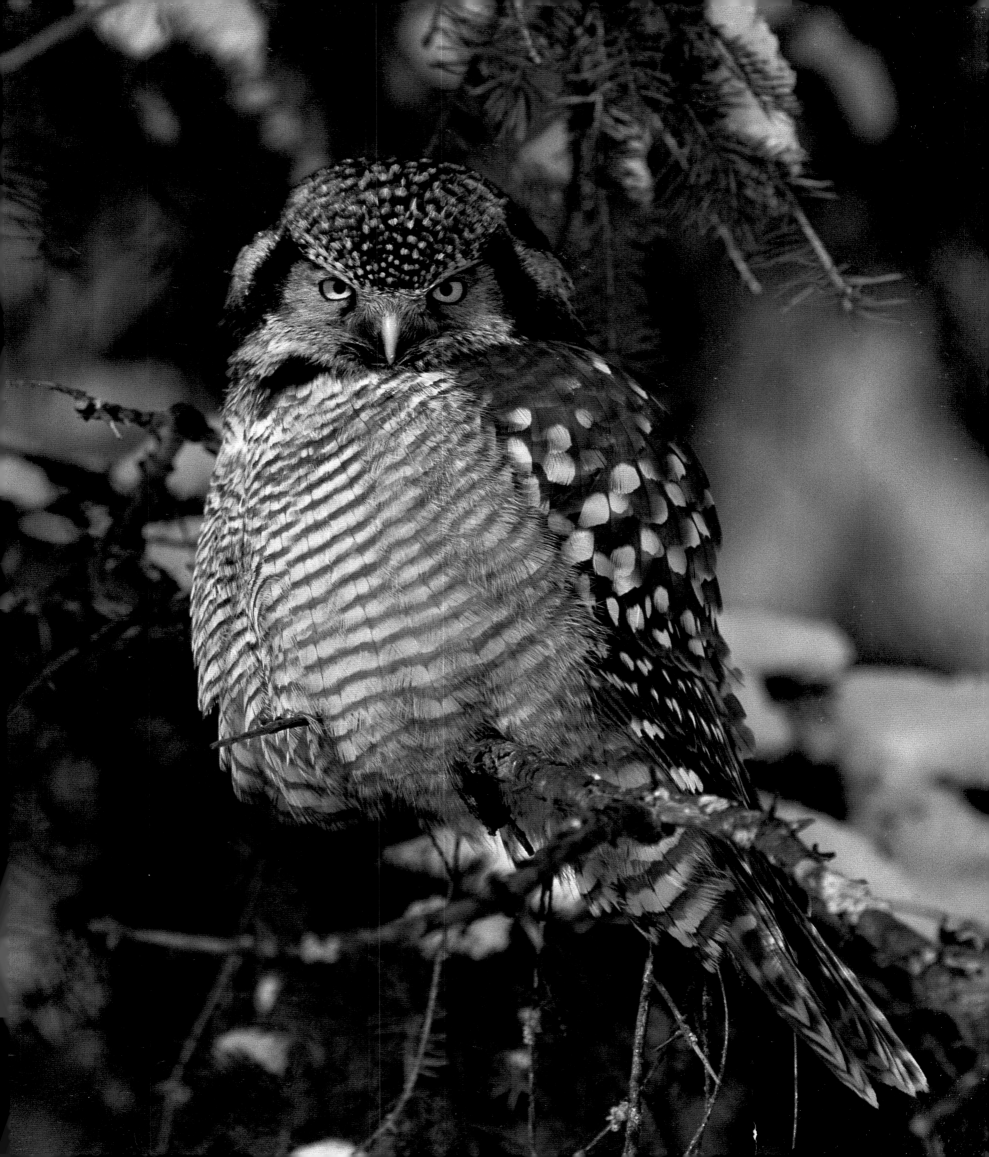

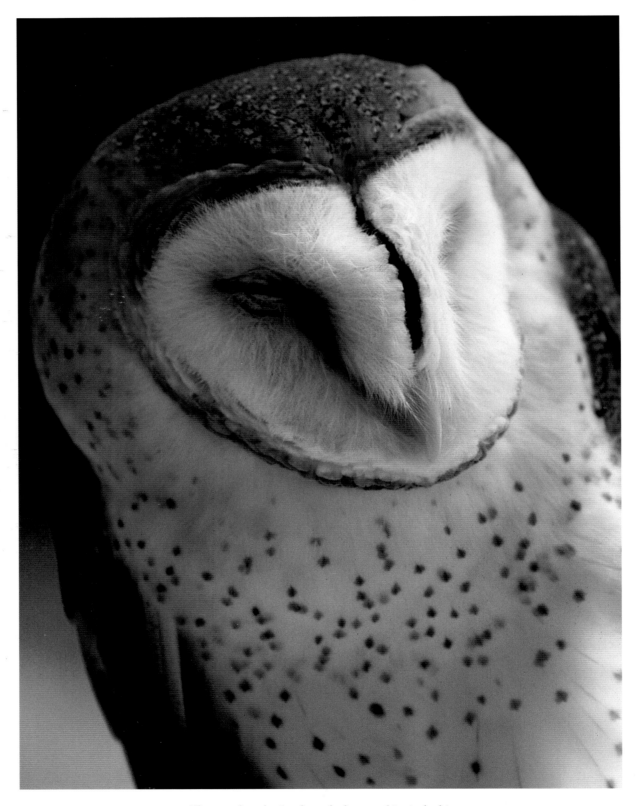

*The sound-gathering face of a barn owl is pinched in
sleep during daytime. A terrific mouser, the bird can
guide itself to prey in pitch darkness by cupping sounds
in its heart-shaped face, as you might put a hand to
your ear. A pair with young can rid a farm of more
rodents than ten cats. Loss of farmsteads and
barns abet its decline in the eastern U.S.*

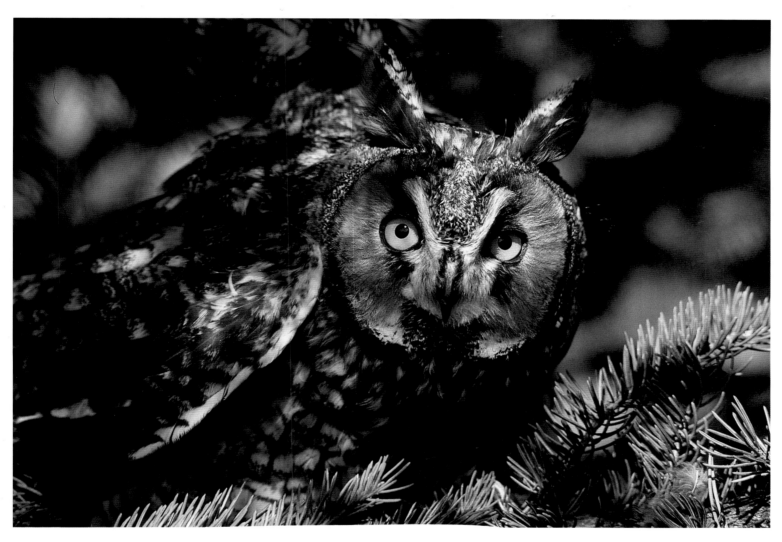

*Rabbitlike tufts easily mark the long-eared owl. Finding
one's nest is more difficult, for the rust-faced birds,
though believed plentiful, scatter their homesteads
widely in eastern forests and freeze in camouflage
against tree trunks when danger is near.
Sharp-eyed hawks and larger owls catch
and eat many of them.*

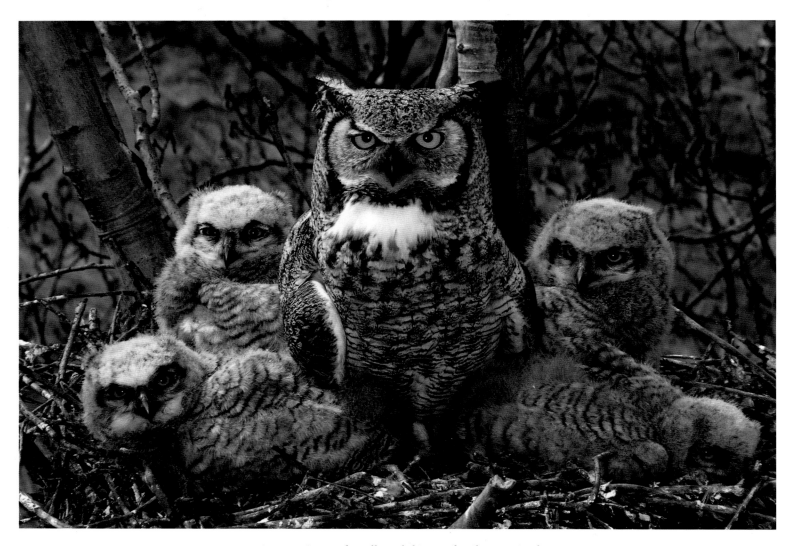

An attentive mother allowed this rare family portrait of great horned owls in Canada. Most parents drop food off to nestlings this size, then leave; this one spent an abnormal amount of time with her brood. She raised all four young, also unusual when eggs are laid two days apart and the competition for food often starves the later, smaller hatchlings. Backs to the camera, two at rear show the ease with which owls rotate their heads up to 180 degrees. Eastern and southern birds are darker and more brown.

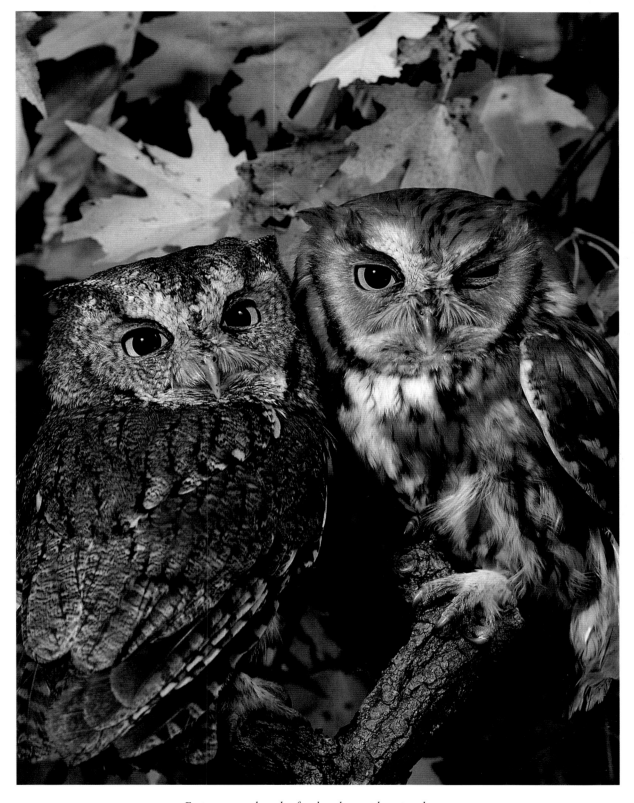

*Eastern screech owls of red and gray phase perch on a
silver maple in autumn. Those with the red coloration
tend to predominate in the South and the grays are
more numerous in the North. These two straddled
the genetic borderline in Virginia. The little owls
feed at night on small mammals, insects,
and occasionally birds.*

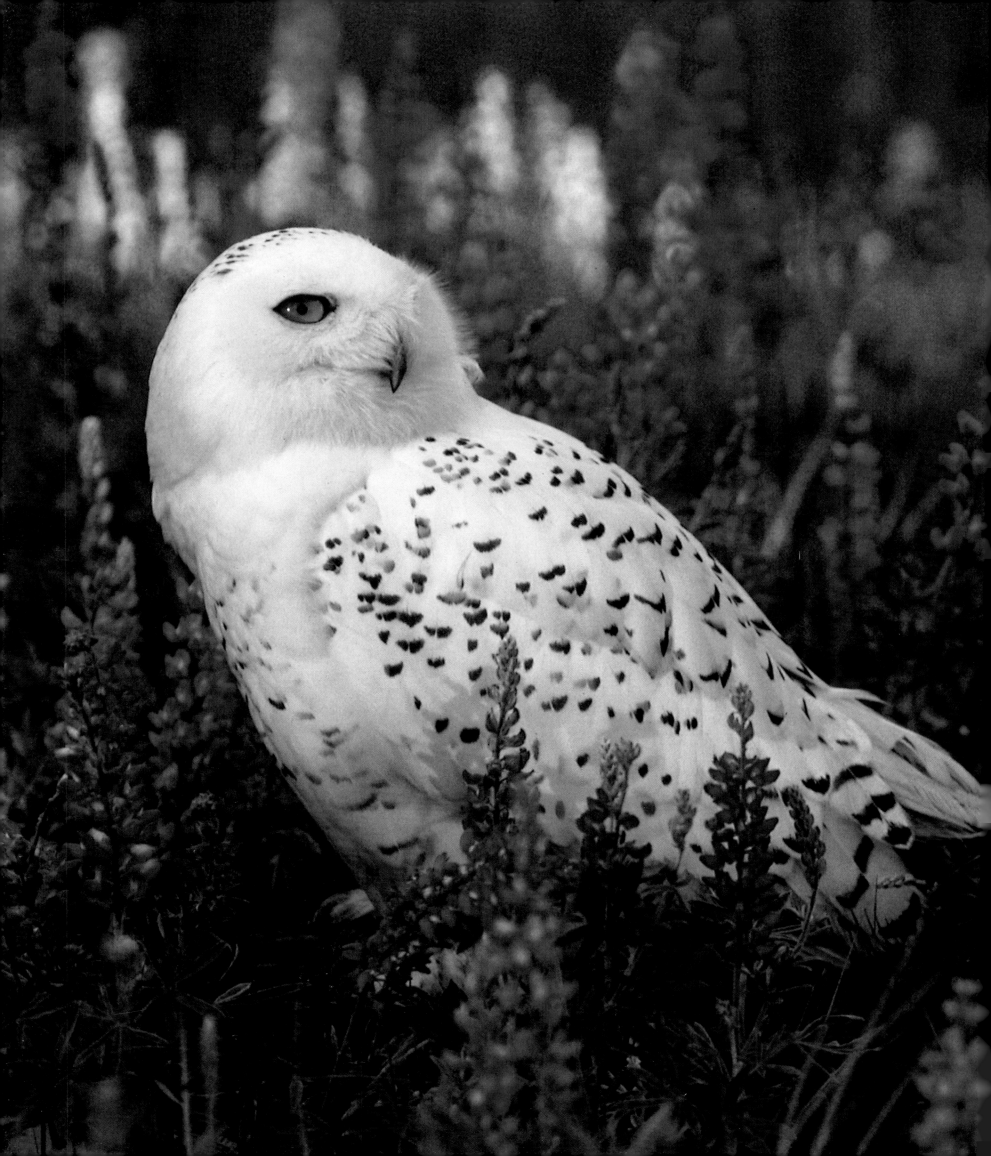

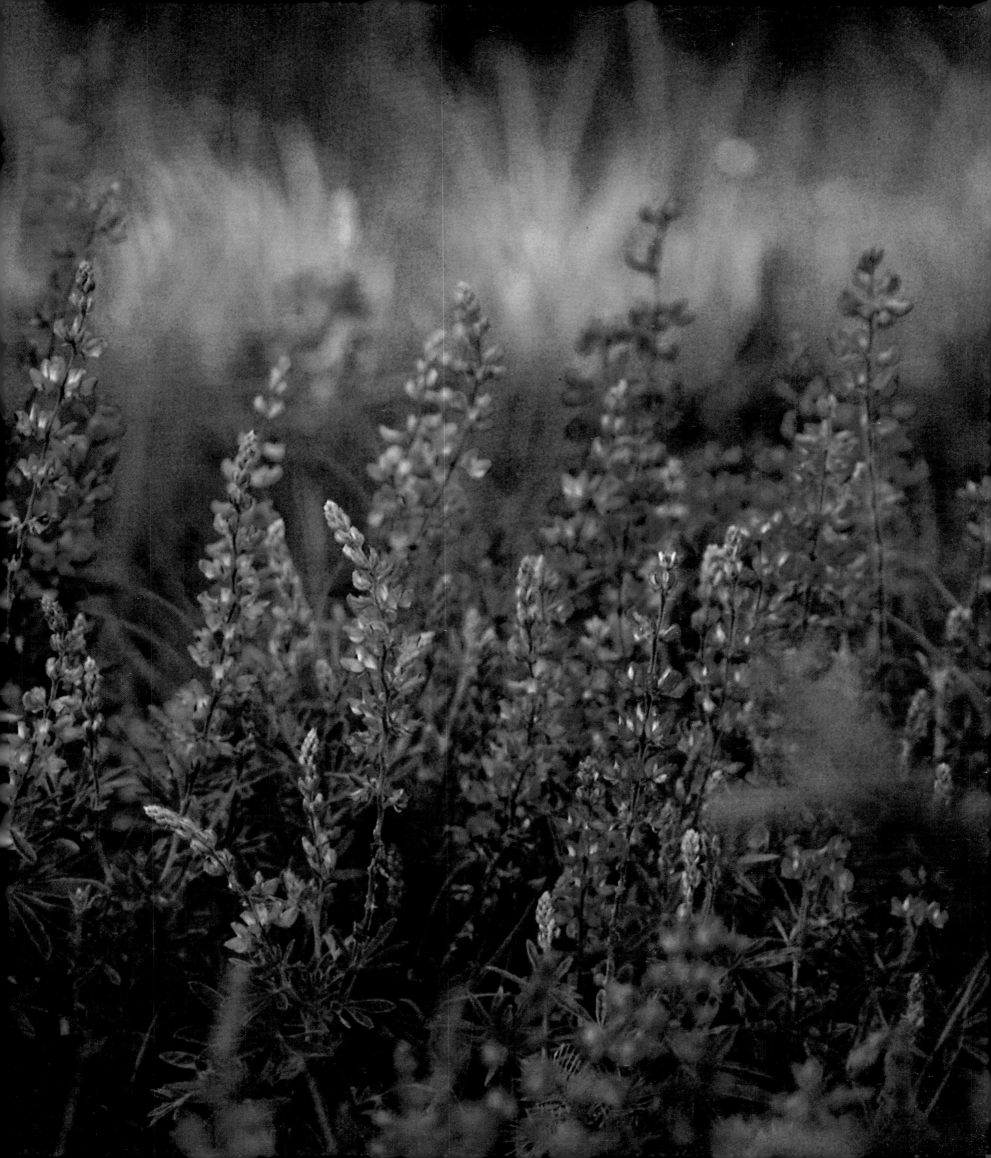

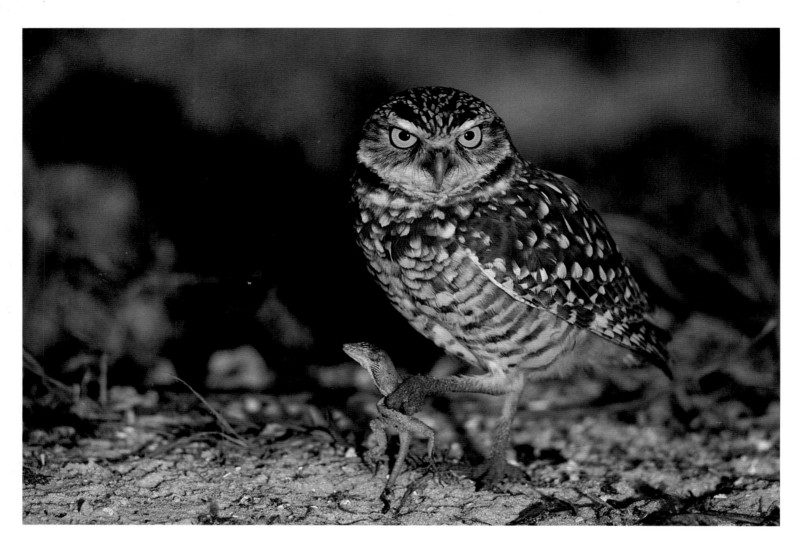

A meal in the claw is worth two in the sand; a burrowing
owl holds an anole in its grasp (ABOVE). Minutes later,
most of the reptile has disappeared down the bird's
gullet (OPPOSITE). Although capable of digging its
own hole, the underground dweller readily adopts
the abandoned homes of rabbits, prairie dogs,
badgers, and skunks. If disturbed in the den
it can mimic the sound of another burrow
borrower, a rattlesnake.

PAGES 92-93
Like a ghost of winters past, a snowy owl sits amid purple
and blue lupine. Though it breeds in arctic tundra, this
captivating bird retreats in winter south of areas
of 24-hour darkness. Scarcities of rodent prey
sometimes send it much farther, mesmerizing
birders as far south as the Gulf states.

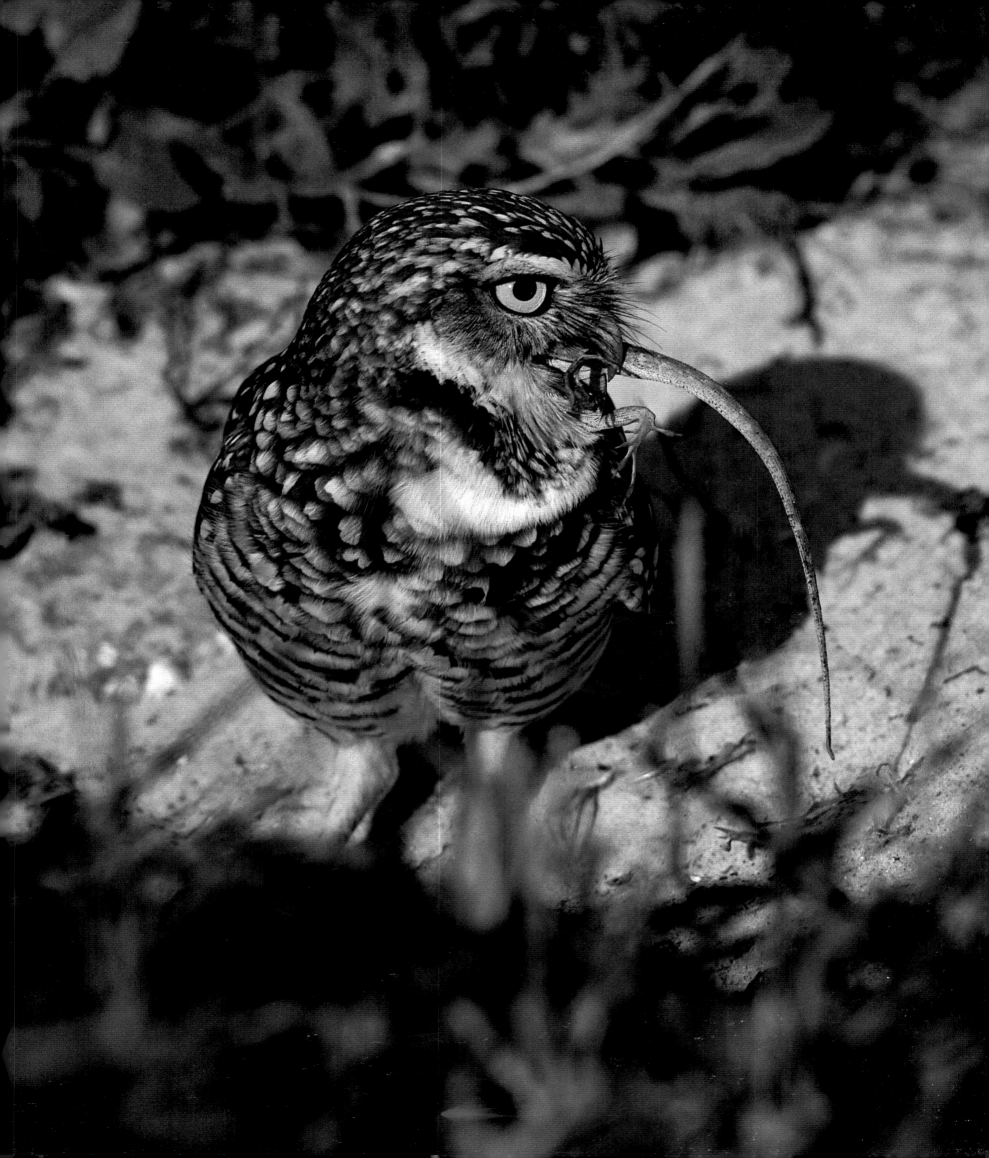

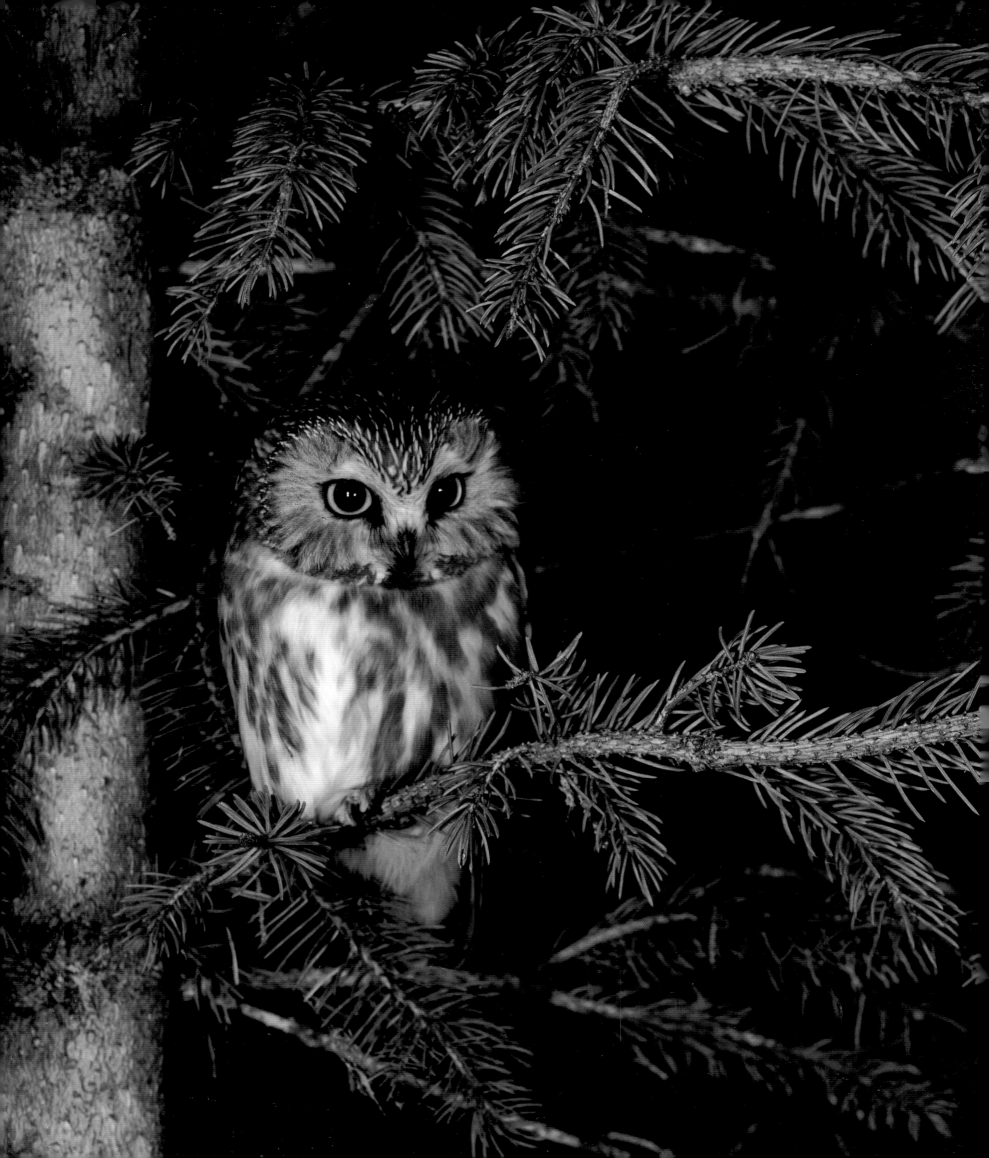

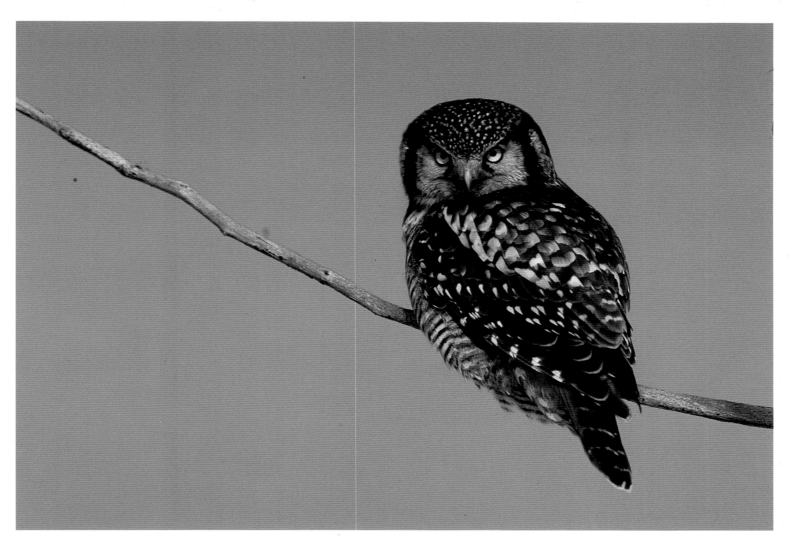

Cuddliest of its kind, the northern saw-whet owl
(OPPOSITE) can melt hearts. Equally charming, it can
be closely approached by humans once it is spotted.
So agile in flight that it catches insects in the air,
the doe-eyed owl is also a superb mouser. Rarely
seen south of the Canadian border, the boreal owl
(ABOVE), sighted near Sault Ste. Marie, Michigan,
also hunts strictly at night.

PAGES 98-99
Largest of the owls in appearance, the great gray often
measures more than two feet long but the massive look
is mostly feathers; adults weigh two to three pounds,
less than a great-horned owl. The eyes, so distinctive
on most owls and often larger than their brains,
seem small for the great gray's large head.

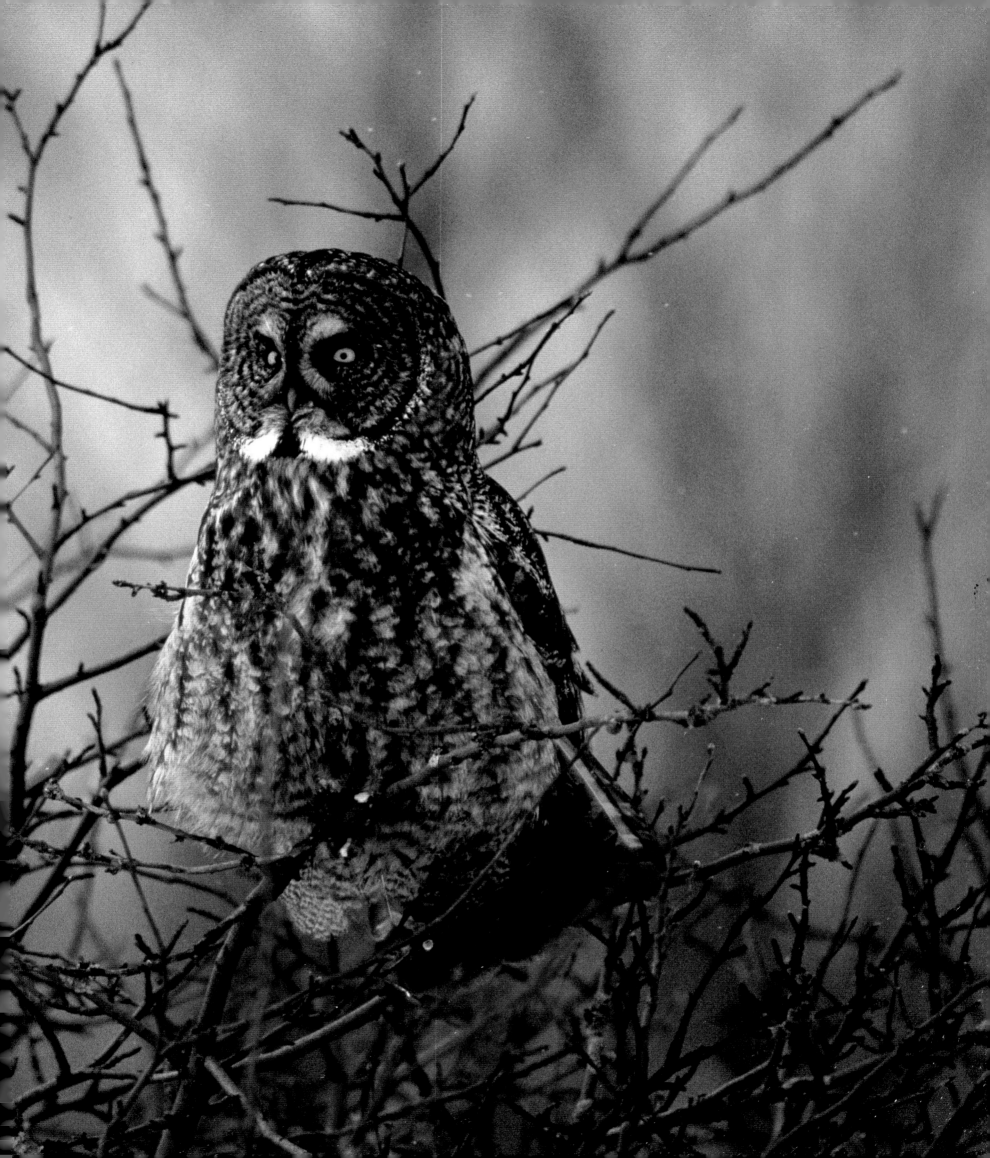

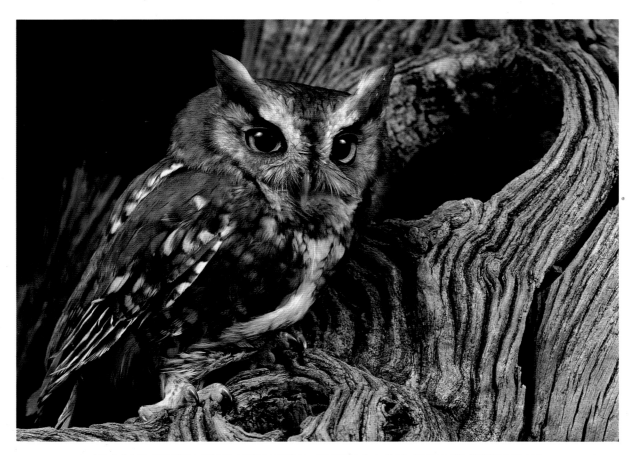

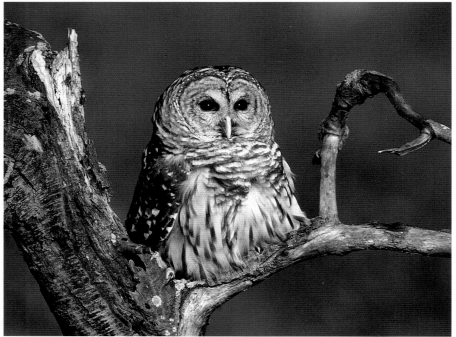

*The streamlined short-eared owl (OPPOSITE) can catch a
speeding jackrabbit and out-maneuver the northern
harrier hawk in aerial dogfights. A day hunter, it
frequents open country and nests on the ground.
Of more classic owl features and nesting habits
is the eastern screech owl (TOP) perched by
its tree hole. Evening brings a barred owl
(ABOVE) out of its daytime hiding place
and onto a dead tree snag.*

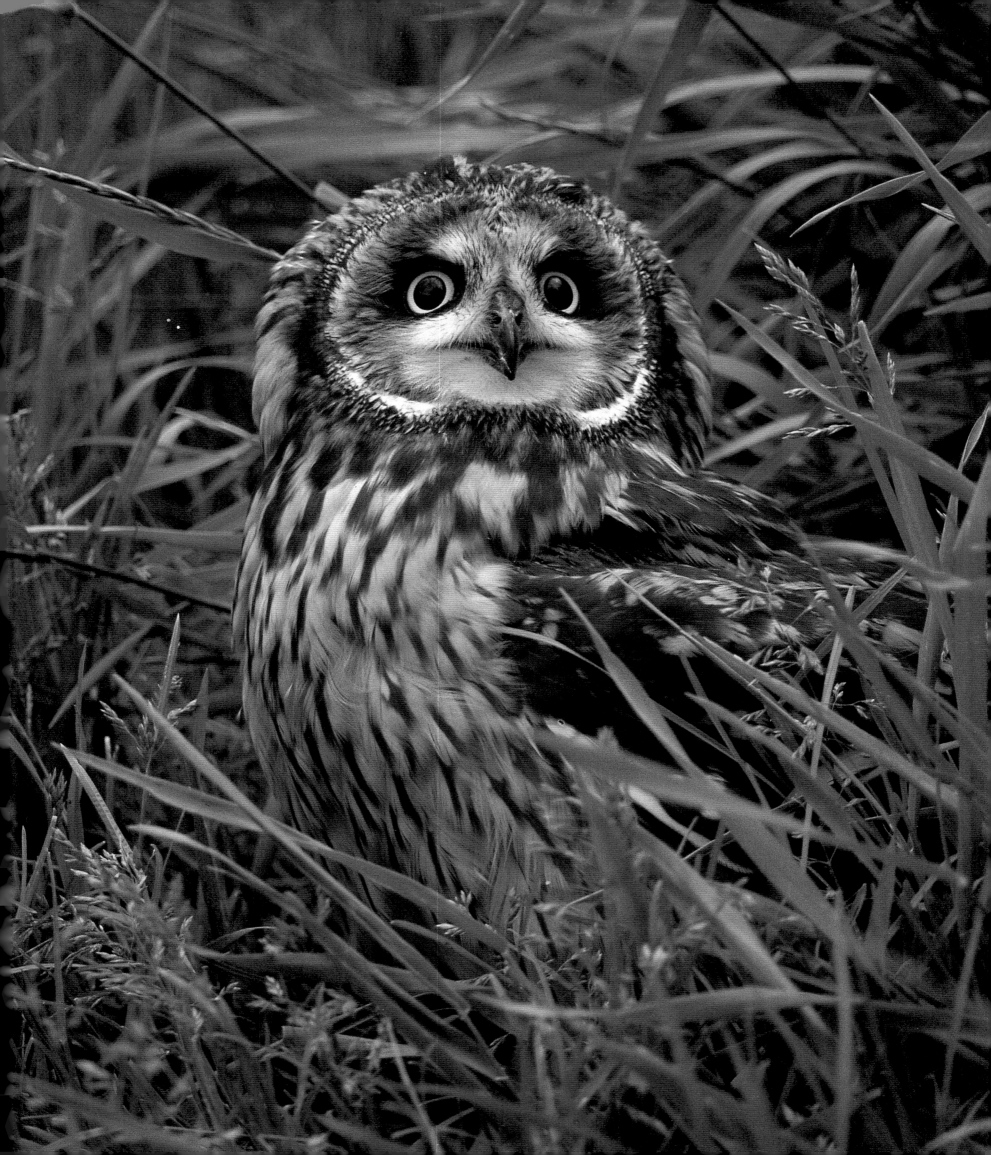

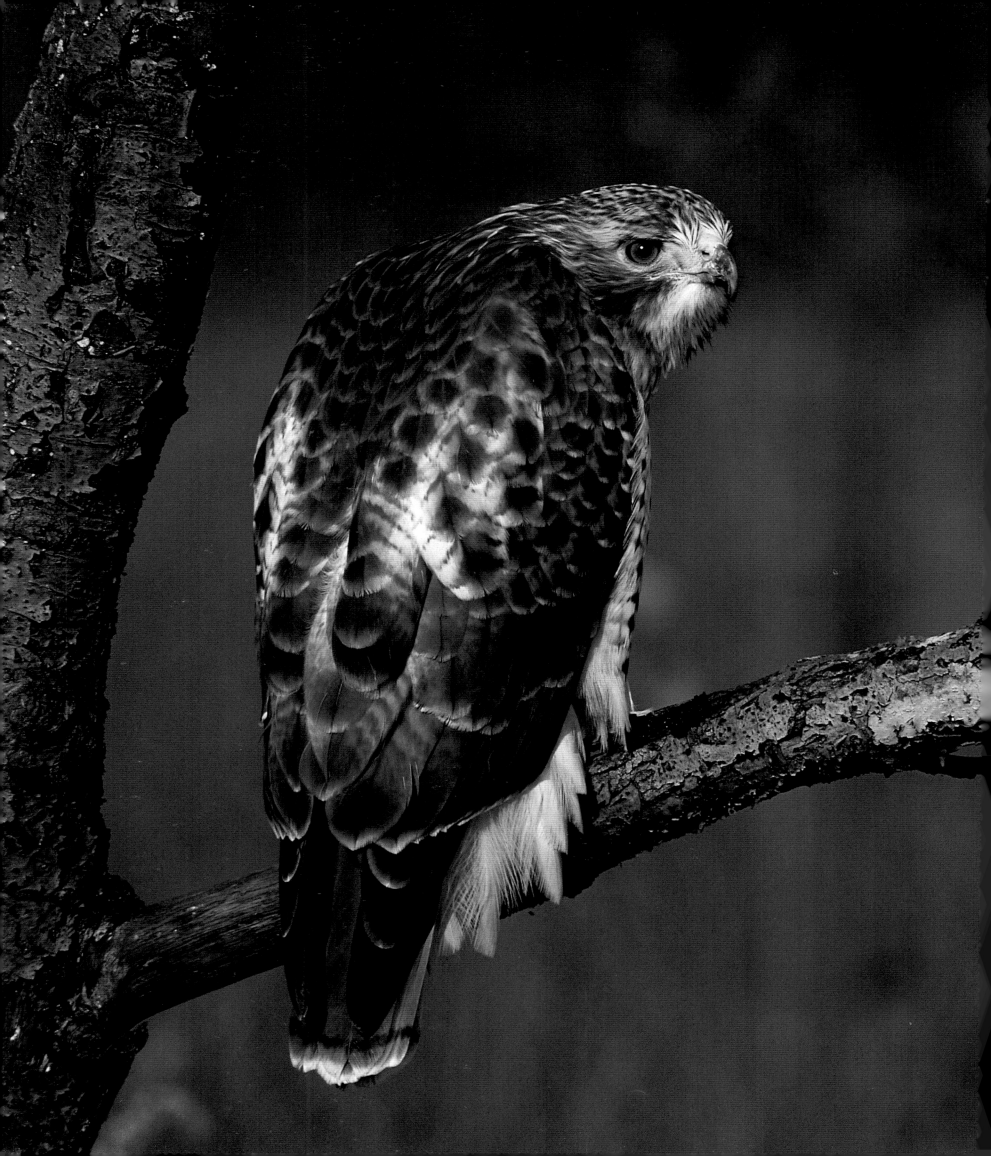

The continent-wide red-tailed hawk (OPPOSITE) can be
seen from Alaska to Mexico, perched in trees, or soaring
high on broad wings. Variable in color as this dark phase
western bird shows, North America's most common
buteo (ABOVE) may frequent prairies, deserts, or open
woodlands. A slow flyer, it took the brunt of earlier
hunting pressures but today remains plentiful.

PAGES 104-105
Emblem in the making, a juvenile bald eagle stretches its
wings at an eagle release tower in Alabama. To restore
bald eagles to southern habitats, eggs are taken from
Florida nests, where the birds are more abundant,
and incubated in captivity. The birds are fledged
elsewhere. The white-headed plumage
appears at the age of four or five years.

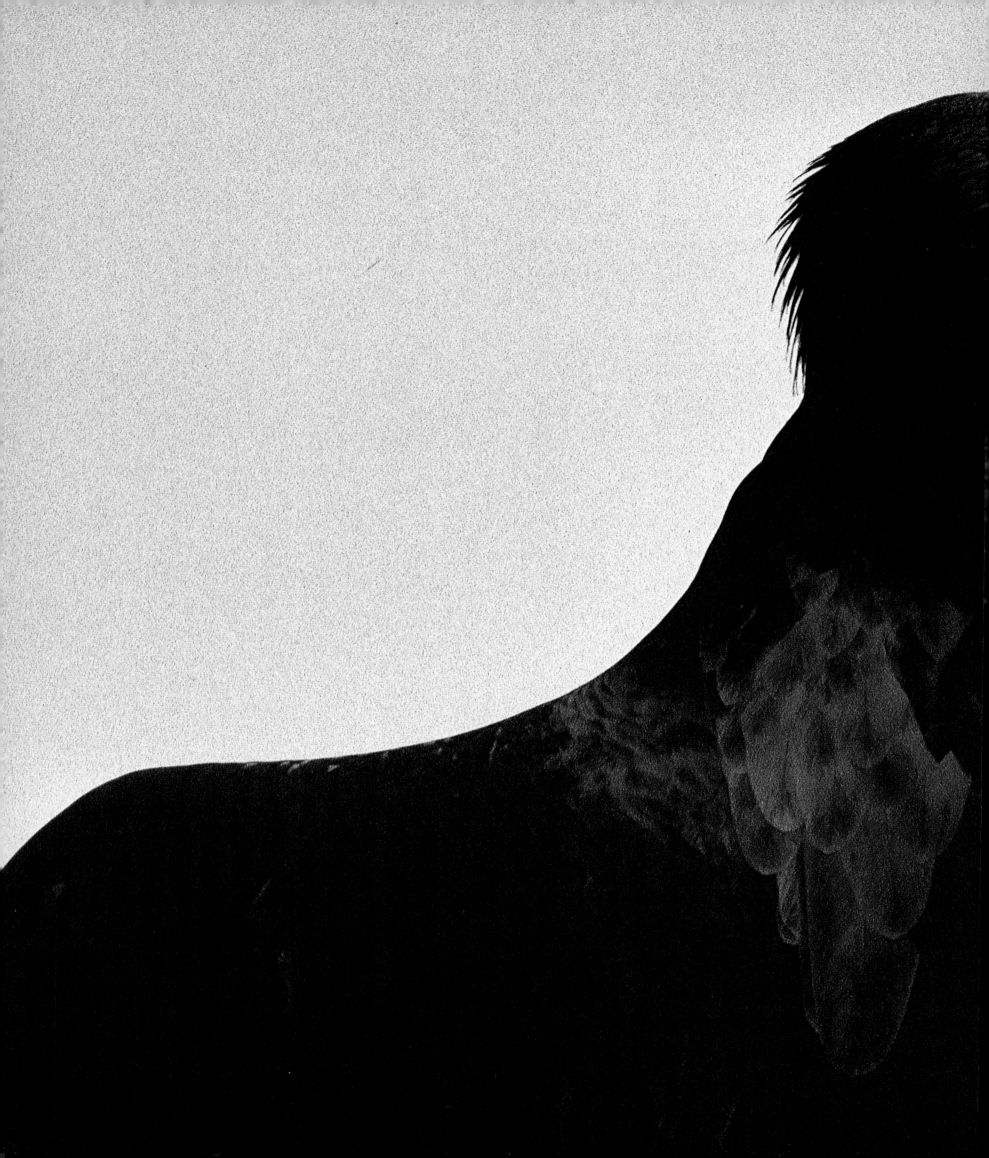

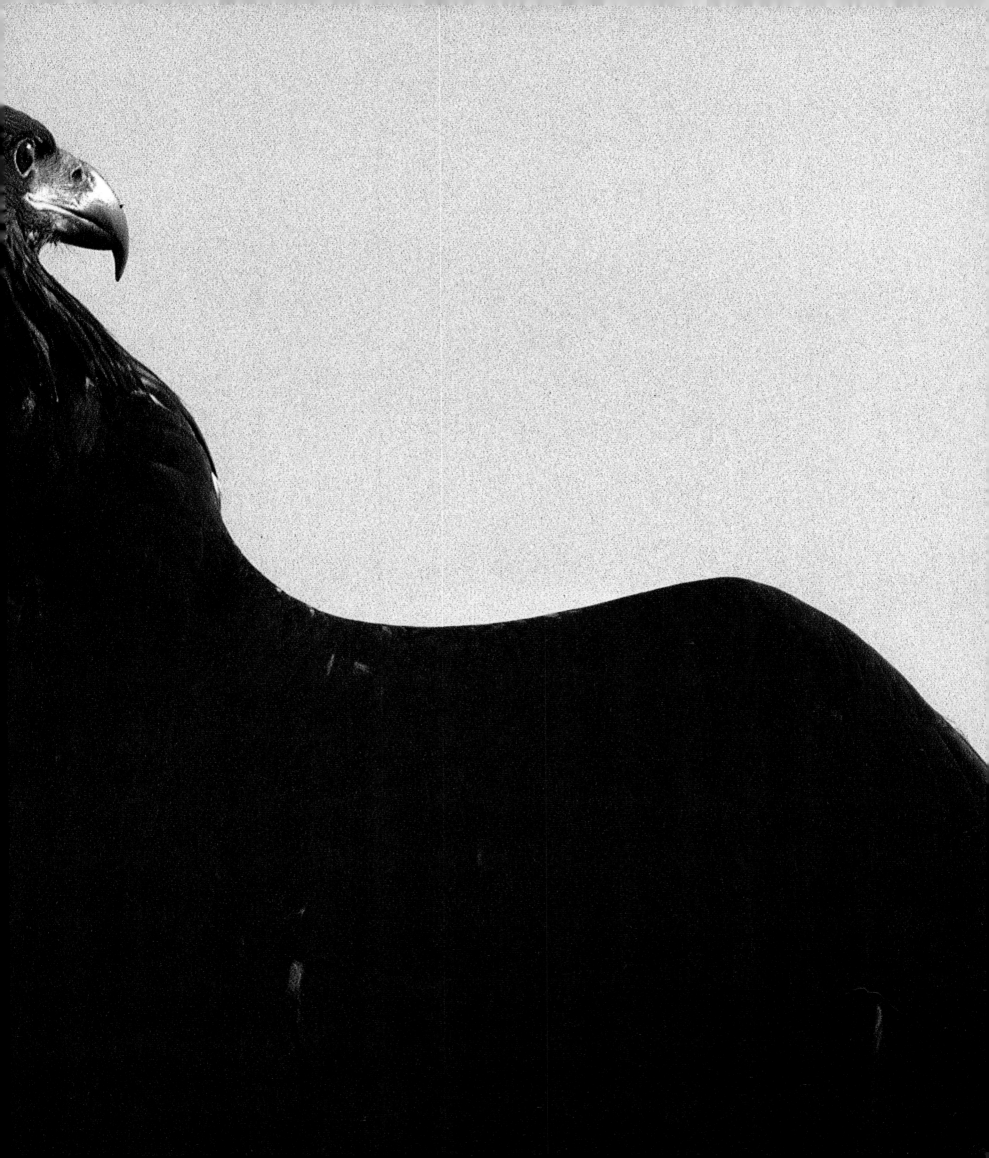

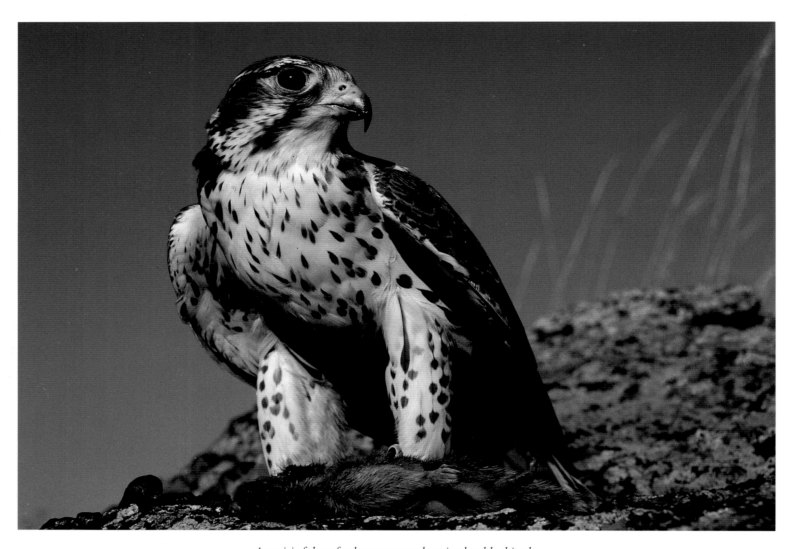

A prairie falcon feeds on a ground squirrel nabbed in the Snake River Birds of Prey National Conservation Area in southern Idaho. Abundant populations of Townsend's ground squirrel and black-tailed jackrabbits draw hundreds of raptors to the 483,000-acre facility. Airplane traffic and hunting are limited to help protect the birds.

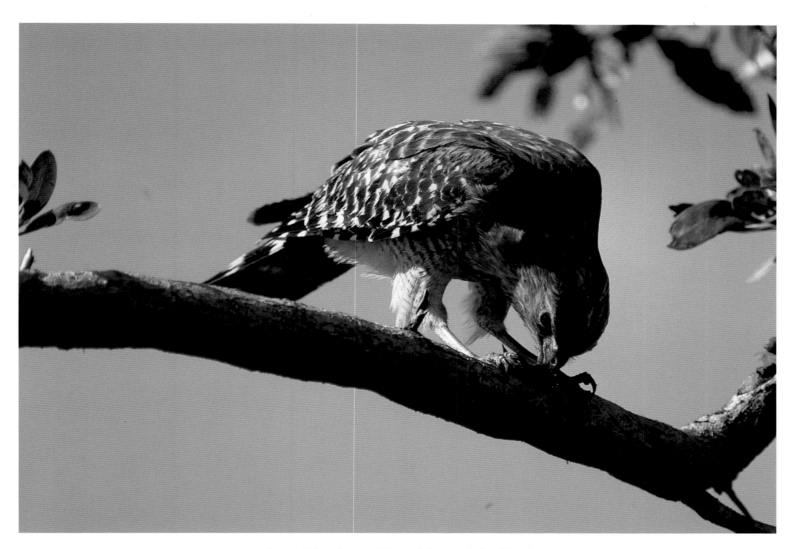

*A crawfish makes a quick snack for a red-shouldered
hawk in Florida, where the birds are smaller and
paler than individuals of the same species farther
north. Although the red-shoulder resembles the
more widespread red-tail, and home ranges
of the two overlap, they refuse to share
their hunting territories.*

PAGES 108-109
*Though perched in fruit, this male American kestrel feeds
on insects, reptiles, birds, and mice. North America's
smallest and most common falcon often perches on
telephone wires, scanning the ground for small prey.
It was formerly known as the sparrow hawk.*

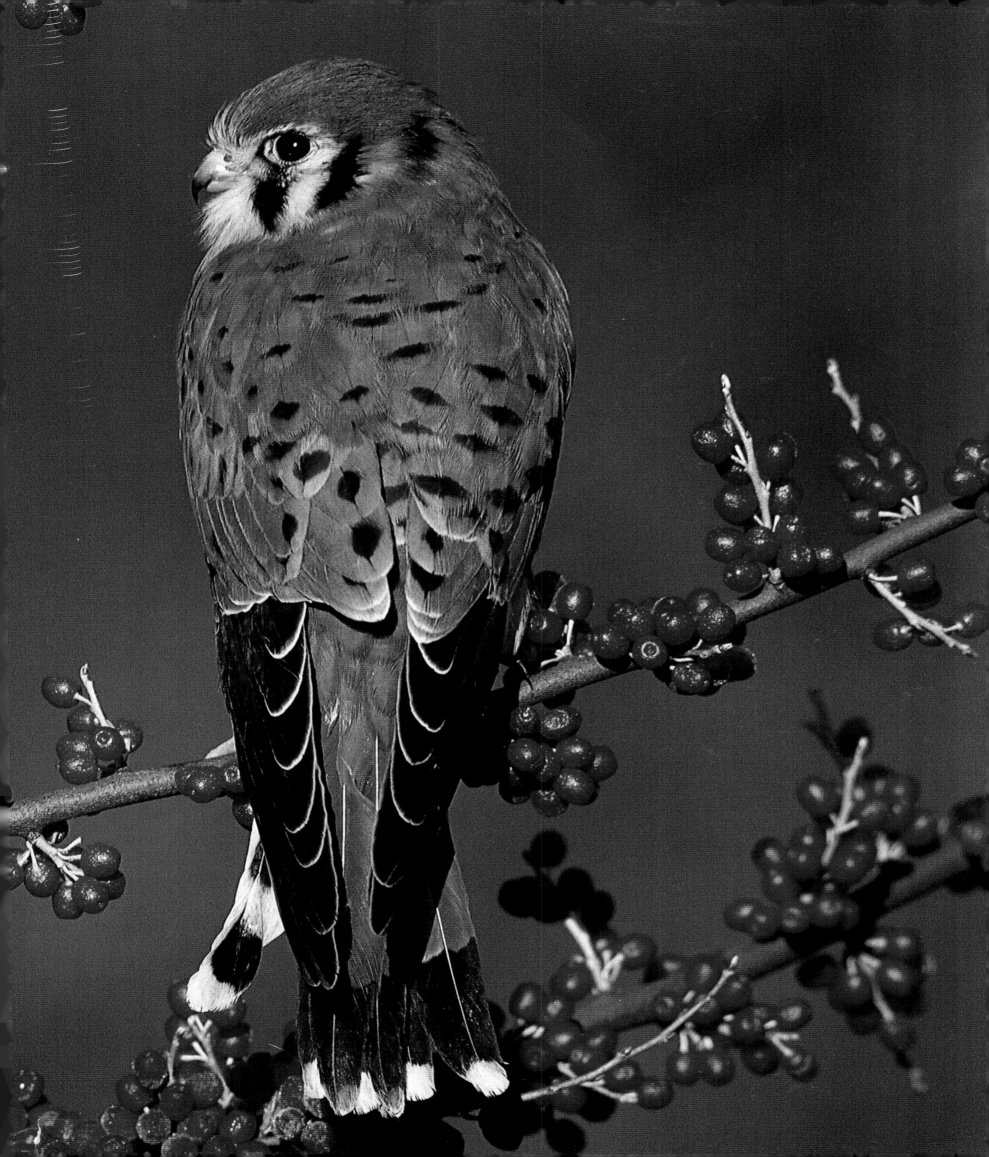

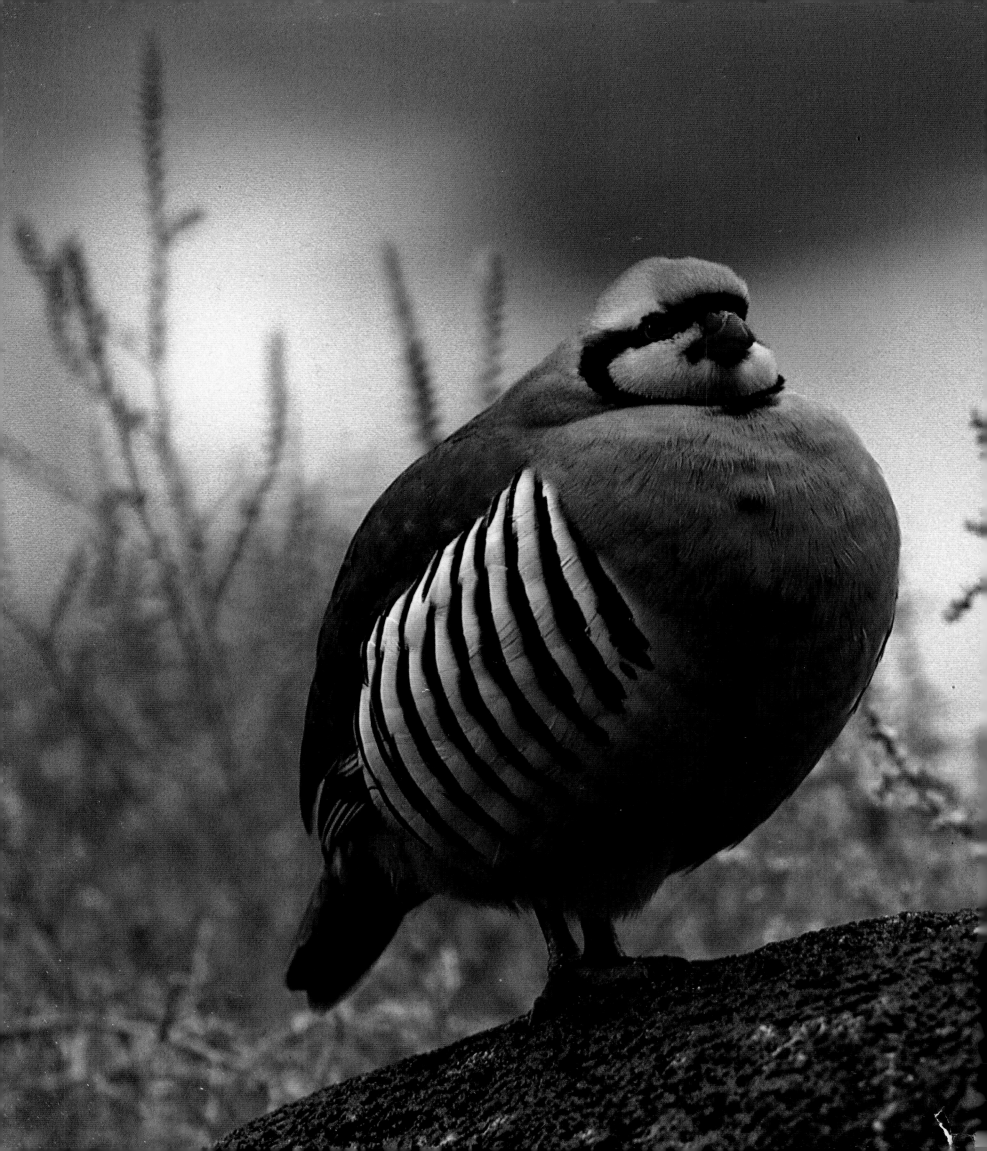

GAME BIRDS

FOOD ON THE WING

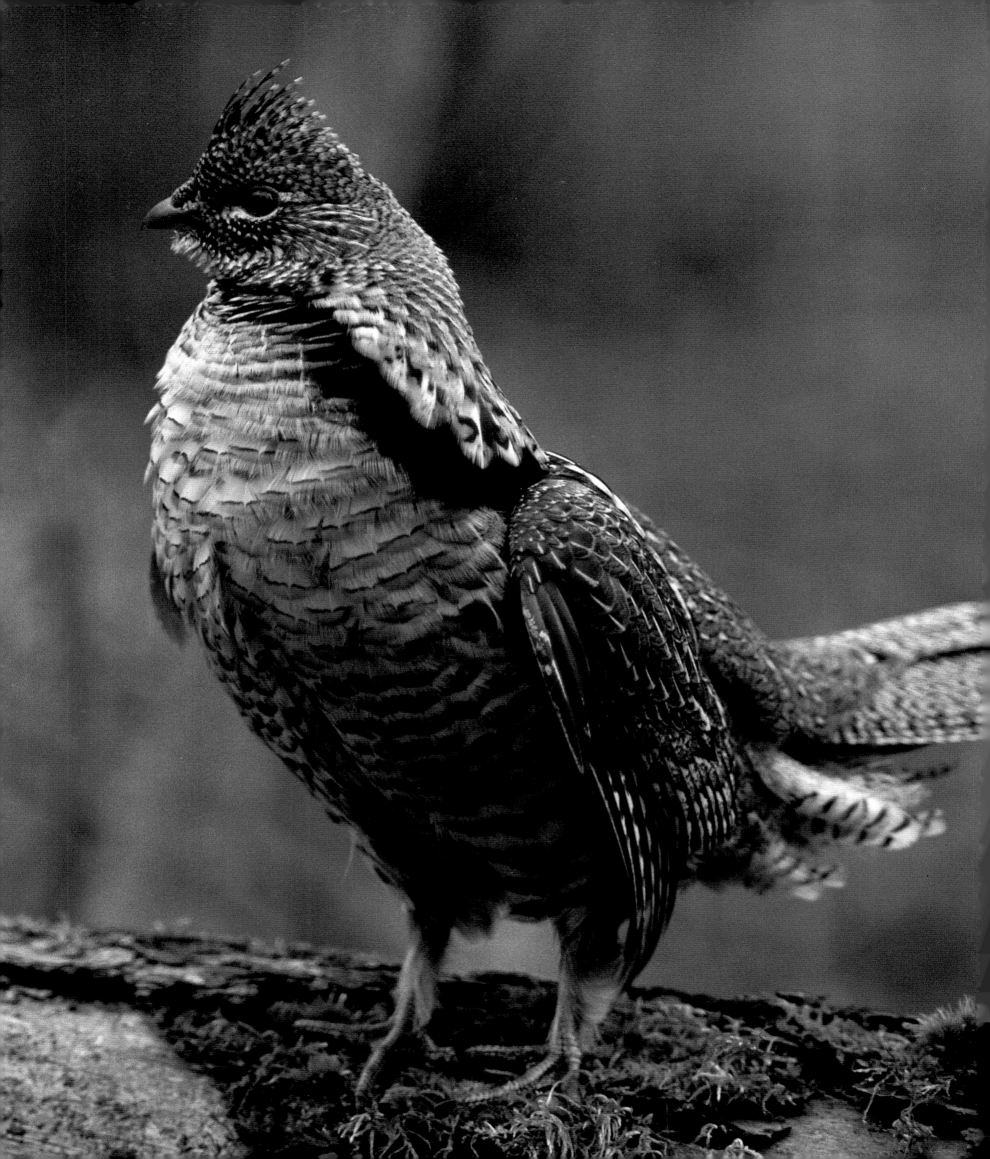

GAME BIRDS

FOOD ON THE WING

O N A CRISP FALL MORNING in Georgia an Atlanta insurance adjuster walks a brushy hillside with two of his friends, as a pair of setters sweep back and forth in front of them. Long minutes pass with no sound but the snapping of brittle weeds and the swish of dry grass against canvas trousers. Then one of the setters freezes and the hunters ease forward, anticipation dangling electric in the air. Six feet past the dog's nose the grass explodes almost under the feet of the hunters and fat little birds rocket in several directions before the bark of shotguns brings two down. By day's end three more have entered the game bags.

Five quail would not sustain the three hunters and their families very long, let alone justify the expense of ammunition, dog food, and transportation. But the process of taking the birds sparks some primal tinder within the men and fires a sense of contentment. The fact that poultry can be bought wrapped and bloodless in a plastic bubble does not remove their desire to hunt, developed over tens of thousands of years of garnering food from the wild with one's wits.

Hunting is a huge industry in North America, with nearly sixteen million licenses sold annually in the United States alone. Fees for the licenses, tags, permits, and stamps come to nearly half a billion dollars, money that goes toward creating more habitat for the hunters' prey. In the process of feeding their psyches and filling their tables with game birds, hunters also feed local economies by spending an average of $203 each for supplies and transportation, according to the U.S. Fish and Wildlife Service. Sensitivities toward animals and the appeal of so many other means of recreation have decreased the number of hunters in many states. Still, hunting in the U.S. generates more than $3 billion annually.

The same instincts that exult in the pursuit of game can also lead to excesses, for not all hunters are disciplined. With prey before them and adrenaline pumping, many hunters disregard quotas set to protect declining populations, or shoot before properly identifying the target. Today, habitat loss poses the greatest danger to game bird populations, although birds

already stressed by fewer nesting sites can be depleted further by poor hunting practices.

Upland game birds have been supplying meals to us directly throughout North America's human history. For thousands of years before contact with the Europeans, Indians dined on grouse, turkey, prairie chicken, pigeon, quail, and ptarmigan. The first Europeans were astounded at the abundance of food on the wing. Most numerous in colonial times and for some time after were the blue-tinted, rose-breasted passenger pigeons. Some three to five billion, approximately 25-40 percent of the entire bird population of what is now the United States, darkened the eastern skies. In 1709 naturalist John Lawson described flocks that took hours to fly overhead, that when they roosted broke down the limbs of large trees. "They were very fat, and as good pigeons, as ever I eat," he added.

Eat them Americans did, by the billions. Still, by 1829 Alexander Wilson wrote of single trees holding some 100 nests, and squabs so fat they were melted down as a substitute for lard or butter. During passenger pigeon migrations, wagon loads of them poured into market. By 1842 they were still so numerous that in one nesting colony in Michigan professional netters killed 25,000 a day—700,000 a month. By the turn of the century they were finally thinned out, and in 1914 the billions were down to one bird named Martha in the Cincinnati Zoo. When Martha died, a food resource and a means of recreational hunting were lost forever.

Although in numbers not as impressive, other upland birds as prey have waxed and waned through the years, depending on the species. To American wild larders were added Asian ring-necked pheasants, which adapted readily to the Midwestern grain belt, and the Old World chukar partridge, which has become established in arid, mountainous regions of the West. We added these birds, but we nearly subtracted our own wild turkeys, whose appearance at a colonial feast started a Thanksgiving tradition. Wild turkeys occurred naturally only in the New World, and ten million may have occupied parts of North America in colonial times. It is an oft-told story that Ben Franklin favored the wild turkey over the bald eagle as a national bird, but the story apparently is false. The jocular Franklin was merely pulling the legs of legislators when he recommended the barnyard turkey, whose stupid behavior and ugly appearance were qualities that would never be attributed to its wild counterpart.

In the 1800s wild turkeys began disappearing rapidly, with overhunting and the importation of European poultry diseases mostly to blame. By the 1930s perhaps 20,000 survived in twenty-one states, but like the bald eagle, the wild turkey was saved from extinction. Relocation of turkeys from areas of relative abundance to areas of scarcity brought them back, the wily gobblers proving more adaptable than once thought. Grasses growing in logged areas suited them fine, as did scrub brush where timber had been. Extremely hardy, they have been known to survive three weeks in severe winter weather without food or water. Today wild turkeys run through fragmented woods in every state

but Alaska, and the population is back to nearly half what it was in colonial times.

While the wild turkey is elusive, the chubby bobwhite has long been a fixture around America's farms, its cheerful, upbeat call imitated by anyone who can whistle: bob-bob-white. Bobwhites are one of the few game birds whose numbers were originally enhanced by early farming practices in North America. They don't mind open spaces; they thrive on grain spilled in the harvest. Alexander Wilson noted in the early 1800s: "Where they are not too much persecuted by the sportsmen, they become almost half-domesticated; approach the barn, particularly in winter, and sometimes in that severe season mix with the poultry, to glean up a subsistence."

Of the six American quail only the plumed California quail is as tolerant with human activities as the bobwhite. The Gambel's, scaled, mountain, and harlequin quails seek more remote land in deserts and mountains. Gregarious birds, quail hang out in coveys most of the year, huddling together for warmth at night with heads outward to watch for danger. Despite their vigilance, three quarters of them die every year, falling to winter starvation and predators. To make up for this high mortality, females lay twelve to fifteen eggs in a clutch. Unlike the helpless young of tree-born birds, the newly hatched quail chicks scamper after their parents as soon as their down dries. The little ones freeze and blend into the background when danger is near.

Although fond of grain, quail cause almost no damage to farmers, and bring numerous benefits. Almost 90 percent of their diet is vegetable matter, but most of that consists of the seeds of ragweed, one of their favorites, plus smartweed, bristle grass, sunflower, and lespedeza. The animal portion includes grasshoppers, crickets, caterpillars, centipedes, ants, and slugs. They require some cover for nesting, and the disappearance of hedgerows and grasslands in modern, heavily farmed areas cuts their numbers.

"Quail populations exploded when farming first spread across the U.S.," says Dr. Leonard Brennan, a biologist with the Tall Timbers Research Station near Tallahassee, Florida. The station, situated on the Florida-Georgia border, has tracked quail numbers and needs for some 60 years in both states to maintain a popular sport in the face of diminishing birds.

"Now their numbers are being hurt by modern, clean farming, which involves using pesticides, and removing hedgerows and fence lines so big machines can operate more efficiently. That takes away both food sources and cover, and pesticides may kill some birds directly. Clean farming has driven quail hunters onto public lands, where surveys show that more people are hunting a decreasing number of birds."

Out of thirty quail-hunting states, all but three—Texas, Oklahoma, and Wisconsin—show declines in quail populations over a twenty-year period. A decade ago more than two million quail were taken each year in Mississippi. Today hunters there take about 200,000 annually, less than the number of deer shot. Part of that reduction, admitted a state

PAGES 116-117
With a blur of wings a ruffed grouse drums while standing on a log in breeding season. The rapid flapping of cupped wings compresses the air in a thmm-thmm-thmm sound that either summons a potential mate or challenges a rival male to combat. A forest dweller, the ruffed grouse occupies a huge range from Alaska to California and coast to coast through the heart of Canada.

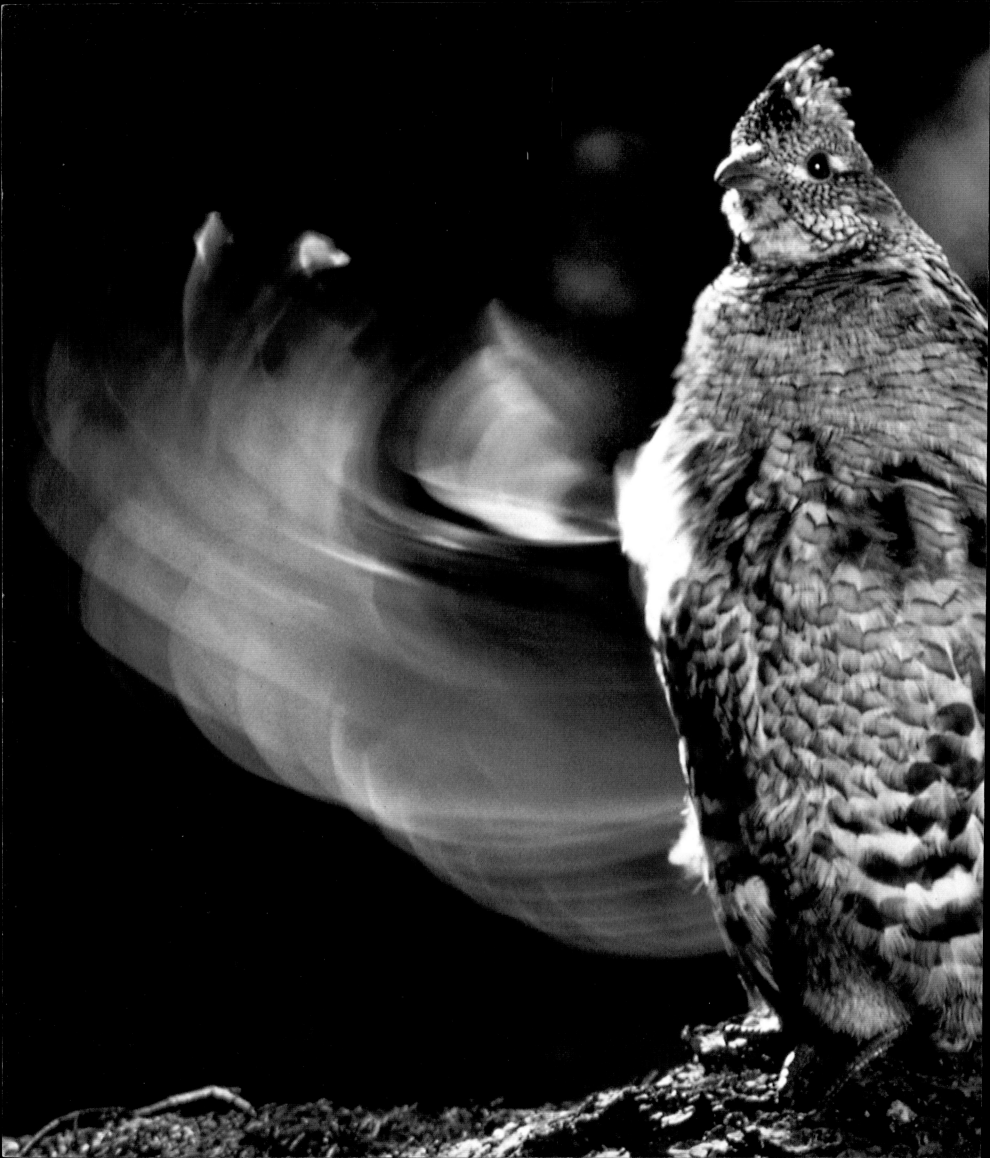

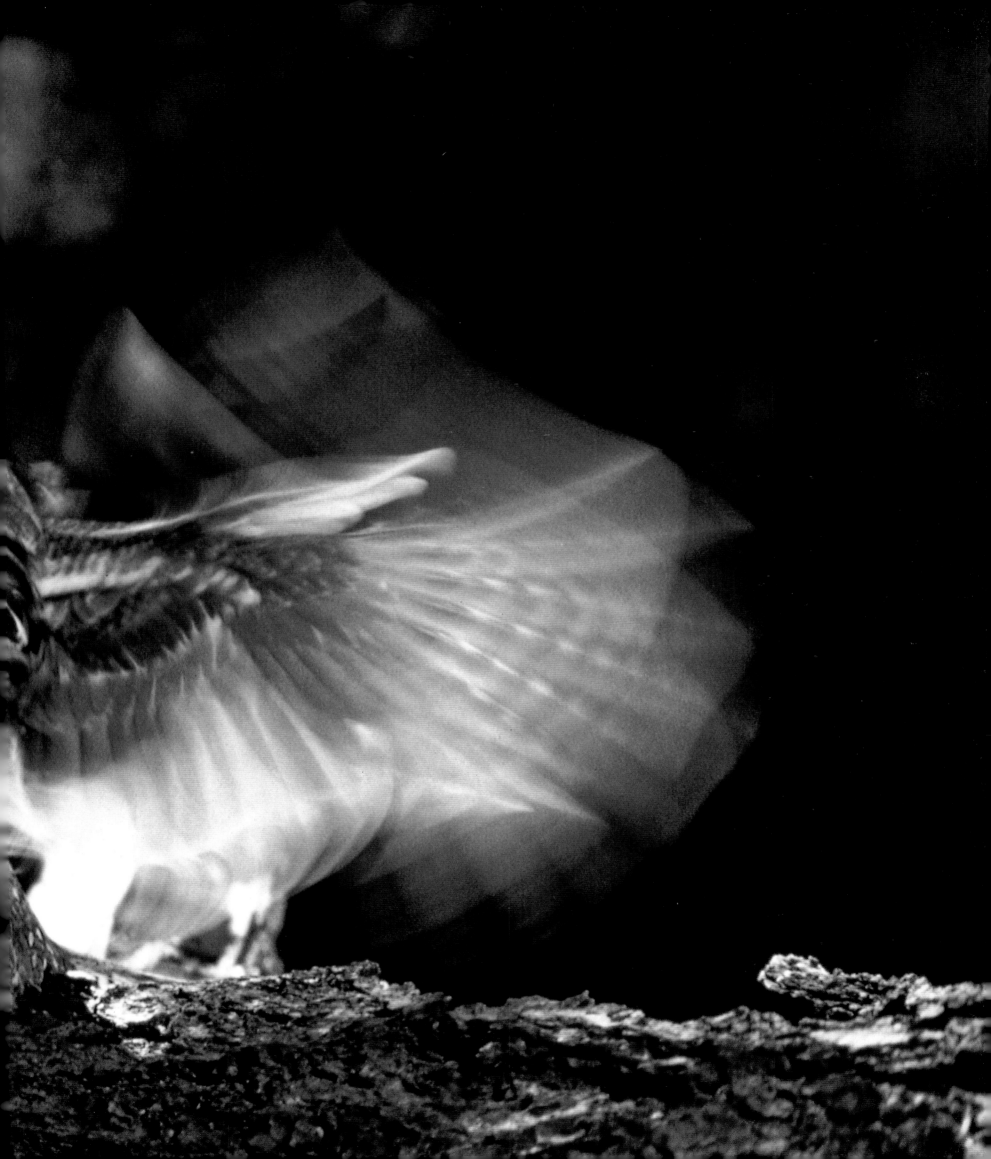

game official, may result from a diminishing number of hunters as people drift to other means of recreation, but it also reflects a shrinking population of birds.

Most species of grouse in the U.S. and southern Canada show historical declines. The grasslands grouse—sharp-tails and prairie chickens—have taken a beating as wheat has replaced native grasses needed for nesting. The sage grouse, found in eight western states from Wyoming to California, persists wherever sage brush remains, but suffers in comparison to numbers of a half-century ago. "When I was a kid," said one rancher in his seventies, "sage grouse were so thick I could step off a hay rake and throw a hammer to knock one down for dinner."

Declining numbers cannot be blamed on breeding apathy. Grouse have passionate and elaborate courtship displays that resemble the bravado shown by young boys on a junior high playground. At first light in spring, male sage grouse gather on open-ground staging areas called leks. Largest of the grouse at seven pounds (the dusky blue is next at three and a half pounds and the spruce, ruffed, and sharp-tailed grouse all weigh less than two pounds), the sage male ruffles its feathers to increase its size, and fans its tail like a Thanksgiving turkey. To complete the puffery it sucks air into two frontal sacks that expand its chest until its head nearly disappears. Half-spreading its wings to supplement the bluff, it rushes at other males in quick, stiff-legged steps, while strumming the leading edge of its wings against its breast feathers. Meanwhile it

forces air from the chest sacs in a gurgling sound like thick liquid being poured from a jug. Males that flinch and retreat from this show are out of the dating game.

When the females arrive later, a dozen or so dominant males establish strutting or display posts. The females move across the strutting grounds, each selecting a dominant male whose flashy appearance, establishment of territory, and air of self-confidence appeals to them for breeding. Sound familiar?

The mating display of the sharp-tailed grouse, whose range extends into Canada and Alaska, is more intense than that of the sage grouse, and the mating more immediate. With the appearance of a hen, the males show off frenetically with much stamping of feet, turning, and ruffling of feathers. The hen stays off to the side at first, pretending to ignore the competition. Then she walks onto the stage and squats before the male of her choice, and copulation occurs immediately. Closer to an orgy than the square dance of the sage grouse.

To early explorers across the Great Plains, tasty prairie chickens seemed in inexhaustible supply. Like the bison and the pronghorn, however, they weren't, and today the birds exist in remnant populations mostly in Colorado, Kansas, and Missouri. The smaller, eastern version, known as the heath hen, has disappeared completely from open areas. Hunting decimated the greater prairie chicken as well, with thousands of barrels of them shipped to market, but it was the excessive loss of grasslands to plains wheat that truly tolled its doom. One of the loudest courtship

Plucky little survivor of the arid Southwest, Gambel's quail wears a tear-shaped plume on its forehead like a 1930's flapper. Fleeing enemies, chicks can manage short flights on stubby wings at the age of eight to ten days. Seeds of desert plants make up more than 90 percent of the Gambel's diet, with insects filling out the remainder.

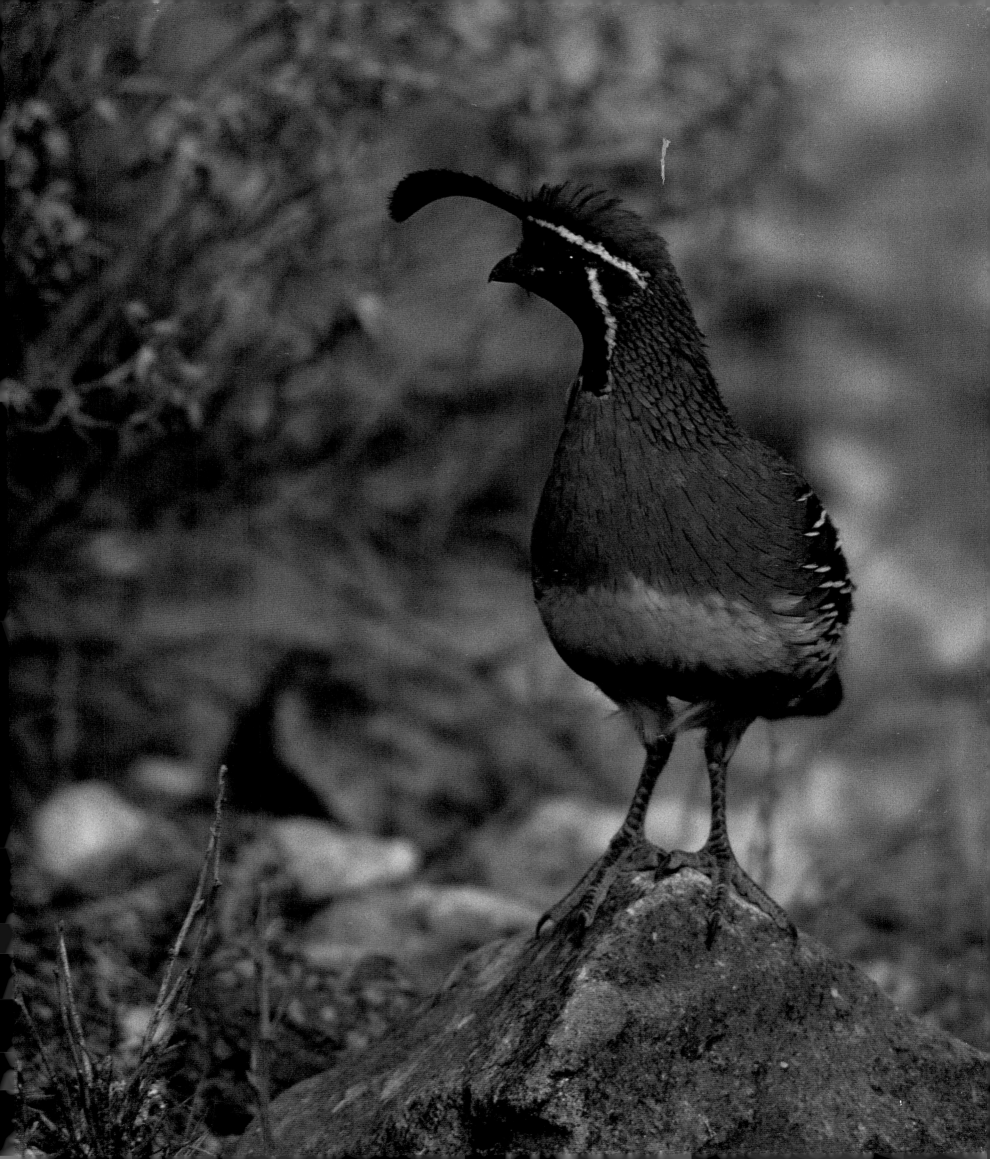

displays of any of our native birds was thereby quieted. Besides prancing and ruffling its feathers, the prairie chicken inflates large air sacs with tympanic membranes alongside its esophagus and forces air through them, creating a booming noise. The sound has been compared to air being blown over the opening of an empty bottle, but so highly amplified it can be heard more than a mile away.

Strange noises in the agony of love are understandable. For weirdness, the everyday language of the ptarmigan—also in the grouse family—is hard to match. Northern birds, their call in Alaska has been compared to the croak of a Louisiana bullfrog. All three ptarmigans, the willow, rock, and white-tailed, change color for camouflage, turning white in winter and earth-colored or mottled in summer. Although tasty when they feed on the seeds, berries, and greens of summer, they turn bitter on a winter diet of dry twigs and grasses.

Where flavor is concerned, many are disappointed in the taste of our most successful game bird, the mourning dove. The dove thrives throughout the lower forty-eight states, and offers a difficult shot as it darts away swiftly and erratically. The taste is as challenging as the target. Preparation of the fat breasts can include wrapping them in bacon or smoked meat to disguise the gamy flavor. Workable recipes doubtless exist, for millions of doves are shot each year, more than any other upland game bird. They sustain such carnage because they have multiple broods in a year and frequent a broad range of habitats; a golf course seems to suit them for nesting as well as a hedgerow.

The leader in questionable taste among game birds may be the woodcock, whose heavy diet of earthworms is often blamed for a strong flavor. In courtship, however, it becomes a sweet-voiced poet. Or nerd, some might say, for the woodcock is an improbable-looking bird; large, protruding eyes sit far back on its thin head so it can see danger everywhere. Woodcocks once ranged all over the eastern woodlands but soil-tilling has removed much habitat. The bird's protective coloration is so perfect that one can stand directly over a stone-still woodcock without seeing it. If you do spot a ground-nesting female she is so faithful to the nest that you can stroke her as she sits on the eggs.

If the amorous grouse is a disco dancer in Spandex and silk, the woodcock is a librarian in white collar and tweed. Picking a small open stage on the ground it paces about like a nervous suitor, calling in a plaintive, high-pitched *peent*, that sounds like it was said through a kazoo. Suddenly it takes off with a whistling of wings, circling until it gains altitude for a high aerial display of loops and dives, accompanied by extravagant musical sounds generated by vibrating wing feathers. Hoping some female has seen and heard all this, it swoops back to the stage and resumes its plaintive *peent*ing, all the while pacing and turning nervously, as though hoping a sweetheart will come but wondering what he will say when she does. Sadly, diminishing stocks mean none may be within earshot.

A nobler bird than its domestic cousin, the wild turkey offers no easy meal for Thanksgiving. Much-hunted males grow wary of calls simulated to draw them close. North America's largest game bird can weigh fourteen to seventeen pounds. Once nearly extirpated, it now thrives after extensive restocking and stringent hunting limits.

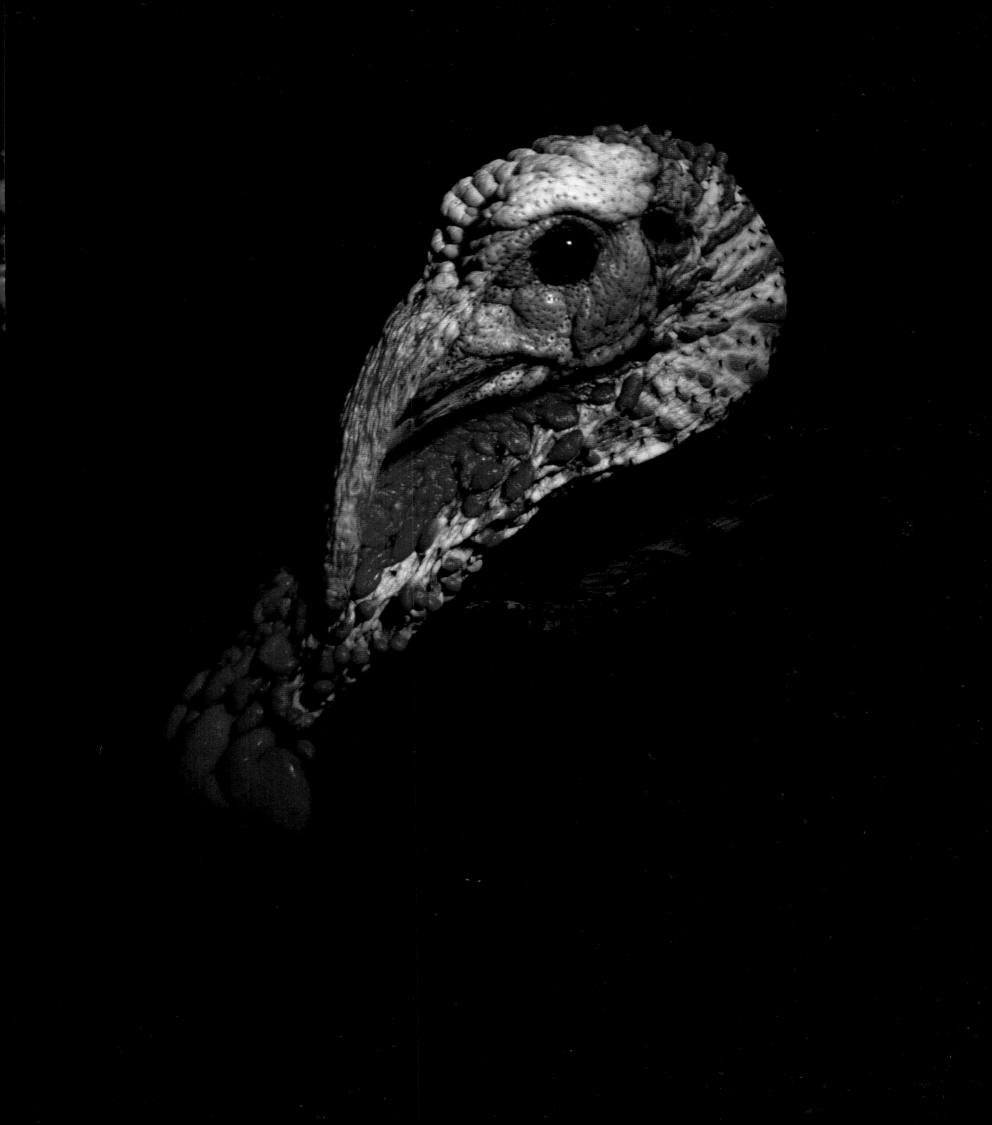

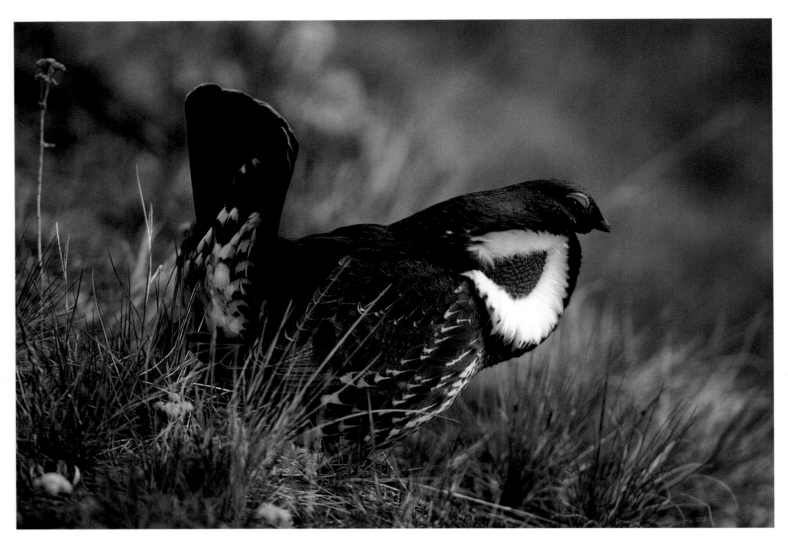

*A blushing neck reveals the ardor of a blue grouse in
spring, when the male puffs up air sacs and gives a
hooting call. The "blue" color is actually sooty gray,
set off by orange combs above the eye. A reverse
migrator, the western bird moves to higher
altitudes in winter where it lives on
tree buds and conifer needles.*

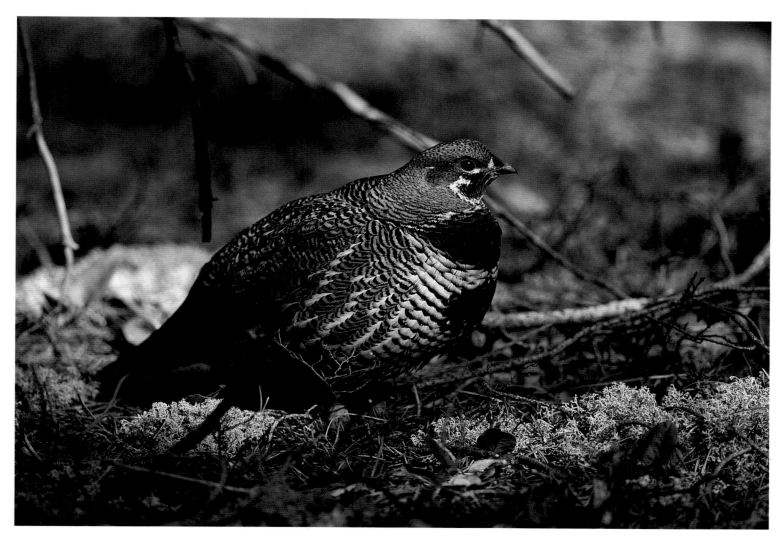

*Sitting still as a stone is a defense of the spruce grouse, a
wilderness dweller so faithful to motionlessness that it
sometimes can be caught by hand. Nesting hens may
be stepped on before they flush. The faint red lines
above this male's eye spring erect and in flaming
red when he struts and fans his feathers
to impress a female.*

PAGES 124-125
*Taking his bow as a top-flight dancer, a sharp-tail grouse
points his naming feature skyward in a mating display.
In early April, males gather for whirling, foot-stamping
dances aimed at impressing hens into selecting them
for breeding over competitors.*

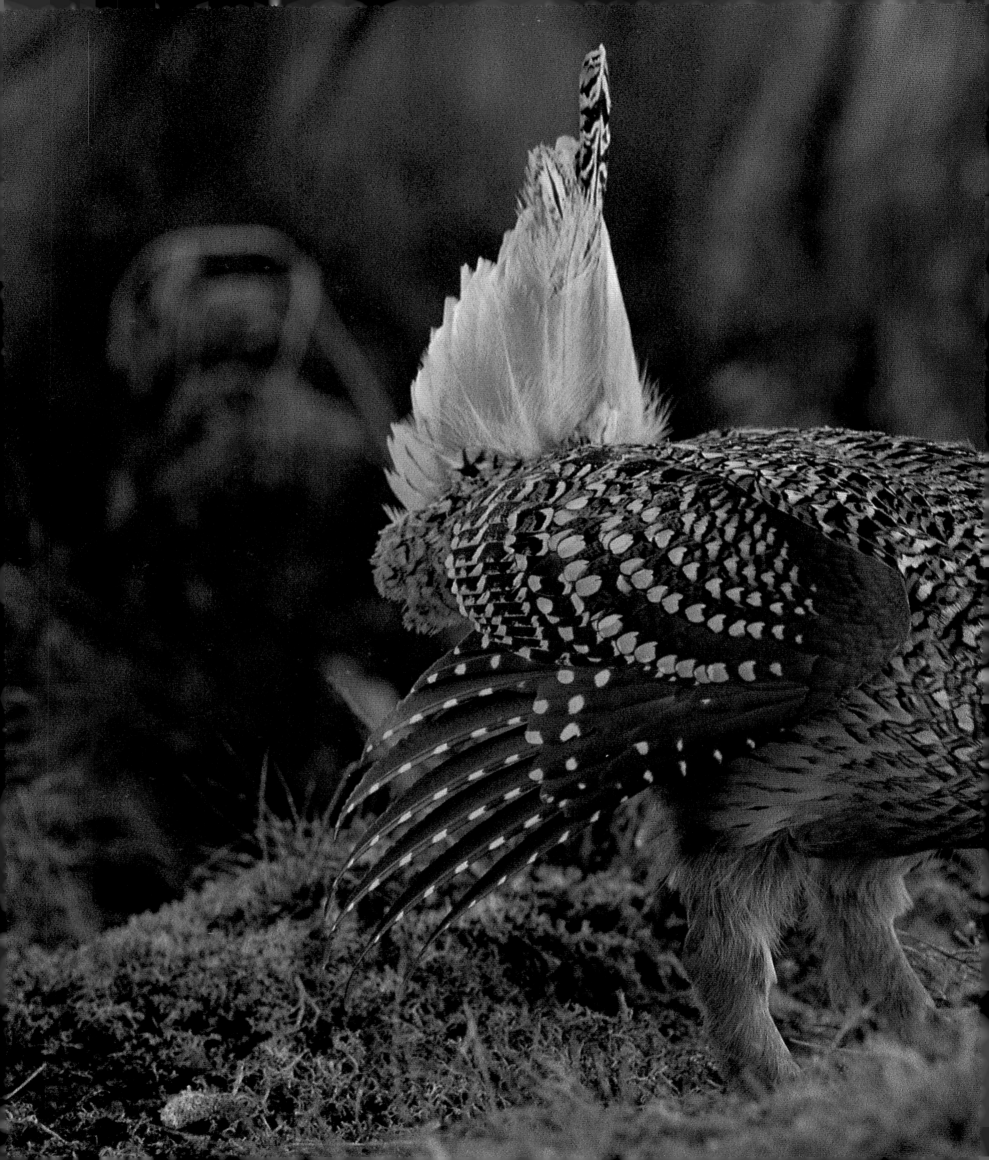

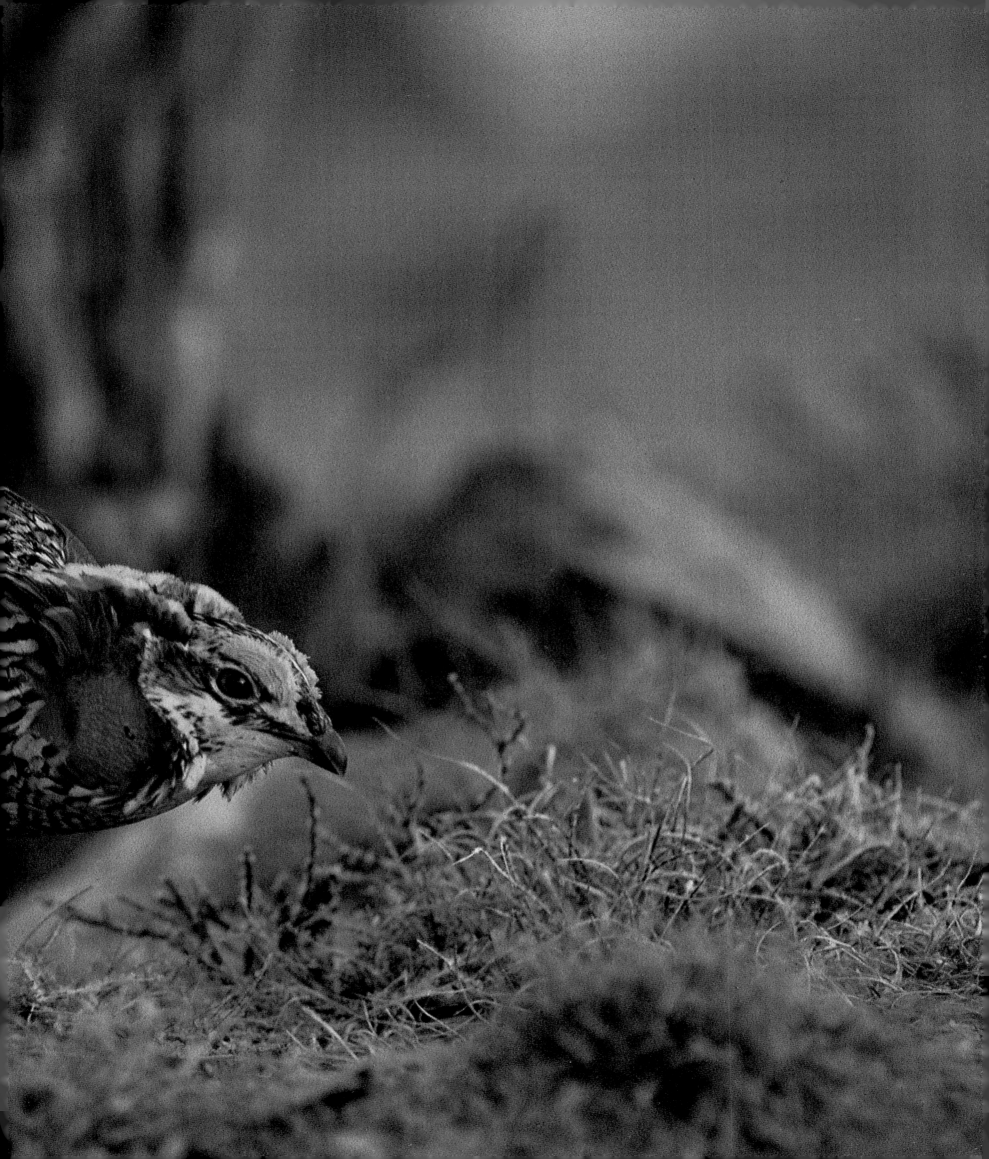

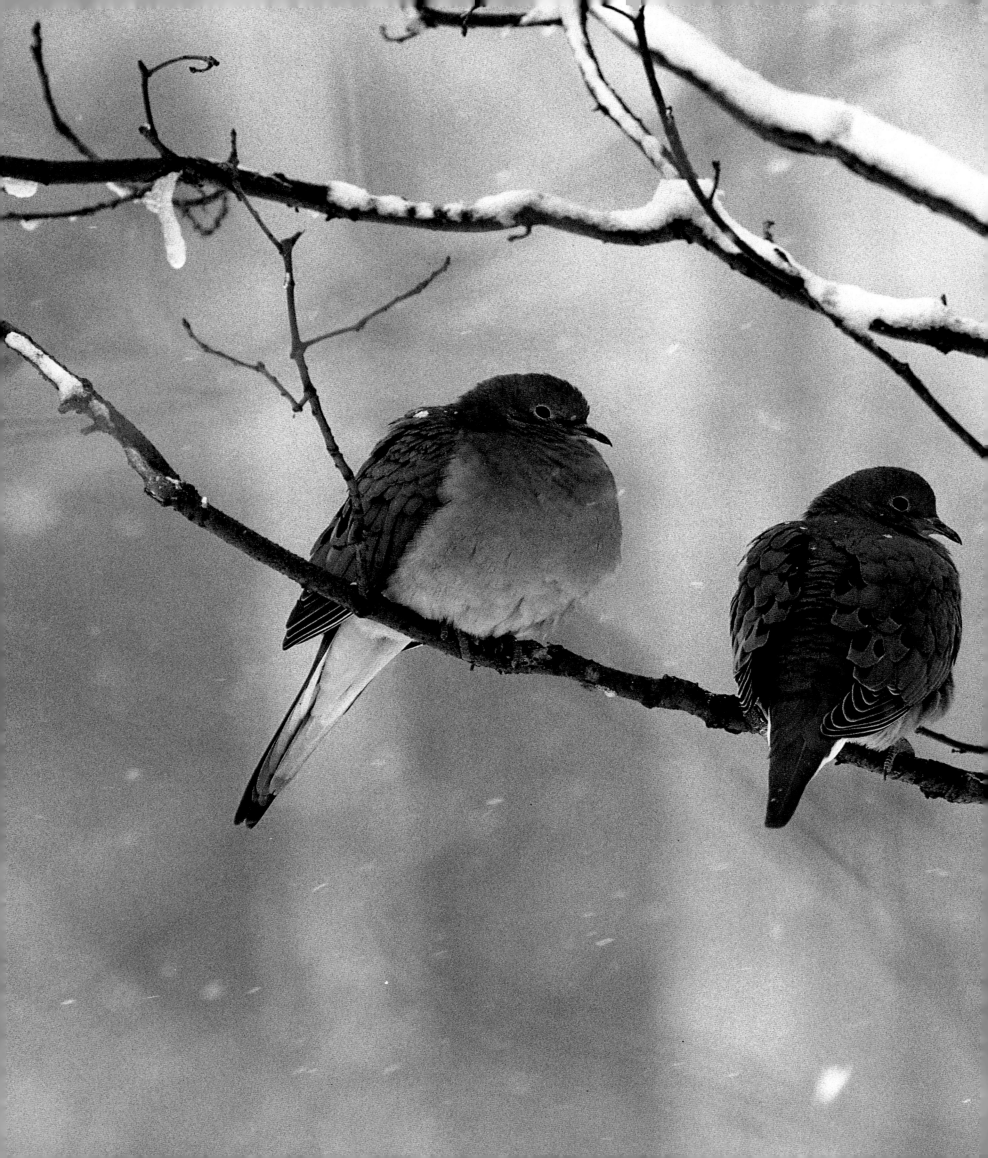

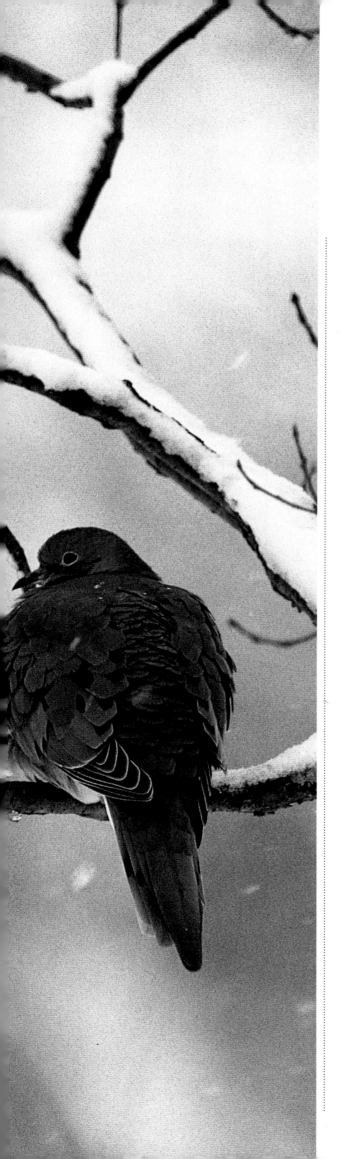

Our most-hunted game bird is the most affectionate to
others of its kind. Mourning doves bill and coo all year
long, and usually mate for life. Males in courtship
strut like a cock turkey, with feathers puffed up,
wings dragging the ground, and tail fanned out.
Plain brown from a distance, a male in close-up
profile shows a blue cap, reddish bill,
and bluish eyeliner.

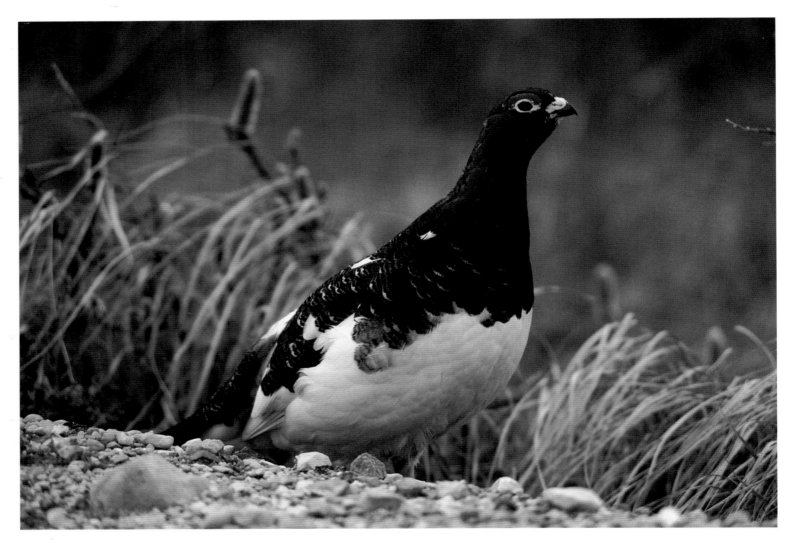

*Costume changes allow ptarmigans to blend with their
northern surroundings year-round. In winter they turn
all-white; a willow ptarmigan (ABOVE) shows the
darker plumage of summer. Change-over in spring
and fall brings the mottled color of the white-tailed
ptarmigan (OPPOSITE). Feathered toes act as
snow shoes in both species in winter.*

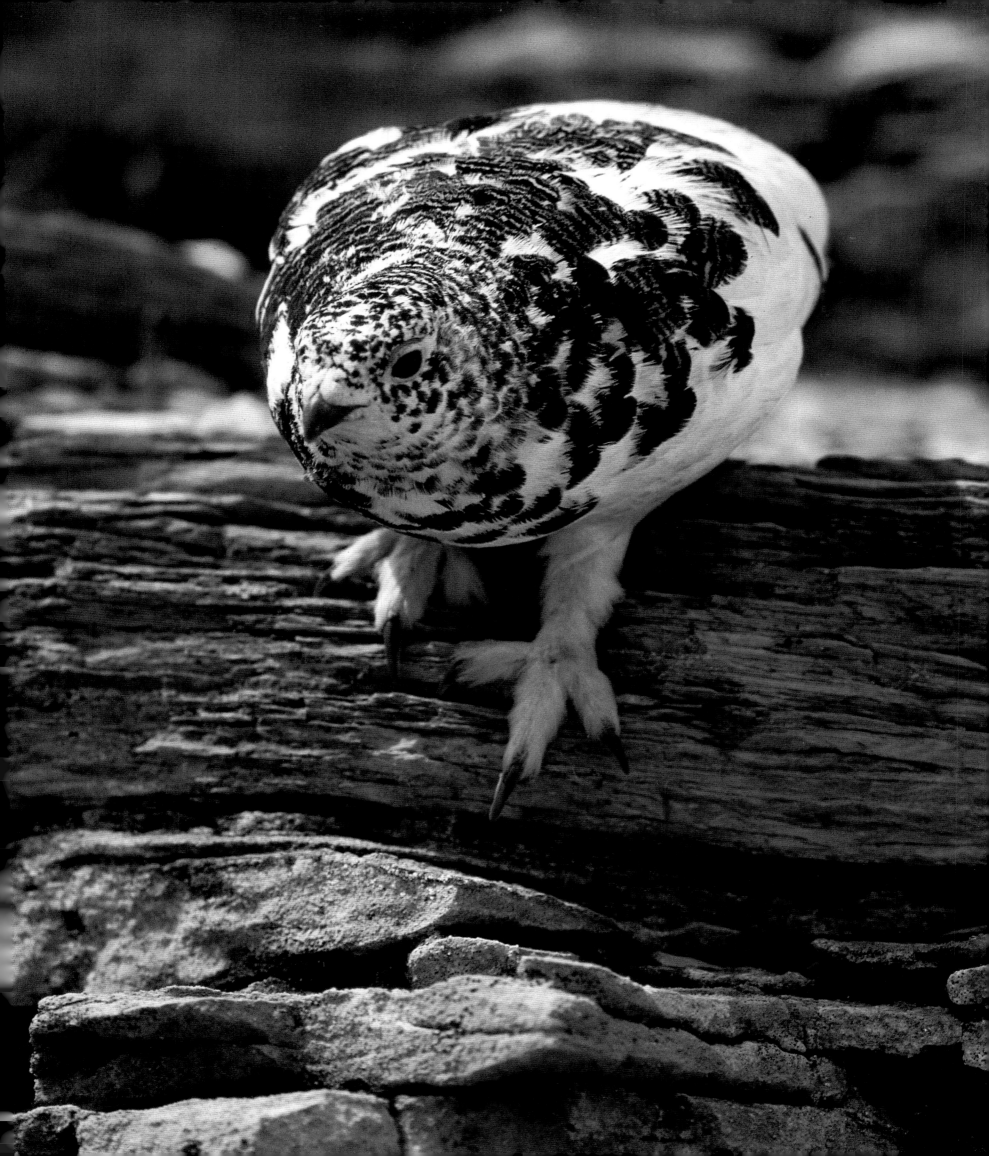

SPECIALISTS

OUT OF THE ORDINARY

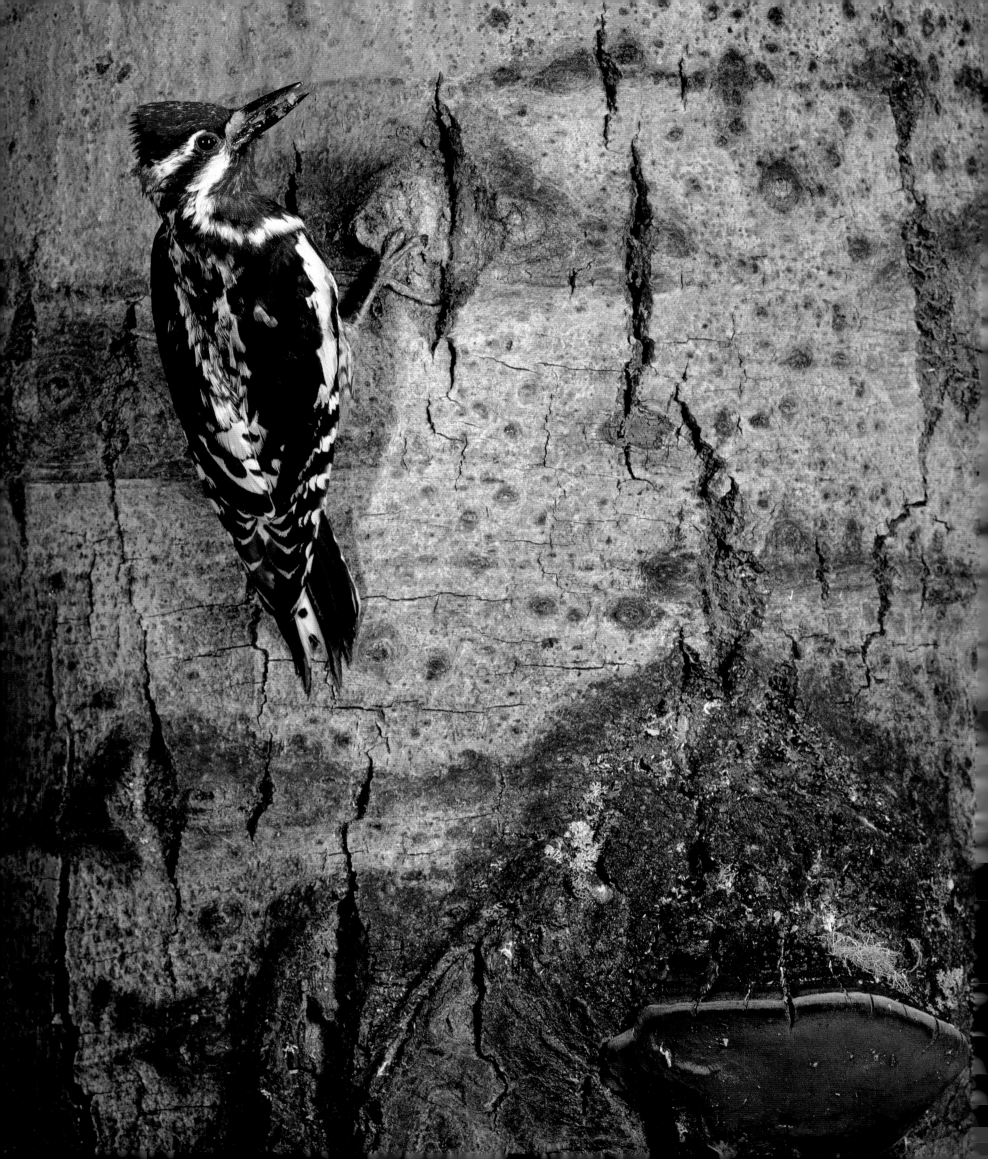

SPECIALISTS
OUT OF THE ORDINARY

DESPITE DIFFERENCES IN FEET, beaks, and bodies, bird anatomy and activity remains essentially similar. Beaks open and food enters, wings flap, and most birds fly. Except when evolution takes a high road and a bird acquires extraordinary capabilities.

Many birds differ in the ways they acquire food, using tools developed over the slow march of time. Let's say that millions of years ago, one bird found nourishment in plant seeds and small insects while another discovered that it could dive down and grab fleshy meals with its feet. Both diets were passed on to their young, and survival among their offspring favored those most capable of feeding themselves: the seed-eaters with short, strong beaks for breaking hulls, and the divers with sharp, grasping toes and hooked beaks for tearing flesh. These characteristics traveled down the hereditary line until finches and hawks ultimately looked very different from each other.

But along the evolutionary line some birds began acquiring food from very different sources, and their specialization became very precise. Such a creature is the hummingbird, so small and with such a radical flying style that at first glance it can be mistaken for a large bee or moth. In fact, the smallest bird in the world, indeed the smallest warm-blooded creature in the world, is the bee hummingbird of Cuba—two inches long from tail to tip of beak and weighing .07 ounces. Our most common hummingbird, the ruby-throat, would nearly balance the scales with a penny. Hummingbirds are found only in the Americas, and after an exhaustive study a century ago, Smithsonian ornithologist Robert Ridgeway referred to them as "without doubt, the most remarkable group of birds in the entire world."

Dynamos come in small packages. While the ruby-throat hovers, its wings are beating fifty-eight times a second, compared to eight times for a pigeon traveling at top speed. The blur of movement creates the humming sound for which it and others of its kind were named. During that time its heart is humming along as well, at twenty beats per second.

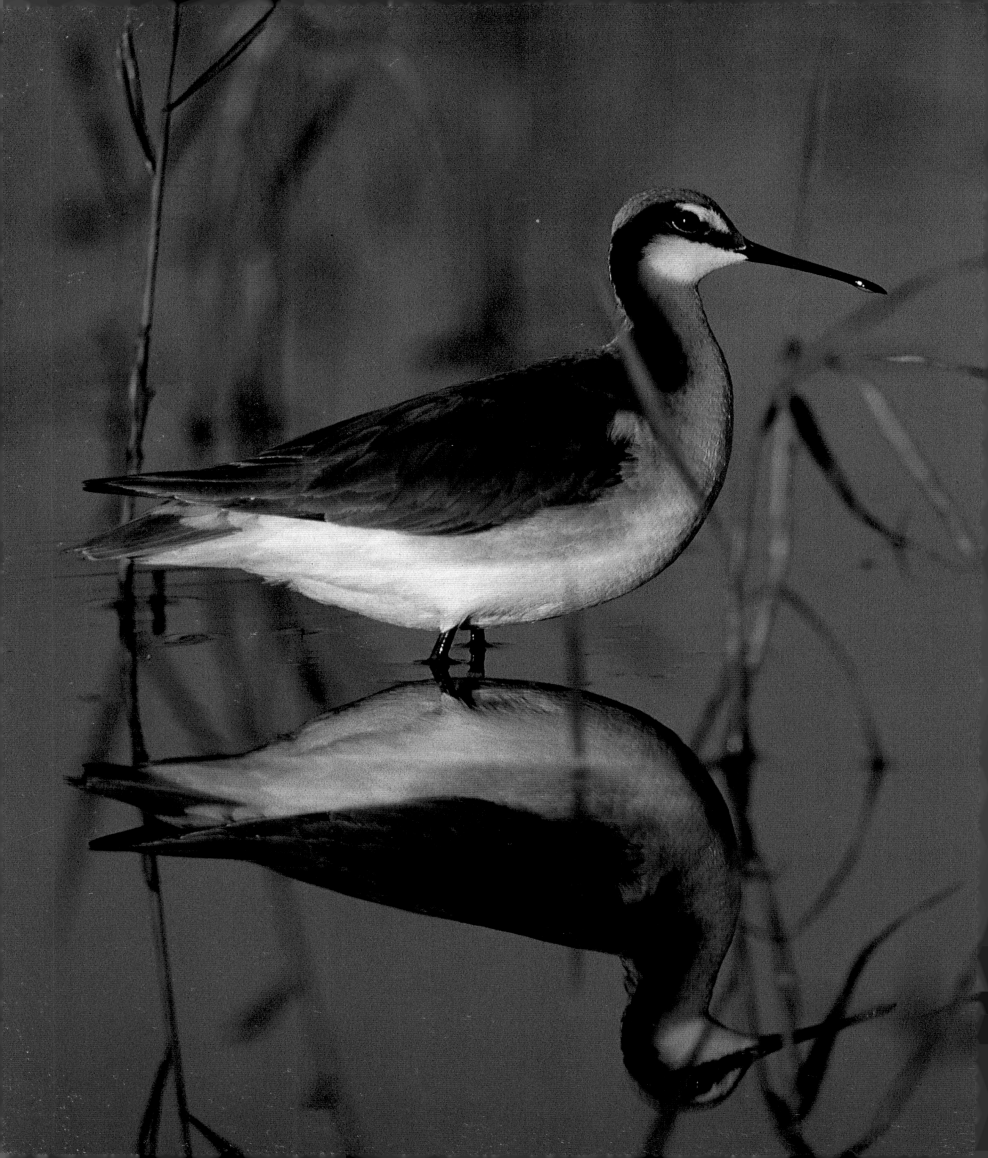

Sex roles are reversed among Wilson's Phalarope. This elegant female in Michigan will aggressively court males, even fighting other females for the right to mate with her selection. After she lays the eggs, he takes over incubation and cares for the chicks that are hatched, while mom gambols about in the shallows with her reconciled sister hens.

If a man could maintain the equivalent energy put out by this penny-weight creature he would probably catch fire. To avoid that fate, calculated Crawford H. Greenwalt, industrialist turned fast-action photographer, a man would have to cool himself with 100 pounds of perspiration an hour. He would also need to burn 155,000 calories a day, which means he would have to be eating and drinking continuously while running at world class sprinting speed. To maintain its own frenetic activity, the hummingbird refuels frequently while on the wing, probing its long beak into flower blossoms for highly caloric, sugary nectar. This is pumped in through a grooved tongue that moves the goodies up the line toward the throat in a rapid, lapping action. Sweets are not enough; the hummingbird also snaps up gnats, aphids, and other tiny insects for protein. Total daily intake equals more than half the bird's weight.

Hovering at the edge of the flower to feed resembles flying like a helicopter. The wings do not just flap up and down, they oscillate back and forth in a figure eight pattern. The front edges of the wings lead on the forward stroke, then the wings swivel and the front edge leads on the back stroke as well. A comparison would be a swimmer treading water and sweeping hands back and forth to maintain buoyancy. On the forward sweep the palms press down; on the back sweep the backs of the hands press down. Imagine doing this fifty-eight times a second!

The wing speed and movement give the hummer unmatched maneuverability, allowing it to fly forward or backward, or when making a quick change of direction, upside down. Takeoff from a branch is straight up, not a forward launch. The legs are so underdeveloped that the hummingbird cannot be said to walk. It flies everywhere, if only to move a few inches or to turn around on a perch. Even forward movement differs from that of other birds, which stroke downward with fully extended wings, then fold the wings in the upward stroke before extending them to stroke again. Hummingbird wings remain extended throughout flight, and with their highly flexible shoulder sockets, revolve in an oval configuration.

The energy cost for all these aerobics is high, sometimes too high. If the constant daytime search yields too little nectar, hummingbirds can starve to death overnight. As a last-ditch defense after a bad flower day, they lapse into an energy-saving torpor. Breathing becomes shallow, and the normally racing heart slows to thirty-six beats a minute, slower than ours. That may get them through the night, but if food deprivation has been extreme the little bird never wakes up to search for more calories.

The tight food budget makes it even more remarkable that the ruby-throat, among others, migrates thousands of miles to winter in Central America, including a 500-mile overnight flight just a few feet above the Gulf of Mexico. It must be assumed that many do not make it and fall into the huge gulf with a very small splash. Those that survive do so because they managed to build up adequate amounts of energy-storing fat before the flight. If your garden caters to hummingbirds with

red flowers (they are attracted to red) and a feeder (one part sugar to four parts water is the acceptable mixture) the surviving globe-trotter will return unerringly the following spring. Hummingbirds have been seen hovering near a bare nail where a feeder hung the year before.

Hummers are remarkable in appearance as well as activity, their iridescent feathers flashing brilliantly, green, red, violet, or crimson, depending on the species. Aztec royalty wore robes of hummingbird feathers that gave them a supernatural glow. In the late 1800s, Europeans became so charmed by these bejeweled birds unknown to their own continent that barrels of preserved skins were shipped across the Atlantic.

They are remarkably unafraid of people, perhaps due to confidence in their own mobility, perhaps because they have few large predators. Wear a red cap and you may find a hummer probing the air holes for something sweet. Small enemies, even insects, are the hummingbird's undoing, for they can be killed by a large praying mantis or a dragonfly. During their winter sojourn down south they may become entangled in strong spider webs and eaten by the proprietor. In the North, small hawks such as kestrels sometimes catch them, and in the Southwest roadrunners can nab them as they hover at flowers. Bullfrogs and snakes may gulp them down if they hang around the edge of a stream or pond.

To increase their kind hummingbirds are enthusiastic suitors, the males writing love letters in the air with intricate arcs and loops. After mating, the philandering male deserts to another conquest while the female molds a

walnut-size nest of lichen and plant fluff, held together with spider silk. If you happen to spy her sitting on two eggs the size of coffee beans you will find her immovable, glaring fearlessly at a giant whose thumbnail nearly matches her weight. Although generally friendly, they have been known to attack humans, dogs, and cats encroaching on their space, as well as jays, crows, and even hawks! Were all wild creatures so fearless and fiercely territorial in relation to their size, larger tracts of wilderness might remain undisturbed. Imagine the slashing charges of eight-point bucks, the ambushes of angry foxes and bobcats, lance attacks by diving herons!

For their courage and swiftness, Navajo Indians ranked hummingbirds alongside wolves and mountain lions. Aztec warriors gave their god of war the name of the hummingbird: Huitzilopochtli, which means "shining one with weapon like cactus thorn." The Portuguese name is gentler—*Beija flor,* or "flower kisser." Like us, residents of the Lesser Antilles named them for their sound, calling them *murmures.* "Murmurers" they may be, but their specialness speaks with great clarity.

Another specialist announces itself with a drum roll. "Woodpecker" is too slight a word for this excavator. If it hadn't been discovered before pneumatic tools were invented it might be called the jackhammer bird. "Peck" brings to mind a nodding of the head, a tapping at something with a hard object. The woodpecker head is a piston, its beak a chisel. Chips fly and sawdust scatters as it drills through solid wood.

So industrious are woodpeckers that a little

Stream-bottom stroller, the American dipper holds itself beneath the surface in swift mountain currents with wings and claws as it searches for small fish, aquatic insects, and other invertebrates. Heavily oiled feathers and an undercoat of down help ward off the water's chill, and moveable flaps close over the nostrils when it submerges. As if relishing a good splash, it sometimes flits in and out of spray for no apparent reason.

industrial safety equipment is necessary. Their nostrils have an overlay of fine feathers to act as a dust mask. Their skulls are hard hats of highly ossified bone, and strong muscles cushion the impact of pecking to prevent the bird from becoming punch drunk. To hold these steeplejacks in place during their chores, the woodpecker's four toes oppose each other and are tipped by sharp claws for digging into tree bark. Tail feathers are stiff, and brace against the tree like the third leg of a stool as the birds work in a vertical position.

The bill is hard and sharp. Powerful muscles in the neck drive the head forward and back, and the action can go on for hours. It must not be painful or headachy because many woodpeckers labor for days to excavate a hole for a nest, then abandon it after a season

and start a new one the following spring. The result is a bonus of second-hand homes for a host of other birds, squirrels, or bats. No shallow caves, the holes sometimes extend nine to ten inches, even deeper for the large pileated woodpecker. Little clean-up is required before occupancy. For all the work they put into building a home, woodpeckers lay their eggs on a simple bed of a few leftover wood chips.

Sure, some woodpeckers cater to softer, rotted trees in search of the grubs within, but most attack the hard stuff, wood that would nicely grip a ten-penny nail. Red cockaded woodpeckers carve their nests out of living, mature pine trees, although always those with red-heart disease. The sap that pours out of the wound may act as a sticky moat against invaders. One western utility company found

that pileated woodpeckers were drilling homes in utility poles, weakening them to the point that electric lines sometimes fell. Damages were estimated at $200,000. Home construction is not the only reason for wood-pecking. Drumming is a signal to others of their kind, perhaps a territorial warning to males. Chopping also exposes insects for eating, and here another special tool comes into play.

If we had a tongue like a woodpecker we could lick an envelope without raising it from the writing desk. The length of extension varies with the species, but the longest woodpecker tongues extend nearly four times the length of the bird's bill. Red-bellied and red-headed woodpeckers project theirs twice the bill's length. From its tip, the muscular tongue extends along the bottom bill to the back of the beak, curls around the skull and over the cranium to the nostril on the upper bill. When necessary, this coiled length can be extended to reach deep into insect tunnels in tree trunks and root out a meal. The tip of the tongue is sticky with saliva and has barbs that rake prey toward the mouth.

As one might expect, all this insect-eating generally works in our favor. In an invasion of codling moths in the apple orchards of Nova Scotia in the 1950s, little downy woodpeckers ate more than half the moth larvae and brought the epidemic under control. Lewis's woodpecker in the Far West snatches flying insects such as flies out of the air. The northern flicker—a type of woodpecker— eats more ants than any other American bird. Such benefits far outweigh the occasional irritations. The woodpecker that chooses to hammer on

your metal roof or rain gutter to attract a mate can wake the dead. And in the spring of 1995 a launch of the space shuttle Discovery was delayed after a pair of flickers pecked holes in the foam insulation of the spacecraft's external fuel tank. Repairs were made and the shuttle returned to the launch pad festooned with balloons with frightening eyes painted on them.

For all our fascination with woodpeckers we failed to honor the realm of the prince of chippers, the rare ivory-bills whose wings spread nearly a yard wide. These largest of the woodpeckers preferred southern virgin forests where blow-downs and other dying trees harbored fat beetle larvae that could be exposed with the ivory-bill's white dagger. Virgin forests where trees are allowed to die and rot are now in short supply. Ivory-bills, never plentiful and unable to adapt to human development, are probably extinct, except possibly on eastern Cuba.

An improbable master of adaptation to a very specialized environment is the American dipper. Improbable because the dipper lives on, in, and near the water, but looks more like a large wren than a duck or other traditional water bird. No webbed feet, no long neck, no spoon-shaped bill. In fact, Europeans first seeing the dipper called it the water ouzel (the Old English name for a thrush), which it resembled, until it walked into a torrent of rushing water and just kept on walking, like a stockbroker after a serious crash.

Fairly common in the far western states, Canada, and Alaska, dippers hang around clear, frothy streams of the high country. They feed

Punker hair on a big head easily identifies the belted kingfisher, which plunges into water headfirst after small fish. The heavy bill and strong feet help it dig nesting burrows in stream banks, where both parents take turns incubating the eggs. Highly cooperative in feeding and raising their young, the birds then become loners for the rest of the year.

on invertebrates found on the stream floors and in their search, walk on the bottom. In calm water they can simply grasp rocks with agile toes. In swift currents that would sweep a person away they use their wings like the diving planes of a submarine, turning the backside of the wing upward so the force of the water holds them down. The bottom-walk may last only thirty seconds until a shift in the planes pops the bird to the surface with an insect in its beak, although some dippers have been observed staying underwater for two to three minutes. During that time a special flap clamps over their nostrils and the third, transparent eyelid keeps their eyes clear of suspended particles. The oil gland found on their rump is ten times the size of those on other songbirds, for super-application of water-proofing. The bird is actually oily to the touch.

It not only lives exclusively around swift, icy waters, it seems to relish the aquatic life, flying through spray and waterfalls, singing joyously all the while. The dome-shaped nest with a side entrance is also near the water, on an inaccessible ledge or crevice or even behind a waterfall. The bird goes home by flying straight through the torrent. Even in winter it does not migrate, but merely moves down-country to open water when its alpine habitat freezes over.

For all its love of water the bird's name does not derive from always "going for a dip," but for its habit of bobbing up and down, sometimes forty or fifty times a minute. Maybe it's only vigorously approving its own genius at specialization.

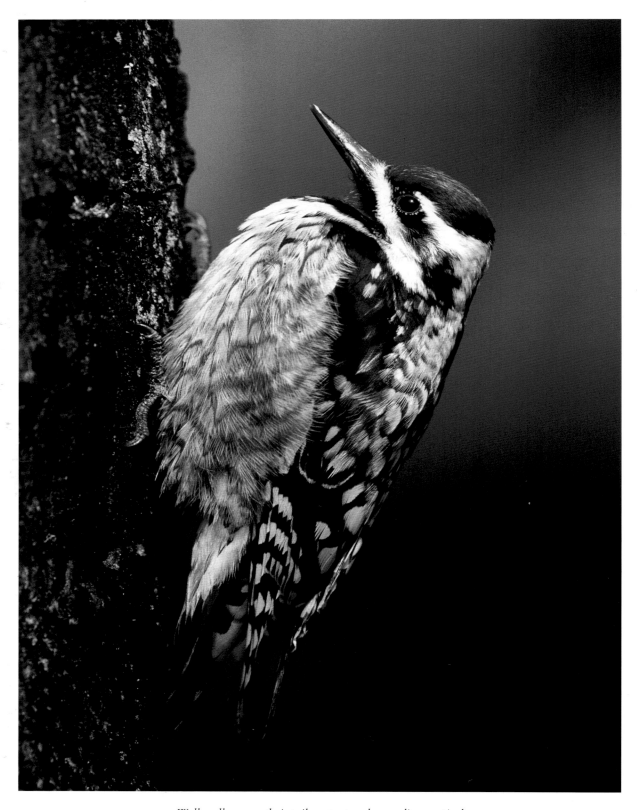

Wall walkers use their tails as props when scaling vertical tree trunks. Sap wells that benefit several species, drilled by the yellow-bellied sapsucker (ABOVE), can be found in more than 250 species of trees and shrubs. Whole chunks of wood fly when the pileated woodpecker (OPPOSITE) attacks a tree with its chisel of a bill, exposing carpenter ants and insect larvae.

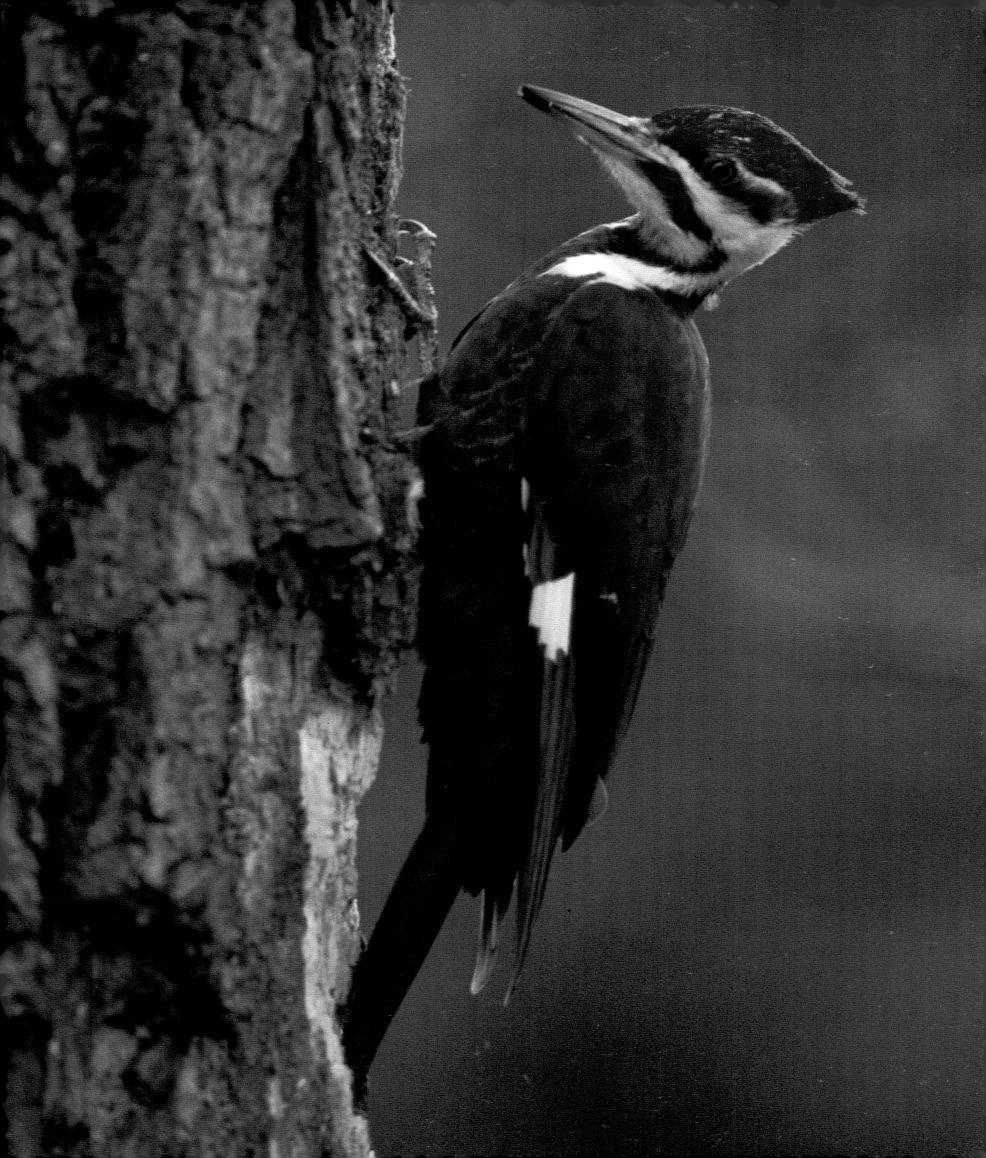

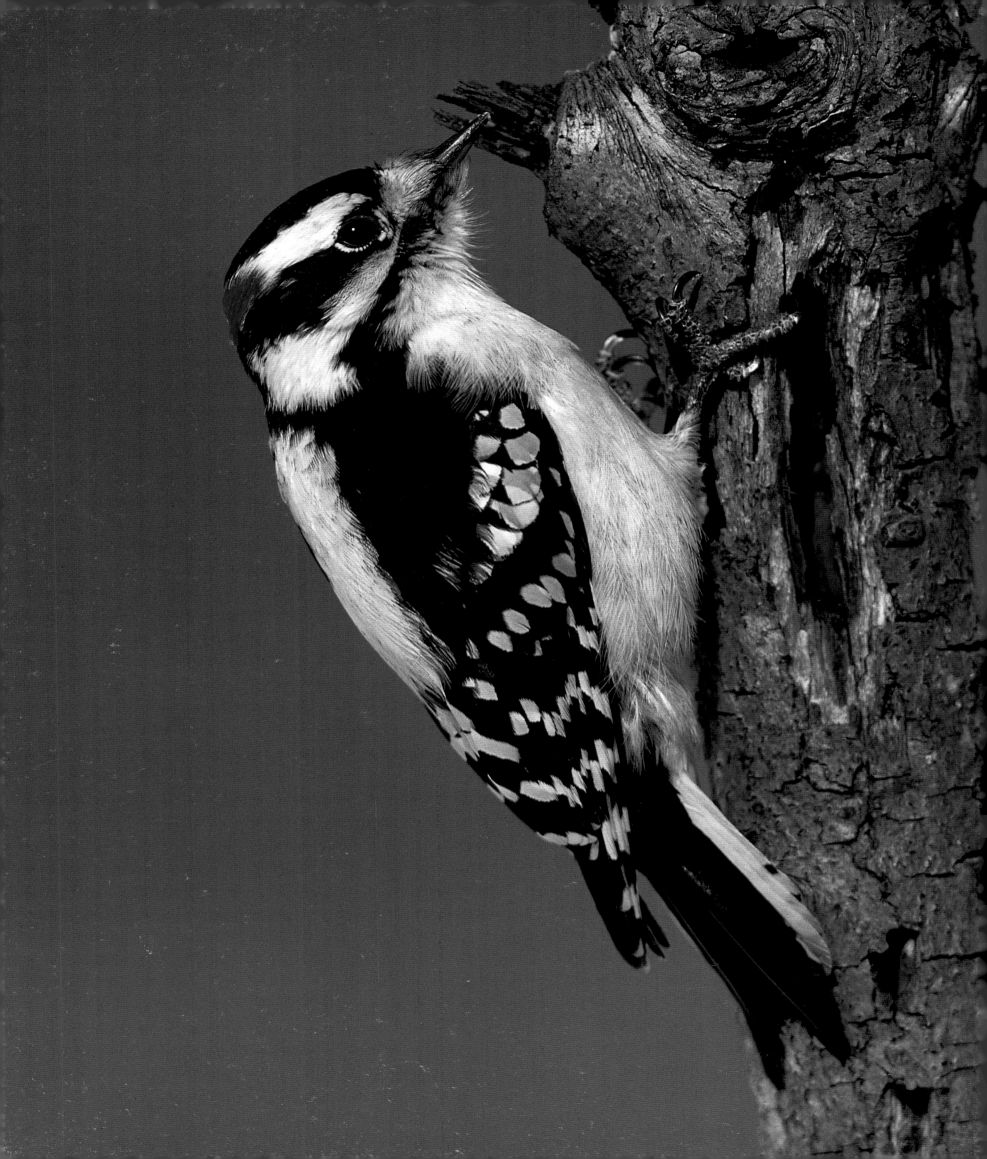

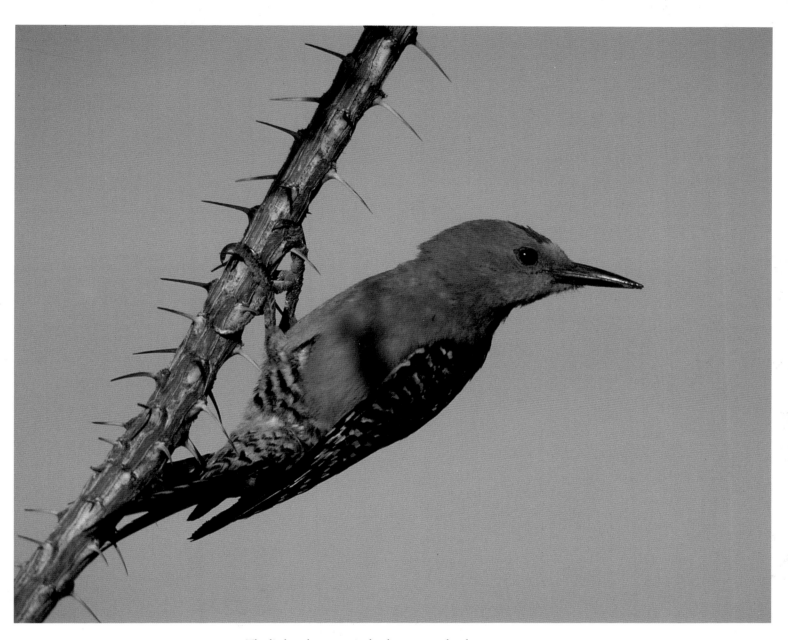

The littlest drummer is the downy woodpecker (OPPOSITE),
only six or seven inches long. Its head-blurring tattoos on
trees often serve as mating calls or the marking of territory.
Slightly larger is the gila woodpecker (ABOVE) of the desert
Southwest. Holes itcarves in giant saguaro cactus often
become apartments for snakes, mice, and flycatchers.

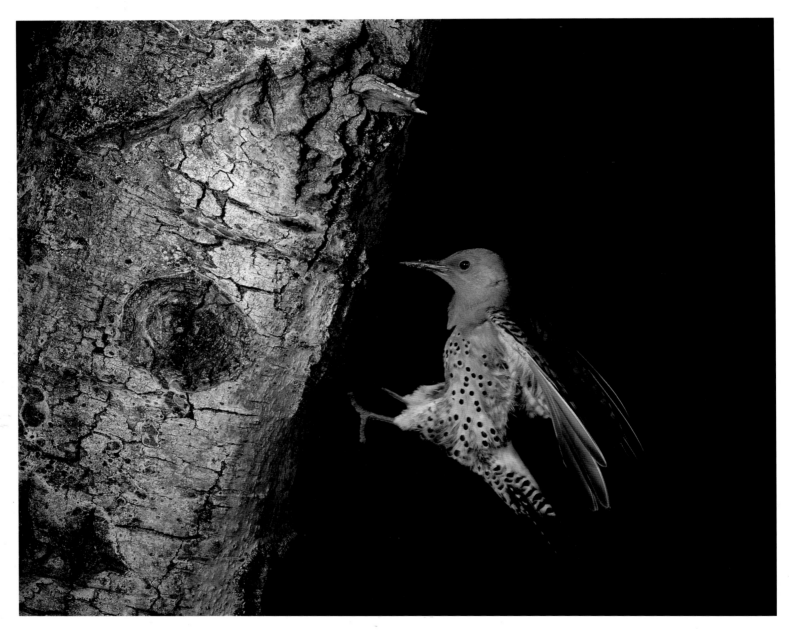

A popular tree trunk in Alberta draws two different forms of northern flicker. A vertical landing reveals the underwings of a yellow-shafted form (ABOVE) normally found east of the Rockies. At the same location two years later sits a red-shafted subspecies, a western bird (OPPOSITE). Where their ranges abut, the two forms interbreed, creating color combinations.

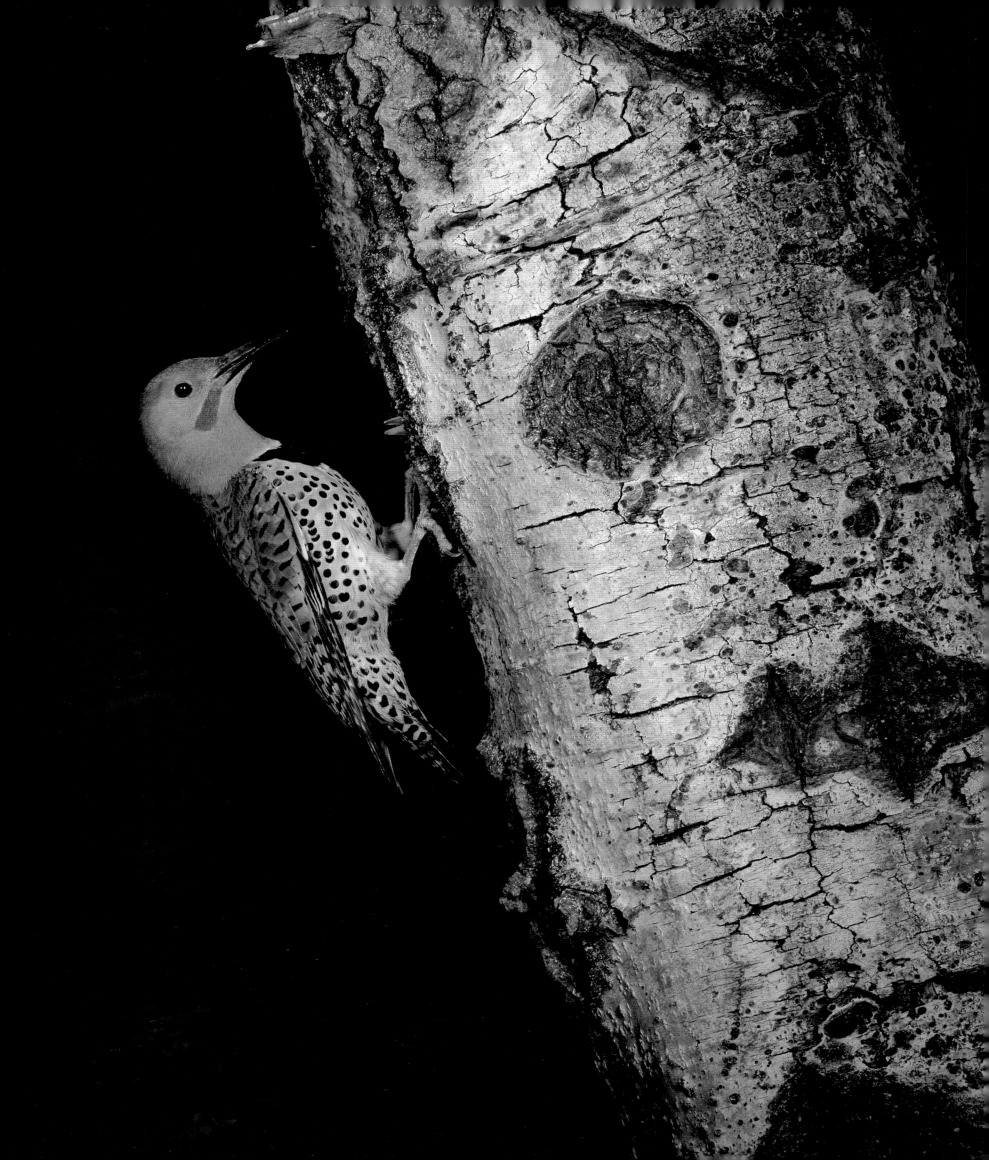

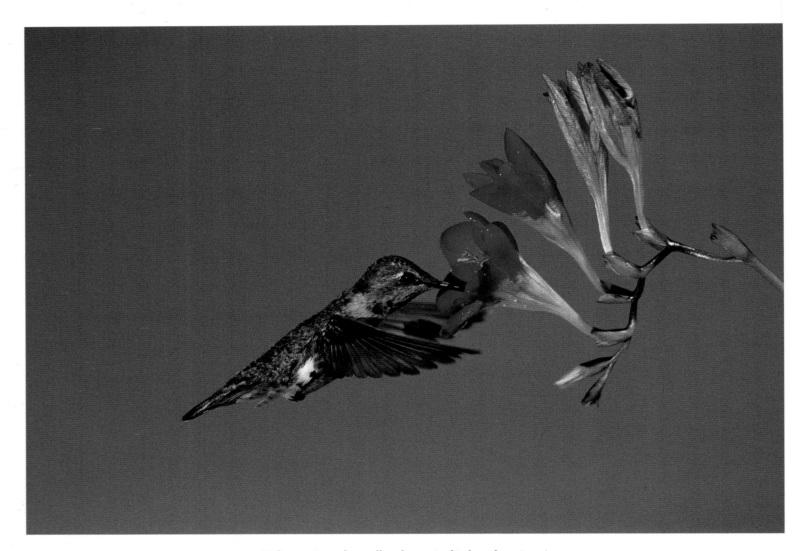

*Helicoptering talents allow hummingbirds such as Anna's
(ABOVE) to hang steady in the air while extracting nectar
from flowers. Red blossoms are the color of preference.
A hovering black-chinned hummer (OPPOSITE) rotates
his wings so the front edge leads on both forward and
back strokes, like a swimmer treading water.*

PAGES 146-147
*The snug nest of Costa's hummingbird keeps eggs
the size of navy beans insulated against the cold.
The eggs comprise 10 to 20 percent of the tiny bird's
body weight, similar to an average-sized human
mother giving birth to a twenty-pound baby.
Fierce protectors of their nests, hummers will
dive with rapierlike beaks on intruding
cats, dogs, or humans.*

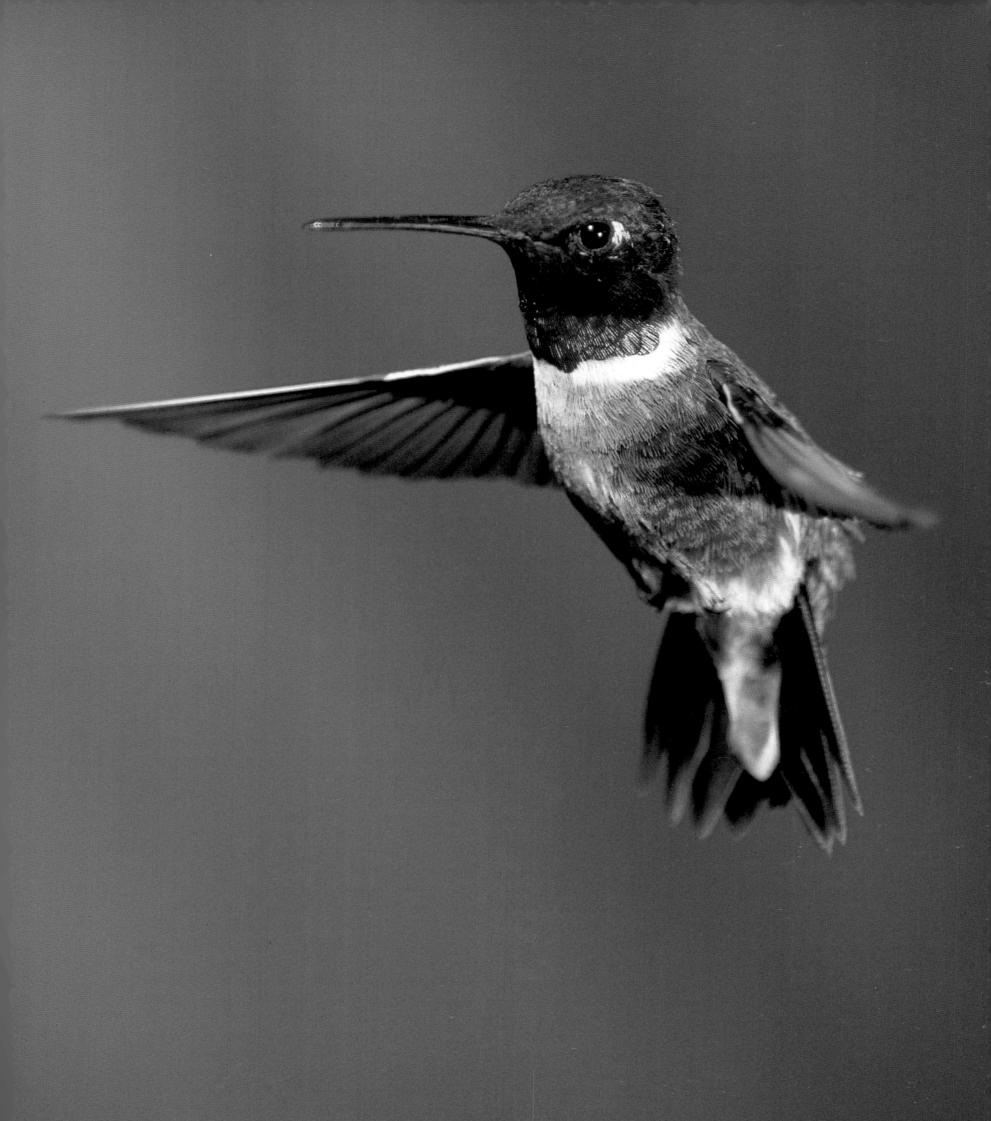

SHORE BIRDS

LIFE AT THE EDGE

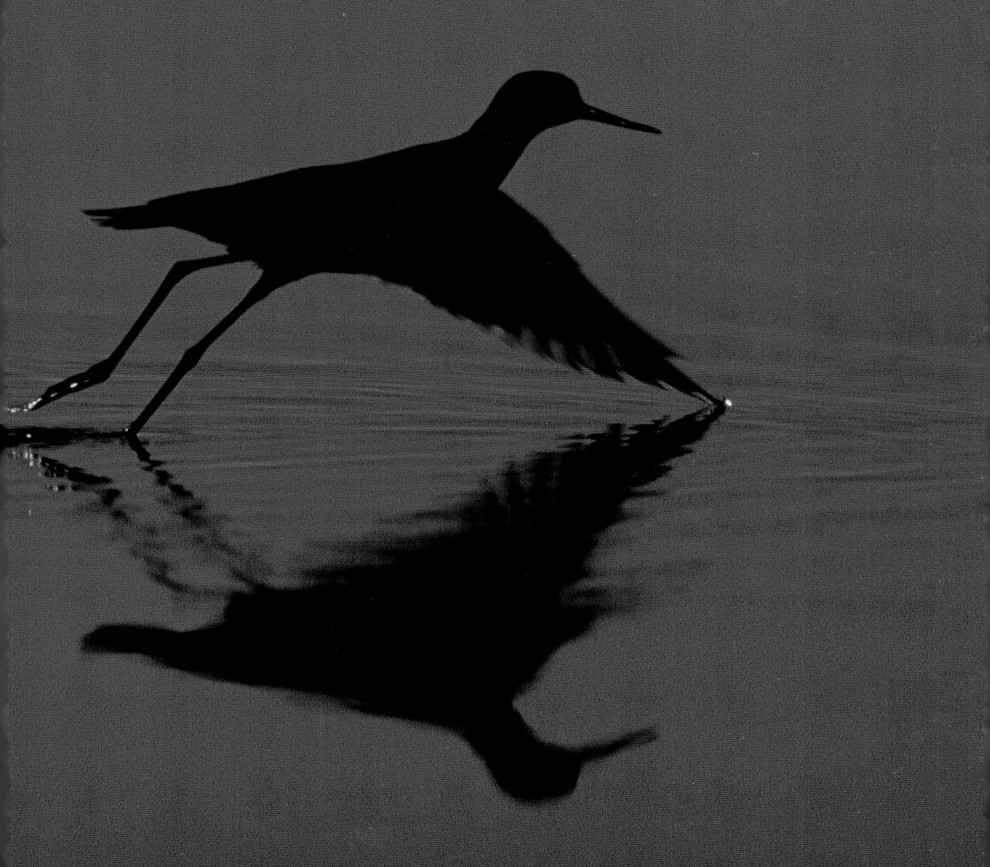

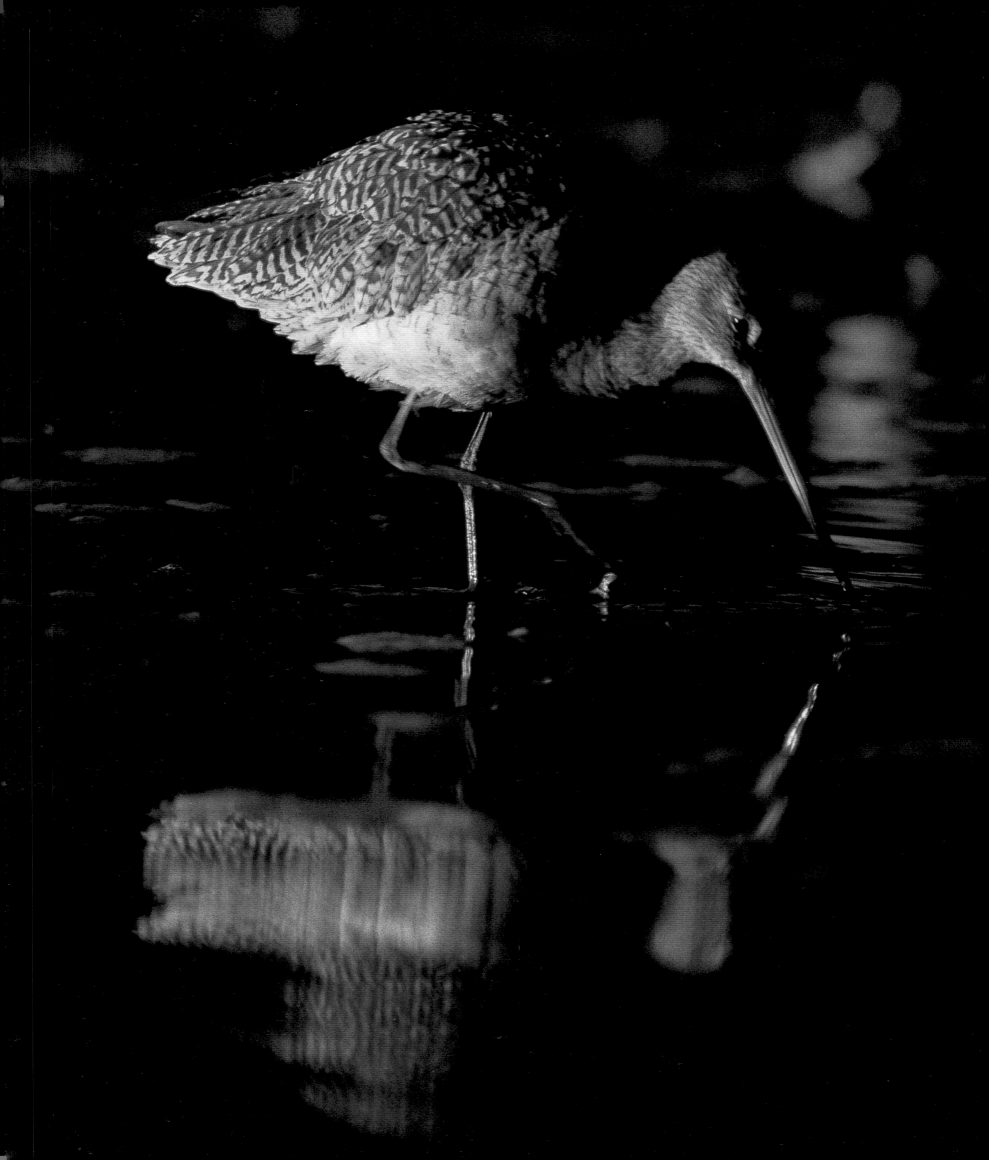

SHORE BIRDS

LIFE AT THE EDGE

T HE FEATHERED POST-LIZARD known as *Archaeopteryx*, found in Bavaria, reigns as the earliest known version of a bird. But the earliest collection of numerous species was found where a shallow inland sea once lapped at the land in Kansas some eighty million years ago. Among them, now-extinct *Ichthyornis* was the first known bird with wings developed for sustained flight. It had teeth and probably ate fish. *Ichthyornis* and the numerous others found at this site confirm what we conclude today when we see the abundant bird life at shorelines: life at the edge can be fruitful.

Where habitats meet, nutrients usually flow, as numerous creatures take advantage of two very different environments. Of all the edge habitats none offers more riches than the shallows just offshore from many of our ocean coasts. Vegetation, insects, and microscopic tidbits wash in off the land, crustaceans and aquatic insects wait to feed on them in the water, and larger animals feed on them in turn. In the rich mud grow waving forests of spartina grass and sea lettuce, offering food and places to hide. Many deep-sea fishes, valuable to us commercially, begin their lives in these shallow nurseries where they find nourishment and safety from large predators. All this provides a pantry for birds equipped to raid it.

Birds of many unrelated orders rely on long legs that let them stride through the water while peering or probing into it in search of prey. Their legs are even more remarkable when one considers that they are but variations of our own limbs. Our knee joint bends forward, while that of the wader appears to bend in the opposite direction. In fact, the bird's equivalent of our knee is further up the leg, the hinge with which the "drumstick" connects to the second joint. The part that we see bending backward halfway down the bird's leg is not a knee, but the equivalent of our ankle, and the leg below that joint is actually a foot that has evolved into fused bones ending in four toes.

The herons are a large family of long-legged waders that includes the egrets and bitterns. Herons tend to be long-necked as well as long-legged, and they fly with their necks folded back

Patient harvester of the shallows, a marbled godwit probes the mud with its long bill for snails, worms, insects, and crustaceans. Its entire head often submerges in the search. A brave incubator, the marbled godwit is known to sit motionless while predators tread just inches away.

PAGES 150-151
Trailing a foot and a wingtip, a lesser yellowlegs takes off from Squaw Bay in Lake Huron. A shore bird that nests in the tundra and winters in South America, it is seen in the continental U.S. mostly in transit.

in an "S" shape. They hunt the shallows with patient, measured steps, the neck again bent until it unwinds with a lightning thrust at a frog or fish. Reddish egrets, related to the herons, forage with wings extended, creating dark shadows before them. Is it easier to see fish without the glare of the sun, or are they creating a dark area that attracts fish seeking sanctuary? If you think that too calculating for a "bird-brain," consider the green-backed heron, which has been observed very deliberately placing bait into the water, then waiting patiently to capture small fish that come to it.

The most widespread of the large herons is the great blue, found in each of the lower forty-eight states, Canada, and Alaska. Generally seen standing alone in water, they nest communally, sometimes with hundreds of bulky stick nests bristling in tall trees. When morsels are delivered to the brood of three to five nestlings, the unmannerly chicks squabble and squawk, each struggling to nab the frog or fish from the adult's bill, and with good reason. Competition determines who eats, and who dies of starvation. If you're contemplating a closer look at the nest, consider that when danger approaches, the chicks regurgitate food down on the intruder.

A foot shorter than the fifty-four-inch great blue heron is the great egret, whose delicate white breeding plumes brought $32 an ounce around the turn of the century. Snowy egrets were also much in demand. Since it took four dead birds to provide an ounce of feathers, snow-white waders were on a downward spiral until laws protected them and other birds from becoming hat decorations.

The dawn of the conservation movement in America can be traced in large part to the efforts of concerned citizens to stop the plume trade. Bird slaughter spawned the first Audubon Society in 1886, and the efforts of the later national environmental federation by the same name around the turn of the century brought about bird protection laws in thirty-two states. President Theodore Roosevelt established Pelican Island in Florida to provide sanctuary for birds from hunters, and the preserve became the first of more than 500 National Wildlife Refuges now scattered over the U.S.

While good looks have threatened some herons, one marsh heron depends on its looks for camouflage. Sensing danger, the American bittern turns its sharp beak skyward, exposing stripes on its neck and chest that blend in with the vertical shadows among reeds. To complete the disguise it may also sway slowly from side to side as though stirred by the wind. A smaller cousin, the least bittern, can squeeze through narrow spaces in dense vegetation or scramble through the reeds like a squirrel, grasping several stems at a time in its long toes.

The most successful member of the heron family is the cattle egret, an immigrant to the New World. The cattle egret probably crossed the Atlantic on its own in the late nineteenth century from Africa to South America and worked its way north. Preferring the southlands but seen as far north as the Dakotas and Maine, the short, stocky egrets hang around pastures, waiting for bovines to stir up insects as they move through the grass.

The secretive least bittern prefers dense marshlands, where it relies on tricks of camouflage for defense. Upon sensing danger it freezes and turns its head skyward to blend in with tall plants. If flushed it scrambles through the vegetative maze, its nimble toes grasping several stems at once. Nests are woven platforms built just above water level.

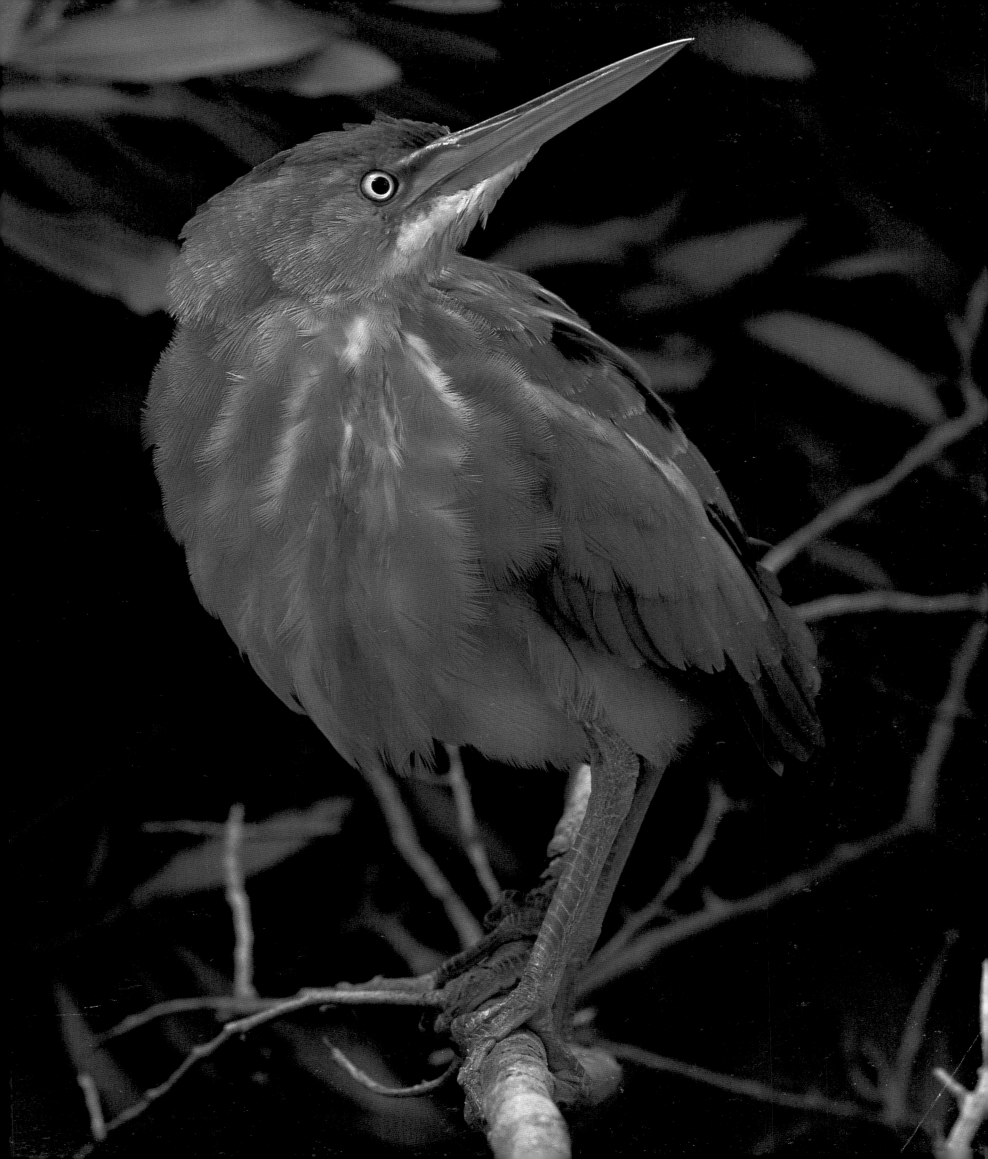

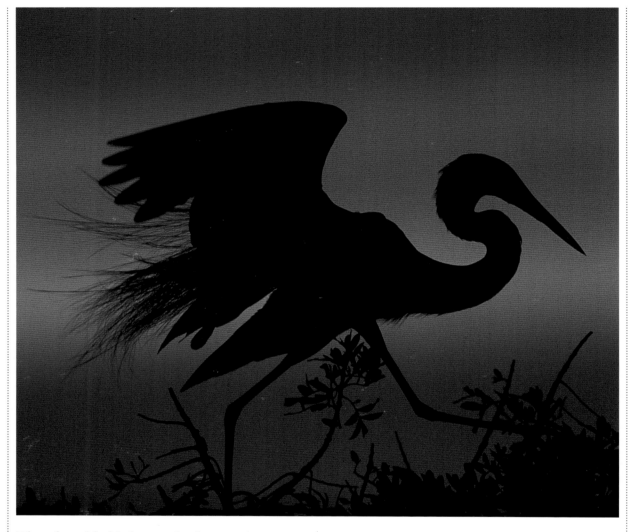

A great egret struggles to find a steady perch against an orange sky. A precarious future lay ahead for the tall white waders a century ago. Thousands were killed for lacy plumes to adorn ladies hats, when one in every 1,000 Americans was employed in the millinery trade. Egret protection helped start the environmental movement in America.

The adaptable birds can also be seen in Africa, Europe, Asia, and Australia, wherever livestock ranges in temperate to tropical climates.

One tall, large-bodied bird of the shallows in North America might seem to be heron, but it is not. Wood storks also feed on fish, frogs, and insects in wetlands of the South, but with their bald heads and scaly necks, their flight, and their appetite for carrion they are closer kin to vultures than herons. Graceful in flight, they stalk the wetlands like hump-backed English professors with dark secrets.

Cranes comprise the royalty of the long-legged waders, and unlike the storks, they inspire awe rather than a sense of foreboding. A regal aura surrounds them in their stately stride. An other-worldly air takes over when they dance in wing-flapping, neck-stretching ballets, sometimes in courtship, sometimes seemingly because they're happy to be alive. Herons nest in colonies, but cranes cluster in huge flocks. During spring migrations, watchers at Muleshoe National Wildlife Refuge in northwest Texas have counted as many as 250,000 lesser sandhill cranes. The sound of their

liquid *ker-loos* as they wing overhead is an ode to wild freedom.

The muting of another crane's call signals a near-tragedy of environmental loss. In colonial America, an Indian gave English illustrator and naturalist Mark Catesby a tobacco pouch made from the skin of a "hooping" crane. "He told me," reported Catesby, "that early in spring, great multitudes of them frequent the lower parts of the rivers near the sea, and return to the mountains in summer."

By 1941 the multitudes had dwindled to twenty-one whoopers and many ornithologists considered these largest of the wading birds lost forever. Their near-demise can be traced to a habit of summering on open plains with plentiful wetlands. We plowed the one and drained the other to raise our food, leaving the regal birds few places to dine.

In this country's first determined attempt to save a species, a major education effort made the birds sacrosanct. A captive breeding program began transplanting the big birds to remnant areas they might find congenial. Eggs laid by captive whoopers at the U.S. Fish and Wildlife's Patuxent Research Center at Laurel, Maryland, and from nests in Canada were placed under wild sandhill cranes in Idaho. The sandhills acted as surrogate parents, teaching the taller, whiter youngsters how to forage, to avoid predators, and to migrate in winter to Bosque del Apache Wildlife Refuge in New Mexico. The International Crane Foundation started a breeding population which now totals thirty-five adults. The Calgary Zoo in Canada's

Alberta Province nurtured fifteen young birds that began laying eggs in 1995.

There have been setbacks. Whoopers die of tuberculosis or collisions with high tension lines. Golden eagles sometimes dive on them as they migrate. Over fifteen years some 200 birds were installed in the Idaho-to-New Mexico sandhill/whooper flock, and the scheme of surrogate parentage seemed to be working. Then rural electrification programs raised power lines along the migration route, and many of the young migrating whoopers collided with the wires. The adopted birds dwindled to four and the program has been virtually abandoned. "After all the preparations and the work, human development once again turned the tables on them," said Dr. George Gee, a biologist in the Whooping Crane Recovery Program.

Nevertheless, by 1983 the total number of whoopers had climbed to 140 birds, and in late 1995 they were slightly above 300, with more than half living in the wild. Today, efforts are focusing on preserving the group of whoopers that winter in Texas and summer breed in Wood Buffalo National Park in Canada's Northwest Territories, and in establishing two more groups. One will be a nonmigratory flock in Florida to avoid the perils of migration (historically there were nonmigratory flocks in Florida and Louisiana), and another will be a migratory population established in Canada.

Surrogate parents of another species would fail with a flamingo, for nothing but another flamingo can teach a member of this long-legged family how to eat. The inside of a

flamingo's elbow-shaped bill is lined with a hairlike fringe called lamellae. The bird submerges its head in water, opens its beak, and lays the upper part of the beak on the bottom. With its head now upside down it swishes the beak back and forth, sucking in mud and bits of organic food before clamping shut on the mouthful of muck with the lower mandible. The tongue forces out the water and mud, leaving bits of food hung up in the hairlike strainer to be swallowed. A Caribbean bird, the reddish flamingo drifts into Florida and the Gulf states.

The beak adaptations of other wading birds are equally ingenious. Spoonbills and ibises are closely related but their bills have taken distinctively different evolutionary turns. The roseate spoonbill is a bird of beautiful, pinkish plumage, but its head looks like a green golf ball with a spatula attached. In feeding, the bird opens the sensitive, spoon-shaped end and swishes it back and forth in mud and water until it encounters fish, shrimp, or insects, where-upon it snaps shut. Ibises look and behave like spoonbills except that their more tubular bills are down-curved. In groups, adults move across shallows like white-coated harvest hands, methodically probing the bottom for tidbits which they quickly toss back into their throats.

Beaks may seem stiff and lifeless but they contain numerous sensitive nerves, much like our lips and fingers. The ibis that dips its beak into the muck can actually feel a morsel of food, and differentiate it from a pebble. The spoonbill wagging its open beak through the water can sense the difference between a drifting twig and a swimming shrimp. The bill of the limpkin, a goose-sized wetland stalker related to cranes but in its own family, not only detects prey but is specially shaped to deal with it. The limp-kin feeds almost exclusively on the apple snail of southern waters, and when one is found it is gripped handily midway in the bird's bill. Rapping the snail open against a hard object, the limpkin then extracts the soft tissue with a sideways slanting beak tip, nifty as a nut-pick.

Waders have no corner on wonderful beak adaptations. Among the shore birds, that of the American avocet can truly be described as lovely and graceful, like the bird itself. You can't mistake an avocet. The needlelike bill sweeps upward at the end. Its neck is sleek as a fashion model, and the head is slender and rust-colored and highlighted by bright eyes. Black and white striped wings complete the formal outfit. Long bluish-gray legs tiptoe politely through shallows while the upturned beak sweeps back and forth just above the mud in search of aquatic insects.

Of less cultured appearance are the feed-ing techniques of many smaller shore birds. Plovers survey the sand until they see move-ment by worms or sand flies, then dash for-ward and seize them like small boys rushing the cookie plate at a church picnic. Sander-lings chase a receding wave down a slanting beach, then race back up the sands inches ahead of the next frothing surge. It's no game; they're trying to collect the many little worms, mollusks, and crustaceans washing

about at the sea's edge. Turnstones got their name by flipping over pebbles on the beach in search of small life hiding beneath them.

Are these feeding methods instinctive or learned? The oystercatcher, at least, teaches its young as carefully as we place a spoon in the hand of an infant. The adult birds first feed their helpless nestlings, then later lead them to their main prey of mollusks and crustaceans and demonstrate proper technique. That technique varies with the parent, and thus varies the diet, brood by brood. Some oystercatchers hammer open shell-protected mollusks, while others stab crustaceans such as crabs with their sharp beaks and then pick out the meat. Rare is the oystercatcher that does both.

Shore bird parenting takes many directions. Marbled godwits are so faithful to a nest they have been known to let a person lift them off it. Sandpipers will squeeze chicks between their legs and carry them away when danger approaches. The solitary sandpiper, on the other hand, seems to have a slight glitch in parental responsibility. Its chicks can run two days after hatching, so a ground nest would seem appropriate. But the mother lays its eggs in the abandoned nests of robins and other tree-happy birds. The restless young sandpipers must bail out from the heights, tiny wings fluttering desperately, so they can scamper about on the ground with mom, looking for food.

Killdeer are doting parents from the beginning, whether faking a wing injury to lure predators away from their young or flying directly at an intruder. Even when a second brood is hatched, the female deals with

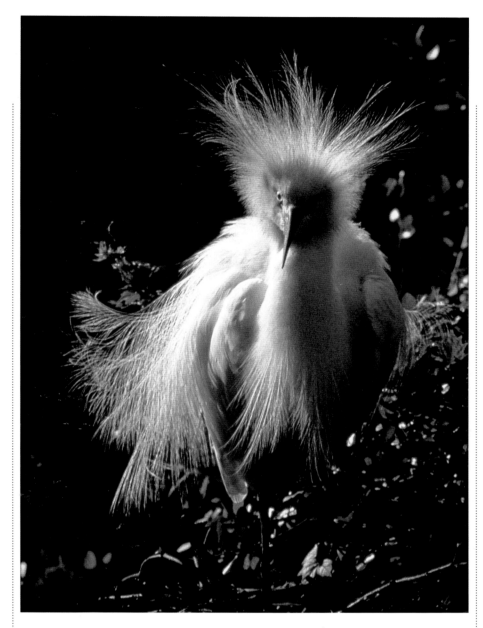

the new babies while dad continues the education of the older chicks. If that sounds like the Ozzie and Harriet of birdland, consider a cousin, the spotted sandpiper, a Jezebel of a mother by our standards. At mating time she fights off other females and struts before a male until he succumbs to her charms. After she lays the eggs, he immediately takes over incubation while she flies off to begin romancing another male. Seduction may continue with four or five males, each of them hatching and rearing the young before she settles down with the last one and finally goes domestic.

A flurry of feathers marks the snowy egret, whose filamentous plumes give it most extravagant raiment. It caught the eye of plume hunters, who hunted it extensively until protection allowed its numbers to rebound.

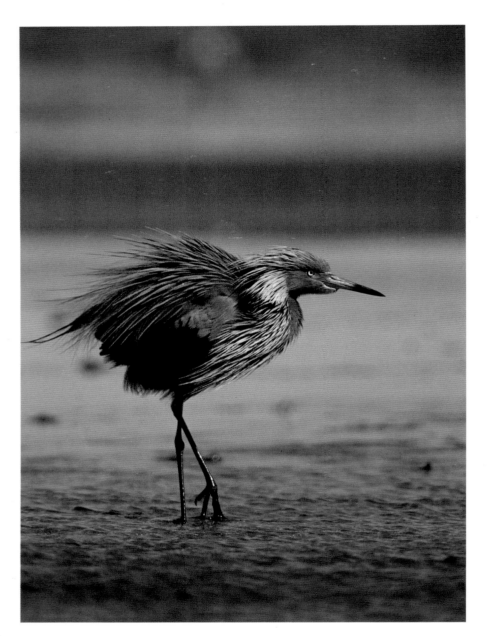

Swordplay determines dominance among great egrets during breeding season (OPPOSITE). The winner establishes his territory, and perhaps claims a mate. Dominance over other herons allows great egrets to nest higher, and therefore safer, in trees. Ruffled for a different reason, the smaller reddish egret (ABOVE) dashes through shallow salt pans with raised feathers to snatch morsels of food.

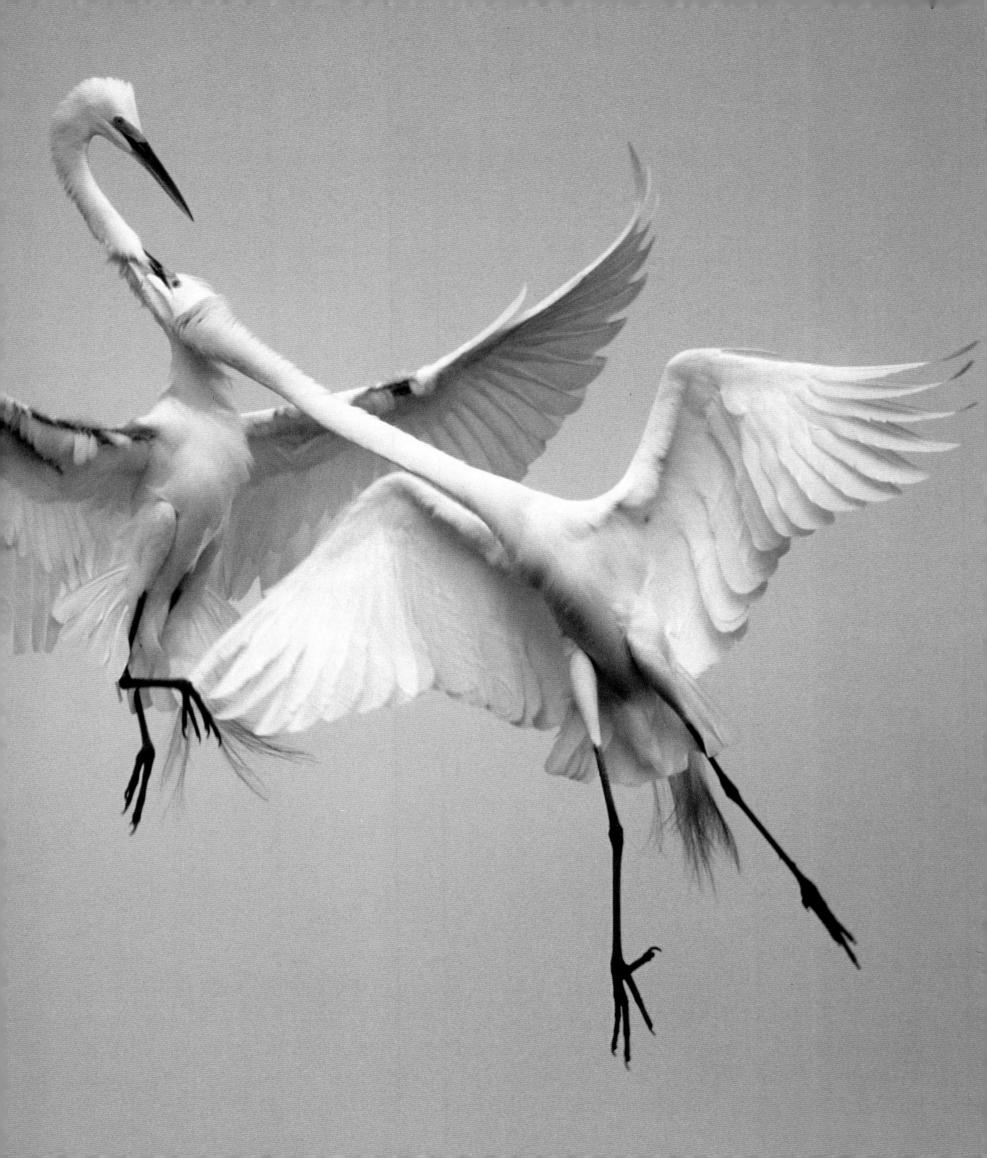

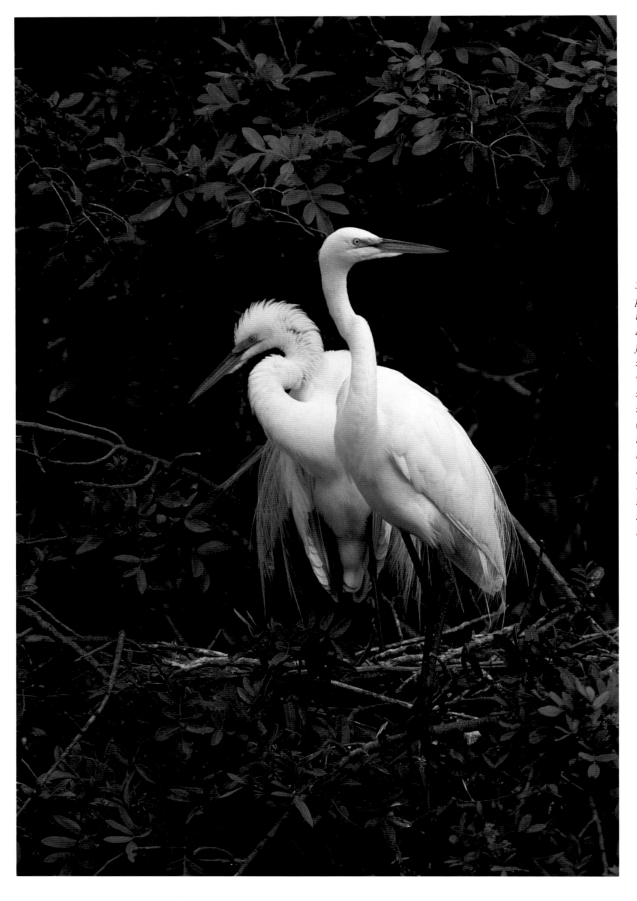

Still in nuptial finery, a pair of great egrets settle into a large nest of sticks and twigs. The long filamentous plumes spilling off their backs will drop off after mating season. One attends squabbling youngsters (OPPOSITE) that will leave the nest after three weeks but stay with their parents until the following spring. Hatching and fledging success of egrets has increased with the banning of DDT.

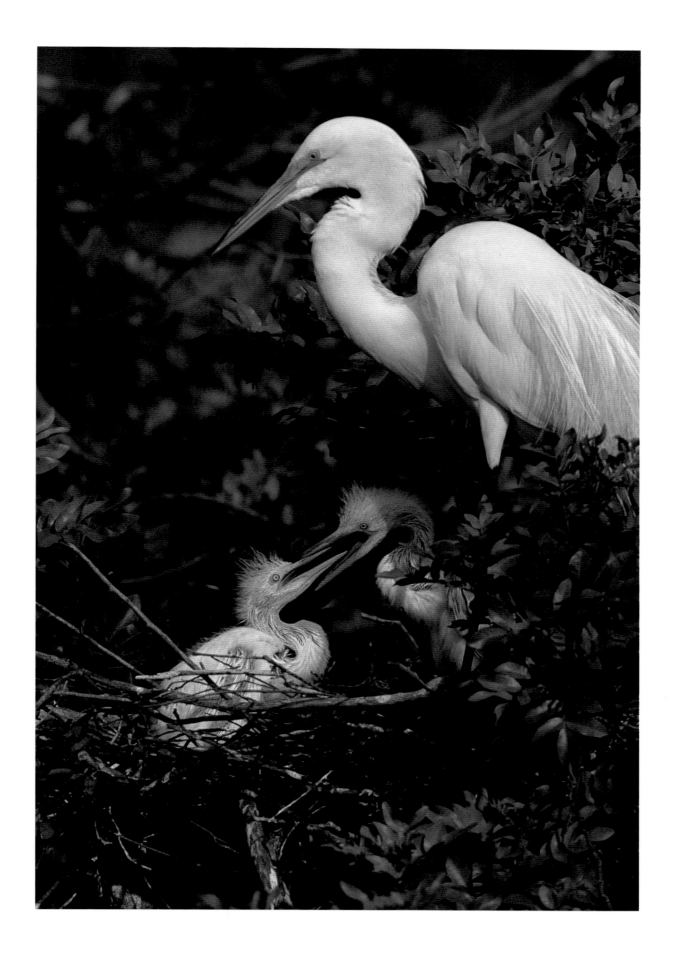

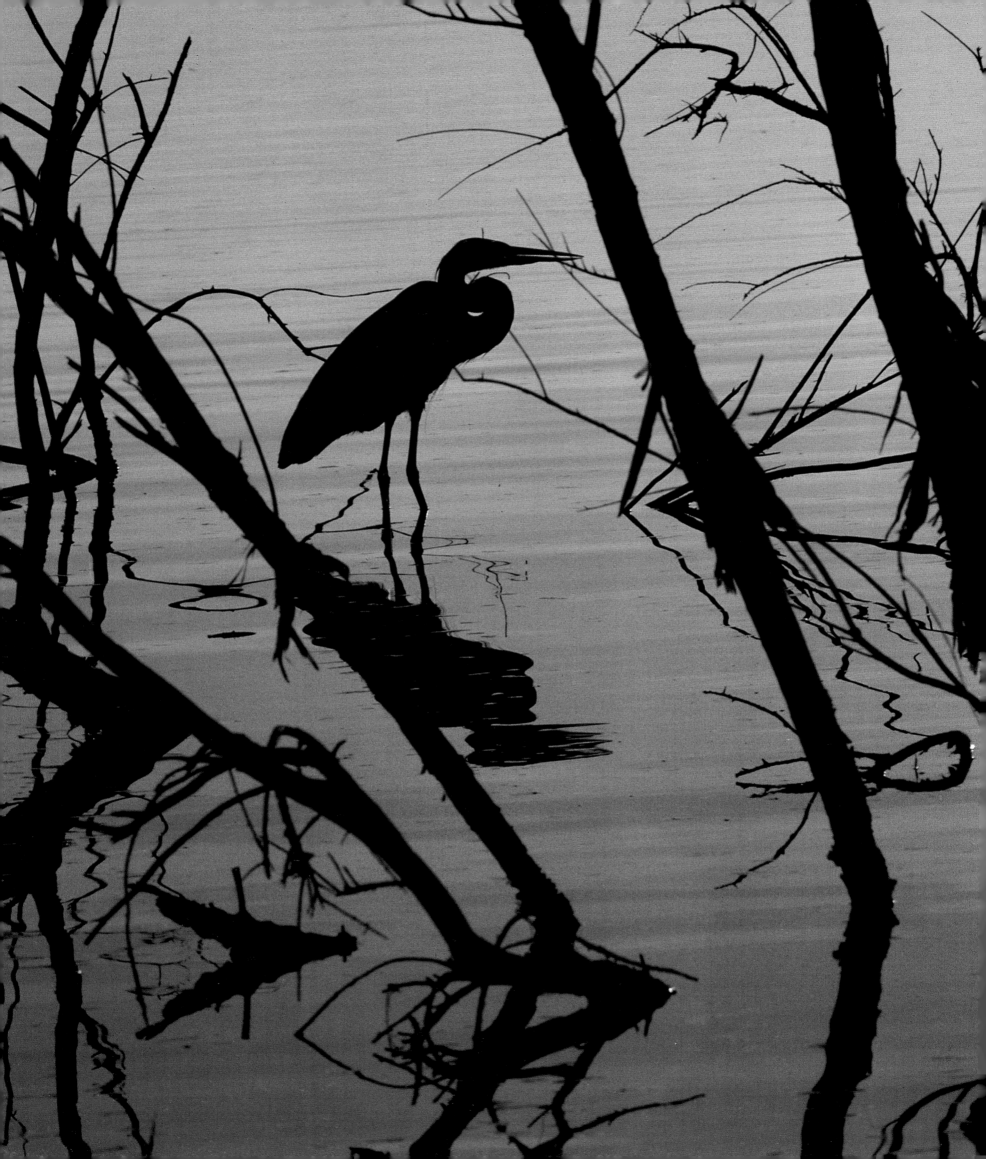

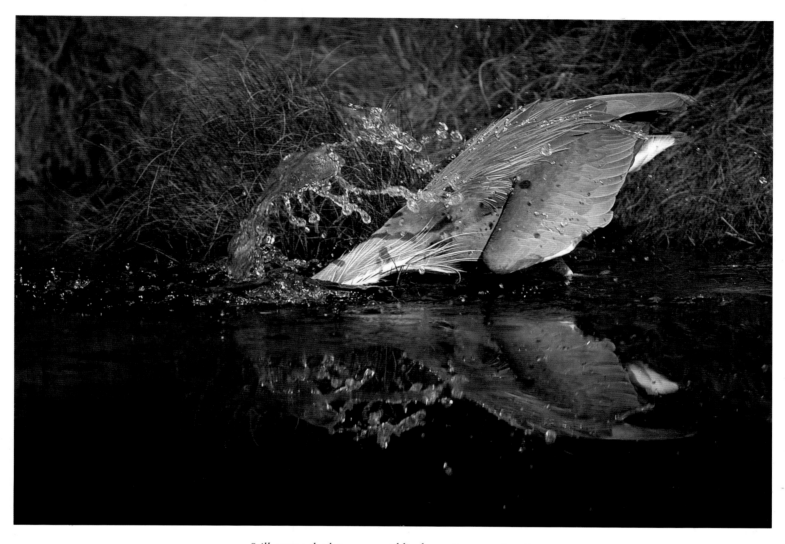

*Still as tree shadows, a great blue heron (OPPOSITE) waits
for a meal to swim by. When it does, the long neck
uncoils with a snakelike thrust to nab its prey, as
demonstrated by the heron above. Largest of the
herons, great blues can stand nearly four feet
tall, with a wingspread of six feet.
They range throughout the U.S.
and most of lower Canada.*

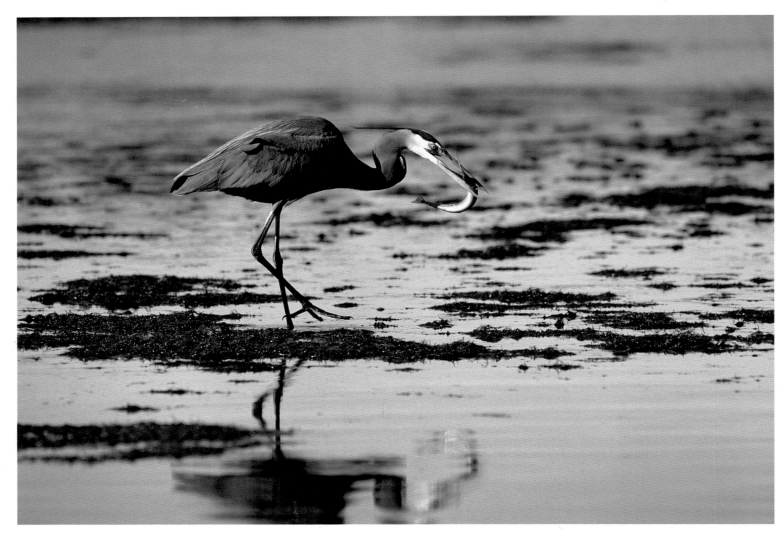

A wriggling catch will be swallowed whole by this great blue heron (ABOVE). Despite the sharpness of their beaks herons generally do not stab prey, but grasp them in a pincer hold. The little blue heron (OPPOSITE) is less than half the size of its larger relative and light enough to tread on water lettuce. Hunting methods are otherwise similar.

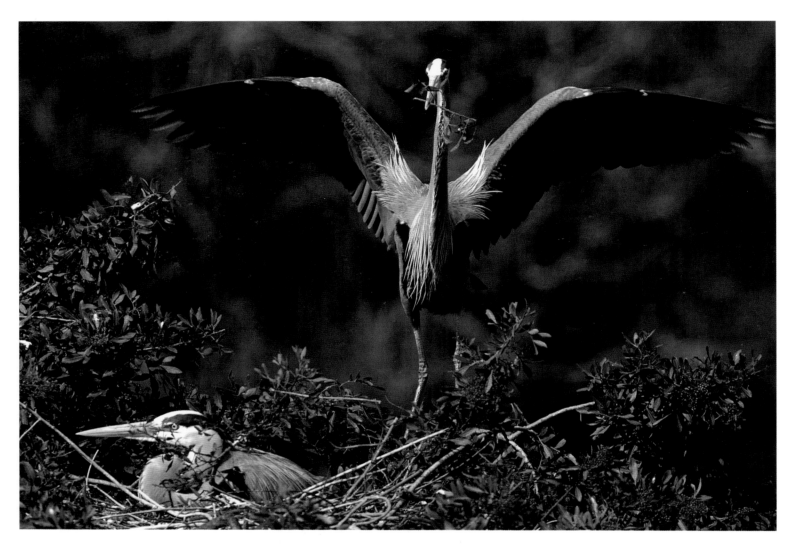

*Showing domestic responsibility, a great blue heron
extends a twig (ABOVE) for the nest his mate already
occupies near Venice, Florida. Great blues continue
such nesting displays even after the pair has bonded.
The youngsters pitch in too, as three nestlings
appear to be helping with a dry twig applied
in repairs (OPPOSITE). Clutches may
include as many as five young.*

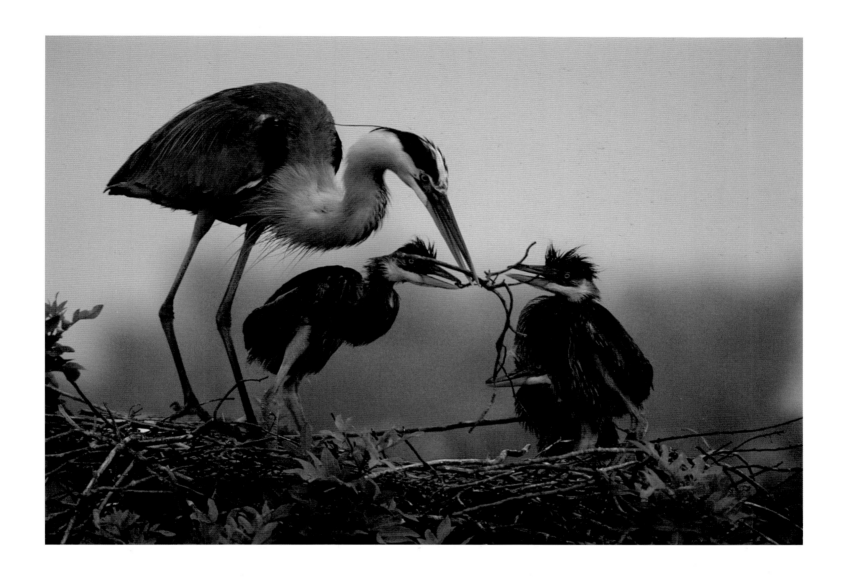

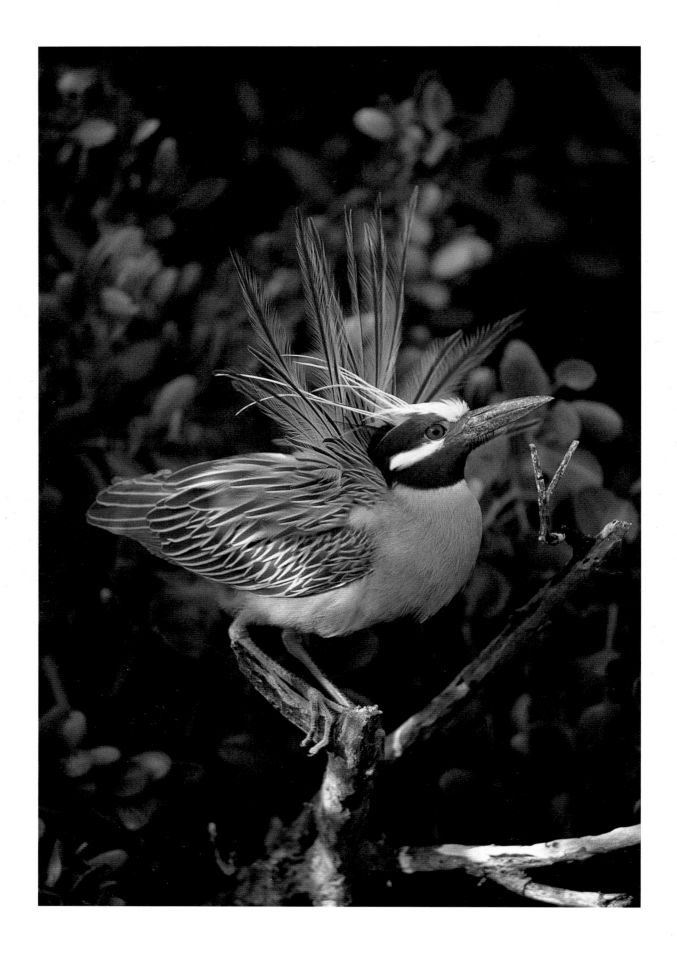

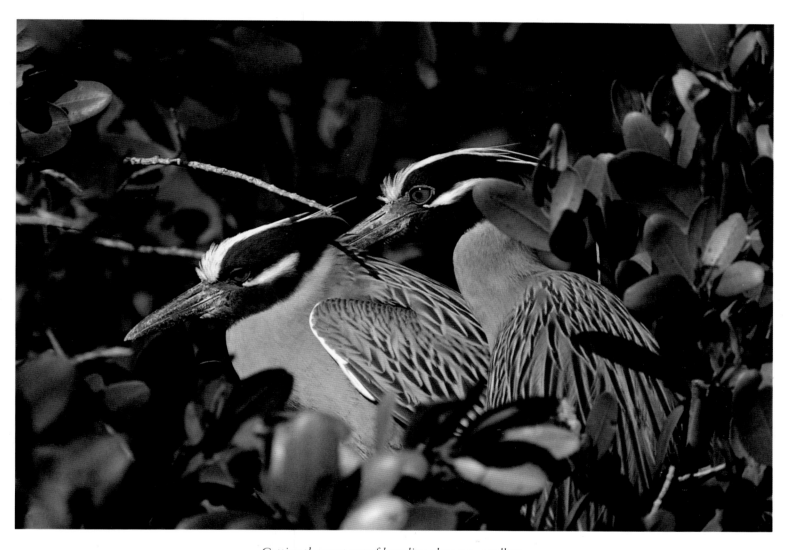

Getting the most out of breeding plumage, a yellow-crowned night heron (OPPOSITE) raises back feathers in courtship. Calling and clacking of the bill may also attract a mate, as one has managed to do here (ABOVE). The strong beak makes this heron a specialist in eating crustaceans, especially crayfish and crabs. Faint yellow atop the head barely qualifies these birds for their name.

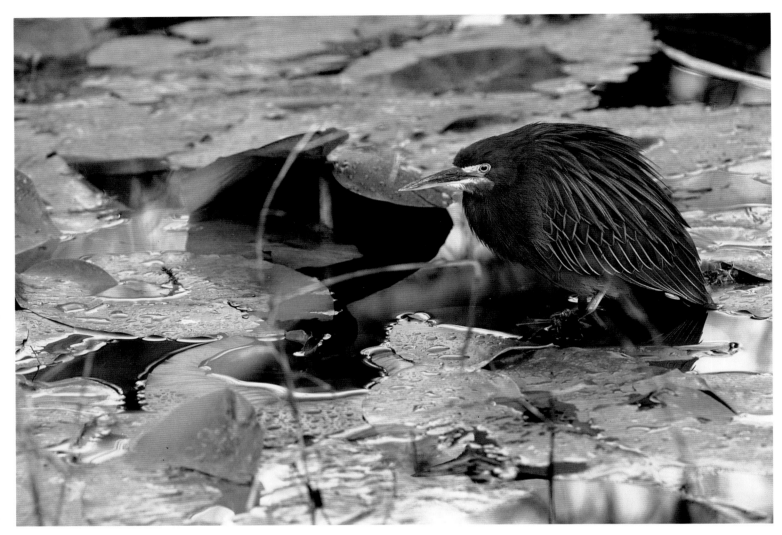

*Small among its kind, the green-backed heron takes on
a chunky look as it raises its back feathers in alarm or
excitement (TOP). Another (ABOVE) tackles a fish that
is more than a mouthful. Green-backed herons have
been seen casting bait to draw fish within striking
distance. At rest from fishing, one perches atop
a decapitated palm tree (OPPOSITE).*

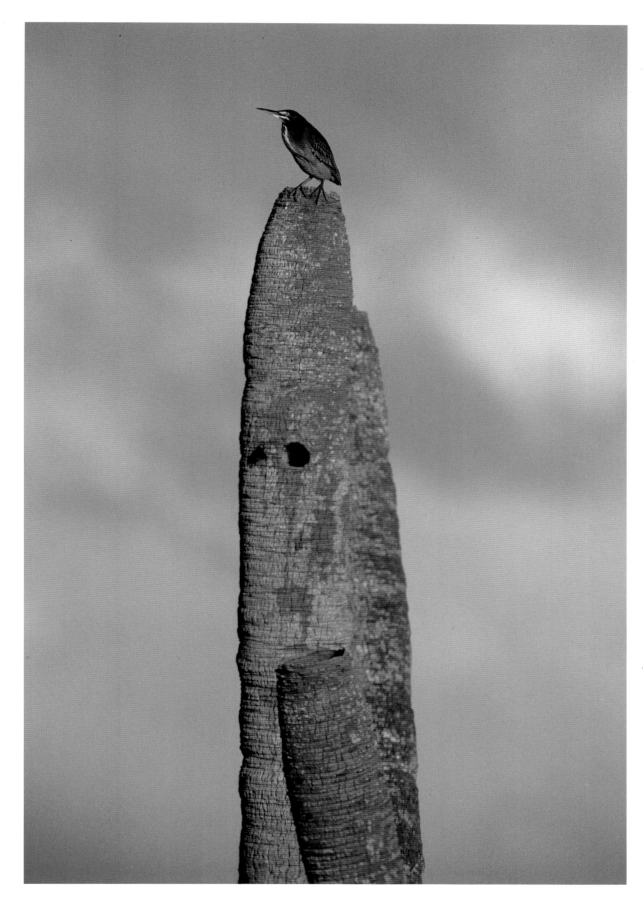

Sanderlings cluster just beyond the wavelets near Monterey on the California coast. On shorelines around the continent the little sandpipers snatch up mollusks and crustaceans exposed by retreating waters.

The demure look of the lesser golden-plover belies the prodigious journeys of this hardy traveler. Migration may carry it thousands of miles from Arctic coasts to Argentina or all the way to Australia. Marvels of efficiency, they may lose only two ounces of body fat in a nonstop flight from Nova Scotia to Venezuela.

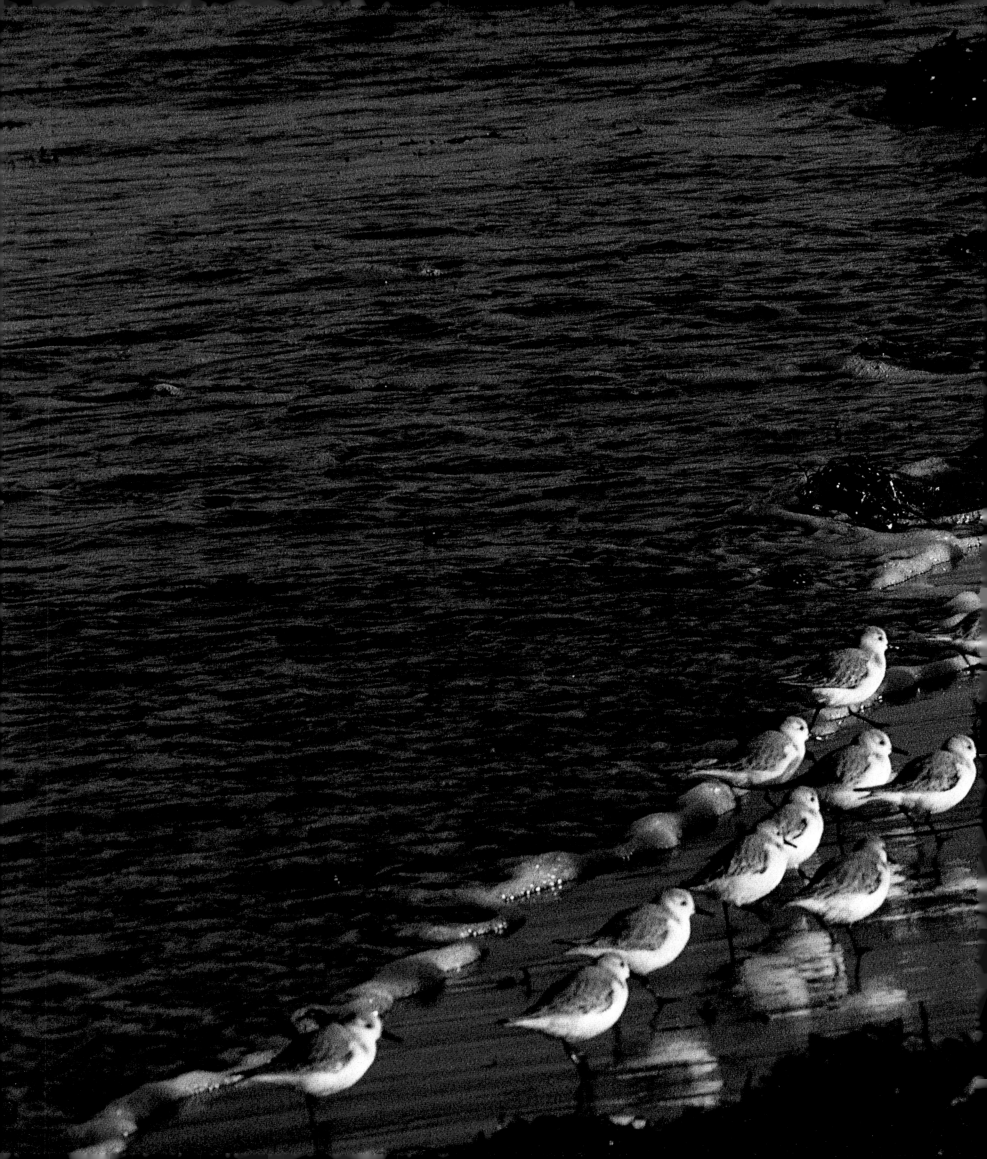

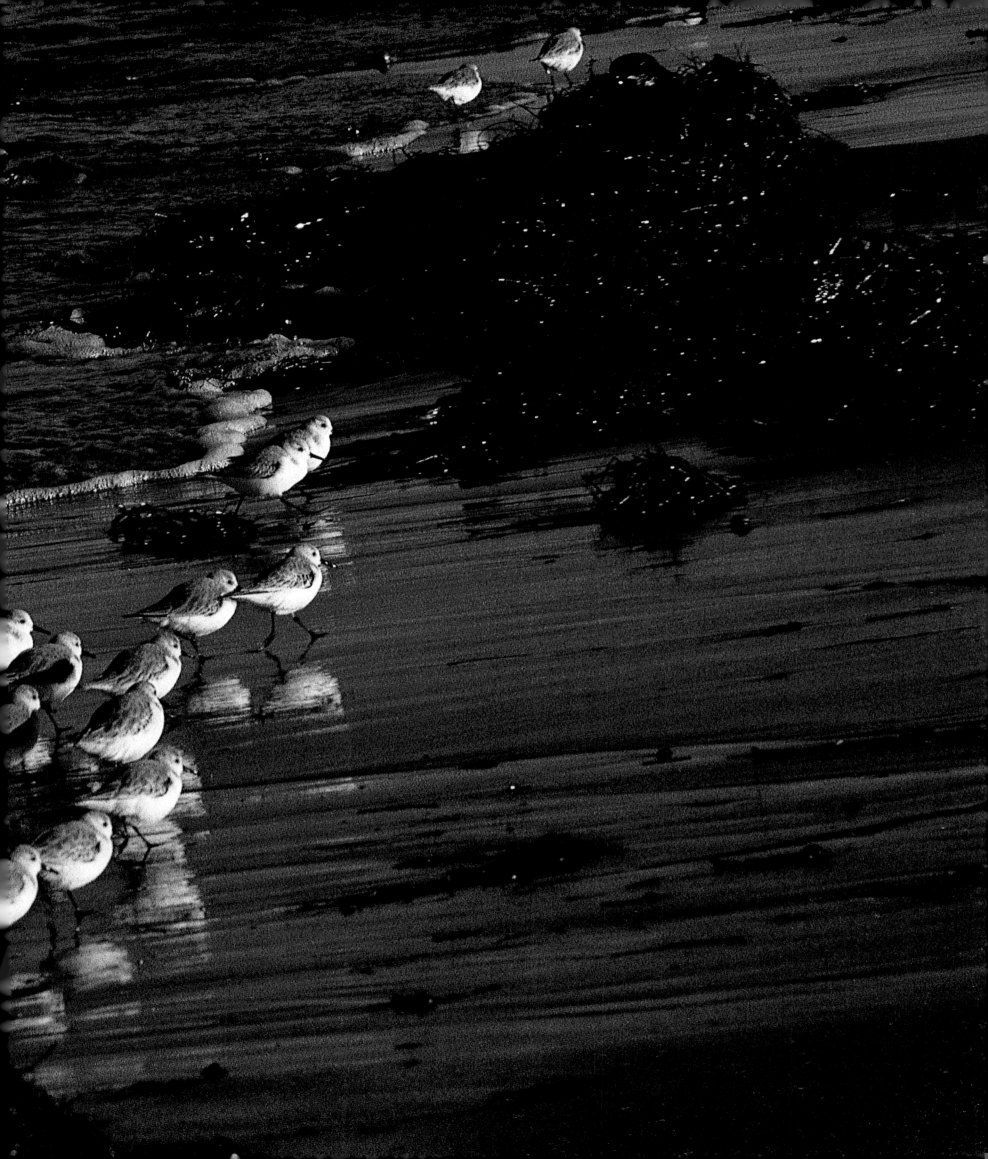

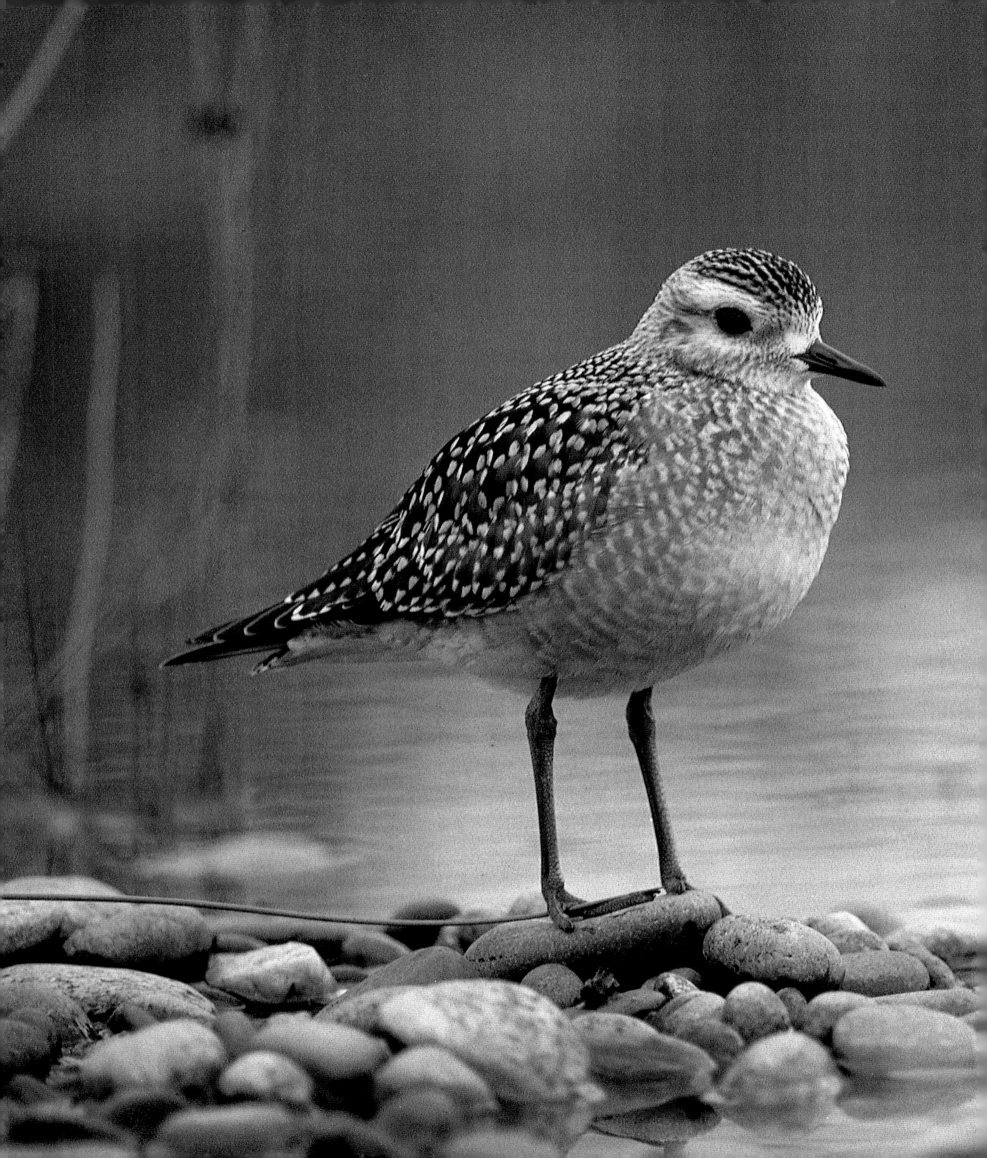

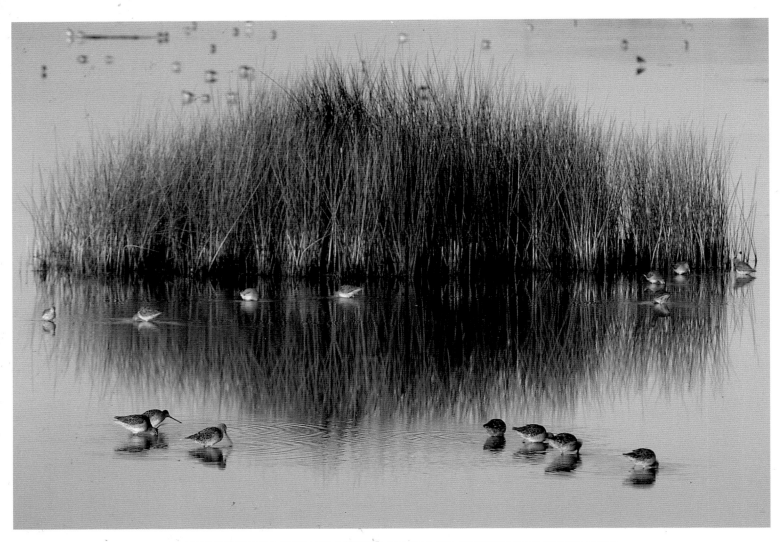

*Numerous shore birds may share a feeding area, their different
techniques and the length of their bills allowing food for all.
Short-billed dowitchers bob like sewing machines in Florida
shallows (TOP). The American avocet (ABOVE) sweeps its
sensitive, upturned bill through muck to detect
edible insects. To keep their flocks abundant, spotted
sandpiper females have several mates, letting males
incubate and care for the young (OPPOSITE).*

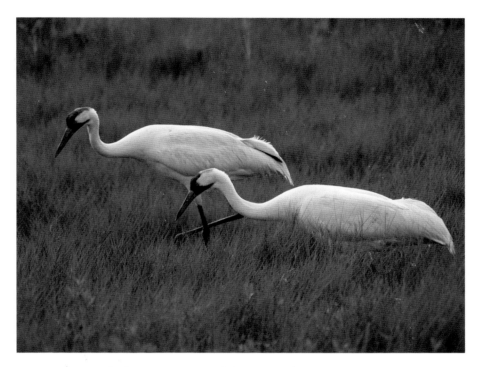

Neck-deep in grain a sandhill crane (OPPOSITE) keeps a wary
eye for intruders. Sandhills in migration congregate by the
thousands every year along the Platte River in Nebraska,
but habitat destruction has reduced their numbers from
earlier times. They are sometimes teamed as foster
parents with the much more endangered whooping
cranes (ABOVE). Both species are renowned for
their elaborate dancing, performed for courtship
and other social communication.

PAGES 182-183
In the ballet of flight a great blue heron carries a stick for
nest construction. Herons fly with long necks crooked
over their backs, while storks, cranes, and flamingoes
fly with necks extended. Great blue rookeries
often include hundreds of nests.

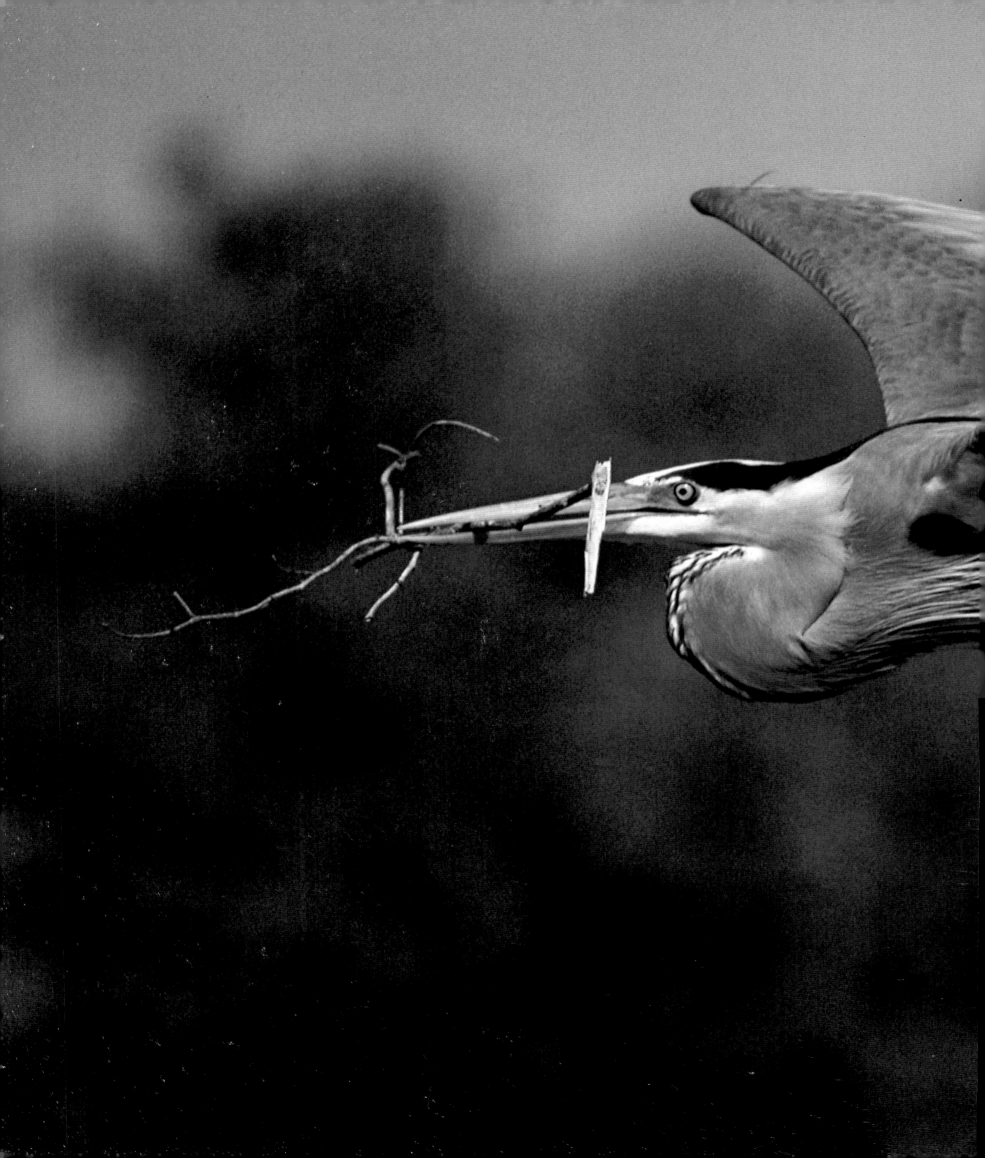

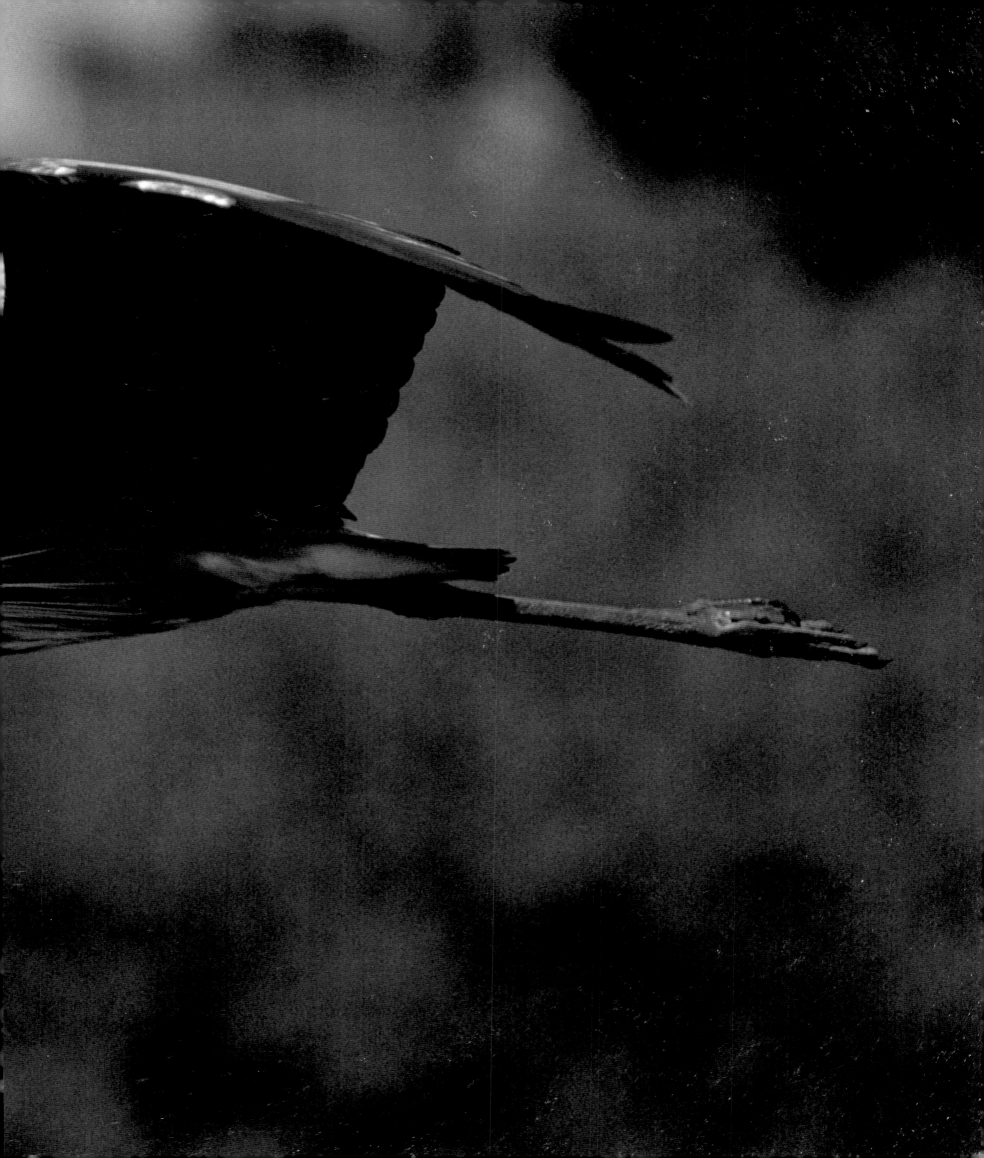

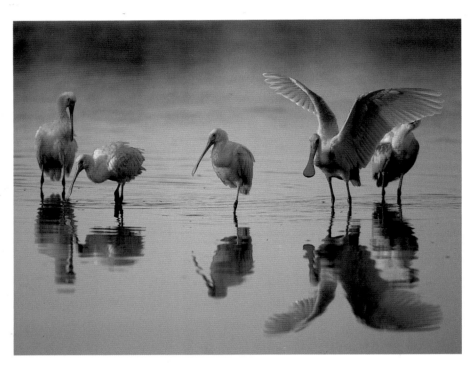

*To dish up its dinner, the roseate spoonbill (OPPOSITE) uses
its uncommon spoon-shaped beak. Swishing it back and
forth in shallows (ABOVE) the bird clamps it shut when
the bill encounters food, instantly sensing that
the unseen object is edible.*

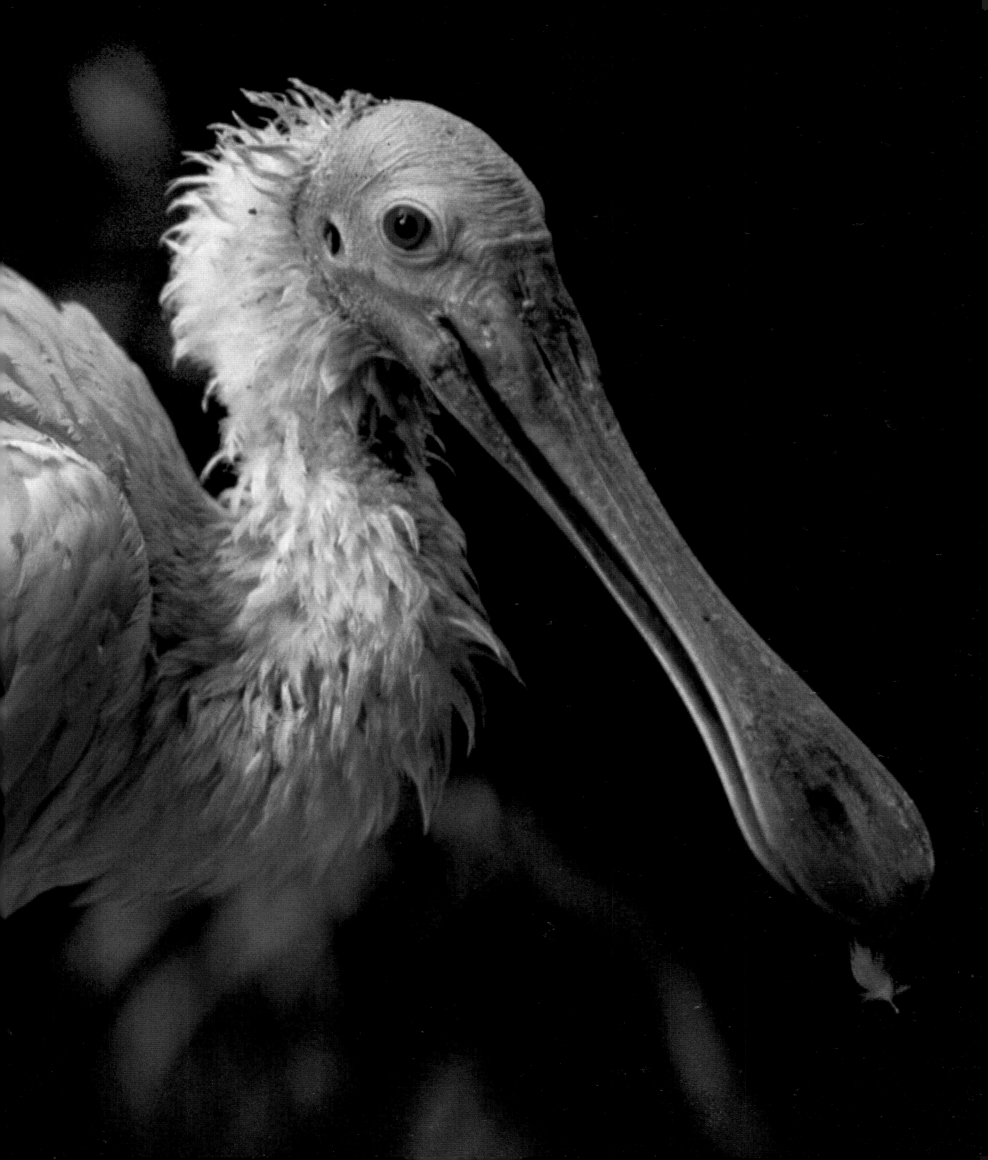

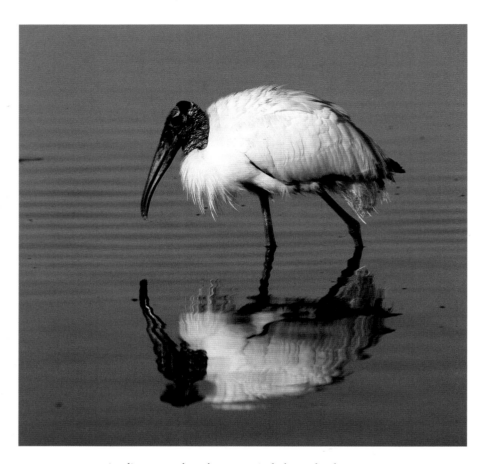

*A solitary wood stork tops a wind-sheared palm tree in
Florida (OPPOSITE). Plainness helped preserve these tall
waders when egrets and cranes were hunted for plumes
or food, but loss of habitat now threatens them too.
Feeding, they mostly probe water with
nine-inch beaks for fish (ABOVE).*

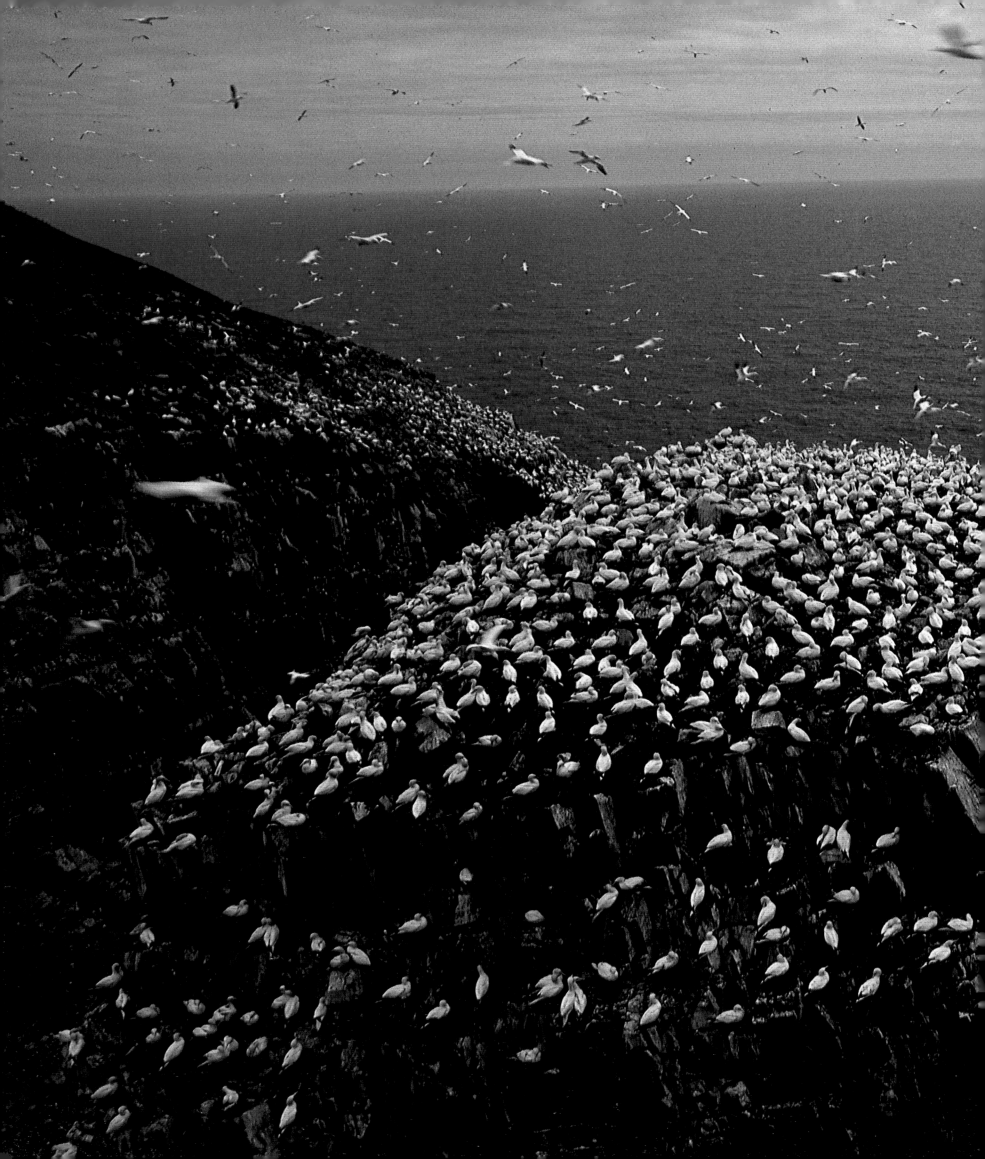

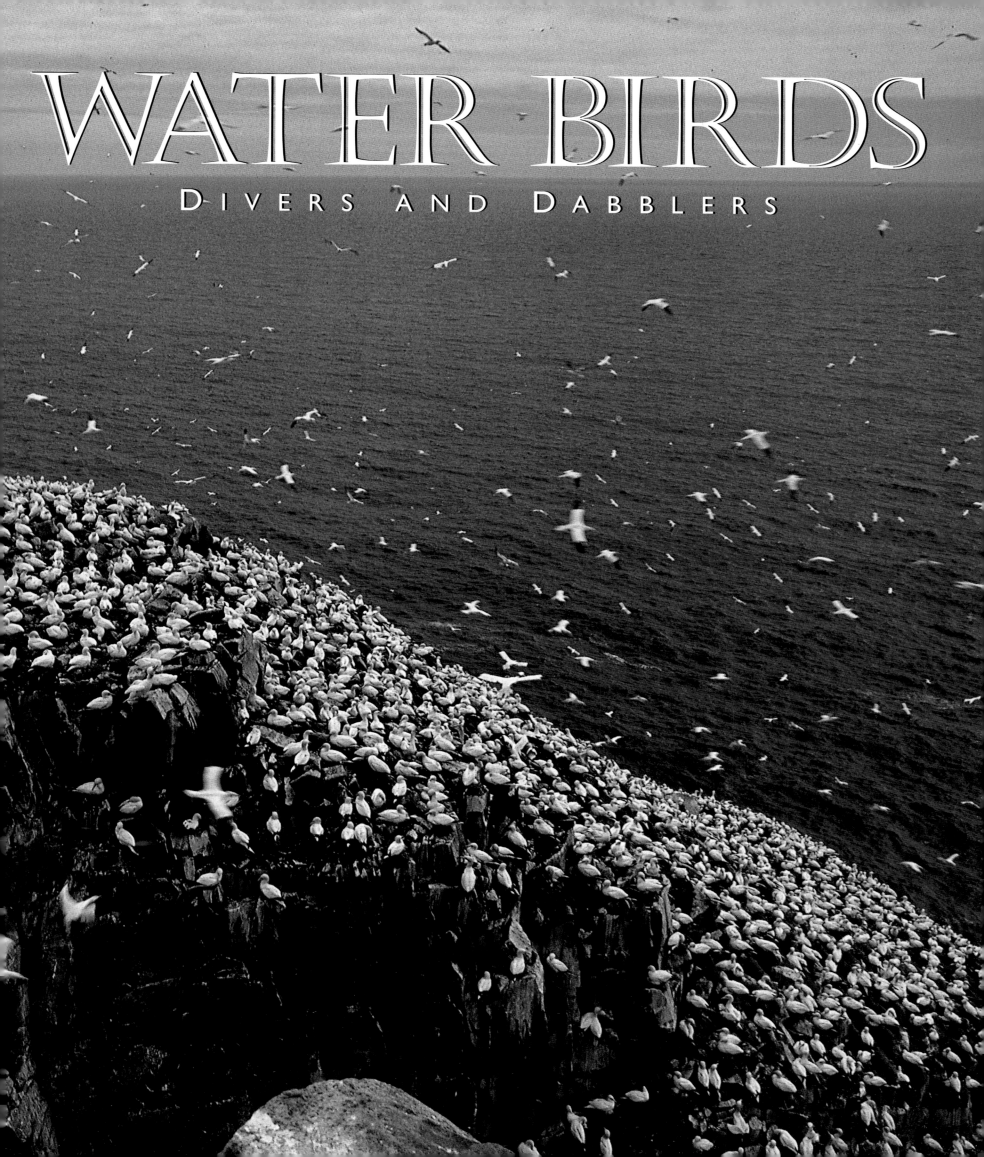

WATER BIRDS

DIVERS AND DABBLERS

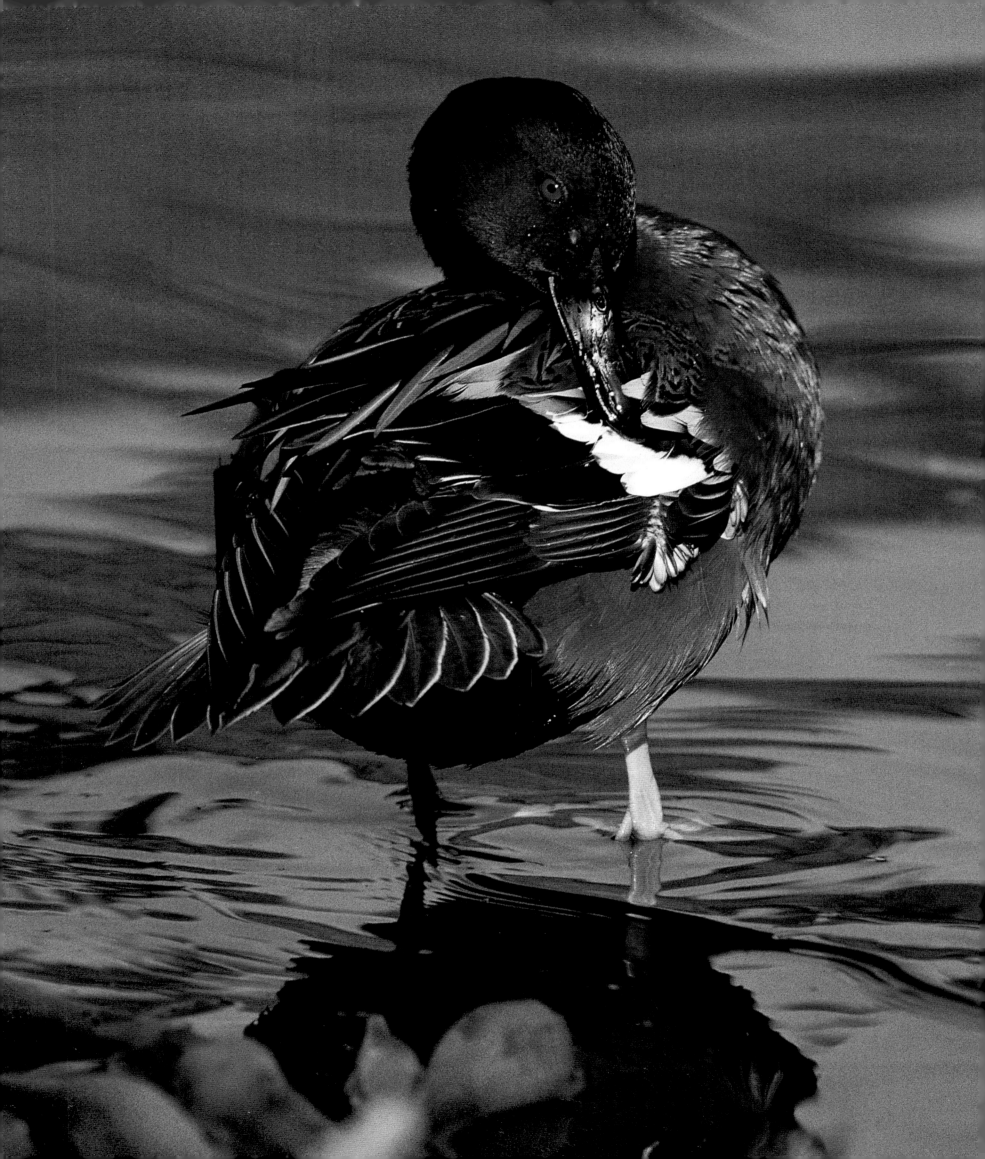

WATER BIRDS
DIVERS AND DABBLERS

ANY OF THE SEVENTEENTH-CENTURY English colonists in their first autumn at Jamestown were listless from hunger, and worried about having enough food to carry them through the winter. Sympathetic Native Americans brought them corn and bread, but help also flew in on the wing. "There came such abundance of fowles into the rivers, as greatly refreshed our weak estates," reported Captain John Smith, "whereuppon many of our weake men were presently able to go abroad." Fellow colonist George Percy noted that the birds "flew over our heads as thicke as drops of Hale; besides they made such a noise, that wee were not able to heare one another speake."

Strangers in a New World, the colonists had no way of knowing that they had settled in the largest estuary of the future United States, and the winter home for millions of ducks and geese. The James River on which they established their little town is but one of fifty rivers that empty into the Chesapeake Bay, a massive inlet 165 miles long with a surface area of 4,300 square miles. For millions of years those rivers have been carrying the Appalachian Mountains—once taller than the Rockies—particle by particle toward the sea, coughing them up in broad deposits of silt. In this rich mud grew marshes of wild rice, smartweed, bulrush, water hemp, and arrowhead. Seeds drop into the water in late August and early September, just in time for the arrival of "fowles" from the north.

Other large wetlands in North America also host huge clusters of waterfowl. Most of those wintering in the Chesapeake hatched in spongy plains of Canada. On the southwest coast of Alaska millions more hatch each spring in the water and marsh mosaic of the Yukon delta, larger than the state of West Virginia. Klamath Basin on the California-Oregon border, although drained to a quarter of its original size, still draws thousands of waterfowl to its shallow lakes and marshes bordered by grain-rich wheat fields. A 41,000-acre dent in the western Kansas prairie called Cheyenne Bottoms can sometimes host 200,000 ducks and 50,000 geese at a time, chowing down before continuing their seasonal migration. Those forced farther south

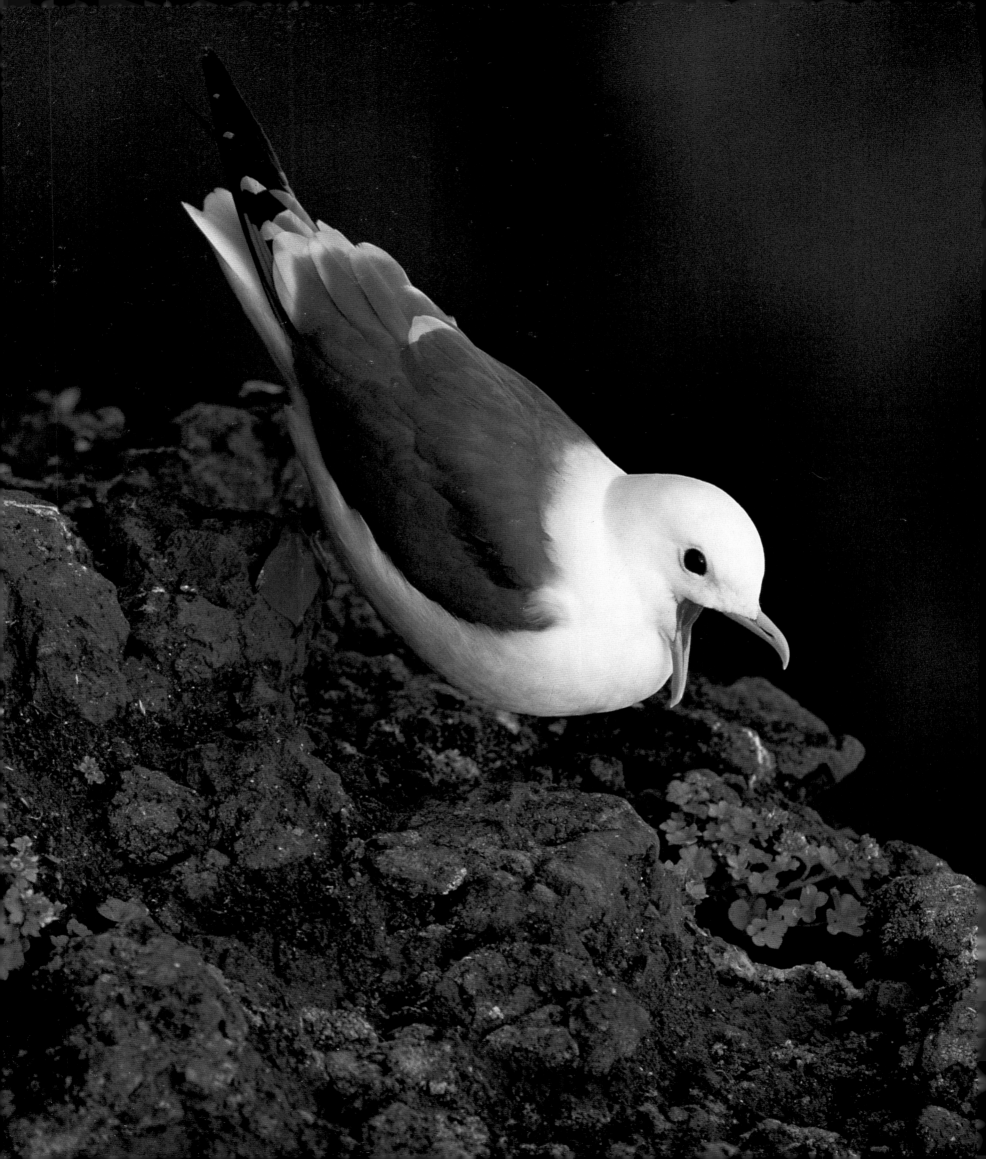

A red-legged kittiwake
sounds off in the Pribiloff
Islands of Alaska. Webbed
feet help it swim after
small mollusks and
crustaceans in the ocean.
Like many pelagic birds
it drinks seawater. The
excess salt, concentrated
in salt glands on top of
the skull, drips from the
tip of the bill. It nests
on the narrow ledges of
sheer cliffs.

by cold weather may end up in the vast fringe of marshes along the Gulf coast.

But for food availability and diversity of habitat, nothing beats the Chesapeake Bay. Midway between north and south, the salty and brackish waters stay mostly unfrozen in the coldest months, important to birds that would rather swim than walk, and that find much of their food on and under the surface. Thirty-seven species of ducks, geese, and swans have been identified in the Chesapeake, some of them dabblers that pick food off the surface or just beneath it, and others divers that completely submerge to feed on the bottom. Geese are dabblers, but mostly grazers that often waddle through a meadow alongside cows. For all, the big bay and the land around it provide a smorgasbord.

Waterfowl are more omnivorous than one might imagine, gobbling up not only plants but also water bugs, minnows, and dragonfly nymphs, or small snails, clams, and invertebrates. Biologists examining the stomachs of mallards in the Chesapeake found seventy-six different food items. One pintail contained snails and mollusks, plus seeds of buttonwood, poison ivy, and sweet gum. In the stomach of a scaup were found remains of a field mouse. Dining at the bay banquet is frenetic in fall, perhaps in anticipation of leaner months ahead. The stomach of one black duck contained 18,000 seeds of dotted smartweed. Geese have been known to gorge themselves to the point of fatal impaction when they choke on seeds piled up in their esophagus.

The intake rapidly becomes fuel or fat, for an animal that flies cannot afford to be weighed down by a bellyful of food. Even the button-size, hard-shelled clams snapped up by mallards are ground up in the gizzard and pass into the intestines within fifteen minutes. Divers such as the mergansers, dining mostly on fish, make stringier, stronger-tasting table fare. The prince of taste among the wild ducks is the canvasback, followed by the redhead. Both are divers, and so delectable that England's Queen Victoria, King Edward, and King George all had shipments of them delivered from America to their kitchens each year.

That hail of birds that passed over the heads of the early, starving colonists is now much reduced, and the mix somewhat changed. The tasty canvasback was once king of the Chesapeake, with millions of them rafting up in the rivers and inlets. For decades hunting pressure on these large ducks was enormous, rivaling the mass destruction of the passenger pigeon. Market hunters at the turn of the century mounted large-bore swivel guns on the bows of boats like small cannons and blasted at the canvasbacks as they huddled together at night. Battery guns—eight or ten barrels arranged side by side in a fan-shape—were fired simultaneously and raked the water with wide crescents of shot, and shrapnel—nails, bolts, screws. Bags of 100 ducks in a night were commonplace, not counting the wounded that fluttered away to die. One hunter in the 1846-1847 hunting season took 7,000 canvasbacks.

The declining numbers were viewed with alarm, and laws curbing the slaughter were passed in 1916. By then a new threat to waterfowl had begun—the loss of habitat.

PAGES 194-195
Primeval pose of the
anhinga allows its feathers
to dry after a dip. Like
cormorants, but unlike
other submersibles that
protect themselves with
waterproofing oil, the
tropical bird opens its
plumage while in the
water so it will lose
buoyancy. Sodden,
it rides low in the
water while
swimming on
the surface.

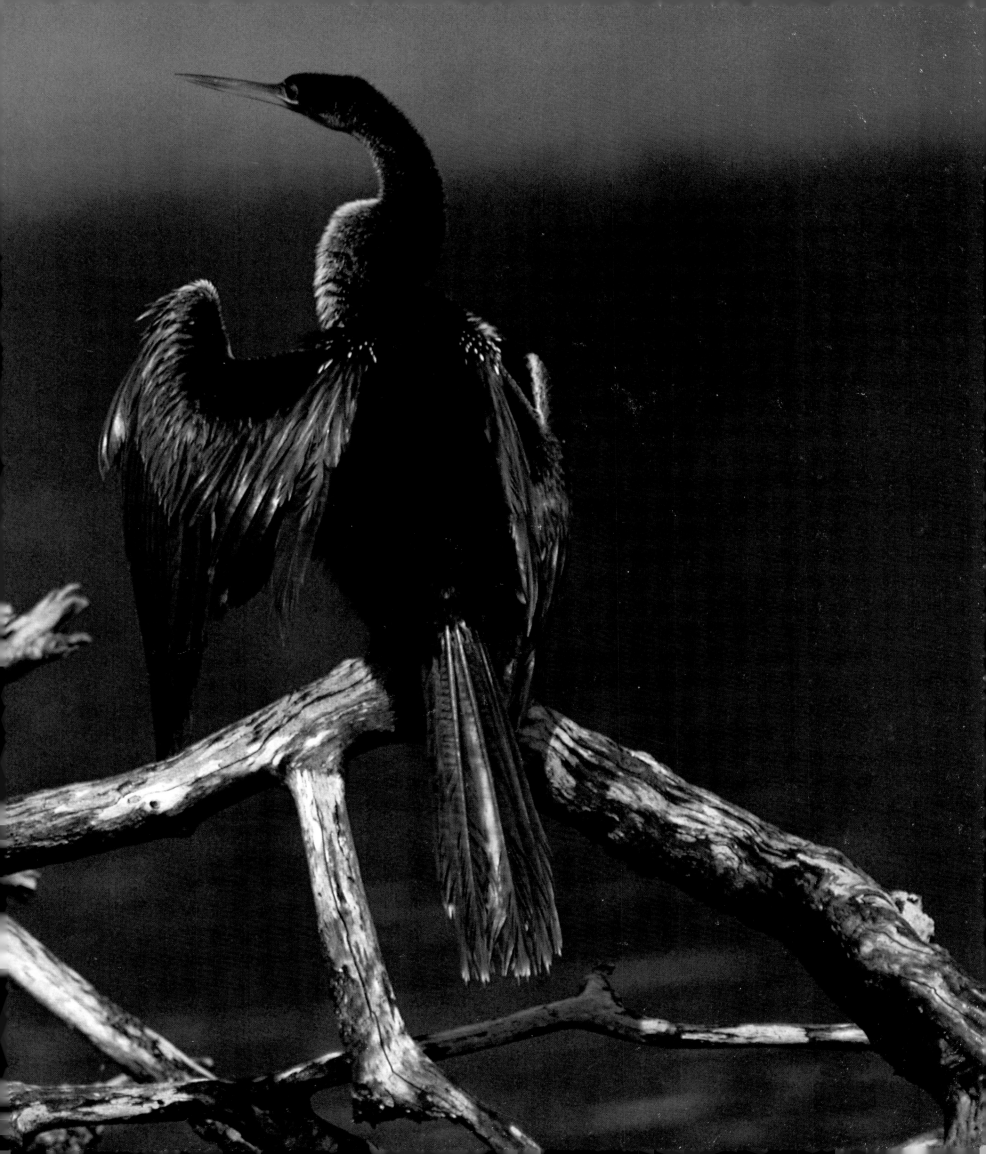

Hundreds of small ponds known as the prairie potholes, nesting nooks for ducks in spring, were drained for agricultural use in Iowa, Nebraska, Minnesota, the Dakotas, and Canada. Then the droughts of the 1930s rolled in and temporarily dried up many that remained. Canvasback populations have never recovered from the combined effects of overhunting, habitat destruction, and drought.

Replacing the big duck as the number one target of Chesapeake hunters was the Canada goose, the fat bird that can feed a hunter's whole family. For a time Canadas proliferated in the bay along with farmers, since the honkers love the bonanza of grain that modern harvesting machines leave on the ground, or the green shoots found in an open pasture or a winter wheat field. Alas for popularity. In the past quarter century goose hunting has become a big industry around the Chesapeake and the high harvest, along with low production in northern nesting areas, now threatens the numbers of the migratory flocks. Resident flocks remain abundant. For several years U.S. Fish and Wildlife wanted to shut down the season on Canada geese, but as one official said, "There was a lot of pressure to keep it open; goose hunting had turned into a $40 million business in the bay area." In 1995, for the first time, fall hunting of migratory Canada geese in the Atlantic flyway was banned.

Snow geese, less predictable and therefore harder to hunt than the Canadas, have prospered in recent years. Lesser snow geese, principally in the western states, are increasing so rapidly that biologists fear they may eat themselves out of northern nesting grounds and suffer a population crash. Duck numbers have also climbed upward. The combined populations of the top ten hunted migratory waterfowl in the central states of America in 1995 were estimated at 80 million birds, compared to 52 million in the mid-1980s.

Perhaps, some game officials speculate, populations have always cycled over the centuries as numbers that were periodically cut by drought and disease eventually rebounded. Unfortunately, we have become an added hazard in those cycles, less by hunting the birds than by crowding them out of their habitat. The "abundance of fowles" noted by the early colonists has been replaced by an abundance of people. Humans now outnumber the wild ducks and geese on the continent of North America.

Moving about in flocks, ducks and geese are our most familiar waterfowl, particularly on fresh water. At the ocean we expect to see hordes of gulls, which we call seagulls despite the fact that many of them nest inland. Perhaps because of their great numbers, perhaps because the many species seem similar, most of us find it difficult to differentiate between these broad-winged soarers. We often fail to distinguish them from the more streamlined terns that plunge into the water instead of picking tidbits from the surface as gulls do. It may be a case of too much familiarity. More adaptable than many modern birds, gulls are actually on the increase in North America. It would be difficult to crowd them out of habitat because they are not territorial (except when nesting) and find food almost anywhere.

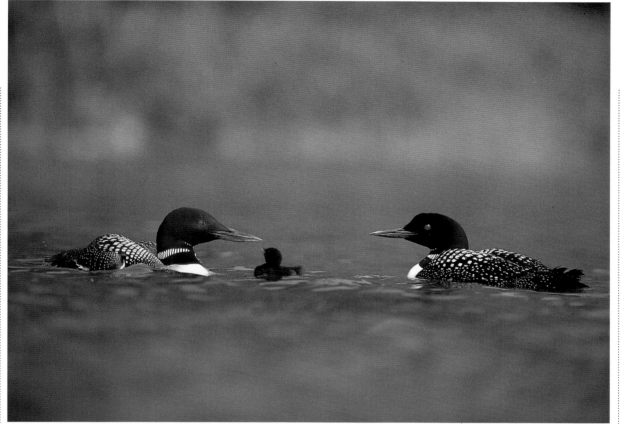

A common loon chick begs for food from an adult. Some distance from their nest, its parents establish a nursing pool of still, shallow water rich in small fish, frogs, and insects to feed their young. Acid rain affecting aquatic life has been partly blamed for declining loon populations in the U.S. in recent years. In their first week the chicks often ride on the backs of their parents.

For other birds of the water, a kaleidoscope of adaptations helps them pursue their preference. Many diving birds wear built-in goggles. While all birds have the third, transparent eyelid that cleans and protects the eyeball, the nictitating membranes of most diving birds also have built-in "contact lens" that improve vision underwater. Water bird bills take on a variety of shapes and uses. The most unusual is that of the pelican, which despite the rhyme saying that "its mouth can hold more than its belly can," uses it to catch fish, not store them.

As the pelican dives into the sea a throat membrane between the two sides of its lower bill balloons into a net that envelopes fish seen near the surface. High-diving relatives in the order Pelecaniformes are the boobies and gannets, which plunge straight down from a height of 100 feet, raising a spume sometimes twelve feet high. Unlike the pelicans, they continue to swim after they enter the water and grasp fish at depths up to thirty feet, using sharp bills with serrated edges to hold the squirmy prey. Puffins, a kind of auk, with their parrotlike beaks make more multiple catches than pelicans with their bill baskets. The little clown-faced seabirds manage to retain one small fish in their bills while snatching another, and another, and another, until six may be seen dangling neatly from their mouths.

Water bird legs and feet are often distinctive. The balance of most bird bodies is set for flight, placing the center of gravity around the wings, not directly over the legs. For the water birds, however, a far-back positioning of the legs becomes an advantage in thrust as the churning feet propel them forward.

Most swimmers have webs between three toes, but those of the order Pelecaniformes have webbing on the fourth hind toe, giving them extra push. The legs of divers are set back even farther than those of the dabblers.

Feathered torpedoes like the cormorants and their relatives, the anhingas, pursue fish underwater. Once close to prey, their flexible necks allow a final, snakelike thrust for capture. The beaks of cormorants are hooked at the end for grasping, while anhingas may be the only dart-beaked birds that regularly spear their food. Surfacing, they toss it up to catch and swallow it, after a dive that may have lasted a minute and a half.

How can these divers stay submerged so long, with part of that time in high-speed chase, when for most of us a half minute underwater is an eternity? While underwater, many diving birds actually ration out their oxygen to tissues that might be damaged without it. They also slow down their usual high metabolism so less oxygen is required, and in a pinch they can borrow oxygen stored in dark pigments found in the blood and muscles.

As always, there are trade-offs for some of these swimming advantages. Webbed feet and set-back legs may be great underwater, but most diving birds stumble about clumsily on the ground or in low tree perches. Loons and grebes cannot be said to walk at all, but only push themselves around on their bellies. When occasionally at night they mistake a rain-wet pavement for water and land on it, they are grounded unless they can slither to a nearby stream or lake.

Some diving birds have also sacrificed that long-evolved bird advantage—weight loss. Unlike the hollow, strutted bones of most birds, those of divers are more solid. Rather than trying to shed water, cormorants actually open their feathers just before a dive to lose

buoyancy. When anhingas surface after a dive, soaked, they lie so low and heavy in the water that only their flexible necks can be seen moving forward and back in time with their thrusting feet, giving them the nickname "snakebird." Wet to the skin after diving, both cormorants and anhingas find a perch and open their wings, standing like a crucifix to dry off, perhaps both to warm themselves and to lose water weight so they can fly.

Take-off from the water for most divers requires a gathering of speed and a pattering of feet on the surface until sufficient momentum is achieved. Loons require an eighth of a mile to get airborne, although once there, a streamlined shape places them among the swiftest of birds. Tom Klein, author of the book *Loon Magic*, says the pilot of a small plane once watched a loon pass him and estimated the bird's speed at 100 mph.

Perhaps no other bird is associated more with wild, natural places than the loon, although if not greatly disturbed, they can learn to tolerate a benevolent human presence. They continue to nest along the Boundary Waters of northern Minnesota and Canada despite being passed by some thousands of canoeists each summer. Vacationers in lakeside houses can thrill to the ghostly calls of the loon as long as they grant privacy to the nests.

The goose-sized common loons are captivating with their blazing red eyes and charcoal heads that look sculpted from marble. But it is their mysterious calls in the stillness of evening that haunt anyone who has ever sat around a northern campfire or snuggled deep into a sleeping bag by a

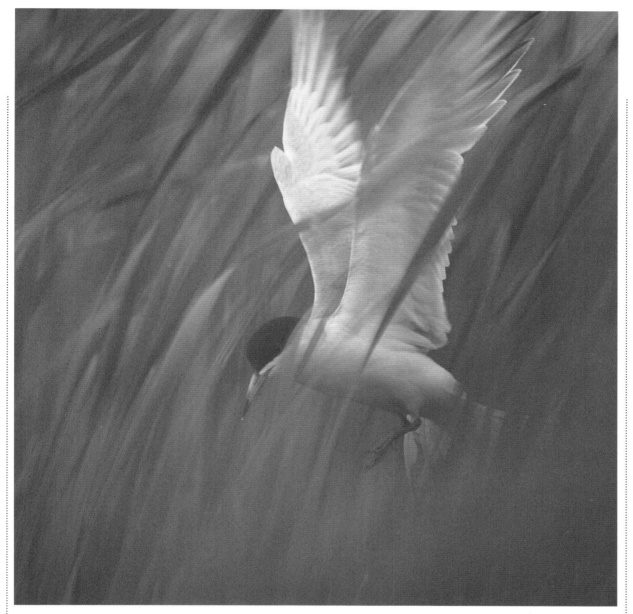

Into an ocean of green a Forster's tern descends toward its nest in a marsh. Unlike many other coastal birds that raise young on cliffs and sandy beaches, Forster's often moves far inland to breed and nest. There it may share space with a yellow-headed blackbird, take over the nest of a western grebe, or nest atop a muskrat mound.

pewter lake. Of the tremolo call of the loon the writer John McPhee has said, "If he were human, it would be the laugh of the deeply insane." The maniacal yodel is a territorial warning that can raise the hair on the back of your neck. The wail, when heard late at night when all else is still, can be one of the loneliest and loveliest sounds in nature. It is a sound in jeopardy as loons struggle to hold on in their northern habitat. While not officially listed as endangered, they are under pressure from chemical pollution, loss of nesting habitat, and predators such as raccoons that have increased because we

eliminated the larger predators that once held them in check.

The cries of birds everywhere put their mark on a place, a season, a way of life. The honk of geese overhead signals the arrival of autumn, the trill of the red-winged blackbird authenticates the arrival of spring. The mewing of gulls mingles with the slap of waves in the sea, and the cry of the loon tells us that some of the wild places still remain. They are all feathered emissaries to a natural world we once knew as intimately as they, and reminders that we must never let it completely disappear. If we lose the loons, can the Earth be far behind?

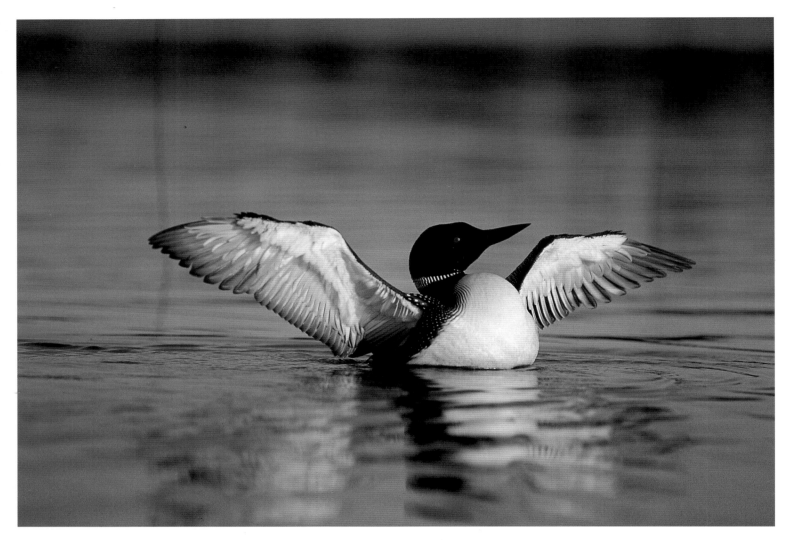

*A common loon in heraldic pose (ABOVE) announces its
territory with a yodeling call that is often described as
ghostly. A red-throated loon nest is located near the
water (OPPOSITE), for this excellent swimmer is
ungainly on land. Boats passing close to a nest
may flush the incubative bird, leaving
eggs accessible to predators.*

PAGES 202-203
*Putting their wild signature on a northern waterway,
a pair of common loons glide through a grassy lake.*

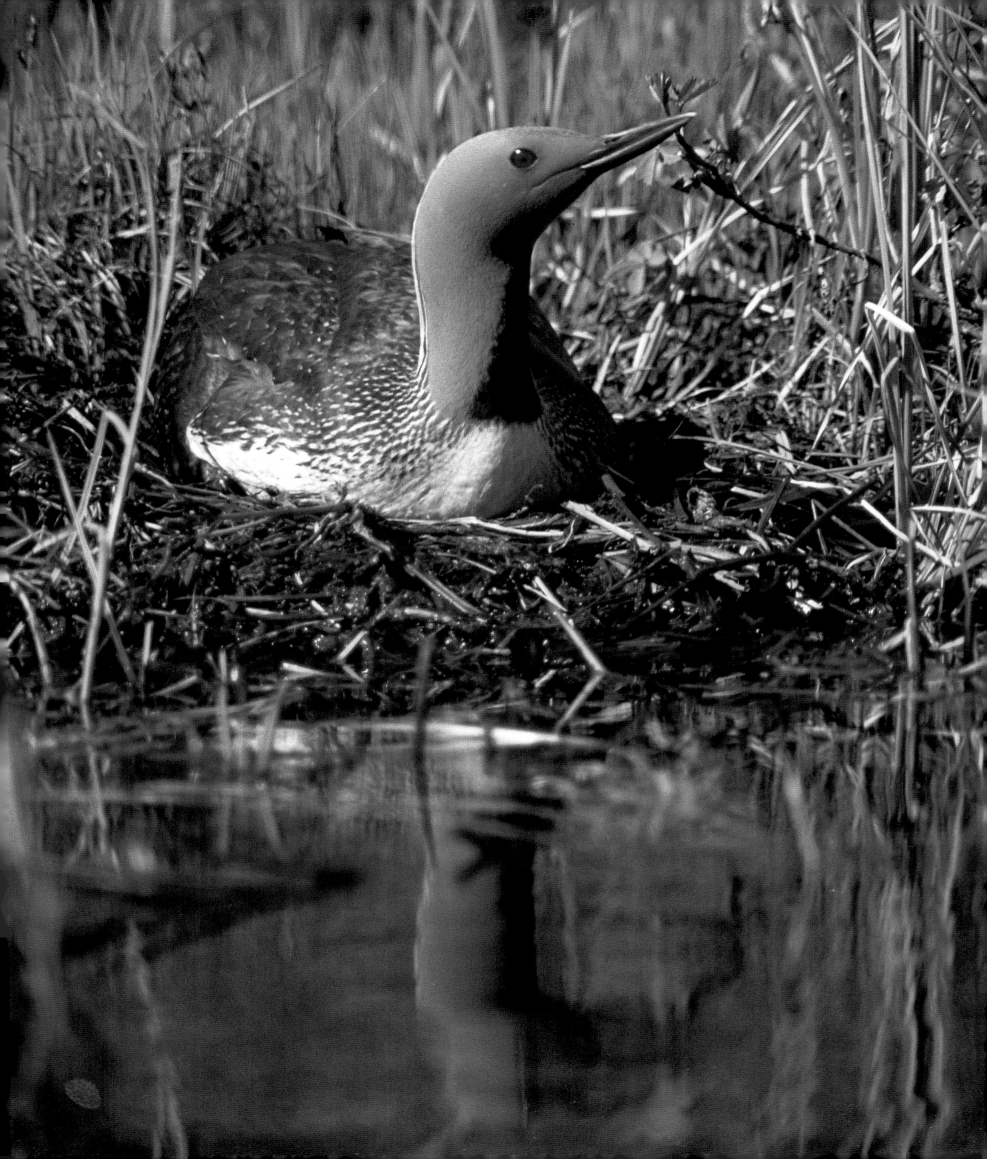

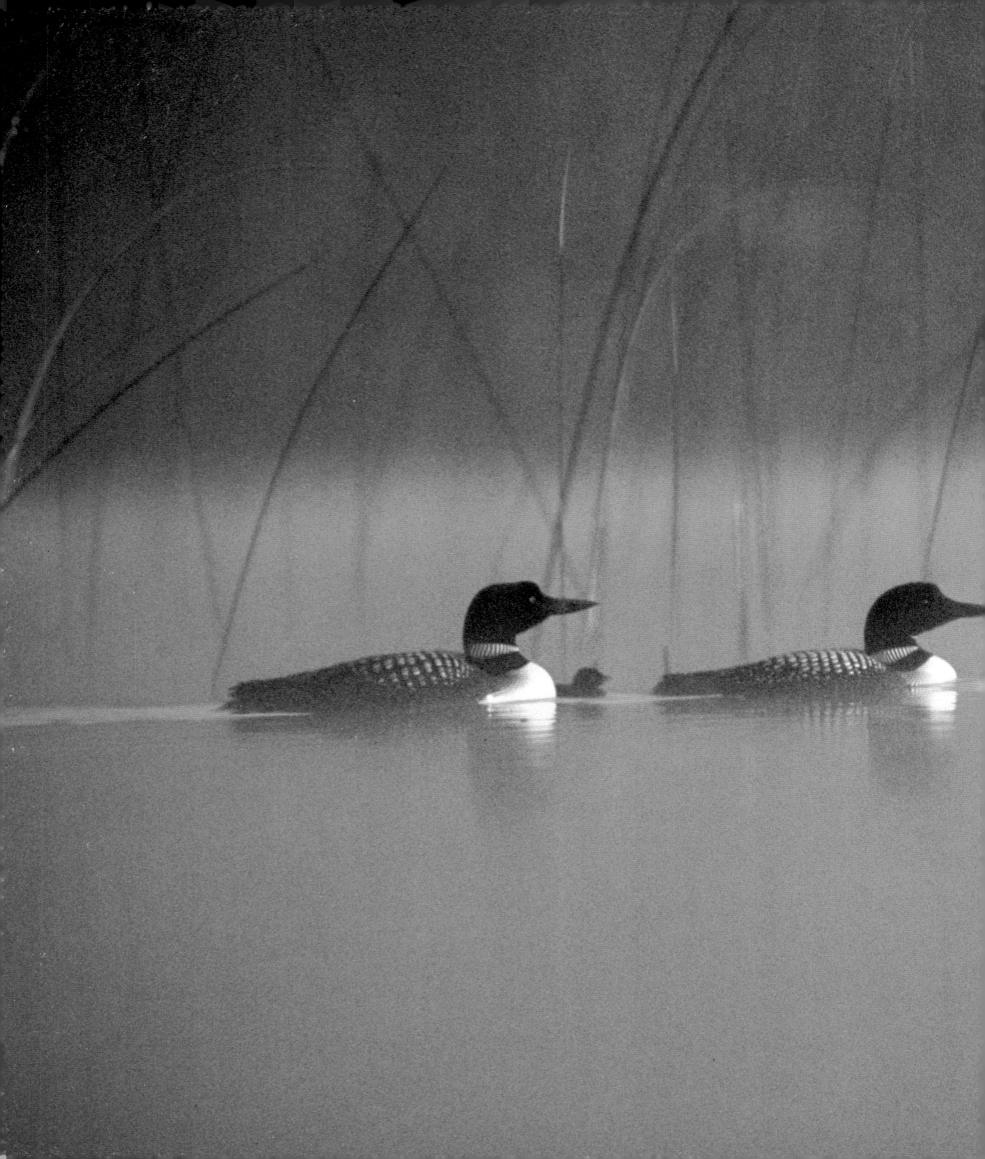

"Thin as a rail" could apply to the Virginia rail, a bird whose narrow physique allows it to slip through dense marshes. One seldom sees this secretive fowl, and if flushed it flies weakly for a few yards and then settles back into the dense vegetation to sneak away on long-toed feet. A nasal call like descending laughter may mock your attempts at another glimpse.

*A common bird, uncommonly seen, the sora frequents
marshes throughout the U.S. and Canada but seldom
shows itself. Like other members of the rail family it
seems a poor flyer, yet often migrates in winter to
South America. Returning north it builds a nest
domed with bent-over vegetation. If pressed, it
can dive and swim underwater, adding
to its elusive ways.*

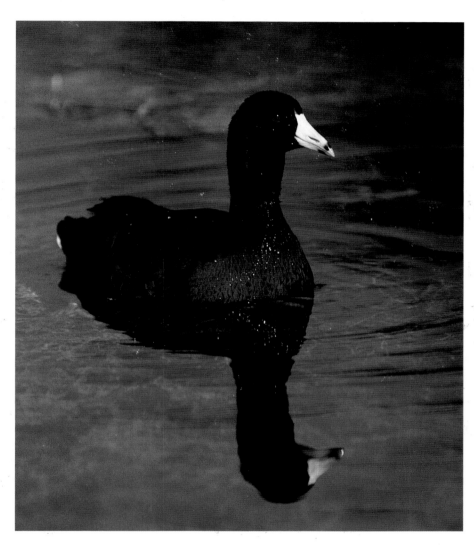

Disguised as a duck, the American coot (ABOVE) is actually a rail. With toes that are lobed, not webbed, it can dive and swim underwater to bring up submerged vegetation, or it may let ducks do the work before stealing choice morsels from them. Coots also forage quietly in the shallows, like these two in a Utah marsh (OPPOSITE).

PAGES 208-209
Seagulls they may be, but ring-billed gulls nevertheless often range far inland, like this squadron over Montana. Farmers in the United States and Canada are happy to see them, for they eat crop-damaging insects such as grasshoppers and follow tractors to gorge on upturned plant-eating larvae.

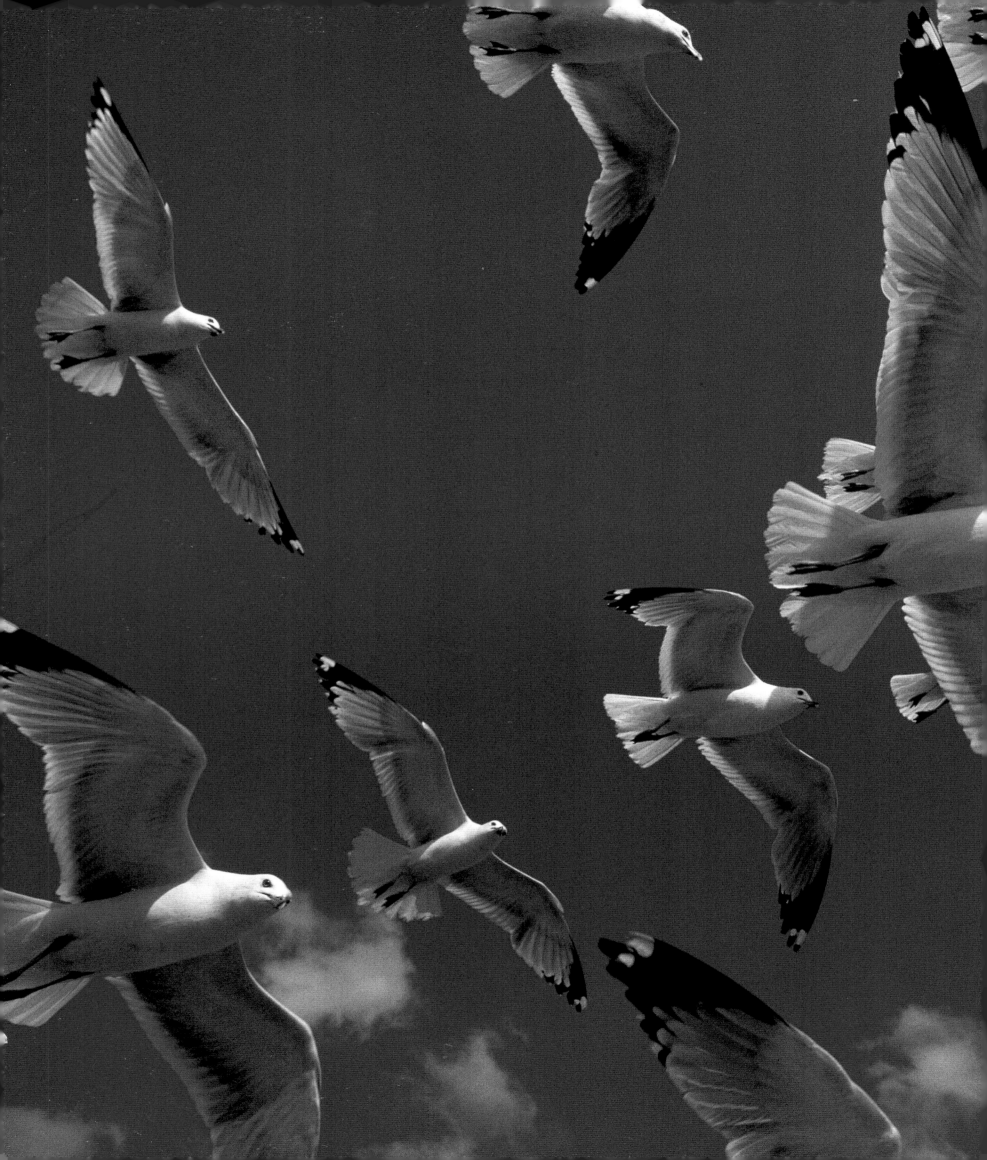

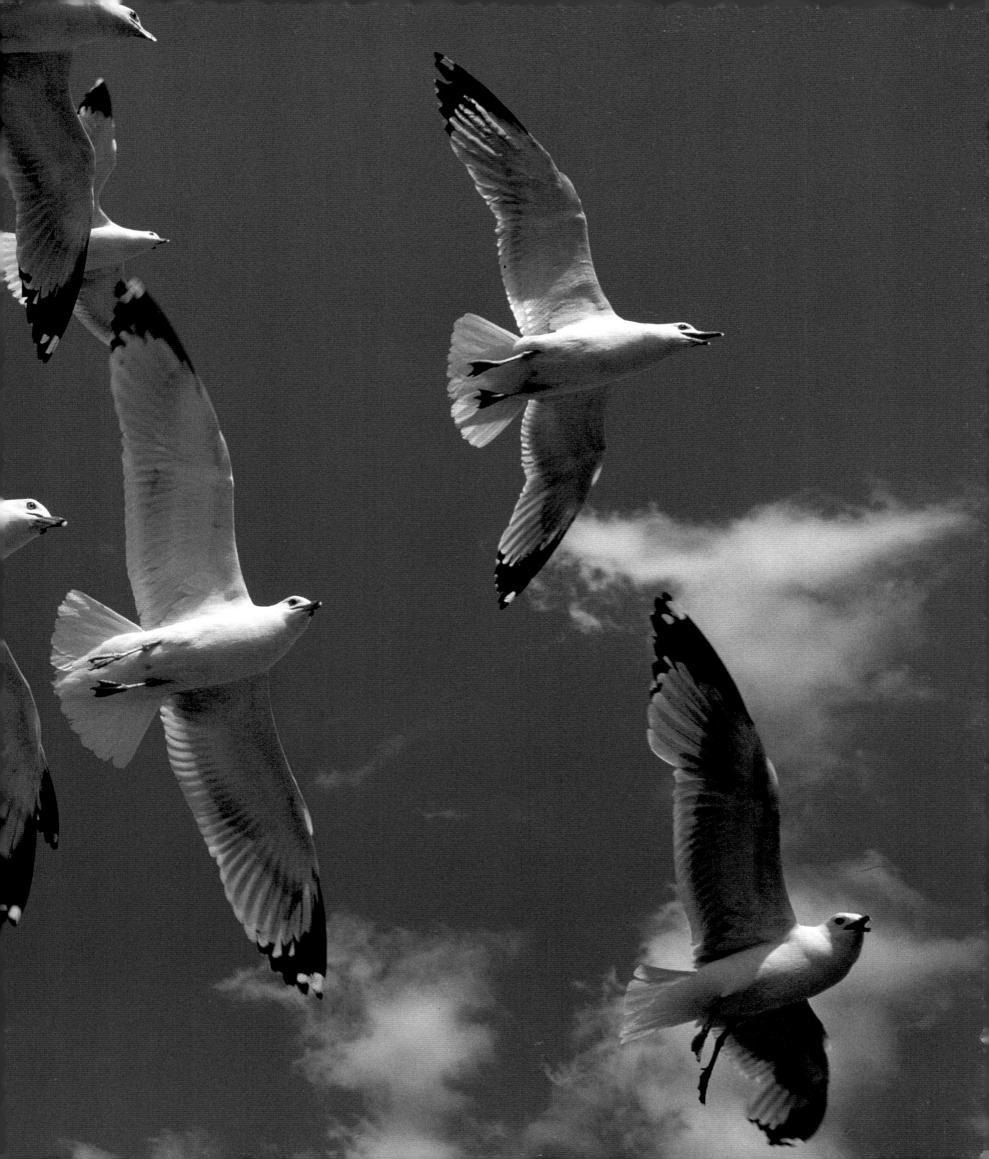

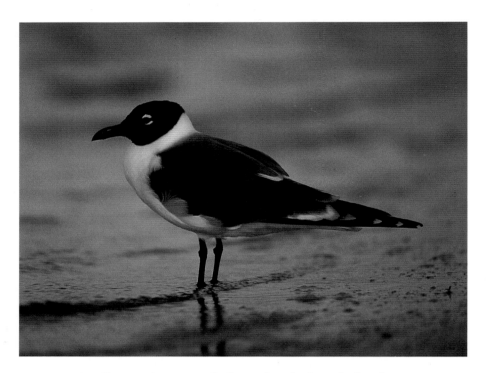

Opportunists, most gulls fly to where food may be found.
The ring-billed gull (OPPOSITE) may soar just above the
waves until morsels living or dead present themselves, or
it may range far inland for insects or human waste. The
increase in human garbage has brought an explosion in
seagull populations. The laughing gull (ABOVE),
named for its ha-ha-ha call, will eat garbage
but rarely strays far from water.

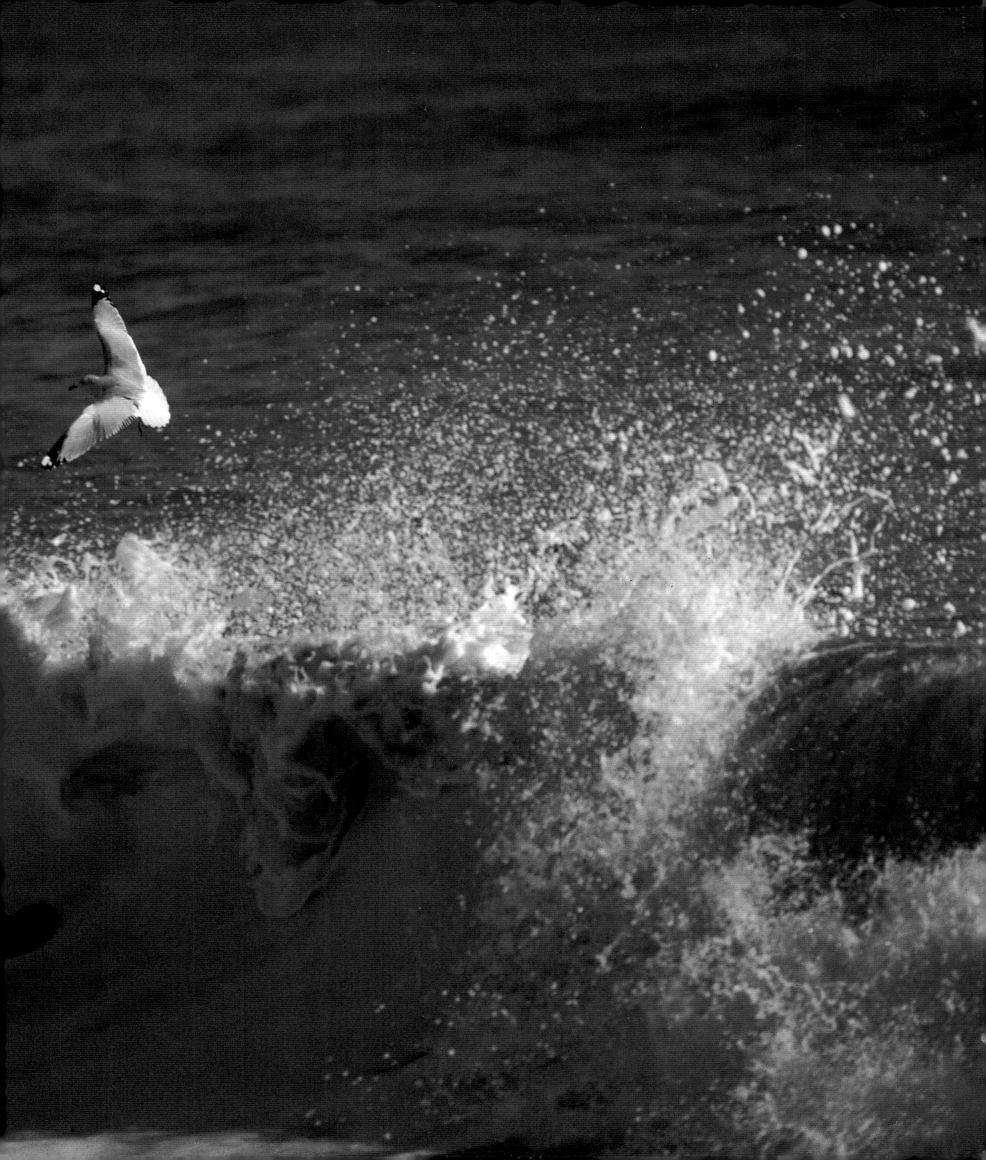

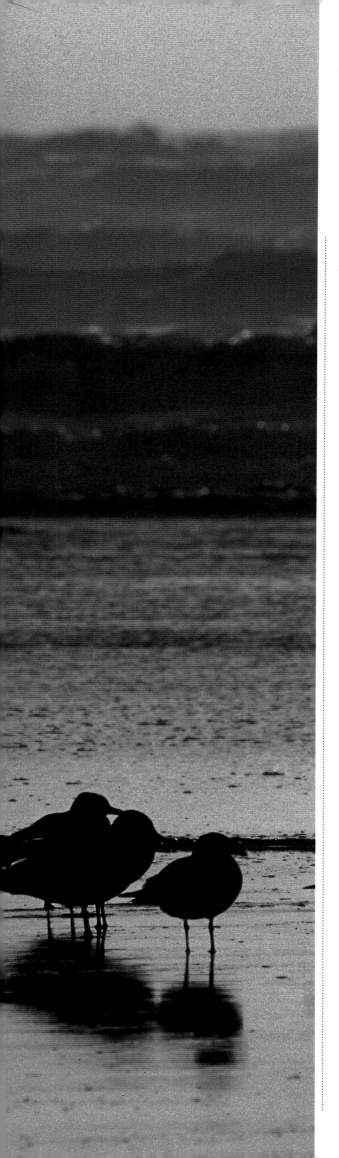

A fraternity of gulls (OPPOSITE)—California, mew, and western—clusters before layers of surf at Gray's Harbor, Washington. Free-ranging gulls defend almost no territory except for a few inches around their nests. Gull chicks are born with eyes open and able to stand, but they stay with the nest for two or three weeks. A ring-bill rests its head on an egg as its sibling begins to emerge (ABOVE).

From under mother's protective wing, a young Caspian tern cries out for food. The male quickly delivers a smelt which the chick grabs as mother seems to look on approvingly. It could be a scene from the "peaceable kingdom" except that Caspians are anything but tender. The male might have robbed the smelt from another parent in the colony, and the next offering could be the chick of a smaller seabird.

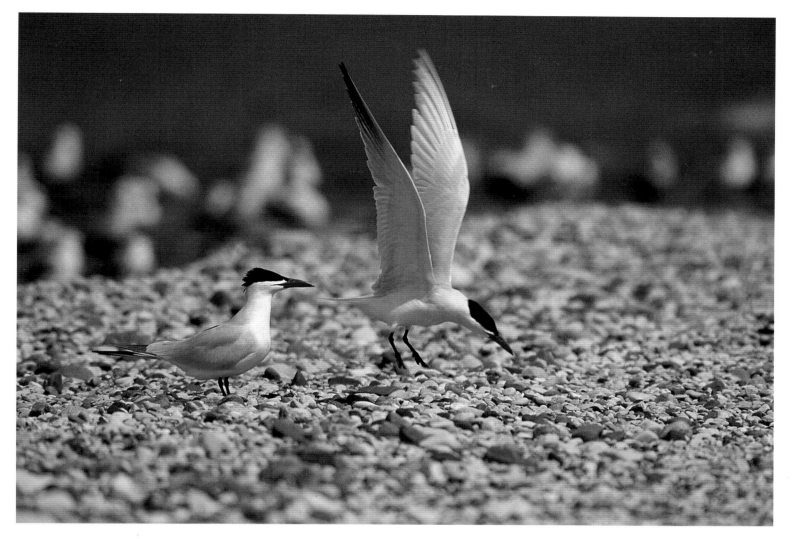

Largest of the terns, the Caspian is often mistaken for a gull. Pointed wings and plunge-diving mark it as a tern, but it often soars like a gull and sometimes paddles on the surface, feeding like one. Fierce Caspians are also among the most doting seabird parents, feeding their young for five to seven months after fledging.

PAGES 216-217
A Forster's tern spreads thirty-inch wings as it drifts over a nesting marsh with a captured fish. The morsel may be a courtship offering. Before presenting herself for mating, females first require numerous food gifts from solicitous males.

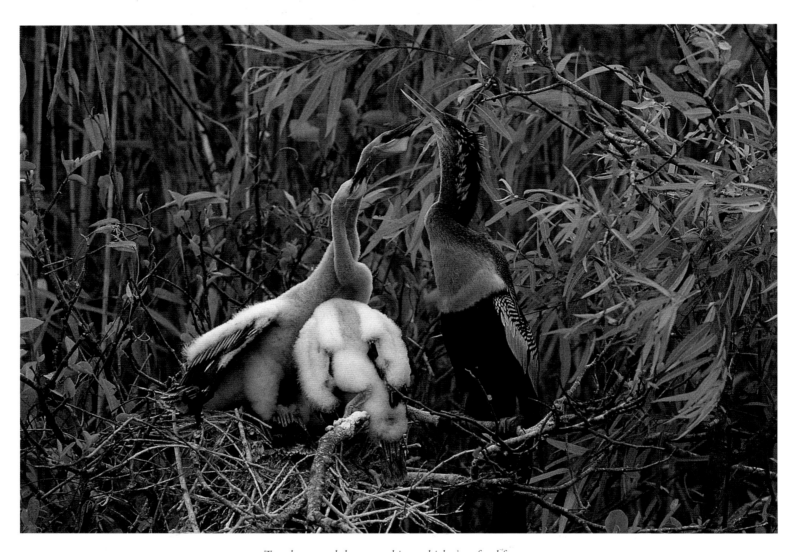

*Two large and downy anhinga chicks beg food from a
returning parent (ABOVE), which will regurgitate so they
can eat. Even on adults, anhinga plumage is so compact
that it looks more like fur than feathers (OPPOSITE).
Agile underwater swimmers, they spear fish with
their sharp beaks and then toss them aloft so
they can be swallowed headfirst.*

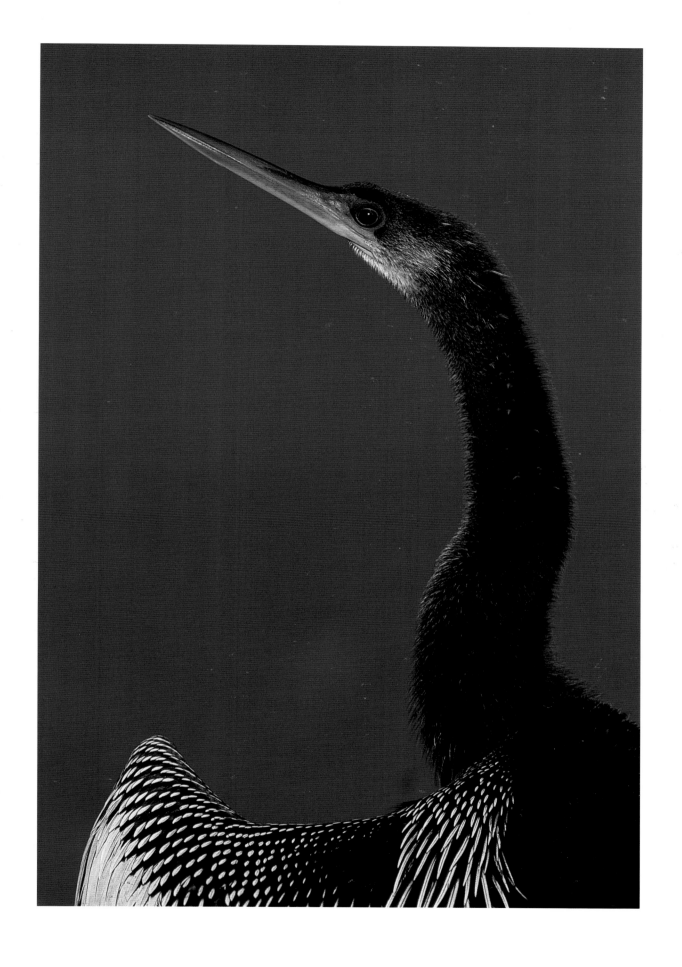

*Mask of the red-faced cormorant (ABOVE) gleams during
breeding season in Alaska's Pribiloff Islands. Males
advertising for mates often hold nesting materials in
their bills. In colonies on far northeastern coasts
(OPPOSITE) common murres build no nests at all
on rocky ledges, but their pear-shaped eggs
roll in tight circles. Pelagic cormorants
share this space with them.*

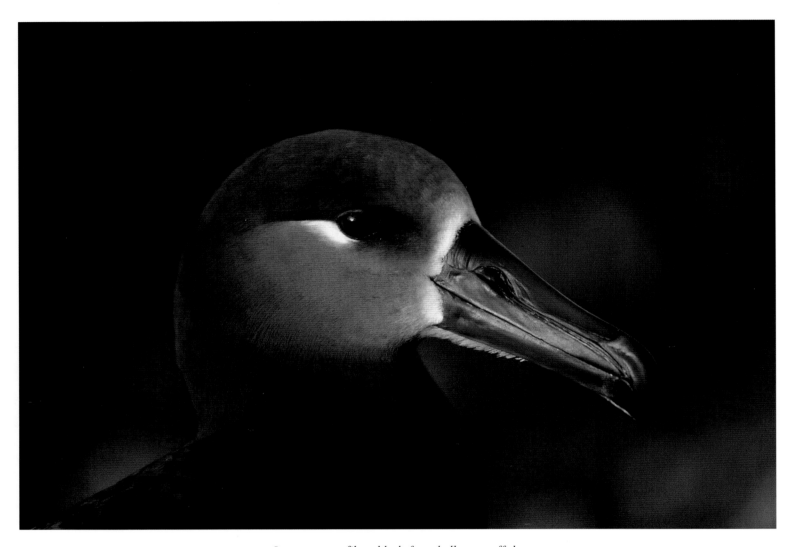

*In coppery profile, a black-footed albatross off the
California coast assumes a noble look. And nobly it soars
on six-foot wingspread behind boats on the west coast,
waiting for offal thrown by fishermen. A pelagic, or
sea-going bird, it has virtually forsaken land except
when it breeds on central and western Pacific
islands, including the Hawaiian archipelago.*

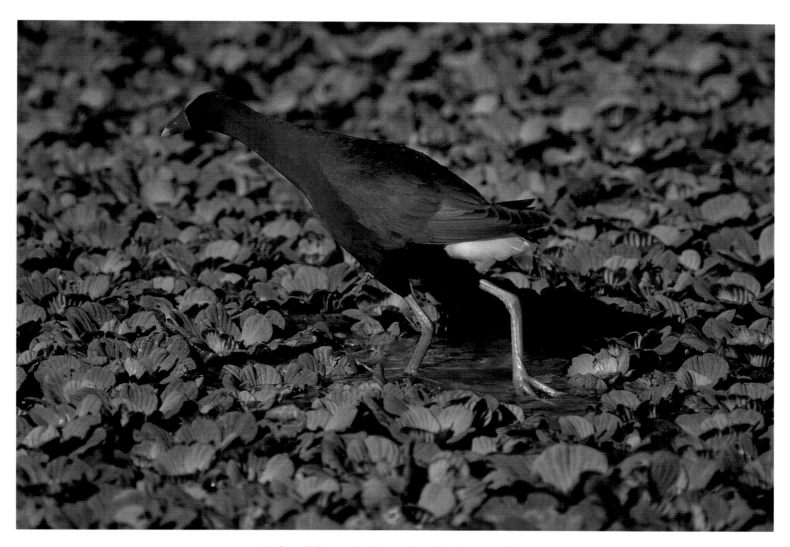

*Bigfoot of the marsh, the purple gallinule can walk on
water if enough vegetation grows in it. Extremely long
toes let it stride across floating plants other birds would
cause to sink. Family birds, gallinules live in groups
of a dozen or more, nonparents helping to feed
the young and defend territory.*

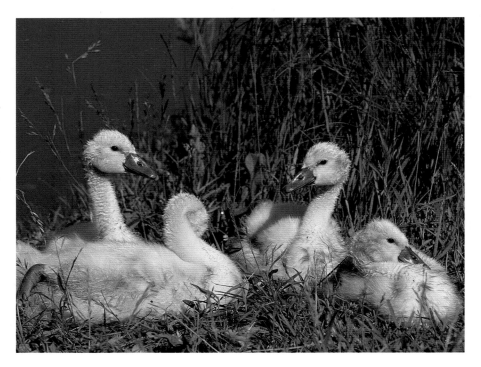

*Mute swan cygnets (ABOVE) are descendants of majestic,
domesticated swans brought from Europe. As twenty-eight-
pound adults they will hiss and snort but remain otherwise
silent. Thousands around the Great Lakes and the East
Coast compete with migrant native swans in winter. At
Swan Lake in Yellowstone, a trumpeter swan (OPPOSITE)
stands in light rain. Pioneers probably shot these
low-flying giants for food along America's
waterways, seriously depleting their numbers.*

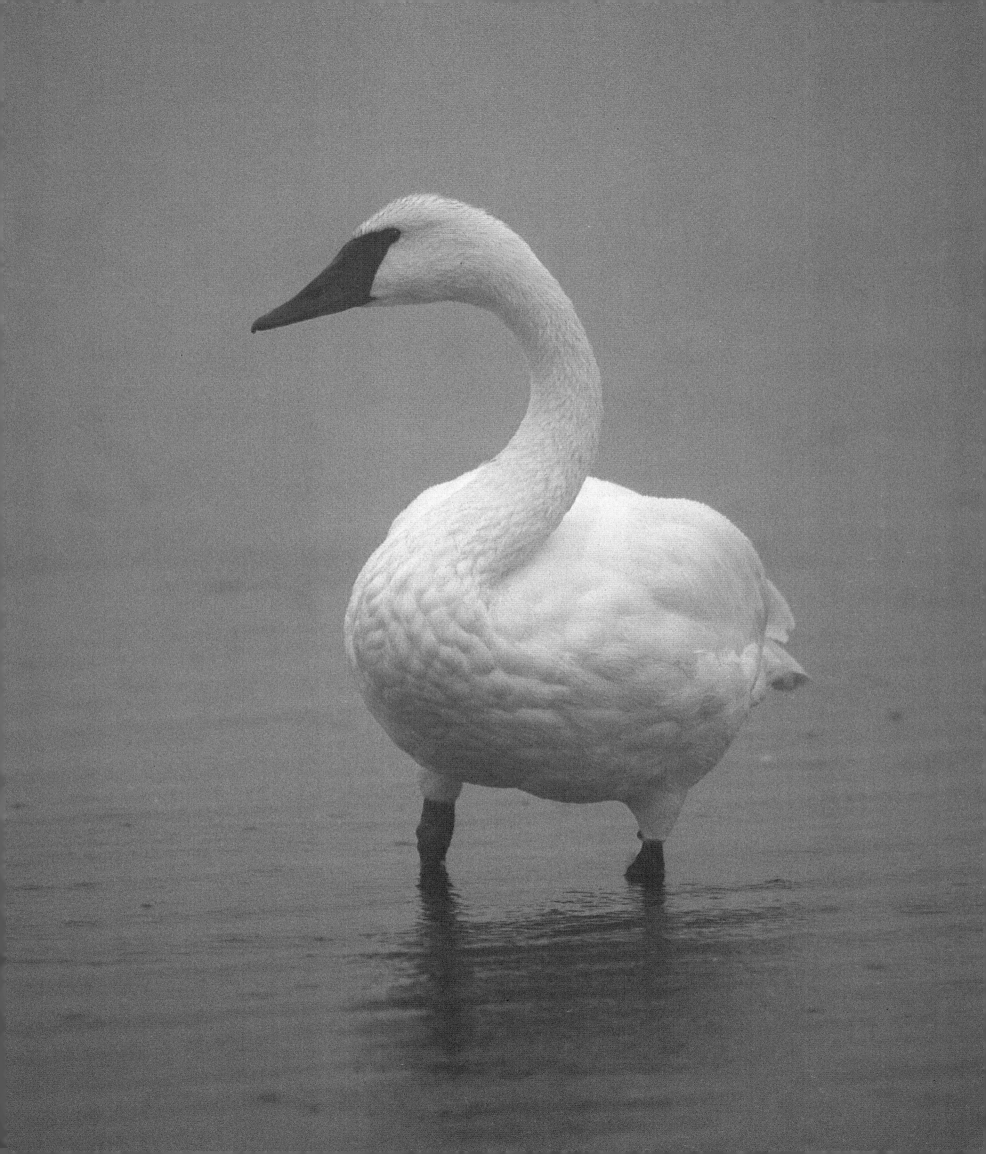

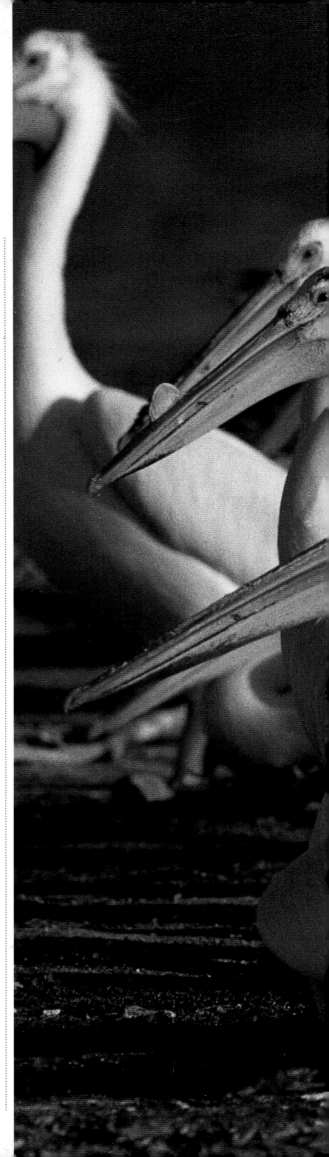

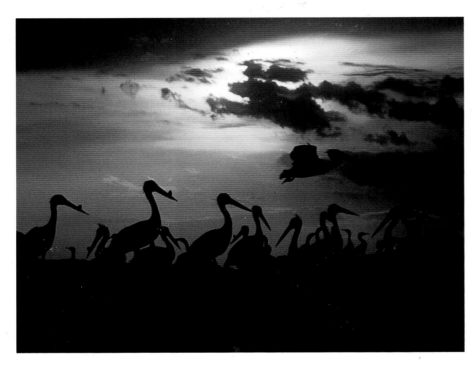

A forest of white pelicans (OPPOSITE) fills a rookery at Lake Winnepegosis in Manitoba. Vertical fibrous plates on the upper mandibles of some will drop off after nesting season. White pelicans swim on the surface and thrust bills in the water to catch fish in expandable throat pouches. Nestlings dip into the three-gallon containers to gorge on the contents. Late day finds the rookery in repose (ABOVE).

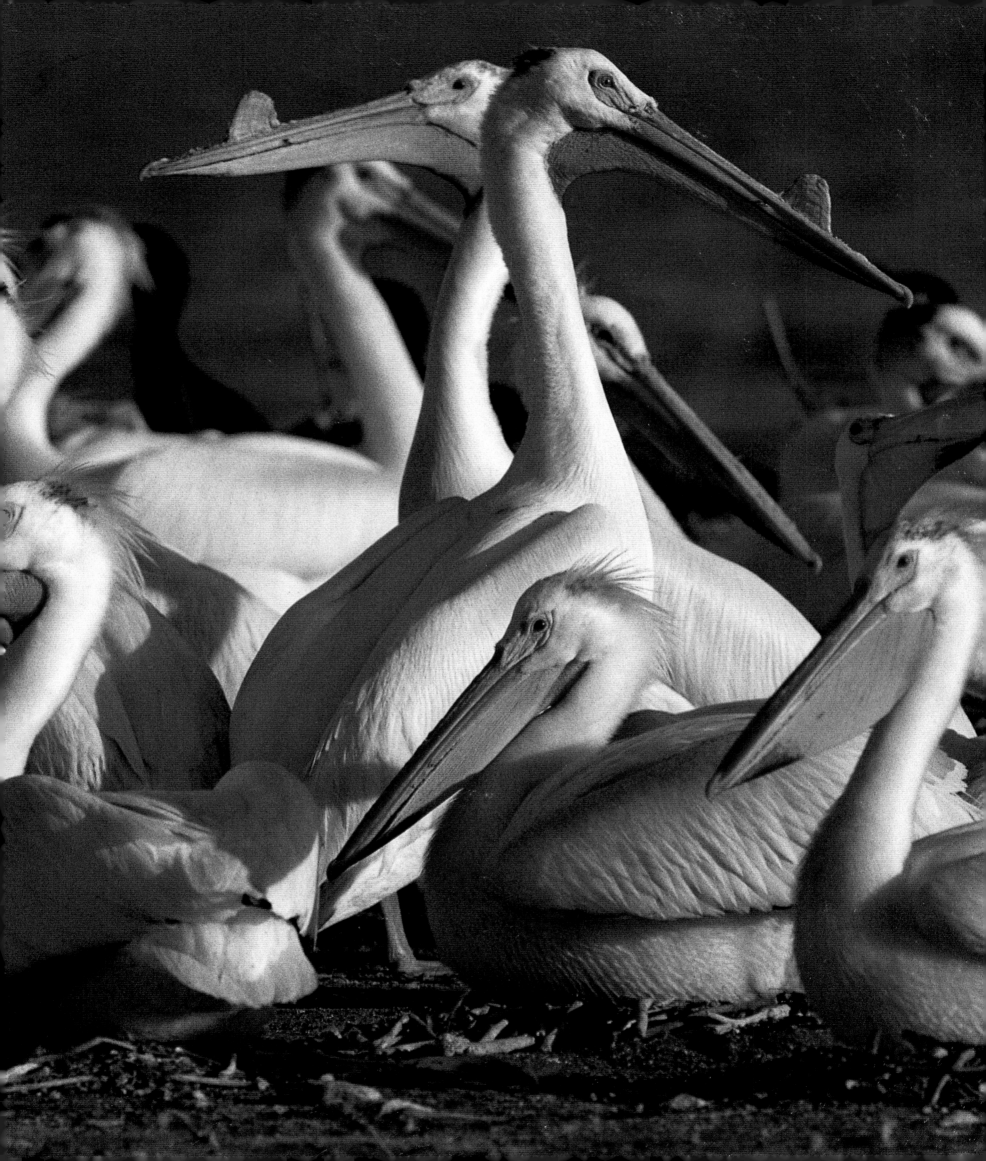

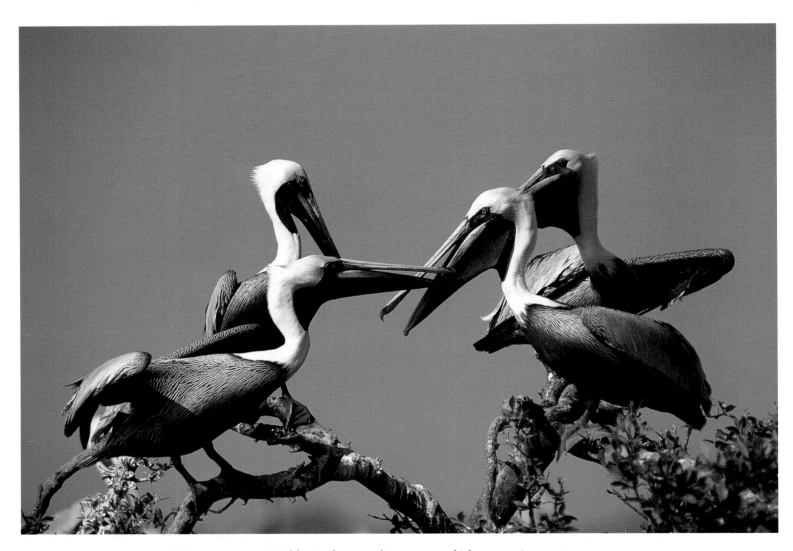

Neighboring brown pelicans (ABOVE) bicker at nesting time. Ungainly on the ground, pelicans are graceful, long-winged flyers and skilled at soaring. Only the browns dive for their food, plunging headfirst to net fish. Tipping the bill downward drains the water so the catch can be swallowed. In a sleeker profile, a pelican (OPPOSITE) displays its empty throat pouch.

Twittering from a California cliff, a pair of pigeon
guillemots announce their breeding bond. With bill
and claws the monogamous couple will scratch out
a rough nest under boulders and between loose
rocks and take turns incubating the eggs.
Diving for seafood, pigeon guillemots
may stay underwater for up
to seventy-five seconds.

*Singing shows off the red mouth of the pigeon guillemot,
most abundant of the auk clan on the California coast.
The equally red webbed feet, set far back, make it an
excellent underwater swimmer but ungainly on land.
Guillemots are related to great auks, flightless birds
two and a half feet tall that were hunted into
extinction in the North Atlantic 150 years ago.*

Crested auklets (ABOVE) spar in the Pribiloff Islands,
their bright orange bills enlarged by extra plating during
breeding season. Curly topknots adorn their foreheads
year-round. With stubby wings they can "fly"
underwater to depths of 200 feet seeking shrimplike
crustaceans. On the other side of the continent an
Atlantic puffin (OPPOSITE), another short-winged
swimmer, takes off from a cliff.

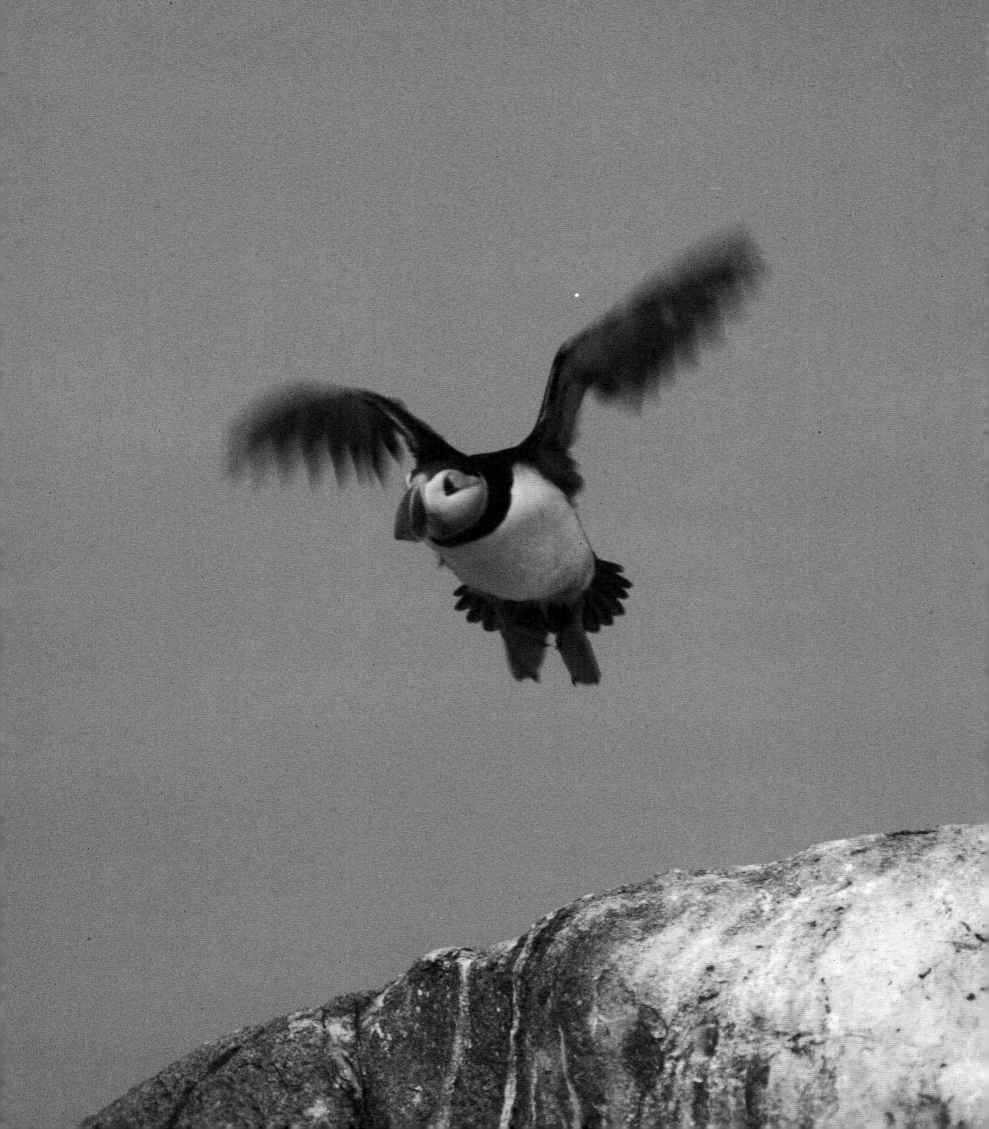

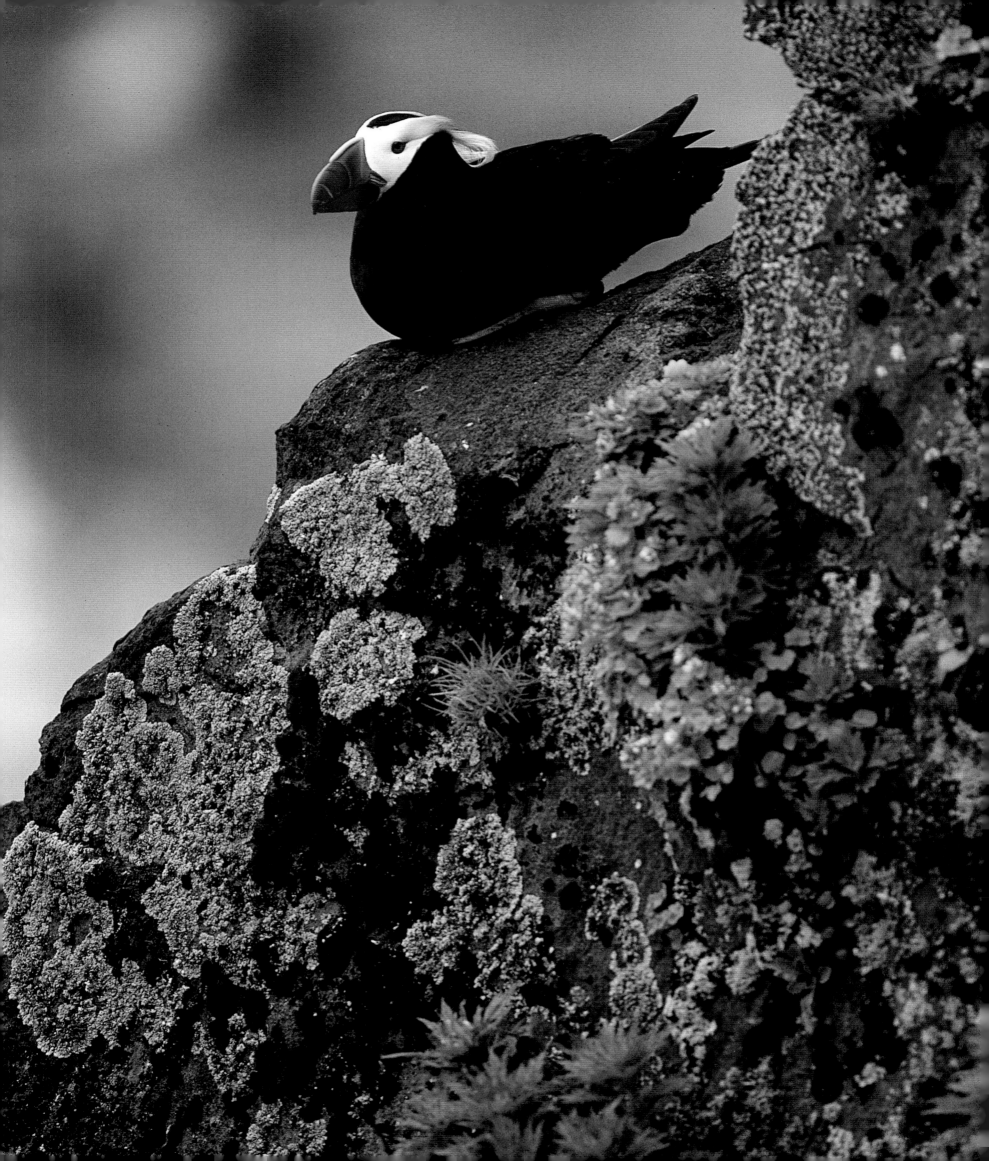

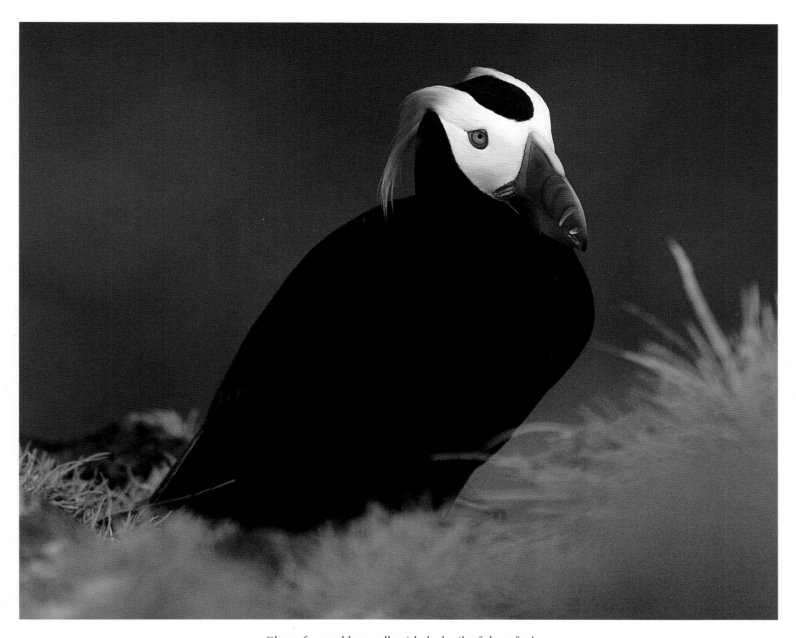

Clown face and long yellowish ducktails of the tufted
puffin are all for show. After breeding season a third of
the colorful beak drops off, the tufts are lost, and the
white face turns dark gray or black. Like other
puffins, the Pacific coast bird swims underwater
after small fish. The massive beak takes
several years to attain adult size.

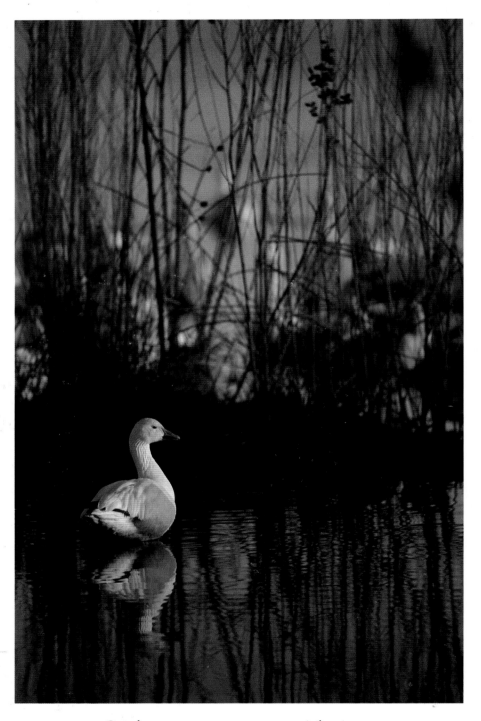

*Canada goose parents (OPPOSITE) stay vigilant in two
directions as they watch over goslings in the central
flyway. North America's most familiar wild goose mates
for life; barring accidents, a pair could stay together 20
years. In its winter home, a lesser snow goose (ABOVE)
mirrors itself in the waters of Bosque del Apache
Wildlife Refuge in New Mexico. The abundant
waterfowl nest on Arctic tundra.*

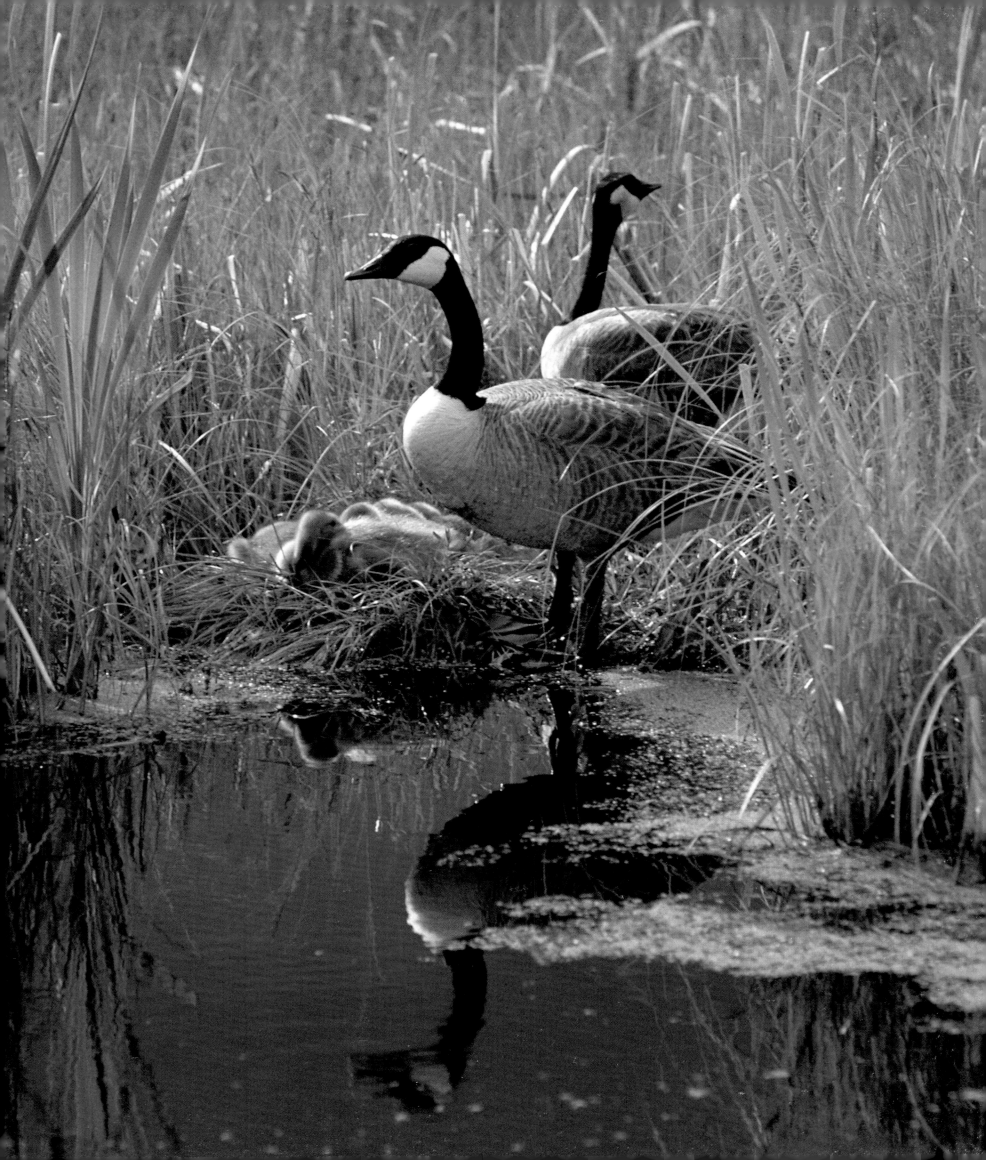

*Stunning headgear highlights many male ducks. Divers in
the northern seas such as the spectacled eider (TOP) wear
extensive down caps to ward off the cold. A king eider
(ABOVE) splashing along the northern Alaska coastline
holds high a rainbow of colors. The continent's
smallest dabbler, the green-winged teal
(OPPOSITE), retreats south in winter but
gives up nothing in head design.*

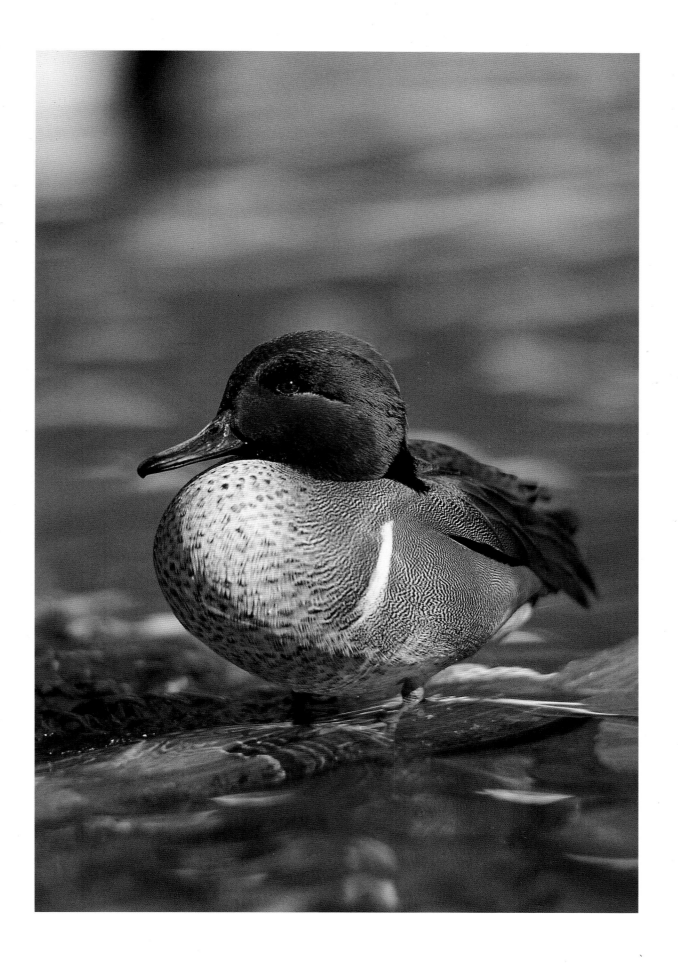

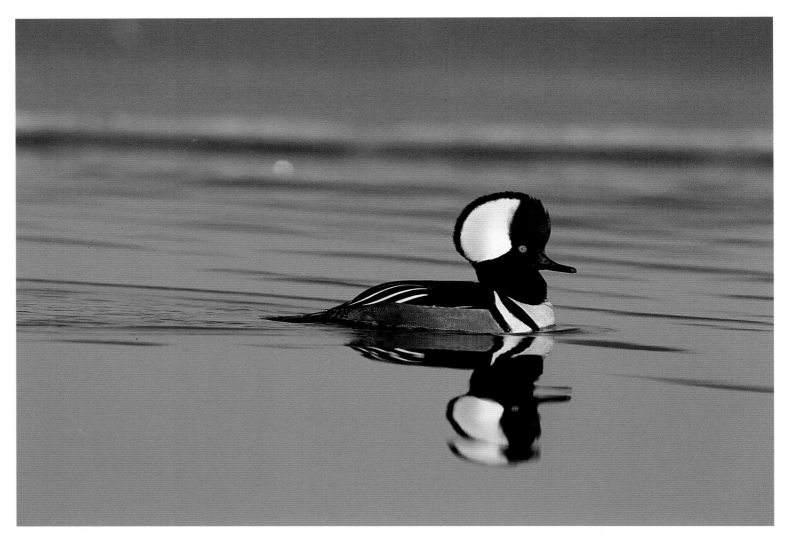

With crest raised when he's excitedly trying to impress a
female, the hooded merganser drake resembles an avian
egghead. Lowered, the white flag appears as a narrow
line. Thin bills of the mergansers are serrated to
better hold on to slippery, darting prey which
they pursue with great skill underwater.

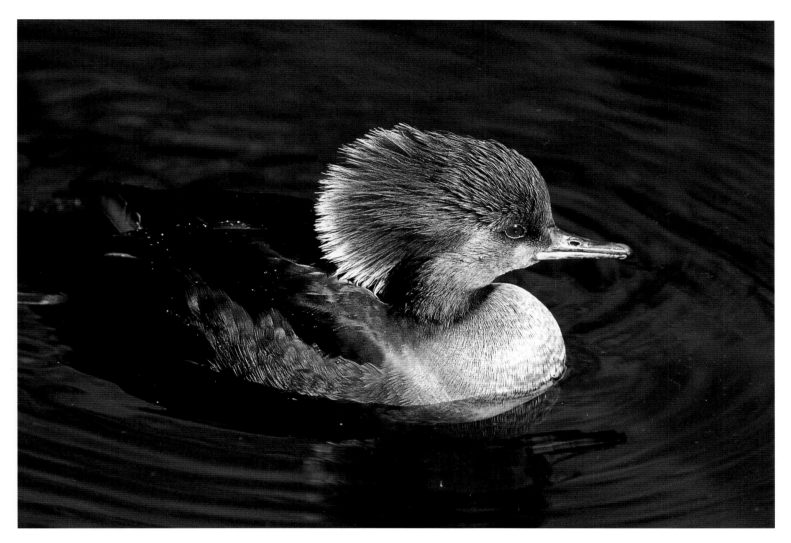

Seemingly indifferent to the courtship antics of the drake,
the hooded merganser hen takes on all the responsibilities
of their brood. Her nest in a tree cavity or man-made
box may be shared with other hens until it contains
nearly a dozen eggs. Ducklings rousted quickly
into the water stick closely to their mother's
side, but some are taken by turtles,
pike, and birds of prey.

PAGES 242-243
A powerful thrust of wings sends a mallard drake
skyward at Bosque del Apache National Wildlife Refuge
in New Mexico. Most abundant of all North American
waterfowl, mallards also breed across Europe and Asia
and are the ancestors of most domestic ducks.

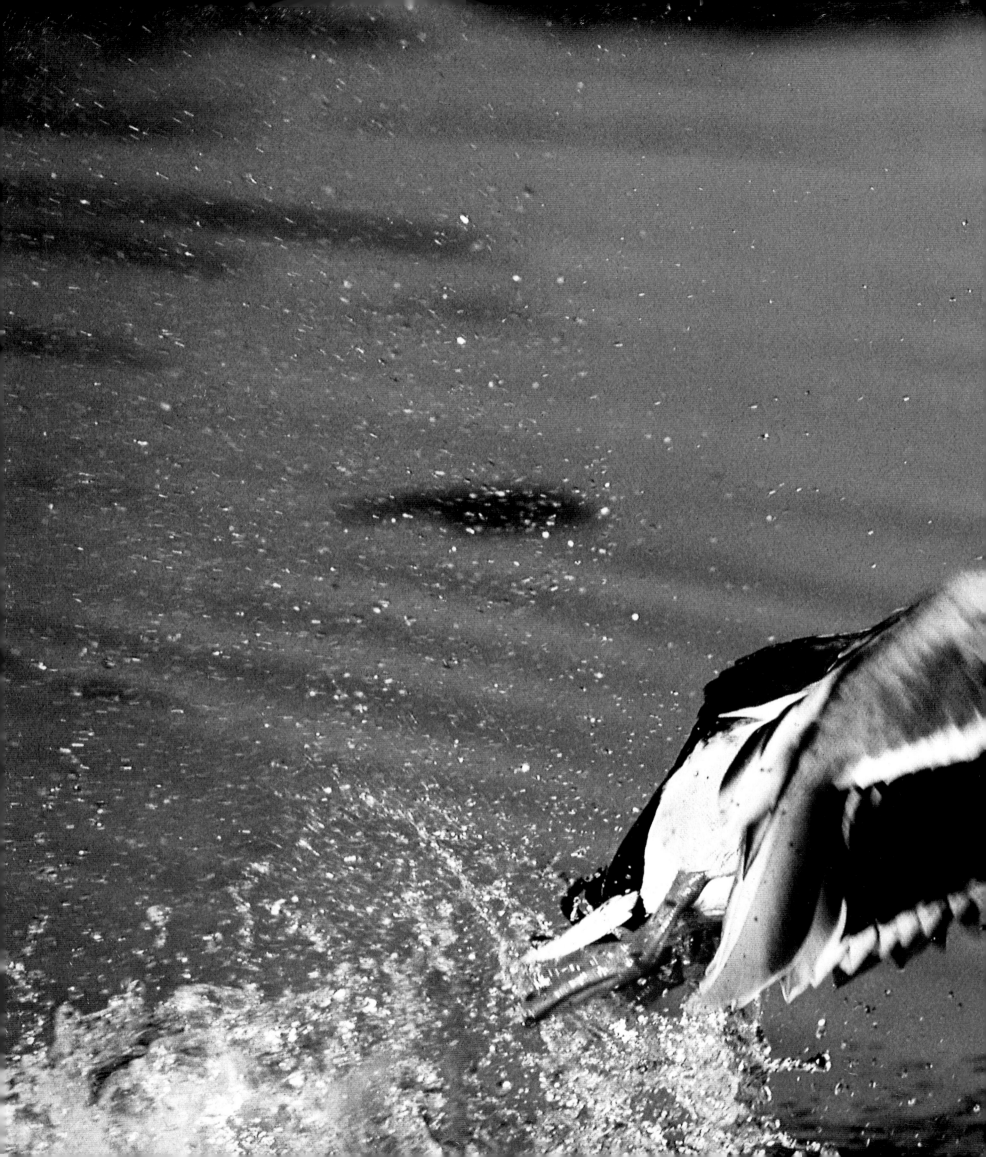

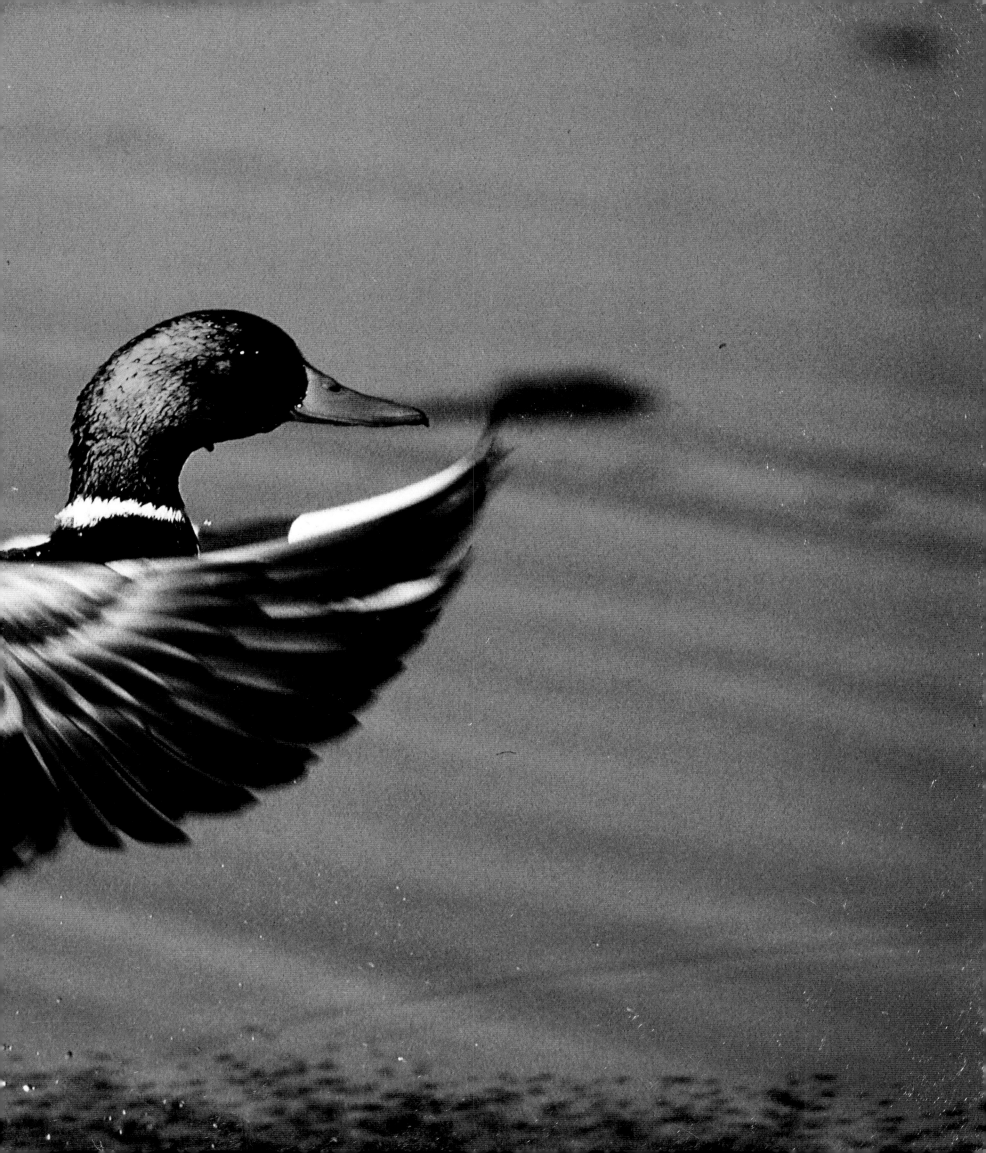

*The cinnamon collar of the ring-necked duck (ABOVE) is
often difficult to see, but the white bands on his bill are
fairly obvious. The pointy-headed bottom-feeder is
highly susceptible to the fatal ingestion of lead shot.
A spiky crest juts from the back of a red-breasted
merganser hen's head (OPPOSITE). Females of
her species may also combine broods
and tend them cooperatively.*

Floating extravaganza, a wood duck drake (ABOVE)
glides through the Oklawaha River in central Florida.
Market-hunted for plumage, food, and eggs, the
spectacular bird verged on extinction in the early
1900s, but has made a comeback. Young in tree
cavities (OPPOSITE) *sometimes leap fifty feet*
to ground or water to join their parents
a day after hatching.

PAGES 248-249
Waterfowl superstar and candidate for most beautiful
bird in the world, a wood duck drake dazzles with its
intricate color. The lives of less-endowed birds
fascinate us as well with their delightful
visitations over the continent.

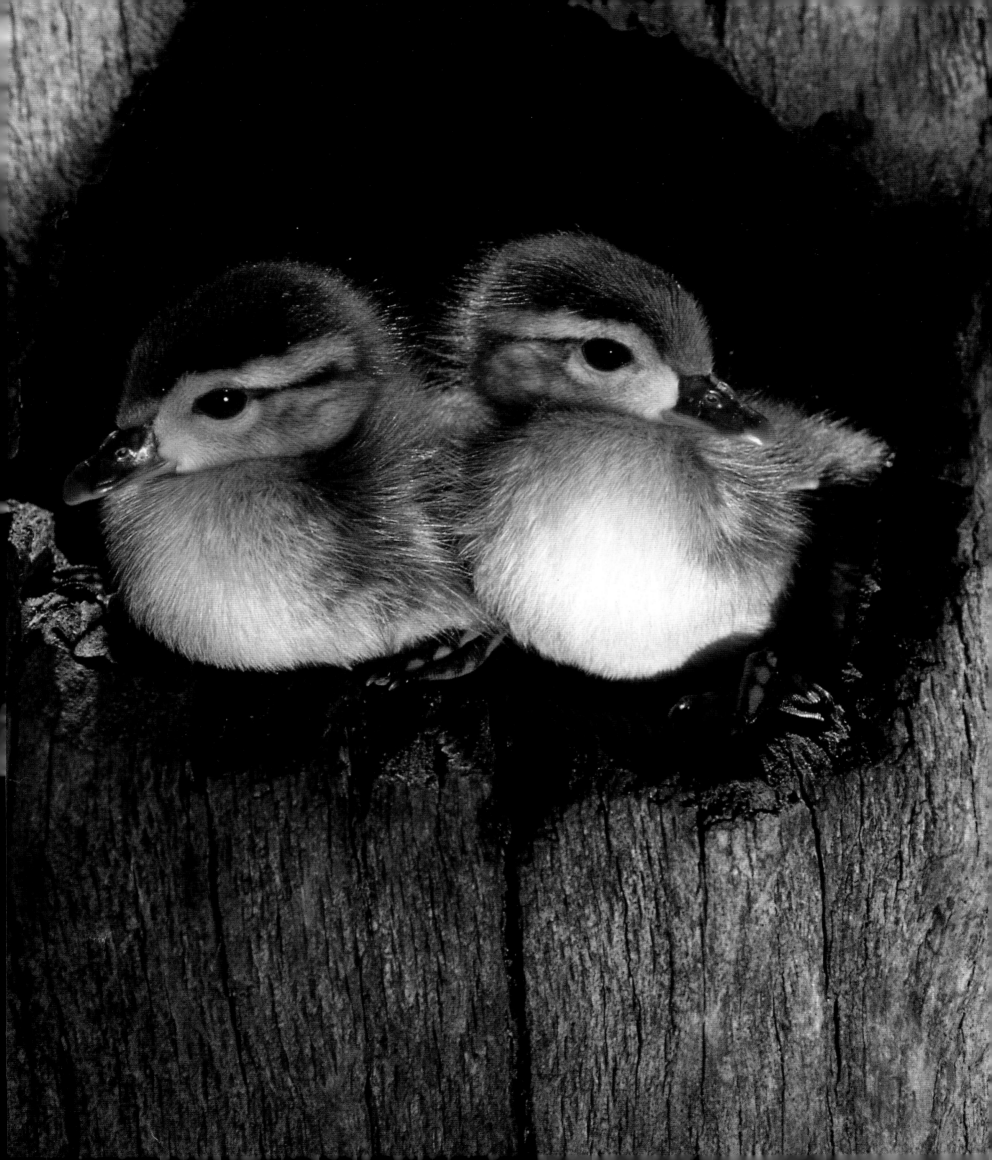

INDEX

THE PHOTOGRAPHERS

ERWIN and PEGGY BAUER have been photographing birds and other wildlife around the world for fifty years. When they are not traveling to remote areas to shoot endangered species, they are at home in Montana's Paradise Valley of the Yellowstone, where they have taken many of their most memorable pictures. The Bauers are the publishers of numerous books, most recently *Yellowstone, Antlers, Wild Dogs of North America,* and *Baja to Barrow.*

BATES LITTLEHALES traveled throughout the world for thirty-seven years as a staff photographer for the National Geographic Society. His second career as a nature photographer has seen him again published in *National Geographic* as well as in the society's other magazines, *World* and *Traveler.* His work has appeared in over fifty books and magazines, including *National Wildlife, Ranger Rick, Reader's Digest, Science World,* and *American Heritage.* Considered a pioneer in underwater photography, Bates also tutors and conducts nature photography workshops.

KEITH LOGAN's large-format prints appear in public, private, and corporate collections in both Canada and the United States, and he has contributed to several books, including *The Wonder of Birds, Earthly Delights,* and *The Last Wilderness.* He lives in the foothills of the Canadian Rockies, where he is able to shoot the variety and diverse habitats of over 20 percent of Canada's nesting species of birds. In addition to photography, Keith also makes fine furniture.

ROD PLANCK turned a childhood fascination with birds into a career as a professional natural history photographer. For twenty years he has traveled and photographed throughout the world, and his shots have been featured in magazines such as *Audubon,*
Sierra, Birder's World, and *Ranger Rick,* as well as several large-format books including *Nature's Places* and *The Spirit of the North.* Rod also works as a tour guide, photographic instructor, and lecturer. He lives in Spruce, Michigan.

CARL R. SAMS II and JEAN STOIK are professional wildlife photographers from Milford, Michigan. Carl learned composition from Jean, who is an art teacher, and Jean learned photography from Carl. Their award-winning photography of loons is featured in *Loon Magic,* and Carl will be the featured artist at the 1997 Northern Wildlife Festival. Together Carl and Jean focus on birds and mammals near their home, photographing the same "families" every year.

ROB SIMPSON's work as a nature photographer has taken him from the Canadian Arctic to the cloud forest of South America. His picture credits include *Stokes Nature Guide, Birds of the Northeast,* and numerous Audubon Society publications, the *NAS Field Guide to North American Birds,* the *NAS Pocket Guide to Songbirds and Familiar Backyard Birds,* and *How to Identify Birds* among them. Rob's work, which concentrates on species that are rare and hard to photograph, can also be seen in many magazines, posters, and postcards.

GEORGE STEWART's photographs of nature often appear on the covers and pages of *Birder's World* and *Wildbird* magazines, as well as in many publications, including Audubon, Sierra Club, and Landmark calendars. His book credits include *The Joy of Songbirds* and *Birds of Prey.* Although he takes all types of nature photographs, George considers capturing birds on film to be the ultimate challenge. He lives in White Lake, Michigan.

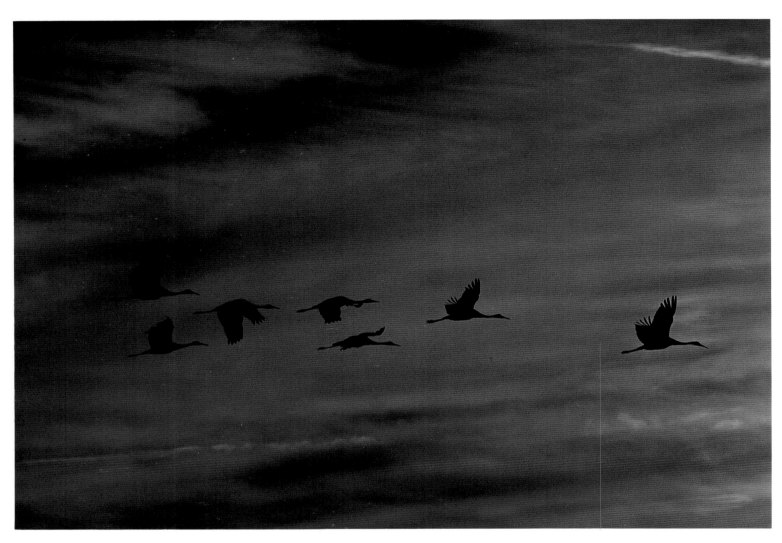

*Sandhill cranes, elegant symbols of North America's
wild bird life, wing past a brilliant sunset.*